PHOTOJOURNALISM
1855 TO THE PRESENT

First published in the United States of America in
2006 by Abbeville Press, 137 Varick Street, New York,
NY 10013

First published in Great Britain in 2005 by Carlton
Books Limited, 20 Mortimer Street, London W1T 3JW

First edition
10 9 8 7 6 5 4 3 2 1

Library of Congress Cataloging-in-Publication Data

Photojournalism 1855 to the present :
editor's choice / [compiled by] Reuel Golden.
 p. cm.
 "First published in Great Britain in 2005 by Carlton
Books Limited."
 Includes index.
 ISBN 0-7892-0895-4 (hardcover : alk. paper) —
ISBN 0-7892-0896-2 (pbk. : alk. paper) 1.
Photojournalism—History. I. Golden, Reuel.

TR820.P54435 2006
070.4'9—dc22
 2005033861

Executive Editor: Stella Caldwell
Art Director: Clare Baggaley
Book Design: SMITH
Jacket Design: Misha Beletsky
Art Editors: Vicky Holmes and Emma Wicks
Picture Research: Sarah Edwards
Production: Lisa Moore

For bulk and premium sales and for text adoption
procedures, write to Customer Service Manager,
Abbeville Press, 137 Varick Street, New York, NY
10013 or call 1-800-ARTBOOK.

Front cover: Fall of the Berlin Wall, 1989. Photograph
© Gilles Peress/Magnum Photos.

Back cover: Invasion of Prague by Warsaw Pact
troops, 1968. Photograph © Josef Koudelka/Magnum
Photos.

Overleaf: A volunteer educator from the Africa
Directions Centre performs a play in a crowded
Lusaka market. The plays performed by the centre's
drama groups aim to educate about HIV and AIDS.
Photograph by Gideon Mendel, 2003.

Pages 6 and 7: Children of a migrant worker from
Oklahoma in a labour camp in California during
America's Great Depression. Photograph by
Dorothea Lange, 1936.

PHOTO-JOURNALISM 1855 TO THE PRESENT

EDITOR'S CHOICE

REUEL GOLDEN

ABBEVILLE PRESS PUBLISHERS
New York London

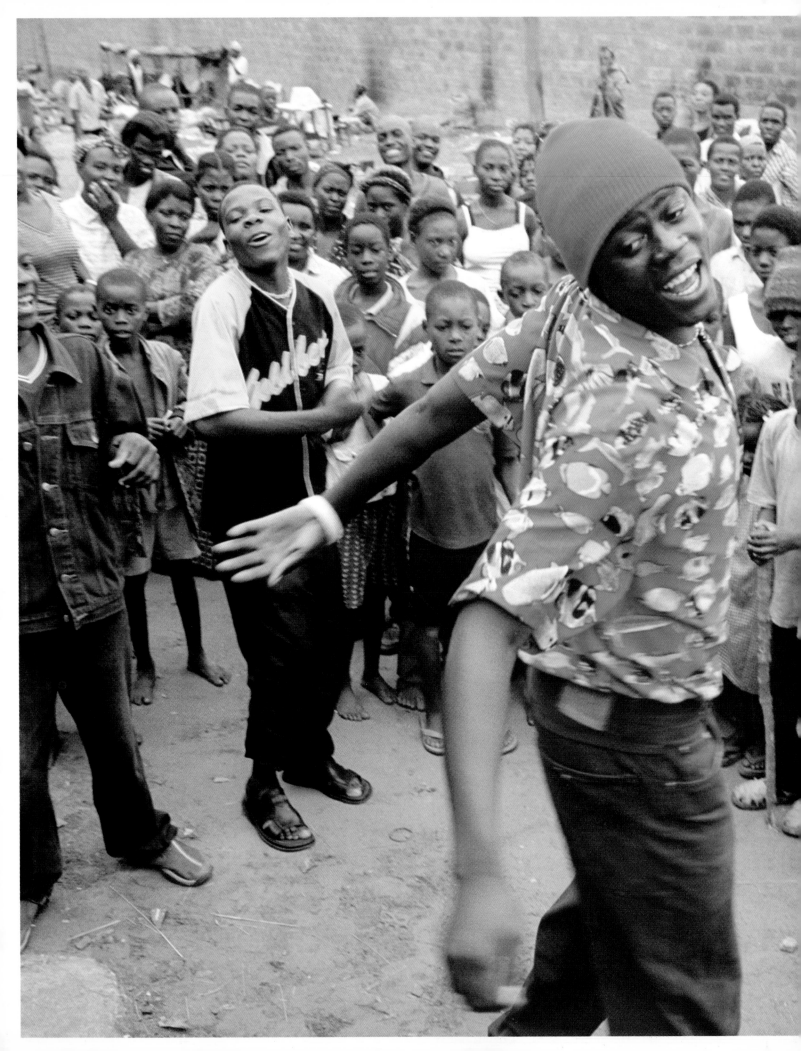

CONTENTS

INTRODUCTION	8
PHOTOGRAPHER BIOGRAPHIES	12
DMITRI BALTERMANTS	18
LETIZIA BATTAGLIA	24
FELICE BEATO	28
IAN BERRY	34
MARGARET BOURKE-WHITE	38
RENE BURRI	42
LARRY BURROWS	46
ROBERT CAPA	52
GILLES CARON	56
HENRI CARTIER-BRESSON	60
LUC DELAHAYE	66
ALFRED EISENSTAEDT	70
ROGER FENTON	74
ALEXANDER GARDNER	80
JAN GRARUP	84
CAROL GUZY	88
BERT HARDY	94
LEWIS HINE	98
HEINRICH HOFFMAN	102
FRANK HURLEY	106
ROGER HUTCHINGS	112
PHILIP JONES GRIFFITHS	116
YEVGENY KHALDEI	120
JOSEF KOUDELKA	124
JOACHIM LADEFOGED	128
JERRY LAMPEN	132
DOROTHEA LANGE	136
GERD LUDWIG	140
DON M^cCULLIN	144
PETER MAGUBANE	148
ALEX MAJOLI	152
MARY ELLEN MARK	156
PETER MARLOW	160
SUSAN MEISELAS	164
GIDEON MENDEL	168
BERTRAND MEUNIER	174
DAVID MODELL	178
RALPH MORSE	182
CARL MYDANS	186
JAMES NACHTWEY	190
ZED NELSON	194
MARTIN PARR	198
JUDAH PASSOW	202
GILLES PERESS	206
RAGHU RAI	210
ELI REED	214
EUGENE RICHARDS	218
HENRYK ROSS	222
SEBASTIAO SALGADO	226
W. EUGENE SMITH	230
JOHN STANMEYER	234
TOM STODDART	238
WEEGEE	242
LI ZHENSHENG	248
INDEX AND CREDITS	252

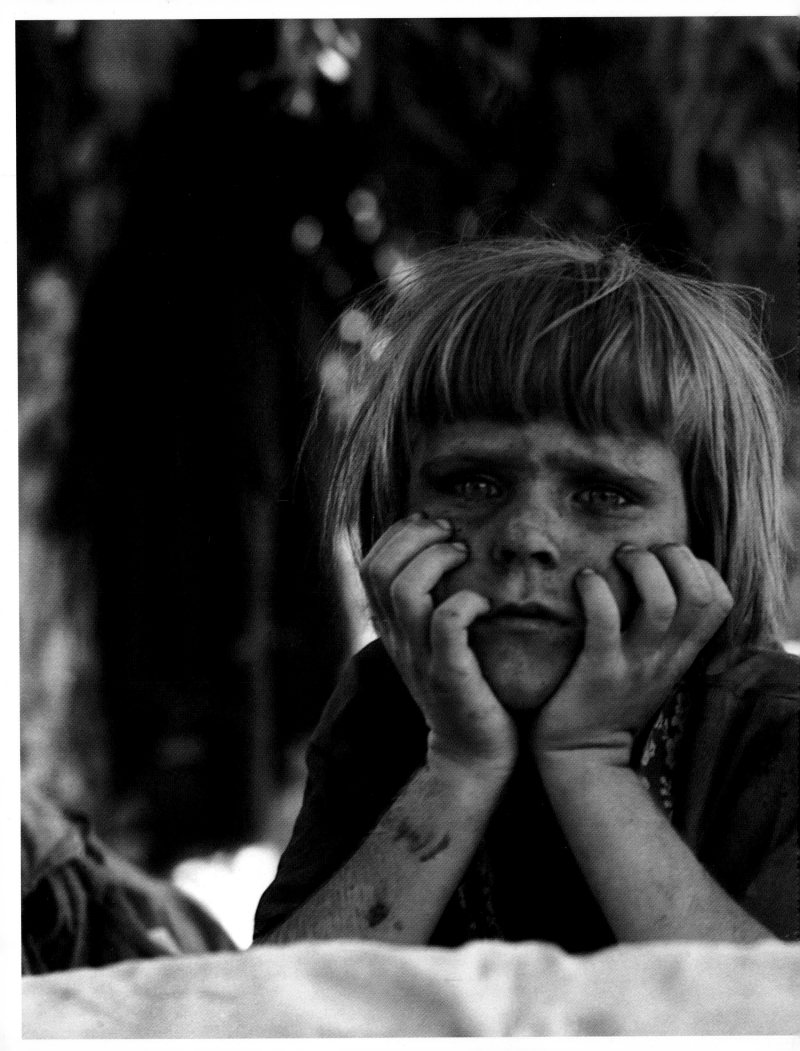

INTRODUCTION

The war in Iraq and its aftermath were relentlessly covered by thousands of television channels from all over the world. Journalists filed reports from burnt-out rooftops, from inside American tanks making their way toward Baghdad, from refugee camps. It was a big story, as war always is, and the 24-hour news channels were anxious not to miss anything — yet invariably they did. From all the hours, days and weeks of moving footage, there is nothing that really lingers in the memory from this strange time. The television coverage was immediate, dramatic and neverending. It showed us a lot, but taught us very little. It is the still photographs of the conflict that are memorable. The famous image of a statue of Saddam Hussein being toppled over by a jubilant crowd was a powerful symbol of repression and subsequent liberation. On the flip side of that, there were the chilling images taken by an anonymous American soldier with a cheap digital camera of Iraqi prisoners being abused by their US captors in the hellhole of Abu Ghraib. When historians look back at this period and try to make sense of what happened, it is these images, as well as photographs taken by people such as Luc Delahaye, Tom Stoddart, Jerry Lampen, James Nachtwey and dozens of others, that will be used as evidence.

Photojournalism's perspective

These photojournalists and all the others featured in this book were the key witnesses to a series of events that together make up recent history. They are our eyes on the world. Great photojournalism witnesses events that we wouldn't necessarily see or be allowed to see, or even want to think about. At its most basic definition, photojournalism is the presentation of stories through photographs — photojournalists are journalists with cameras. Since the inception of the medium, when Roger Fenton photographed the Crimean War in the mid-nineteenth century, photojournalists have been preoccupied with photographing humanity at the extreme edge of existence. War, civil unrest, famine, disease, natural disasters, poverty, homelessness: these are the grim stories told by photojournalists for more than 150 years.

Some critics resent this narrow, bleak viewpoint and continually question why photojournalists focus only on the negative. These are valid criticisms, but they can be rebutted. First, photojournalists are working in a commercial environment where there has always been a demand for this kind of image and story. Sadly, good news has never helped sell newspapers. Second, photographing a harrowing or dangerous event presents the photojournalist with a series of logistical, aesthetic and moral challenges. By challenging themselves, they in turn challenge the viewer on an emotional and intellectual level. The best photojournalism gets us to see and feel what is happening and more importantly forces us to ask "Why?".

The logistical challenge is to get the photograph in the first place; the aesthetic challenge is to make the image as compelling as possible. Often this means beautifying misery and suffering, and the more enlightened photojournalists are conscious of this dilemma. Yet they also realize that a well-composed, attractively toned and perfectly lit print is the most effective way of connecting and engaging an often indifferent audience.

The other moral challenge facing photojournalists is the notion of conveying an objective truth. As bystanders, they are supposed to merely record events and not influence them in any way. In this book there are controversial examples where the photographer supposedly "set up" the shot - the more extreme cases of a photojournalist tampering with the truth. Yet the notion of objectivity is ambiguous, and every time the photojournalist takes a photograph subjective judgements are being made, starting with the fundamental decision about what to photograph and equally importantly what to leave alone. Many factors will influence how the image is perceived and interpreted: how the image is composed and cropped; whether it is shot in colour or black-and-white; the detail that is included; whether the photograph is shot in close-up or the camera is pulled back; the accompanying caption. This doesn't mean that the photographer is not telling the truth; it is just one version of the truth. Click the shutter again and the viewer is confronted with a new version.

The evolution of the genre

There were some remarkable photojournalists in the nineteenth century: the pioneering Roger Fenton, the enigmatic Felice Beato, and Alexander Gardner, who photographed the American Civil War. (He, rather than the more famous Matthew Brady, makes it into this book, since there has always been some controversy over Brady, who claimed sole copyright from all the photographers who worked under him.) Yet overall two factors hindered the development of the medium. Firstly, cameras were extremely bulky and unwieldy contraptions involving glass plates and long exposure times, fine for formal portraiture, but not suited to the spontaneous nature of photojournalism. Secondly, there was no demand for journalistic images, apart from private collectors and museums.

This was to change in the first 20 years of the twentieth century. In 1910 the rotary printing cylinder was invented, which meant that text could now be combined with photographs. Following on from that was the development of the small hand-held camera, the Leica, which was to change the genre forever. Armed with a Leica, a photojournalist could get close to the action, taking photographs in quick succession, as the camera followed the movements of the human eye. These twin developments propelled photojournalism into people's consciousness and homes with a spate of photo-led publications.

This "golden age of photojournalism", as it became known, was roughly to last from the mid-1930s, when *Life* magazine started, to the mid-1950s, with the advent of television. At one point, *Life* was selling by the millions and even by today's standards photographers were being paid a lot of money to shoot stories, $20,000 in the case of the legendary Robert Capa. *Life* magazine loyally served its readers with its use of extended photo essays, where the photographer was

given sufficient space to develop a coherent narrative over page after page.

Photojournalism was perceived as glamorous and the photographers, led by those such as Capa and Cartier-Bresson, had a high self-regard. What they lacked, however, was power. This was to change with the formation of the Magnum photo cooperative in the late 1940s. Magnum established the principle that the copyright of the photograph belonged to the creator. Since one of its founders was Cartier-Bresson, Magnum also played a significant role in elevating the genre from a craft into an art form, and in time photojournalism would be displayed in galleries and reproduced in glossy books. Magnum also created an infrastructure that allowed its members to spend a long time on stories, to reflect, rather than just react to news.

The Second World War shaped the careers of a generation of legendary photographers, such as Robert Capa and W. Eugene Smith. Similarly, the Vietnam War around 20 years later established a new kind of photojournalism, which produced its own legends – photographers such as Larry Burrows, Don McCullin, Gilles Caron and Philip Jones Griffiths. These (sometimes colour) images were brutal in their depiction of war. They were graphic and technically very sharp, since the quality of film and cameras had improved significantly. While Capa saw war in heroic terms, these men clearly identified with the victims of war, rather than with the occupying force. They wanted their photographs to bring about change and to a large extent they succeeded.

Their sensibility, dedication and moral responsibility was adopted by the third generation of war photographers who covered the conflicts in the Middle East in the 1970s and 1980s and in particular the civil war in the former Yugoslavia in the 1990s. Photographers such as Gilles Peress, Luc Delahaye, Roger Hutchings, James Nachtwey, Tom Stoddart, Carol Guzy, Eli Reed and many others were committed, brave and passionate, but less idealistic than their 1960s counterparts. Sceptical and at times distrustful of both their role and the media in general, these photographers also now had digital technology at their fingertips, which revolutionized the taking and transmission of photographs. Images could be taken in a war zone, transmitted down the wire in a matter of just a few seconds and, make it on to the front pages of a newspaper within minutes.

The witnesses

Most of the photographers featured in this book are traditional photojournalists who report from the front-line. Their images of major world events were, and are, seen on the front pages of newspapers. The selection process for a book of this nature is never easy, and inevitably great photographers are going to be omitted. There is not one criterion that justified selection but rather a combination of many factors: technique, originality, consistency, versatility, dedication to the point of obsession to a particular story, political awareness. Above all else, however, everyone in this book has produced memorable and compelling photographs that move us in some way.

There are also photographers here like Martin Parr, Zed Nelson, Sebastião Salgado, W. Eugene Smith and Lewis Hine who are as remarkable as any photojournalist, even though their work falls within the genre of social documentary. This is photography that moves away from the purely dramatic news event and focuses on how we live and interact with each other. These photographers are included in the book because almost all of them started out as "hard news" photographers who then evolved into a different type of storyteller. Boundaries are never clear-cut, and history is not just the unfolding of dramatic events. Social, economic and cultural issues like gun control, migration and tourism are also part of what form, in the words of Henri Cartier-Bresson, the "decisive moments" of history.

The future of photojournalism

People have been writing about the death of photojournalism since the invention of television. Fifty years on, in our celebrity-obsessed world, there might appear to be little room for serious stories and photographs. But even in the "golden age" of *Life* magazine, most of its covers featured film stars and even W. Eugene Smith's seminal essay on the country doctor wasn't a cover story. As long as there are newspapers, current affairs magazines and web sites, there will always be a space for serious news photographs.

There are genuine concerns that the ease with which a photograph can be digitally manipulated means that the camera can indeed lie. Yet photographers have always had the ability to manipulate an image, either by setting a shot up or by making alterations in the darkroom. True, clicking a mouse in Photoshop is a lot easier than spending hours changing a print in the darkroom, but this has made both viewers and the newspapers themselves much more alert to the possibility of anything underhand going on. During the last war in Iraq, the *LA Times* sacked one of its more distinguished photographers for digitally altering the perspective of an image.

Everyone these days has a digital camera or an image-taking device on his or her cell phone. As a result, whatever is going on in the world, there will be someone present who will be able to record it and then sell his or her images to a newspaper or web site. The barriers are therefore being broken down between the committed photojournalist and the amateur snap shooter. There are billions of photographs pinging around in cyberspace and there is a danger of image overload, where we are jaded and feel that we have seen everything there is to see.

Will photojournalism still have an important function in the years to come? The war in Iraq gave us a glimpse into a future where serious photojournalism will simply work in tandem with the amateur opportunist, like the aforementioned American soldier who took those deeply disturbing photographs from the Abu Ghraib prison. If the twenty-first century is as bloody and violent as the century that preceded it, then photojournalism will still have a role to play as an observer and a witness. That is both the bad and good news.

Reuel Golden

PHOTOGRAPHER BIOGRAPHIES

DMITRI BALTERMANTS
RUSSIAN
BORN: POLAND, 1912; DIED: RUSSIA, 1990

Baltermants was born in Poland when it was still a part of Imperial Russia. In 1914, when his father was killed at the beginning of the First World War, he moved with his mother to Moscow. As a child he experienced the turbulent period of the revolution and the civil war. Part of a cultured family, he studied mathematics from 1928 to 1933, and then taught geometry in an artillery school. Self-taught in photography, he worked part-time for *Investia* during this time, then was sent (or "drafted" as he later described it) by the newspaper, official organ of the Communist Party, to photograph the Russian invasion of eastern Poland in 1939. He was active on many of the fronts of the "great patriotic war" and in 1945 he became a photographer on the leading weekly news publication *Ogonyok*. He was the official photographer for Nikita Krushchev's visit to China and for Leonid Brezhnev's visit to the USA.

Key book: *Faces of a Nation: The Rise and Fall of the Soviet Union, 1917–1991* (1996)

LETIZIA BATTAGLIA
ITALIAN
BORN: SICILY, 1935

A journalist by trade, Battaglia turned to photography initially as a means of supplementing her income from writing, then more seriously in the early 1970s when the Palermo communist newspaper for which she worked, *l'Ora*, asked her to become its photo editor. Her work has largely focused on the impact of the Mafia on Sicilian society, although it also contains much more about the daily life of the Sicilian people. She has founded a feminist publishing firm, and became a local municipal councillor for the Green Party, in addition to pursuing a career as a photographer. She is a former winner of the W. Eugene Smith Award.

Key publication: *Passion Justice Freedom: Photographs of Sicily* (1999)

FELICE BEATO
BORN: ITALY OR CORFU C. 1825; DIED: PROBABLY BURMA, C. 1907–08

Beato learnt photography, along with his brother Antoine, from James Robertson (1813–88) in around 1850. He became Robertson's assistant in Malta, then a partner in their work in the Near East, then in Crimea (where they replaced Roger Fenton in 1855) and in India until 1862, before working independently. He was the first Western photographer to reside in Japan from 1863 until 1884, when the failure of his business there led him to the Sudan, then to India and finally Burma, where he established a curio and furniture business.

Key publication: *Of Battle and Beauty: Felice Beato's Photographs of China* (2000)

IAN BERRY
BRITISH
BORN: ENGLAND, 1934

On leaving school, Berry travelled to South Africa in 1952 to work for a family acquaintance, the photographer Roger Madden, who had been an assistant to Ansel Adams. Berry carried out commercial photography, and then began work as a photojournalist. He was a staff photographer on the *Rand Daily News* and then the black *Drum* magazine in 1960, where his political conscience was sharpened. The only photographer at the Sharpeville massacre of 1960, his pictures were not used by *Drum* for fear that the government would close down the magazine. Berry managed somehow to get the pictures to London. He left South Africa in 1961 and joined Magnum in 1962. Assignments have taken him worldwide, documenting Russia's invasion of Czechoslovakia, conflict in Israel, Ireland, Vietnam and Congo, famine in Ethiopia and a long-term project on water.

Key publication: *Living Apart* (1996)

MARGARET BOURKE-WHITE
AMERICAN
BORN: USA,1904; DIED: USA, 1971

In her day, Bourke-White was one of the world's most famous photojournalists, and was immortalized in the Oscar-winning film *Gandhi* (where she was played by Candice Bergman). She took up photography seriously in the mid-1920s while studying at Cornell. Later she moved to Cleveland and started a successful studio, shooting dramatic industrial photographs at night and elegant homes and gardens during the day. She was appointed chief staff photographer of *Fortune* magazine in 1929 after impressing owner Henry Luce. In 1936 she signed on as one of five staff photographers for the new magazine *Life*, a working relationship that would last until the 1960s. During her career she covered everything from the Great Depression to the Second World War and the liberation of the concentration camps. After the war, she worked in Pakistan, South Africa and India and took the last photograph of Mahatma Gandhi before he was assassinated.

Key publication: *You Have Seen Their Faces* (text by Erskine Caldwell), 1937

RENE BURRI
SWISS
BORN: SWITZERLAND, 1933

Burri originally studied design in Zurich, his hometown, taking up photography during his military service between 1953 and 1955. At around this period he came to the attention of Magnum members and was taken under the wing of Cartier-Bresson. He travelled extensively in Europe and the Middle East and in 1959 became a full-time member of Magnum. He then spent six months in South America photographing the gauchos. In the late 1950s and early 1960s he produced two of most famous photo-essays, intimate studies of Picasso and Che Guevara. The latter includes the famous shot of the charismatic revolutionary smoking a cigar. Throughout the 1960s and 1970s he reported from a number of war zones including Vietnam and Cambodia and in the 1980s he went to Beirut.

Key publication: *Photographs* (2004)

LARRY BURROWS
BRITISH
BORN: ENGLAND,1926; DIED: SOUTH-EAST ASIA, 1971

Part of a generation of war photographers who made their name covering the conflict in Vietnam, Burrows worked almost exclusively in the region from 1962 until his death, while on assignment, in 1971. Burrows started his photographic career aged 16 as a lab-room technician in the London offices of *Life*, eventually working his way up to the position of staff photographer on the magazine. Prior to Vietnam, he covered conflicts in the Middle East and the Congo, as well as more gentle assignments such as photographing the Taj

Mahal and British society. During his lifetime he won many awards, including Magazine Photographer of the Year in 1967, and his work appeared on no fewer than 15 *Life* magazine covers.
Key publication: *Larry Burrows: Vietnam* (2002)

ROBERT CAPA
HUNGARIAN (NATURALIZED AMERICAN)
BORN: AUSTRO-HUNGARY, 1913; DIED: INDOCHINA, 1954

Endre Friedman (Robert Capa) was brought up in what was then the Austro-Hungarian Empire. Alienated by the right wing and anti-Semitic Horthy regime, he left for Germany in 1930 to follow studies in political science. Penniless, he found work as a darkroom technician at the Dephot agency. Its editor, Simon Guttman, taught him the emergent techniques of photojournalism, its business principles and the importance of the picture story. He scored his first scoop with his pictures of the Russian Communist, Leon Trotsky. After the rise of Nazism in 1933, he migrated to Paris. He made his name during the Spanish Civil War (1936–39), when *Life* magazine described him as "The world's greatest war photographer". He carried on working through most of the Second World War, and co-founded the Magnum agency in 1947. While photographing "one last war", he was killed when he stepped on a landmine in French Indochina on 25 May, 1954.
Key publication: *Robert Capa: The Definitive Collection* (2001)

GILLES CARON
FRENCH
BORN: FRANCE, 1939; DIED: CAMBODIA, C. 1970

Caron first experienced war during military service in the Algerian colonial war of 1958–61. After working as an assistant to photographer Patrice Molinard, he took up photojournalism first as a member of the Apis agency in 1966, then as co-founder (with Raymond Depardon) of Gamma photo agency in 1967. Dubbed "the French Robert Capa", he covered the Six-Day War in Israel in 1967, conflicts in Vietnam and Biafra (Nigeria) in 1968, the May 1968 student demonstrations in Paris, riots in Northern Ireland in 1969, anti-Soviet demonstrations in Prague in 1969, and the Toubou uprising against the central government in Chad in 1970. On 4 April of that same year his meteoric career was cut short when he went missing in a Khmer Rouge-controlled area of Cambodia. His fate is unknown to this day.
Key publication: *Gilles Caron* (1998)

HENRI CARTIER-BRESSON
FRENCH
BORN: FRANCE, 1908; DIED: FRANCE, 2004

Born to an extremely wealthy family, Cartier-Bresson originally trained as a painter. His decisive moment came in the 1930s, when he discovered the Leica, a light and portable 35mm camera that liberated the composing and taking of photographs. He started out by taking surreal art-based images, but with the rise of fascism his pictures became more photojournalistic and politically motivated. In 1947 he co-founded Magnum, the highly influential photographic agency. He is best known for his concept of "the decisive moment" in photography, a philosophy and working method that is still influencing the way people take photographs today. A tireless traveller, he

spent much of the 1940s, 1950s and 1960s working in places such as China, India, the USA, Cuba and the USSR. By the late 1960s, his interest in photography had waned and he returned to his original love of drawing and painting. He remained a somewhat enigmatic semi-recluse until his death in 2004.
Key publication: *The Decisive Moment* (1952)

LUC DELAHAYE
FRENCH
BORN: FRANCE, 1962

One of the most skilled and versatile photojournalists of the past 20 years, Delahaye has constantly reinvented himself and his audience. Throughout the 1980s and 1990s he worked in Lebanon, Rwanda, Chechnya and Bosnia. In the past few years he has covered the conflicts in Iraq and Afghanistan and been extensively exhibited in the USA and Europe. A member of Magnum for 10 years until 2004, his work has been published all over the world and he is also a contract photographer with *Newsweek*. He has had six books published and won every major award going, including The Robert Capa Gold Medal (twice), the ICP Infinity award, and first prize at the World Press Photo Awards (three times). In 2005 he was the winner of the Inaugural Fine Art Deutsche Borse Photography Prize.
Key publication: *Luc Delahaye: History* (2003)

ALFRED EISENSTAEDT
AMERICAN
BORN: WEST PRUSSIA, 1898; DIED: USA, 1995

A photographer with the Associated Press in Berlin in the early 1930s, Eisenstaedt fled Nazi persecution to start a new life in the USA. He joined *Life* magazine in 1935 as one of five staff photographers when it was still known as "project X". "Eisie" was synonymous with the very best of *Life* and during a career spanning 50 years with the highly influential magazine he shot 80 covers and worked on over 2,500 assignments. He took the photograph of a couple celebrating the end of the Second World War with a passionate embrace in Times Square, which became one of the most famous images of the twentieth century.
Key publication: *Eisenstaedt: Remembrances* (1999)

ROGER FENTON
BRITISH
BORN: ENGLAND, 1819; DIED: 1869

Born into a family of bankers and mill-owners, Fenton initially studied law before turning to painting, receiving an academic training in Paris. Inspired by the Pre-Raphaelites on his return to Britain around 1847–48, he exhibited work in this style at the Royal Academy in 1850–51, but soon thereafter took up photography. From 1852 to 1860 Fenton was enormously active, both as a photographer and as promoter of the new art and profession. He was a founder member of the Photographic Society of London, and the first official photographer of the British Museum. He gave up the medium in 1862, returning to the practice of law until his death.
Key publication: *All the Mighty World: The photographs of Roger Fenton, 1852–60* (2004)

ALEXANDER GARDNER
BRITISH
BORN: SCOTLAND, 1821; DIED: USA, 1882

One of the pioneers of unflinching war photography, Gardner began experimenting with photography in 1851 after seeing an exhibition of Matthew Brady's work. He moved to New York a few years later and started working for Brady's studio. He became an expert in the new collodion (wet-plate) process that was replacing the daguerreotype, gaining a reputation as an outstanding portrait photographer. In 1861 he was part of a team of around 20 photographers sent by Brady to cover the American Civil War. Although Brady did not actually take the photographs, he signed them in his name, a practice that alienated Gardner, who went on to open his own studio in Washington, DC. He later became the official photographer of the Union Pacific Railroad.
Key publication: *Gardner's Photographic Sketchbook of the War* (1866)

JAN GRARUP
DANISH
BORN: DENMARK, 1968

At the age of 15, Grarup began freelancing after school for a local newspaper. In the late 1980s he studied photography at the Danish School of Journalism. While still a student, he began covering various conflicts, beginning with the fall of Romania's communist regime in 1989. After graduating in 1991, Grarup joined the staff of the daily newspaper *Ekstra Bladet*, where he began covering war, conflict and genocide in Europe and the Middle East. Currently a staff photographer for the daily *Politiken*, Grarup is represented by the Rapho agency in Paris. In 2000 he won first place in the World Press Photo awards for his coverage of the war in Kosovo. He is a two-time winner of the UNICEF Children's Award, and a two-time finalist in the W. Eugene Smith memorial fund for humanistic photography.

CAROL GUZY
AMERICAN
BORN: USA, 1956

Guzy originally trained as a nurse, but after graduating she decided to pursue a career in photography. While attending the Art Institute at Fort Lauderdale in Florida, she did an internship at the *Miami Herald* and joined the paper full-time in 1980, working there until 1988. At the paper, she received her first Pulitzer Prize for her work covering mudslides in Colombia. In 1988 she moved to the *Washington Post*, where she still works. Guzy has since won two more Pulitzer Prizes for her coverage in 1995 of the American intervention in Haiti and more recently in 2000 for her work on the plight of refugees from Kosovo.

BERT HARDY
BRITISH
BORN: ENGLAND, 1913; DIED: 1995

A true Cockney, Hardy came from a poor working-class family of seven children. Leaving school at 14 to work in a darkroom for 10 shillings (50p) a week, he wanted to be a successful photographer. A keen cyclist, he managed to acquire an early Leica to take pictures of races, and began to work for picture agencies. From 1940 he worked for *Picture Post*, then was mobilized as an Army war photographer until 1945, during which time he covered major campaigns such as D-Day, the liberation of Paris and the invasion of Germany, as well as the opening of the Nazi concentration camps. He continued with *Picture Post* until

its demise in 1957, when he turned to advertising photography and printing.
Key publication: *Bert Hardy: My Life* (1985)

LEWIS HINE
AMERICAN
BORN: USA, 1874; DIED: USA, 1940

Hine took up the camera seriously in around 1904 to document the life of immigrants on Ellis Island in New York. After meeting Paul Strand in 1905, who encouraged his "sociological" photography, he began to document child labourers in 1907, and shortly after was appointed photographer to the Pittsburgh Survey, a major investigation of living and working conditions in the heavily industrialized city. From 1908 he served as staff photographer for the National Child Labor Committee, travelling the southern and eastern states to document working conditions in factories, mines and farms. From 1917 to 1920 the Red Cross sent Hine to photograph wartime conditions in Europe. In 1920 he began as series of Work Portraits, and in 1930–31 he photographed the last stages of construction of the Empire State Building.
Key publication: *America and Lewis Hine: Photographs 1904–1940* (1997)

HEINRICH HOFFMAN
GERMAN
BORN: GERMANY, 1885; DIED: GERMANY, 1957

The son of a photographer, Hoffman worked in his father's photography shop until 1914 when he joined the German Army as an official photographer. His first book of photographs, based on his experiences in the First World War, was published in 1919. In 1920 Hoffman joined the Nazi Party, (NSDAP) and became friendly with Adolf Hitler. Named as Hitler's official photographer, he was a close associate and travelled widely with him. Between 1920 and 1945 he took hundreds of thousands of photographs of the Nazi leader. Hoffman became extremely wealthy and politically influential, and was elected to the Reichstag in 1940. Arrested in 1945 by the Allies, he was sentenced to 10 years' imprisonment in 1947 for war profiteering.
Key publication: *Hitler Was My Friend* (1955)

FRANK HURLEY
AUSTRALIAN
BORN: AUSTRALIA; 1885; DIED: AUSTRALIA, 1962

Australia's most famous photojournalist, Hurley was present at some of the key moments of twentieth-century history, including both world wars and as the official photographer for Ernest Shackleton's expedition to Antarctica, aboard the *Endurance*. He originally ran away to work on the docks aged 14, and at 17 bought his first camera. In 1910, aged 25, he went on his first trip to the Antarctic with the Australian explorer Douglas Mawson, and this was the start of a career of relentless travelling. Almost immediately afterward, he went on his most famous voyage accompanying Shackleton for 22 months between 1914 and 1916. In 1917, he became official photographer for the Australian army during the First World War and was a witness to the third battle of Ypres. Between the wars he returned to Antarctica and worked in New Guinea, the Middle East, Europe and the USA. He was also a keen filmmaker. During the Second World War he repeated his role as a photographer for the Australian army.
Key publication: *South with "Endurance": The Antarctic Photographs of Frank Hurley* (2001)

ROGER HUTCHINGS

BRITISH

BORN: ENGLAND, 1952

After studying documentary photography at Newport, Wales, Hutchings started freelancing for the *Observer* in 1983, and a year later joined Network Photographers. Between 1986 and 1990 he worked in Sudan, Sri Lanka and India and covered the fall of communism in Eastern Europe. Between 1992 and 1997 he worked extensively in Bosnia and Croatia documenting the conflict and break-up of Yugoslavia. He has also photographed stories from Haiti, Turkey and Berlin. In recent years he has moved away from traditional market-led photojournalism and turned his attention to the fashion industry, leading to a book collaboration with Giorgio Armani in 2002. He is presently working on another book, *Armani in China*. A winner of every major photojournalism award, he has also chaired the World Press Photo awards.

Key publication: *Bosnia* (2001)

PHILIP JONES GRIFFITHS

BRITISH

BORN: WALES, 1936

Jones Griffiths started his career freelancing for the Manchester *Guardian* and the *Observer*. In 1962 he covered the Algerian War, which started a life-long career documenting conflict. He photographed the Vietnam War from 1966 to 1968, returning in 1970. In 1971 he published *Vietnam Inc*, the definitive photographic account of the war, which mobilized public opinion and helped bring the conflict to an end. He has also worked extensively in the Middle East, Cambodia, Thailand and Northern Ireland. An associate member of Magnum since 1967, he was also President of the cooperative for five years. His work has appeared in every major magazine in the world and he has shot assignments in 120 countries.

Key publication: *Vietnam Inc* (1971)

YEVGENY KHALDEI

RUSSIAN

BORN: UKRAINE, 1917; DIED: RUSSIA, 1997

Khaldei was fascinated by photography from childhood, and at the age of 15 made his first camera from a cardboard box and his grandmother's spectacles. In 1936 he joined the official Soviet press agency TASS, and his work took him to all the major theatres of war – from 1941 to 1945 as a member of the Red Army. Despite the popularity of his work among the Soviet leaders, from Stalin to Gorbachev, his career suffered on a number of occasions because of anti-Semitism, and he was forced to retire in 1972. It was only after the collapse of communism in 1991 that Khaldei's work became known in the West.

Key publication: *Witness to History: The Photographs of Yevgeny Khaldei* (1997)

JOSEF KOUDELKA

CZECH (FRENCH CITIZEN FROM 1979)

BORN: MORAVIA, 1938

Koudelka took up photography as an adolescent, when he befriended a local baker who was an enthusiastic amateur photographer. At this stage of his life he was also obsessed with aeroplanes and trained as an aviation engineer, a career he followed from 1961 until 1967, when he became a full-time photographer. Active as a freelance from 1961, in theatre and in a long-term project on Slovakian gypsies,he took pictures of the Soviet invasion of Prague in 1968 that were smuggled to the West and published to great acclaim. He left Czechoslovakia in 1970 and was officially stateless until 1979, though he had political asylum in the UK. Koudelka became a member of Magnum in 1974. He has worked long-term on a project about gypsies throughout Europe.

Key publication: *Exiles* (1988)

JOACHIM LADEFOGED

DANISH

BORN: GERMANY, 1971

After his original dream of becoming a professional football player was curtailed by injury, Ladefoged studied at the prestigious state-run Danish School of Journalism. His first job was on a small regional newspaper in Denmark. In 1995 he moved on to become a staff photographer at the national newspaper *Politiken*. Between 1997 and 1999 he worked extensively in Albania, Japan, China and the Yemen; he covered the 2004 Olympic Games and most recently the tsunami in South-East Asia. He is the newest member of the prestigious photo collective VII and in a short career has already won three World Press Photo awards, the first ever Dane to do so, and the Essie Award/LIFE Magazine award for Best Photo Essay in 2000.

Key publication: *Albanians* (2000)

JERRY LAMPEN

DUTCH

BORN: HOLLAND, 1961

Lampen's first career was as a professional actor, but after meeting a photographer in 1981 who gave him an idea for a photo, which was published a week later in a newspaper, Lampen gave up the stage for good. He started working for various Dutch agencies and two of the country's biggest newspapers, shooting a variety of domestic stories. In 1990 he started freelancing for Reuters and in 1992 joined the agency on a full-time basis. Now one of its star photographers, he has covered the Olympics and the World Cup, and has shot in Gaza, Pakistan and Iraq. A World Press Photo award winner, he has also won the Photographer of the Year award in the Netherlands.

DOROTHEA LANGE

AMERICAN

BORN: USA, 1895; DIED: USA, 1965

Lange, who had studied under the pictorialist Clarence White and worked for a time with Arnold Genthe, started her own successful portrait studio in San Francisco in 1918 and married painter Maynard Dixon two years later. She abandoned portraiture in the early 1930s after discovering documentary photography. In 1935 she divorced Dixon to marry the economist Paul Taylor, with whom she collaborated for the rest of her life. She took photographs for various government agencies, most notably the Farm Security Administration, between 1934 and 1945. With Taylor, she published *An American Exodus* in 1939, and in 1940 became the first woman to win a Guggenheim Fellowship for photography. Sidelined by health problems after the war, she resumed work in the early 1950s, co-founding *Aperture* magazine with Ansel Adams and others, shooting for *Life* magazine and travelling the world with Taylor.

Key publication: *Dorothea Lange: Photographs of a Lifetime* (1998)

GERD LUDWIG

GERMAN

BORN: GERMANY, 1947

After studying photography in Essen, Ludwig graduated in 1972. The following year he co-founded VISUM, Germany's first photographer-owned photo agency. In 1975 he moved to Hamburg and started working for *Stern*, *Geo*, *Spiegel*, *Time* and *Life*. In 1984 he moved to New York and continued shooting travel stories for all the major publications. In the early 1990s he signed as a contracted photographer for the *National Geographic*, focusing on the social changes in Germany and Eastern Europe. Now based in Los Angeles, Ludwig has photographed in over 70 countries and his work has been exhibited extensively in Europe and the USA.
Key publication: *Broken Empire: After the Fall of the USSR* (2002)

DON McCULLIN

BRITISH

BORN: ENGLAND, 1935

Brought up in a working-class district of north London, McCullin worked initially in a commercial art studio, and learnt photography in the RAF during National Service, 1953–55. His pictures of a North London gang (first published in 1959) brought him acclaim, and he began a freelance career for the London press until 1966, when he joined the *Sunday Times Magazine* as a staff photographer, a post he held until 1983. Since 1961 he has photographed conflicts, famines and human disasters throughout Europe, Africa, Asia, the Middle East and South America – interspersed with travel and landscape photography.
Key publication: *Sleeping with Ghosts: A Life's Work in Photography* (1996)

PETER MAGUBANE

SOUTH AFRICAN

BORN: SOUTH AFRICA,1932

Magubane started working for the influential *Drum* magazine in 1954, first as a driver, then as a darkroom assistant. A year later he got his first assignment covering the ANC convention. He later covered the Treason Trials and the Sharpeville massacre in 1960. Between 1963 and 1964 he worked in London as a freelance, returning to South Africa in 1966. From 1967 to 1980 he worked for the *Rand Daily Mail*. In 1976 he documented the Soweto student uprisings, which brought him international recognition and a number of awards. He was there to photograph the release of Nelson Mandela, but now has moved away from photojournalism and concentrates on travel and fine art photography.
Key publication: *Magubane South Africa* (1978)

ALEX MAJOLI

ITALIAN

BORN: ITALY, 1971

A full-time photographer since 1986, Majoli joined the Grazia Neri agency, Italy's leading photographic agency, in 1990, and remained there until 1995. In that period he covered religions in Italy, as well as the new Republic of Macedonia and post-communist Albania. He also went to Yugoslavia several times to cover the conflict. In 1994 and 1995 he produced his most famous project, documenting the closure of the notorious Leros mental asylum in Greece. He has worked in Brazil, China, Congo, Iraq and all over Europe. His photographs have appeared in *Newsweek*, *National Geographic*, the *New*

York Times and *Vanity Fair*. Since 1997 he has been shooting a long-term essay on port cities in various parts of the world. At the time of going to press, he was working on a book on the US Democratic National Convention of 2004. He has been a full-time member of Magnum since 2001.
Key publication: *Leros* (2004)

MARY ELLEN MARK

AMERICAN

BORN: USA, 1940

After graduating in 1964 with a Masters degree in photography, Mark spent the next two yeas working in Europe and New York. In the late 1960s and early 1970s she started supplementing her photojournalism with shooting production stills on the sets of Hollywood movies. Working on *One Flew Over the Cuckoo's Nest* inspired her to produce her famous essay on a mental hospital, called *Ward 81*. In the 1970s she started working in India and completed a project on prostitutes in Bombay called *Falkland Road*. In the 1980s she shot a seminal essay on Seattle's street children called *Streetwise* and spent several years photographing the troubled Damm family of Los Angeles. Her work has appeared in the world's leading publications and she has won many photographic prizes including the Cornell Capa Award from the International Center of Photography. She has also published 14 books.
Key publication: *Mark Ellen Mark: American Odyssey* (1999)

PETER MARLOW

BRITISH

BORN: ENGLAND, 1952

Marlow graduated with a degree in psychology. His first job as a professional photographer was working for Cunard on a cruise ship. He later joined the prestigious Paris-based photographic agency Sygma and covered the war in Lebanon and the revolution in Iran. In 1980 he joined Magnum and moved away from war photography toward more social documentary work. During the 1980s he worked on his epic project on Liverpool and in 1991 was given an assignment by the French government to photograph Amiens. During the 1990s he was also working on *Non Places*, a body of work on fragmentary landscapes. His work has appeared in *GQ*, the *Sunday Times*, *Arena* and the *Independent*. He has also had solo shows in Japan, Liverpool and London.
Key publication: *Liverpool – Looking out to Sea* (1993)

SUSAN MEISELAS

AMERICAN

BORN: USA, 1948

Meiselas first studied photography while at Harvard, where she received her MA in visual communication. Between 1972 and 1973 she ran workshops for teachers and children in the South Bronx. Her first major photography project was *Carnival Strippers*, for which she spent three summers travelling with her subjects across the USA. She spent two years covering the civil war in Nicaragua and became a full member of Magnum in 1980. In the 1980s she also documented the civil war in El Salvador, where she photographed the unmarked graves of four American nuns, which prompted a US congressional investigation. Throughout much of the 1990s she worked on a visual history of Kurdistan including starting a web site dedicated to the cause of the Kurdish refugees.
Key publication: *Nicaragua* (1981)

GIDEON MENDEL

SOUTH AFRICAN

BORN: SOUTH AFRICA, 1959

A multi-award-winning documentary photographer, Gideon Mendel is best known for his epic project (he has been working on it for the past ten years and it is still ongoing) on the social, cultural and economic impact of the AIDS epidemic in Africa. He began his career as a photographer on the *Johannesburg Star* in 1983, focusing in particular on the popular widespread grassroots campaigns against apartheid. In 1985 he joined the prestigious Agence France-Presse photographic agency and began freelancing for international publications such as *Stern Geo* and the *Guardian*. In 1990 he moved to London and joined the Network Photographers agency. Over the past 10 years Mendel's work has earned six World Press Photo awards, the W Eugene Smith Award for Humanistic Photography and the Nikon Feature Photographer of the Year award.

Key publication: *A Broken Landscape: HIV & AIDS in Africa* (2003)

BERTRAND MEUNIER

FRENCH

BORN: FRANCE, 1965

Meunier is part of a new generation of French photojournalists who are following in the footsteps of Marc Riboud and Cartier-Bresson. Like these two legends, he is a relentless traveller who is fascinated with documenting Asia and in particular China. Self-taught, he first visited China 15 years ago and in 1997 he began documenting the country's changing economic and social landscape. He has also worked in Pakistan, Mexico and Iran. He has been a member of the VU agency since 2000. His work has been exhibited at the festival of photojournalism in Perpignan in France, and in Italy. His images have also been published in some of the world's leading publications such as *Newsweek* and *Paris Match*.

DAVID MODELL

BRITISH

BORN: ENGLAND, 1969

After leaving school at 16, David Modell began taking photographs of local news events, which he then tried to sell to magazines and newspapers. After building up a portfolio, he started working for the *Sunday Telegraph* at the age of 18 and continued to shoot for that newspaper on a regular basis for the next two years. He moved on to the UK colour supplement magazines such as the *Sunday Times Magazine* and the *Independent Magazine* and started working on longer-term assignments. His photo essays have won many national and international awards and he has been extensively exhibited. He has also branched out into making documentary films and his work has been acclaimed at the Royal Television Society awards.

RALPH MORSE

AMERICAN

BORN: USA, 1918

Morse's first job after graduating from high school was working for a photographer as an assistant. A quick learner, by 1939 he was shooting for *Life* after being spotted by Alfred Eisenstaedt. His first assignment in a 30-year career for the magazine was to cover Thornton Wilder making *Our Town*. During the Second World War he covered the US marines at Guadalcanal, the Doolittle raid in Tokyo and General Patton's drive across France. Morse was the only civilian photographer who recorded the surrender of the German armies to General Eisenhower and he also covered the Nuremberg War Trials. In 1958 he began a 15-year period of covering the space programme. During a varied career for *Life*, he shot numerous sports, arts and science stories.

Key publication: *Life Photographers: What They Saw* (1998)

CARL MYDANS

AMERICAN

BORN: USA, 1907; DIED: USA, 2004

Mydans started out on the *Boston Globe* as a reporter, but by the mid-1930s he had started taking a camera with him on assignments. He was hired by the Farm Security Administration, to take photographs of impoverished farm workers. He became the new *Life* magazine's fifth photographer in 1935. In 1937 he met the *Life* journalist Shelly Smith, who become his wife, and together they formed a formidable writer-photographer team. They covered the Second World War together in the Far East and were interned by the Japanese for 22 months. After his release, Mydans went on to shoot some of his most famous images of the Allied invasion of Europe and General MacArthur landing in the Philippines. He carried on working for *Life* until the early 1970s.

Key publication: *More Than Meets the Eye* (1959)

JAMES NACHTWEY

AMERICAN

BORN: USA, 1948

Nachtwey grew up in Massachusetts, studied art history and political science at Dartmouth College, then taught himself photography. In 1980 he moved to New York City to pursue magazine photography. Since then, Nachtwey has ventured to most of the world's bloodiest conflicts, including wars in Central America, the Middle East, Africa, the Balkans and the former Soviet republics. A *Time* magazine contract photographer since 1984, Nachtwey was a member of Magnum (1986–2001) and became a founding member of the photo agency VII. He has won numerous awards, including the Robert Capa gold medal five times, POY's Magazine Photographer of the Year seven times, the World Press Photo award, several ICP Infinity awards and the W. Eugene Smith Memorial Grant.

Key publication: *Inferno* (1999)

ZED NELSON

BRITISH

BORN: UGANDA, 1966

A graduate of Westminster University, with a BA Honours in photography, Nelson has spent the past 15 years on magazine assignments and, when possible, pursuing his own long-term projects and themes. His work in the early to mid-1990s took him to Somalia, Afghanistan and Angola where he covered war, famine and political turmoil. Over a period of three years he documented America's gun culture and the project known as *Gun Nation* brought him widespread international acclaim and five major photography awards. Since then, he has produced essays on the porn industry, obesity in the USA, plastic surgery in Iran and *Toxic Texas – The Environmental Legacy of George W Bush*. His work has been widely exhibited and published in every major magazine.

Key publication: *Gun Nation* (2001)

MARTIN PARR

BRITISH

BORN: ENGLAND, 1952

Parr studied photography at Manchester Polytechnic in the early 1970s and gained early recognition in the UK and Europe when he won three successive awards from The Arts Council in the late 1970s. He became a member of Magnum in 1994 and is now one of England's most prolific and high profile photographers whose idiosyncratic style is instantly recognizable the world over. His work has appeared in all the major magazines and been exhibited at some of the world's most important museums including the Tate Modern and New York's Metropolitan Museum of Modern Art. He has also directed commercials and made television documentary films both for the BBC and in Europe. Parr has also curated photographic festivals, written about photography and had close to 20 books on his work published.

Key publication: *Martin Parr* (2002)

JUDAH PASSOW

ISRAELI/AMERICAN

BORN: ISRAEL, 1949

A graduate of Boston University, Judah Passow has been working on assignments for American and European magazines and newspapers since 1978, specializing in the Middle East. He is also one of the co-founders of Network Photographers, the influential British picture agency dedicated to pure photojournalism. His extensive work on the Israeli-Palestinian conflict has earned him four World Press Photo awards. *Days of Rage*, his CD-ROM brought out in 1995 and based on his work in Beirut from 1982 to 1985, received critical acclaim for its journalistic integrity and technical innovation. In 1998 he was artist in residence at the ICA. His photographs have been exhibited in Europe, Israel and the USA.

GILLES PERESS

FRENCH

BORN: FRANCE, 1946

Originally a philosophy student, Peress's worldview was shaped by the Paris riots of the late 1960s. In 1970 he embarked on his first photography project, a portrait of a French coal-mining village, which brought him to the attention of Henri Cartier-Bresson and an invitation to join Magnum. He next went to Northern Ireland where he made his international name with images of Bloody Sunday. Since then, he has embarked on an ongoing project called *Hate Thy Brother*, which has taken him to some of the most bloody conflicts in recent times including Bosnia and the genocide in Rwanda. He has also produced major bodies of work on Iran, the fall of the Berlin Wall and 9/11.

Key publication: *Telex: Iran* (1997)

RAGHU RAI

INDIAN

BORN: INDIA, 1942

Originally trained as an engineer, Rai joined the staff of the *Hindustan Times* in 1965. In 1966 he became chief photographer for *The Statesman*. In 1976 he quit the paper and became a freelance, joining Magnum a year later. Between 1982 and 1992 he was director of photography for India's leading news magazine, *India Today*. During this period he produced his seminal work on the Bhopal tragedy, which brought him international acclaim. His images have appeared in most of the world's leading publications including *Time*, *Geo*, *Paris Match*, the *Sunday Times* and *National Geographic*. He has served on the jury of the World Press Photo awards and his photographs have also been widely exhibited all over the world.

Key publication: *Exposure: Portrait Of A Corporate Crime* (2004)

ELI REED

AMERICAN

BORN: USA, 1946

Reed studied pictorial illustration at the Newark School of Fine and Industrial Arts, graduating in 1969. After freelancing for several years, he was a staff photographer for newspapers including the *Detroit News* (1978) and the *San Francisco Examiner* (1980). A Nieman Fellow at Harvard University in 1982, Reed joined Magnum as a nominee in 1983 and became a full member in 1988. He completed assignments for *National Geographic*, *Life*, *Time* and other publications. Major projects include his documentation of the African-American experience in the USA from the 1970s onward and a long-term study on Beirut (1983–87). Reed has published several books and won major awards including the W. Eugene Smith Memorial Grant in 1992.

Key publication: *Black in America* (1997)

EUGENE RICHARDS

AMERICAN.

BORN: USA, 1944

Richards studied photography in the late 1960s at MIT and began his career working in eastern Arkansas for the Volunteers in Service to America. Within two years he had helped start a social services organization and community newspaper for which he shot stories. He later joined Magnum, carrying on its best tradition of concerned social photography. He has spent most of his career documenting the underprivileged and suffering within American society. Some of his photo essays have resulted in books, including *Exploding into Life* (1986), *Below the Line: Living Poor in America* (1987) and *Cocaine True Cocaine Blue* (1994). He has won all the major photojournalism awards and his work has appeared in *Newsweek*, the *New York Times* and countless other publications.

Key publication: *Cocaine True Cocaine Blue* (1994)

HENRYK ROSS

POLISH-ISRAELI

BORN: POLAND, 1910; DIED: ISRAEL, 1991

Before the Second World War, Ross worked as a press photographer in Lodz, Poland, until he went into war service during the brief campaign that ended in Polish defeat in October 1939. Confined to the Lodz ghetto in 1940, he became one of two official photographers. Later he went into hiding, buried his negatives, and was in Auschwitz when it was liberated by Soviet forces in January 1945. Emigrating to Israel in 1950, he worked as a photographer and engraver. During his lifetime Ross released only a certain proportion of the surviving photographs from the 6,000 or so he had made during 1940–44.

Key publication: *Lodz Ghetto Album* (2004)

SEBASTIAO SALGADO

BRAZILIAN
BORN: BRAZIL, 1944

Originally Salgado trained as an economist, becoming interested in photography in the early 1970s when he was working for the International Coffee Organization. He first made his name while on assignment for the *New York Times Magazine* and photographed at close hand the assassination attempt on President Reagan. In 1984–85 he produced his famous essay on famine in the African Sahel. Between 1986 and 1992 he shot *Workers*, one of the greatest photo essays of all time. Between 1993 and 1999 he photographed *Migrations*, which is also a seminal and groundbreaking piece of work. His work has been extensively exhibited and published all over the world and he has also won all the major photography prizes.
Key publication: *Workers* (1993)

W. EUGENE SMITH

AMERICAN
BORN, USA, 1918; DIED: USA, 1978

Smith took his first images at the age of 15 and shortly after started selling them to newspapers. He moved to New York to study photography and started working for *Newsweek* magazine in 1937. Between 1938 and 1943 he worked for the famous Black Star photo agency. In 1939 he started shooting for *Life*, with whom he would have a stormy relationship throughout his career. While covering the Second World War for the magazine, he shot some of his most famous images, but he also suffered severe injuries. After a two-year break, he rejoined the magazine from 1947 to 1955. He also joined Magnum in the 1950s, resigning a few years later. His popularity waned in the 1960s and 1970s, but he continued to work on significant projects including extensive essays from Japan where he lived for a year. After his death, his work was rediscovered and he is now revered as the USA's greatest ever photojournalist.
Key publication: *Let Truth be the Prejudice: W. Eugene Smith His Life, and Photographs* (1984)

JOHN STANMEYER

AMERICAN
BORN: USA, 1964

Stanmeyer attended the Florida Art Institute, majoring in art and fashion photography. After graduating in 1983, he moved to Milan and began shooting fashion for *Interview*, *Vanity Fair*, *Harper's Bazaar* and other magazines. While on sabbatical in 1987 he took up street photography in Madrid. In 1989, after returning to the USA, Stanmeyer began pursuing photojournalism as a staff photographer for the *Tampa Tribune*. From there he began documenting international stories including the Sudanese civil war, conditions in Eastern Europe after the end of communism, and unrest in Haiti. He moved to Hong Kong in 1996 and now resides in Bali, Indonesia. A *Time* contract photographer since 1998 and a co-founding member of VII, Stanmeyer has won the Robert Capa Gold Medal (2000) and was named POY's Magazine Photographer of the Year in 1999.
Key publication: *Tsunami: a Document of Devastation* (2005)

TOM STODDART

BRITISH
BORN: ENGLAND, 1953

Stoddart's first job was working for the Berwick-on-Tweed *Advertiser* in the photography department at the age of 16. Since then he has travelled to more than 50 countries shooting virtually every big story of the past 20 years. In 1989 he covered the fall of the Berlin Wall, Rwanda, and the election of Nelson Mandela, and he spent four years in the early 1990s documenting the conflict in Saravejo. In 1997 he was given exclusive access by Tony Blair to photograph his victorious election campaign. In 1998 he shot famine-ravaged Sudan and he was embedded with the British troops in the last Gulf War. His images have appeared in the world's leading publications and he has also won several important photography awards including the World Press Photo award and the Visa d'or Perpignan.
Key book: *iWitness* (2004)

WEEGEE (ARTHUR FELLIG)

HUNGARIAN (NATURALIZED AMERICAN)
BORN: AUSTRO-HUNGARY, 1899; DIED: USA, 1969

Weegee's photographic career began in New York in 1913, where he had a series of jobs as a portrait and street photographer. In 1921 he began press work for the *New York Times*, moving to Acme Photos in New York in 1924, and working there until 1935, after which he freelanced. He specialized in crime photography and from 1938 he was allowed to use a police radio in his car so that he could get to crime scenes rapidly. For the next 10 years he built a career as a publicity-seeking photographer of lurid events – murders, fires and bizarre accidents. In 1947 he left New York for Hollywood to work on a film about his life, and he remained there as extra and photographer until 1952. After his return to New York, he made several short films and experimented with optical distortions, a subject that absorbed him until his death in 1969.
Key publication: *Weegee's New York Photographs 1935-1960* (2000)

LI ZHENSHENG

CHINESE
BORN: CHINA, 1940

The Sino-Japanese War, and the subsequent civil war between communists and nationalists in which his 17-year-old brother was killed, disrupted Li's early life. He was a trained cinematographer but was appointed a news photographer by the government, and from 1963 to 1982 worked on a daily paper in Harbin, capital of the province nearest to the USSR. He photographed the early stages of the Cultural Revolution (1966–76), hiding negatives that the authorities would have destroyed. Denounced in 1968 as "bourgeois", he was sent to the countryside for "rectification" – two years' hard labour. From 1982 he began to teach photography at Beijing University. His work came to light again in 1988, during the beginnings of the liberalization of the Chinese communist regime.
Key publication: *Red-color News Soldier* (2003)

DMITRI BALTERMANTS

Baltermants made several of the most telling pictures of the Russian side of the Second World War. His best-known images show the human suffering associated with events like the battle around Kerch in the Crimea (176,000 Russian dead) in 1942 with a stark yet humanist depiction. The horror of the savagery wreaked upon these people by the Nazi war machine is curiously mitigated by images of mourners tending to the bodies of their family or friends, supplicants to their suffering. It is clear that Baltermants had a pacifist vision, but that his place in the front-line, as a soldier-reporter, took him to scenes of unbelievably brutal carnage. Like so many of his peers, Baltermants's work is steeped in the great Russian photographic tradition, particularly in the struggles between formalism and socialist realism that raged in the 1920s and 1930s. Composed with immense graphic power and yet replete with a strongly humanist perspective, the photographs justify Baltermants's reputation as the "Soviet Capa". The dramatic construction of Baltermants's images, such as the extraordinary *Attack* of 1941, may have served an important propaganda function as well as making their points as evidence of the sheer barbarism of the war in Russia.

One of the problems of reviewing the work of photojournalists who were active during the Soviet era is that their pictures are refracted through the ways in which Soviet media represented the great historical events of the period. They photographed much else besides the horrors of war, but how many of their pictures remain? And when were they seen, and by whom? The history of this photography could only begin to be written after 1991, and the quality of the work is only now beginning to be appreciated. For as Baltermants would write much later, "We photographers make magnificent shots of wars, fires, earthquakes, and murder: the grief of humanity. We would like to see photographs about joy, happiness and love, but on the same level of quality. I realize, though, that this is difficult."

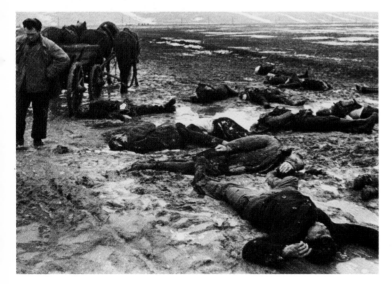

RIGHT: **Baltermants constructed dramatic images, such as this one showing Russian soldiers going into action near Kerch in 1942, probably as a means of ensuring that the picture would be used in a newspaper or magazine. This could be a still from a war film.**

LEFT: **This classic image shows the heavy civilian losses during the battle of Kerch in May 1942. This really does look like a very muddy valley of death.**

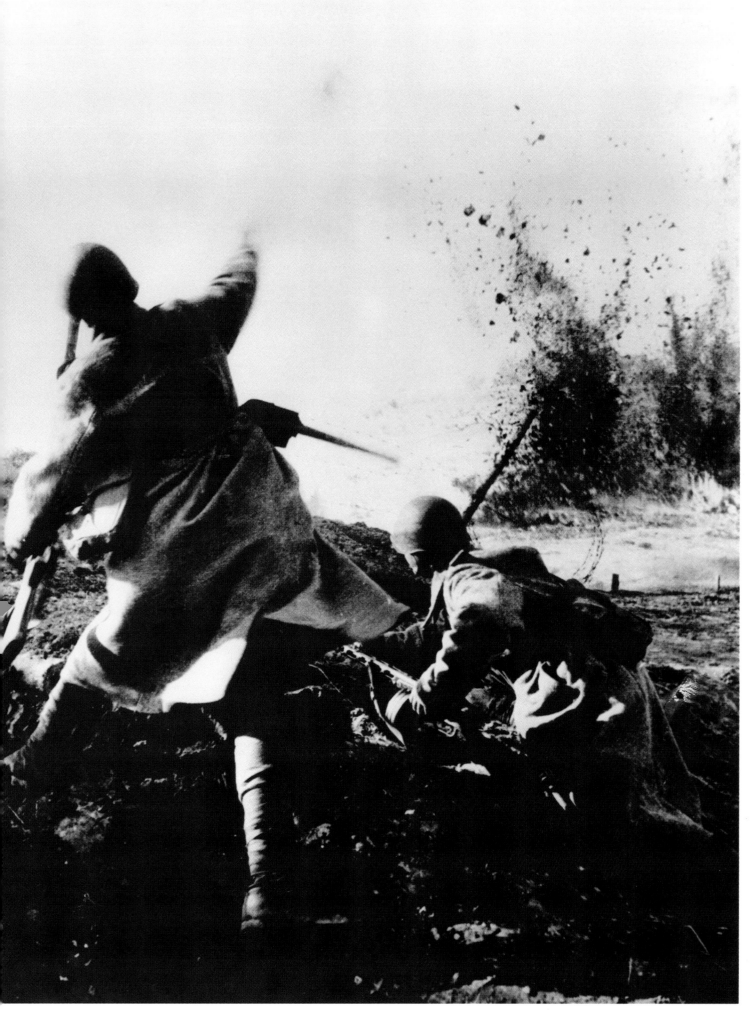

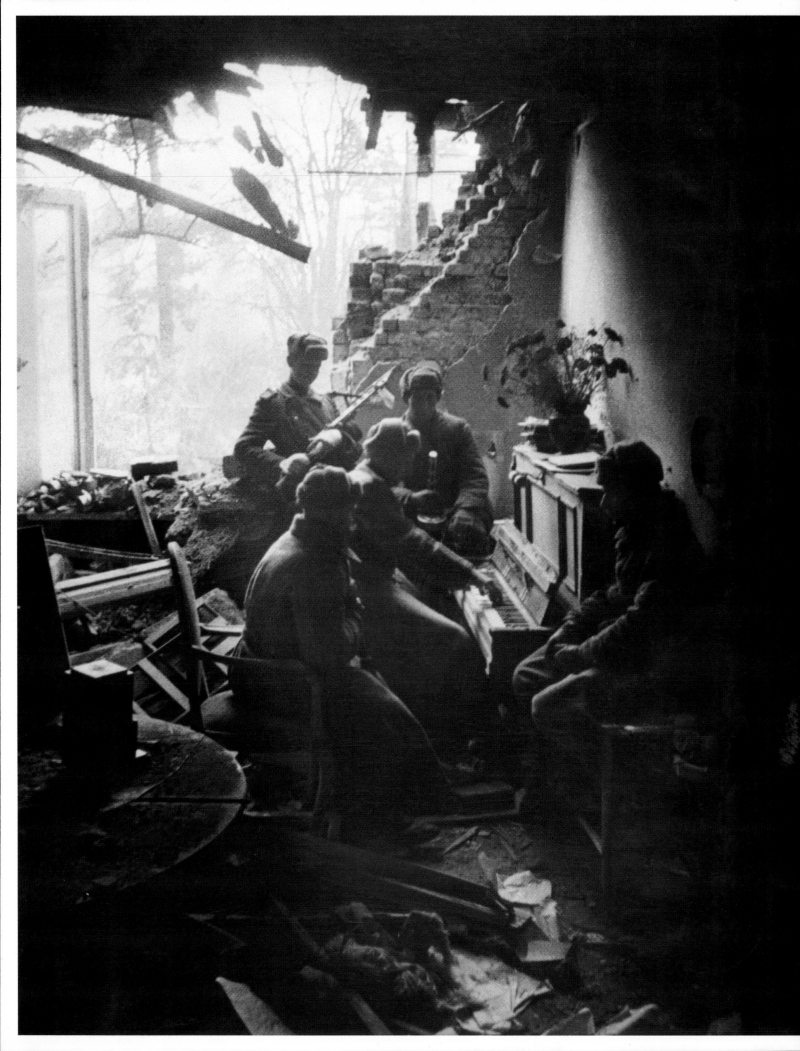

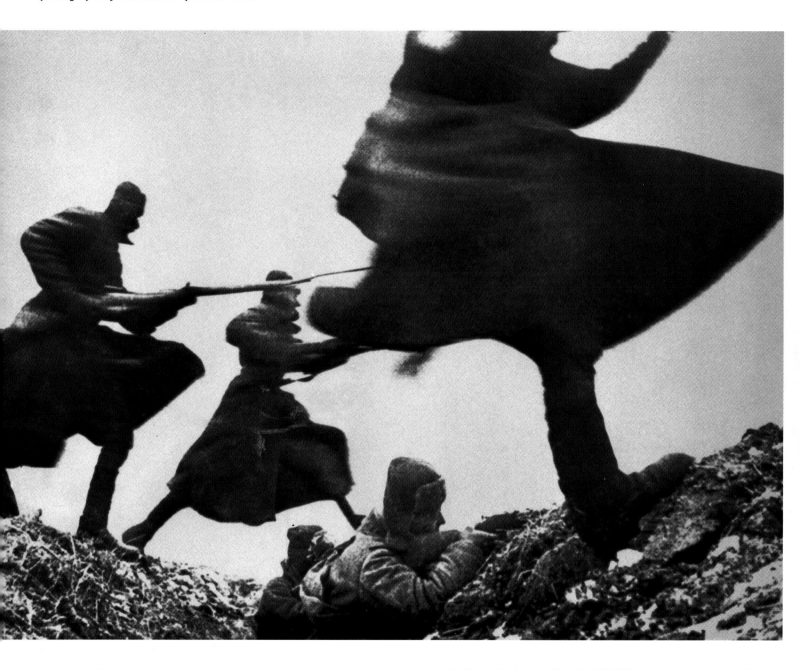

ABOVE: In his semi-abstract *Attack* of 1941, Baltermants uses some of the key pictorial elements of Russian modernist photography, such as the blurring of motion and a low viewpoint, to generate an image of dynamism that is both instantly recognizable as a war photograph, but at the same time vague as to time and place.

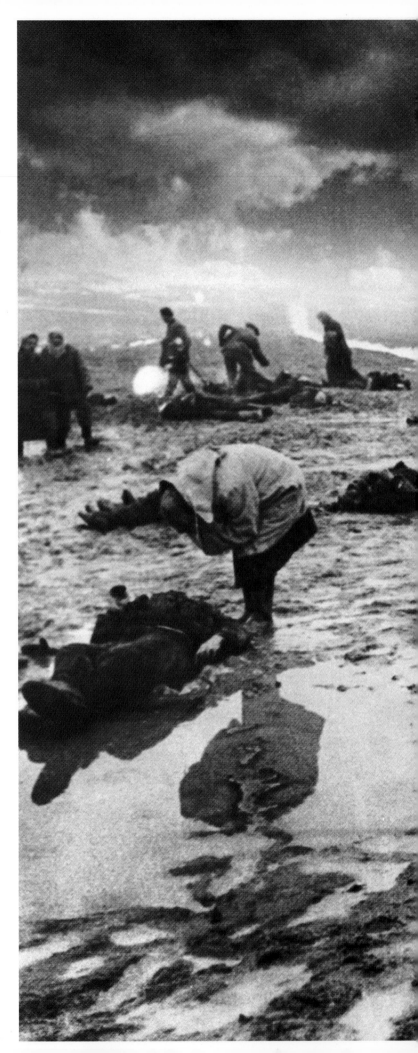

RIGHT: *Grief*, a picture from Baltermants's series on the civilian losses during the battle for the Crimea, near Kerch, 1942. Beautifully constructed as an image, the picture seems almost a *tableau*, made even more dramatic by the overprinting of the sky to emphasize the heavy clouds of war. While some photographers from the West tended to glamourize the Second World War, Baltermants had no qualms about presenting the full horrors of conflict.

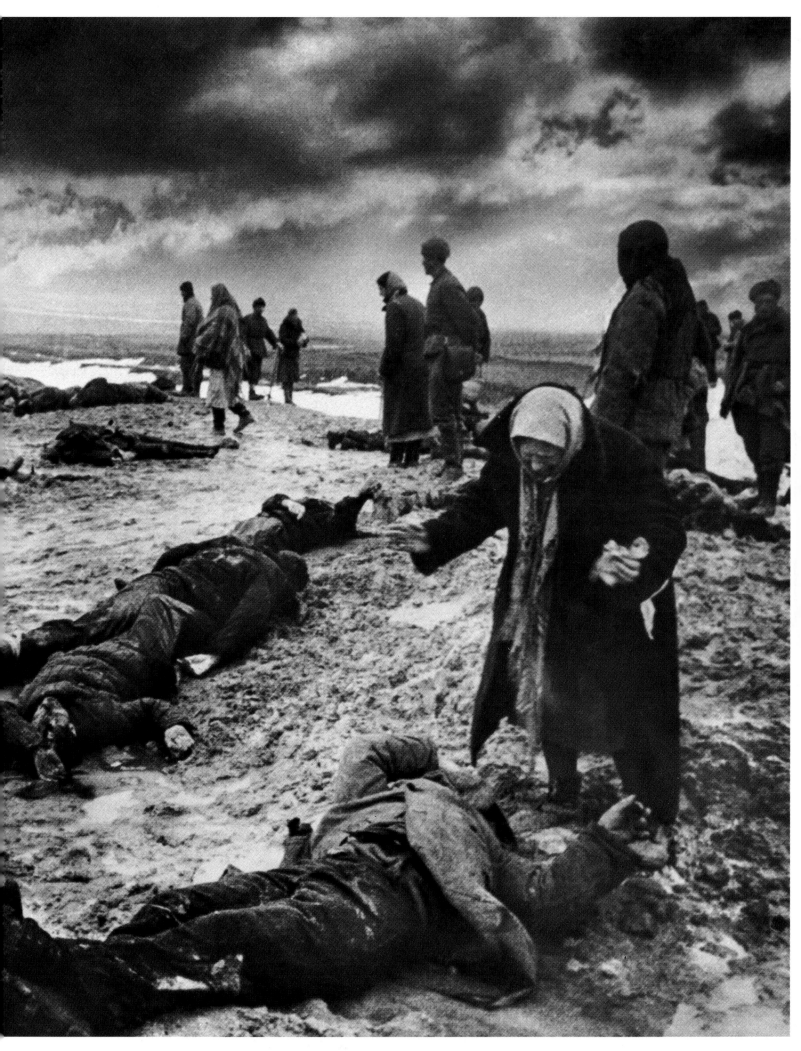

LETIZIA BATTAGLIA

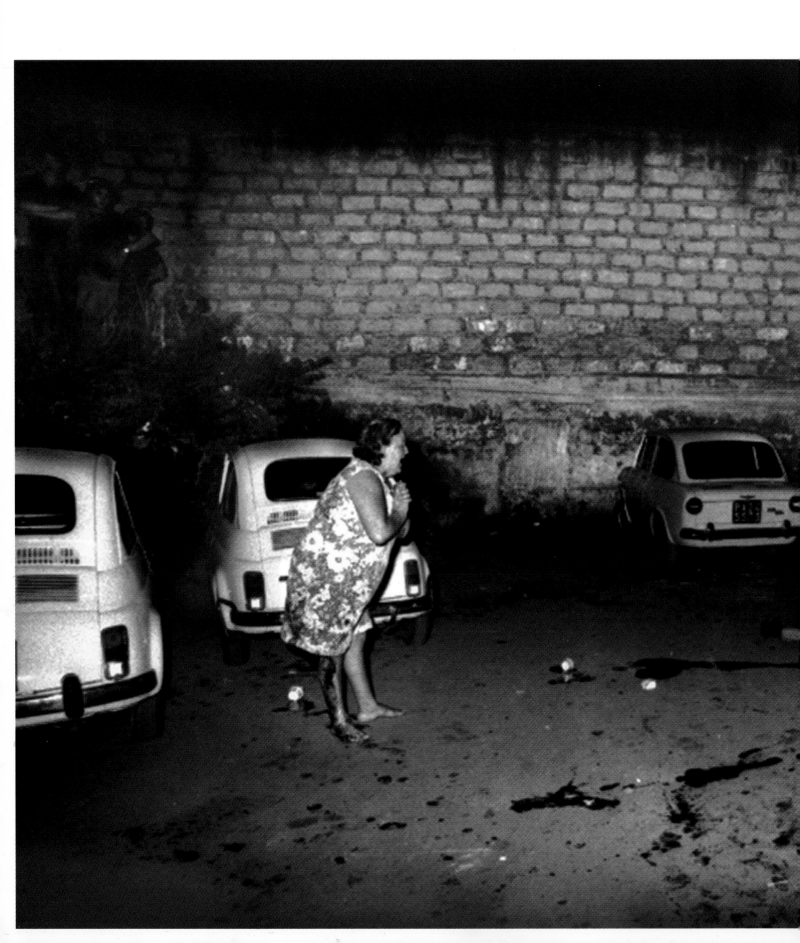

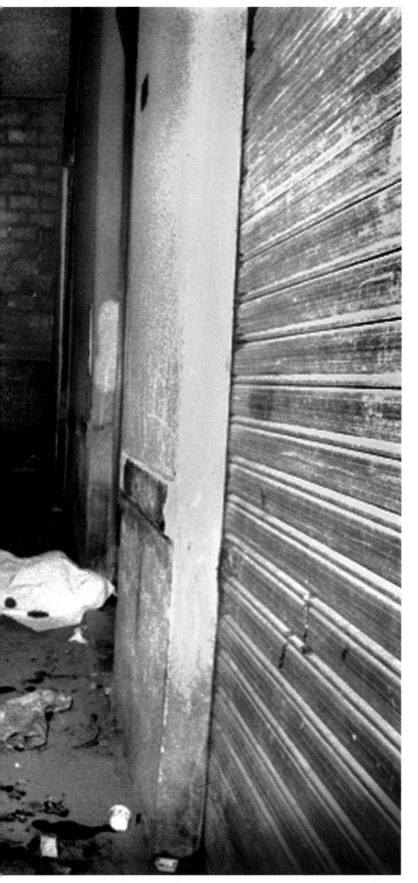

Letizia Battaglia has never covered a war, at least not a conventional one, but she is as courageous and committed as any of the war photographers featured in this book, if not more so. For just under 20 years, she relentlessly exposed the impact of the Mafia on her hometown of Palermo in Sicily. With a grim determination, she photographed the endless cycle of crime and violence, the arrests, the funerals, the trials, the grief, the outrage and the literally vice-like grip that the Mafia has on Sicilian society. She had a Weegee-like knack of being present at a murder scene while the bodies were still warm. Unlike Weegee, however, she was not motivated by a voyeuristic urge or personal glory. Battaglia took these often gory and visceral images because she wanted to change things; the camera is her weapon in her fight for justice. As she says in her book, "I felt it was my responsibility, as a part of the Sicilian people, to fight ... And so with my camera, it turned into a madness, a desperate life where in a single day I might see five men killed, men with families."

Remarkably in such a vendetta-driven society, Battaglia survived, while judges and prosecutors were ruthlessly murdered. Her survival is not just down to luck. The Mafia clans came to respect her because she didn't just take photos of murders, she also documented the living conditions in Palermo, the poverty and social deprivation, as well as the aristocracy, the local rituals, the religious processions and the city's surrounding hills and fields. The Mafia recognized her commitment and love for Sicily and chose to leave her alone. By the early 1990s, Battaglia had moved away from obsessively photographing the Mafia. While organized crime is still thriving, its power had been curtailed by a new generation of prosecutors and it is no longer front-page news. These days Battaglia is very much a hands-on local politician, striving to change the living conditions of ordinary Sicilians. Rumour has it that she is just itching to start taking photos again, which is very good news indeed.

LEFT: **His name was Vincenzo Battaglia (we are assuming no relation to the photographer) and he was killed in the dark amid the garbage. His wife tried to help him, but it was too late. Sad and sordid, this photograph was taken in Palermo, 1976.**

BELOW: **Seconds after this photo was taken in Palermo, 1980, the house collapsed. The Mafia has a stronghold over every aspect of the local Palermo infrastructure and the photographer says that this house was subsequently going to be rebuilt for wealthy people by a mob-tied construction company.**

RIGHT: **Battaglia says of this image take in 1986, "They put the dead father in the entrance hall so that everyone who passed by could honour the death with a greeting." When she met the boy again some years later, he was looking for work — honest work, he specified.**

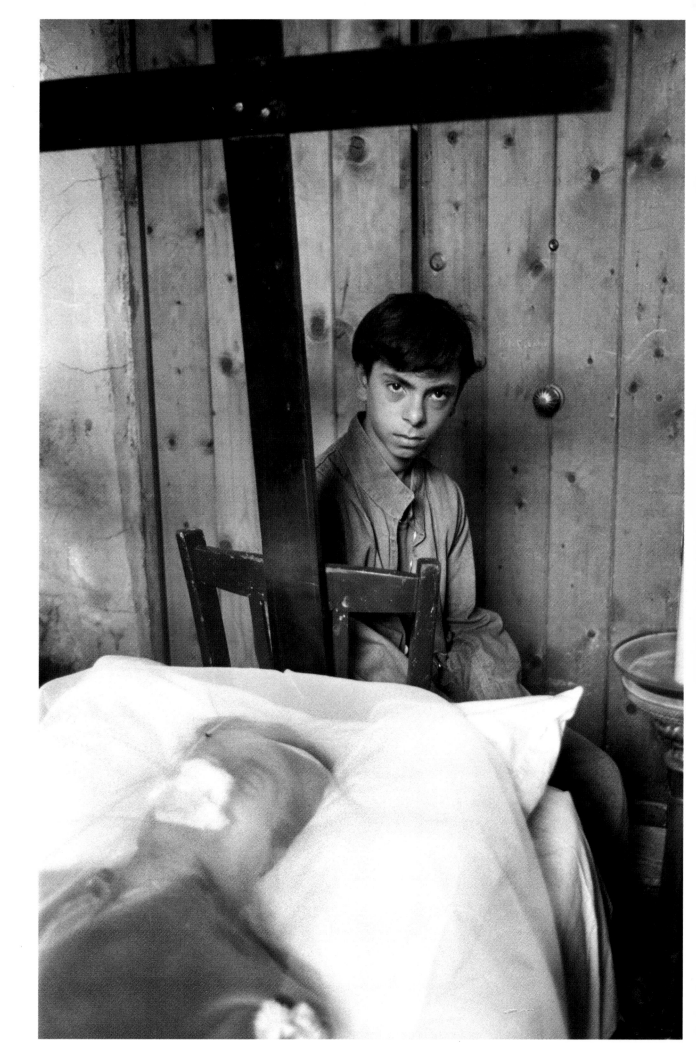

FELICE BEATO

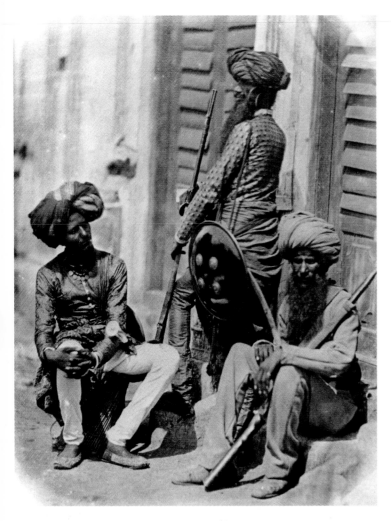

It is possible that Felice Beato was the first photographer to have recorded a military campaign. He may also have been the first (with his brother-in-law James Robertson) to have photographed dead soldiers on a battlefield. Whatever the truth of these claims, there is no doubt that his photographic career was advanced by his presence at a series of conflicts: the Crimean War in 1855; the Indian Mutiny of 1857–58; the Opium War of 1860; the American expedition to Korea in 1871; and the Sudan war in 1885. As a result, Beato, rather than Roger Fenton, is often considered the first of the war photographers, although such a title gives little idea of the huge scope of his work.

Beato made most of his war photographs on a large wet-collodion plate camera of 10 in x 12 in (25 cm x 30 cm). They were produced as individual albumen prints (and sometimes in the form of album collections) to be sold to those who had an interest in their subject matter: soldiers, colonial administrators, the general public. Their commercial and documentary functions are thus neatly dovetailed. There was no photographically illustrated press to reproduce them except when they were copied as engravings. Nonetheless, Beato's pictures served as remarkable records of a period when the West began to impose its rule on the great empires of the East. They are also images that attest to his abiding fascination with exploration and discovery. His work in China during the Opium Wars, for instance, is remarkable not only for the somewhat static scenes of the aftermath of battle, or for his great "joiner" panoramas of the British fleet in Hong Kong and of a captured Chinese fortification, but for the extraordinary beauty of his views of the secret city of Beijing and of a land opened up to outside scrutiny for the first time in its history. Beato's images are poignant records of the imperialism of this era, made at a time when British and French forces were in the process of destroying Chinese military and civil installations such as the Emperor's Summer Palace, and compelling the empire to accept their terms.

ABOVE: **Part of Beato's coverage of the Indian Mutiny and its aftermath, this portrait of a group of Sikh officers in 1858 emphasizes their heroic pose, probably because they remained loyal to the British during the Mutiny.**

RIGHT: **Begum Zenal Mahat, wife of the Shah of Delhi, was exiled to Rangoon after the Indian Mutiny in 1857–58. She stares defiantly at the viewer in this masterful portrait by Beato.**

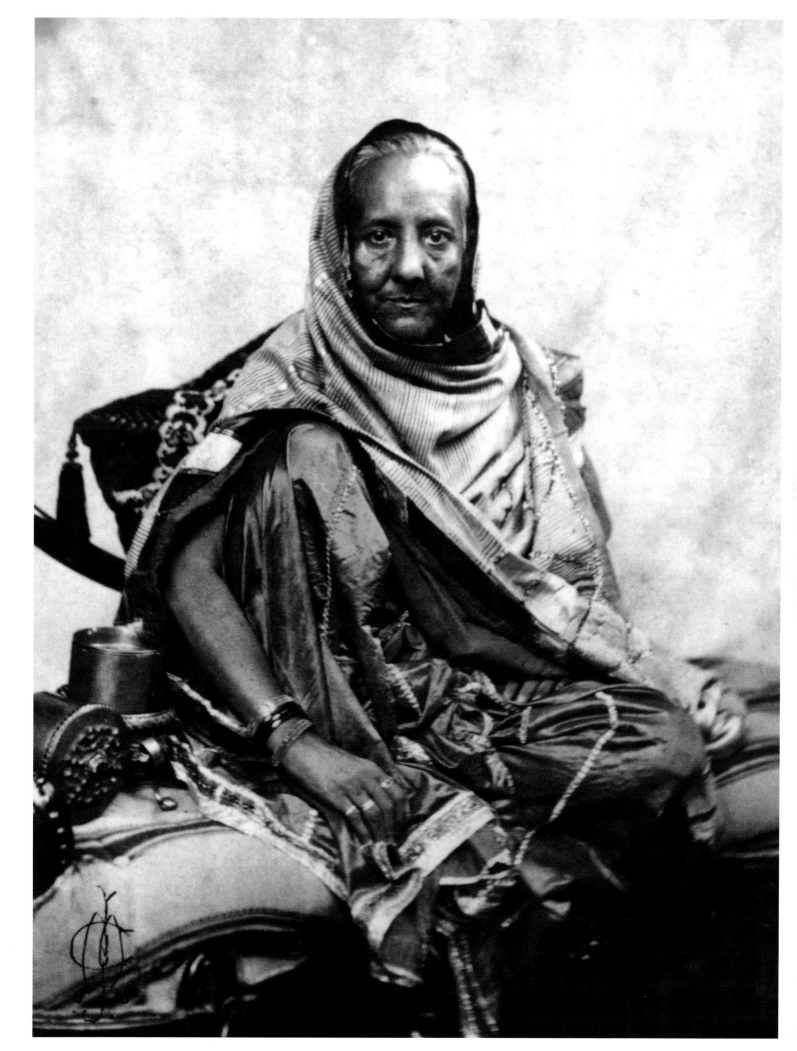

BELOW: At Lucknow 2,000 rebel sepoys were slaughtered by the 93rd Highlanders and 4th Punjab Regiment in 1858. This image of Martimere and Brasyer Sikhs at Lucknow could be seen as underlining the imperial dominance of the British in India.

RIGHT: Hodson's Horse was a mixed troop of British and Indian soldiers, and this photograph of native officers is one of a series of this formation taken by Beato in 1858. The loyal Indian horsemen of Hodson's Horse wore distinctive uniforms, which included scarlet turbans and shoulder sashes over beige tunics. Hodson was also head of the intelligence department, and his spies enabled him to keep the British headquarters accurately informed of events in Delhi, of troop movements and of the damage done by British guns.

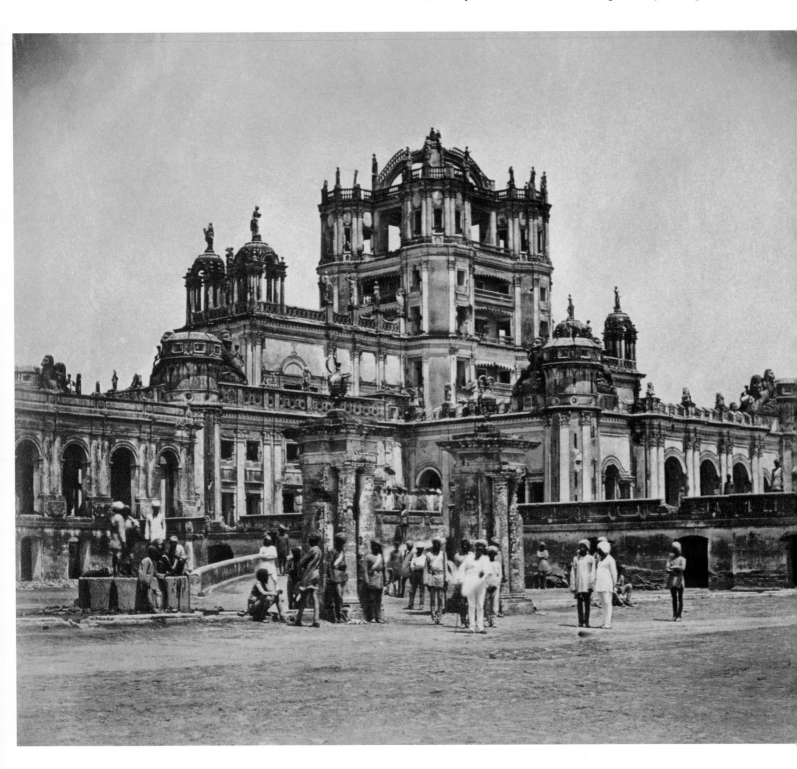

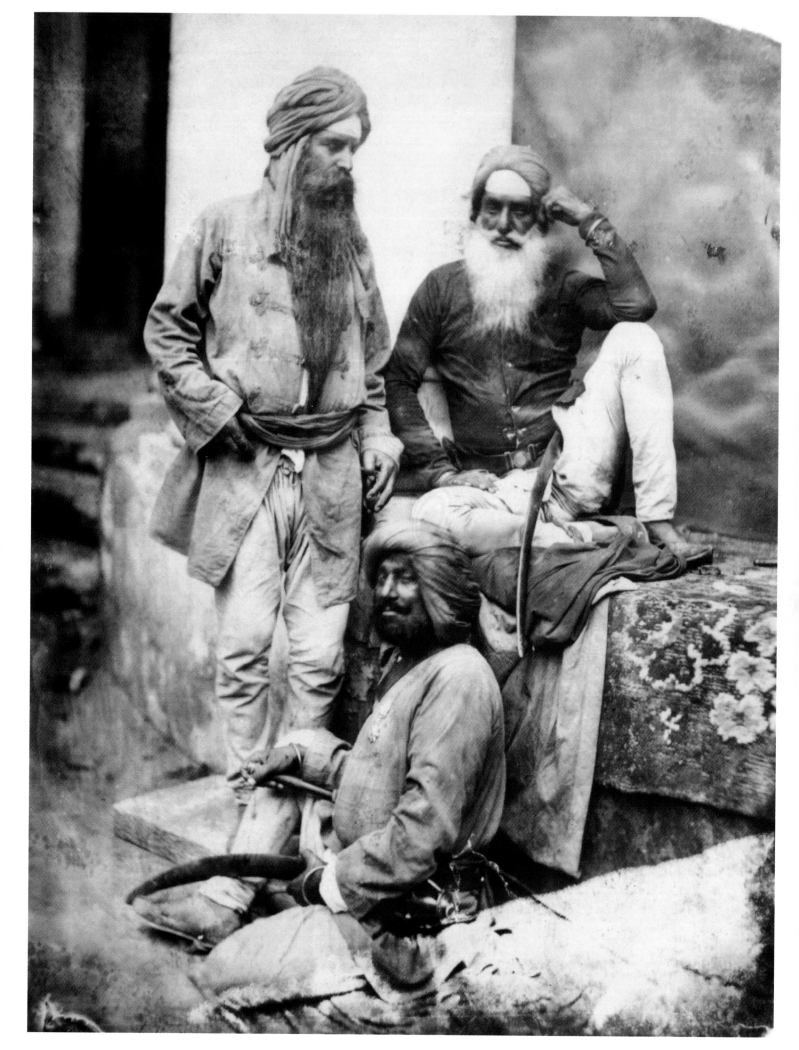

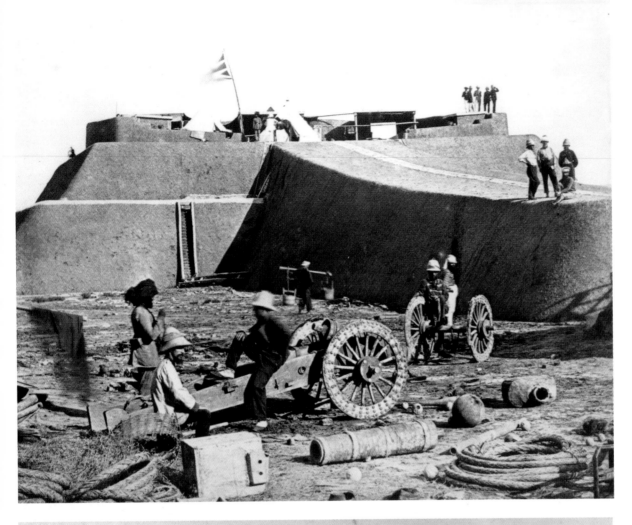

LEFT: British artillery at Pehtang Fort, one of the Taku Forts, shortly after its capture during the Opium Wars in 1860. Beato's views of the aftermath of such actions are carefully delineated documentary images of the scenes, with precisely posed participants who make the image seem like a *tableau vivant*.

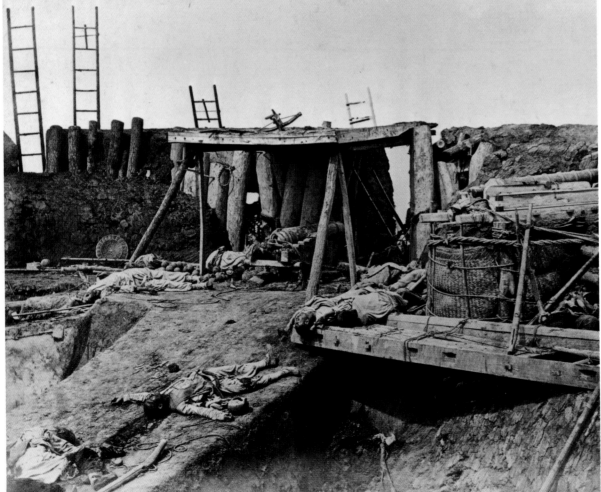

LEFT: The dead bodies of Chinese soldiers lie in the northernmost of the Taku Forts shortly after it was taken by the British and French on 21 August 1860.

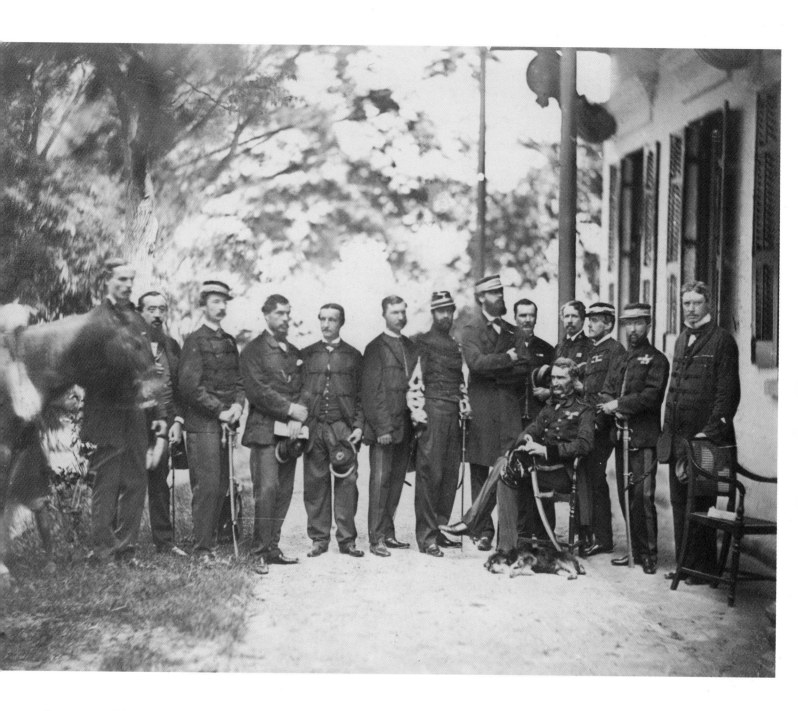

ABOVE: Beato covered the Anglo-French expedition to China in 1860 in depth. This group portrait of British officers is typical of Beato's informally posed groups, a picture made before the stiffer conventions of neatly assembled ranks had become more common.

IAN BERRY

Ian Berry conceives his role as being "to inform, to convey as accurately as one is able to as wide an audience as is possible, the reality of the situation confronting the photographer. The truth is that one will inevitably carry bias or prejudice in any given situation but one should maintain an open mind."

Since the time when he made the historic pictures of life in a South Africa dominated by apartheid, he has seen his subject not in terms just of events to be recorded, but as an exploration of the society that produces them. His survey of the recent history of South Africa is only one of several long-term projects. His work on the politics and social conflicts of water is shown here. It has taken him all over the world but in the case of Bangladesh he had particular interests: "The monsoon, how people adjust annually to being flooded and learn to live with an ever worsening situation." With extensive experience of the problems and dangers of photojournalism, Berry often has to weigh up the cost versus the benefit of photographing politically sensitive situations, as in Bangladesh, where the pollution of drinking water wells with arsenic is an acute problem. "Shooting in such situations is always the photojournalist's dilemma. As a Westerner with a bunch of Leicas one runs the risk of being perceived as a voyeuristic tourist. At the same time, one wishes to keep a low profile because governments invariably dislike being seen to have shortcomings." In all the situations where he has worked, Berry's ability to construct memorable images has been prominent. "For me the great strength of the camera over the brush is the ability to seize a moment, to combine the peak of a situation and meld it into a graphic shape."

BELOW, LEFT AND RIGHT: Ian Berry's current project focuses on the developing water crisis that is affecting people all over the world, as here in Bangladesh, where a village has been left as an island by floods. All travel is done by boat between villages and even between parts of villages. Berry presents us with two perspectives of the same scene.

BELOW: **Fishermen stand for hours on bamboo poles in the floodwaters, raising and lowering a huge net every few minutes to catch talapia, a small fish. These photos were taken in 2000.**

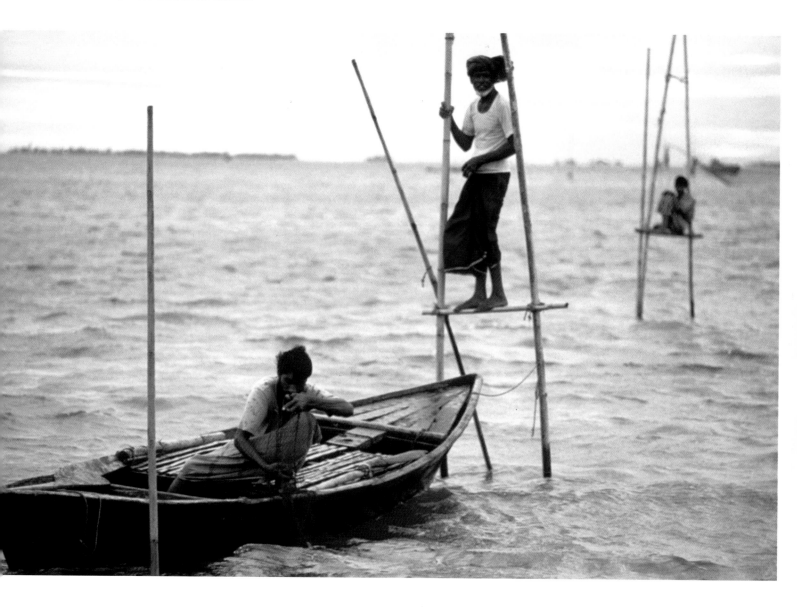

OVERLEAF: **Berry's work documents the social consequences of both natural and manmade situations. In Bangladesh the monsoon brings flooding that often lasts for a considerable part of every year. When the village of Khaliajuri (in north-east Bangladesh) floods, locals must travel by water taxi from one part of the village to another — here they return to their homes from the market with their purchases.**

MARGARET BOURKE-WHITE

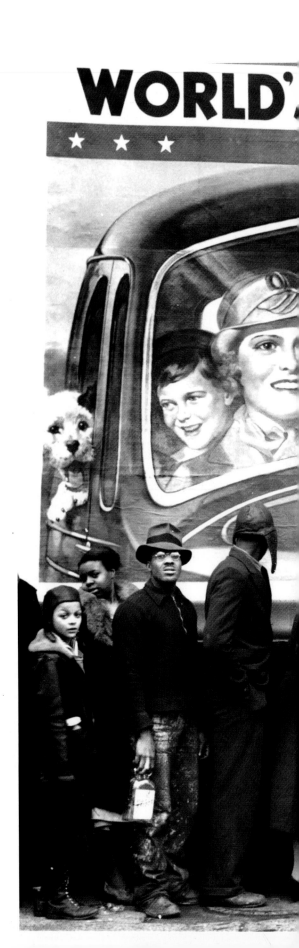

Margaret Bourke-White has never been given the credit she deserves for taking some of the most memorable images of the twentieth century. She was a formidable and tireless photographer, who was prepared to use whatever was at her disposal, in particular her beauty and charisma, to get a shot. Photojournalism is still very much a boys' club, and Bourke-White was seen as manipulative. The readers of *Life*, however, did not care about how the images ended up in the magazine, they just wanted to experience something different. While most of the other *Life* photographers shot on the more flexible 35mm format, Bourke-White stuck to the larger-format cameras that had served her so well as an industrial photographer. She was not keen on experimentation and instead favoured visually simple, but strongly composed and dramatic images.

This more formal industrial style worked best when, early in her career as chief staff photographer for *Fortune* magazine, she travelled to the Soviet Union in 1930 and completed the first major project on the newly emerging communist dictatorship by a Western photographer. She later made a name for herself as a concerned social documentary photographer, touring the southern states and documenting the rural poor who were still in the midst of the Great Depression. Despite her Yankee and Ivy League background, Bourke-White showed great sensitivity for her subjects, resulting in a book collaboration with the writer Arsine Caldwell (whom she later married); images from the project featured in the first-ever issue of *Life* magazine, including the cover. She did lasting damage to her reputation when she smuggled in a camera to shoot the grieving family and friends gathered round a dying Gandhi. She actually took a shot using a flashbulb, and the family were so outraged that they chased her out of the house and smashed her camera. Astonishingly, Bourke-White was far from contrite and tried to talk her way back in. While some would find her actions highly insensitive, others would argue that she had the instincts of a true professional.

ABOVE: It is hard to identify the vantage point from which Bourke-White took this image of a DC4 over New York in 1939; the assumption is that she is in another plane.

BELOW: This photograph, taken at the time of the Louisville, Kentucky, flood of 1937, is such a perfect juxtaposition of fact and fiction that it almost looks like a set-up. Of course, it isn't. It is rather a timeless statement about the inequalities of society and is still relevant today.

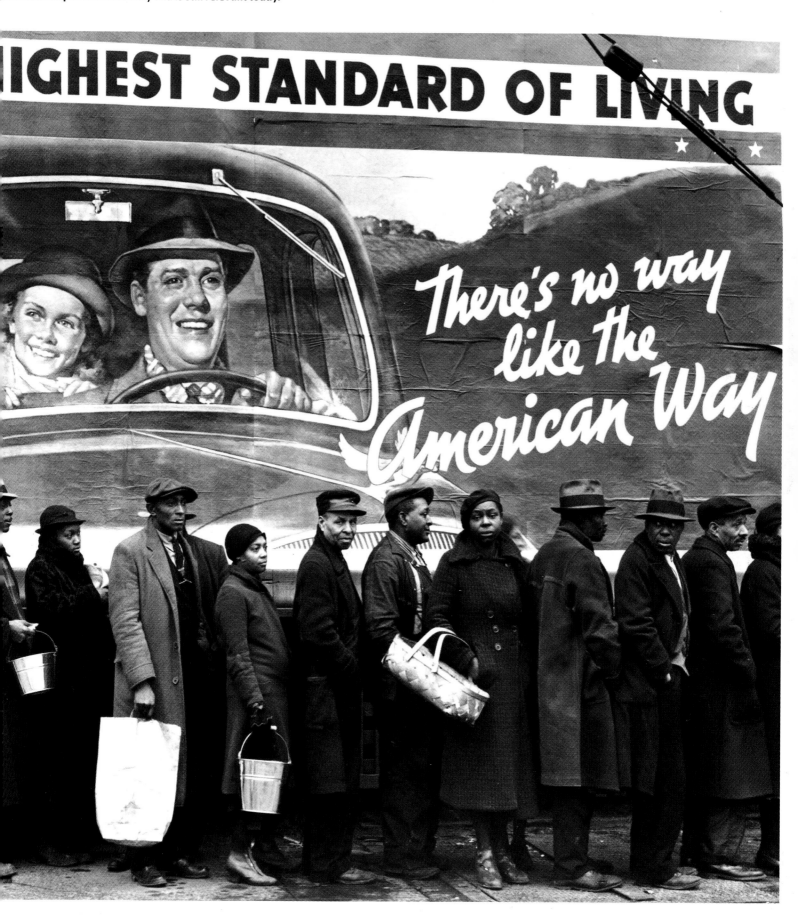

BELOW: Indian leader Mahatma Gandhi reading at home next to a spinning wheel, which looms in the foreground as a symbol of India's struggle for independence. This photograph taken in 1946 is one of the most famous portraits of the twentieth century. Gandhi got on well with Bourke-White, thus allowing her such intimate access. She didn't quite break the enigma, but she certainly tried.

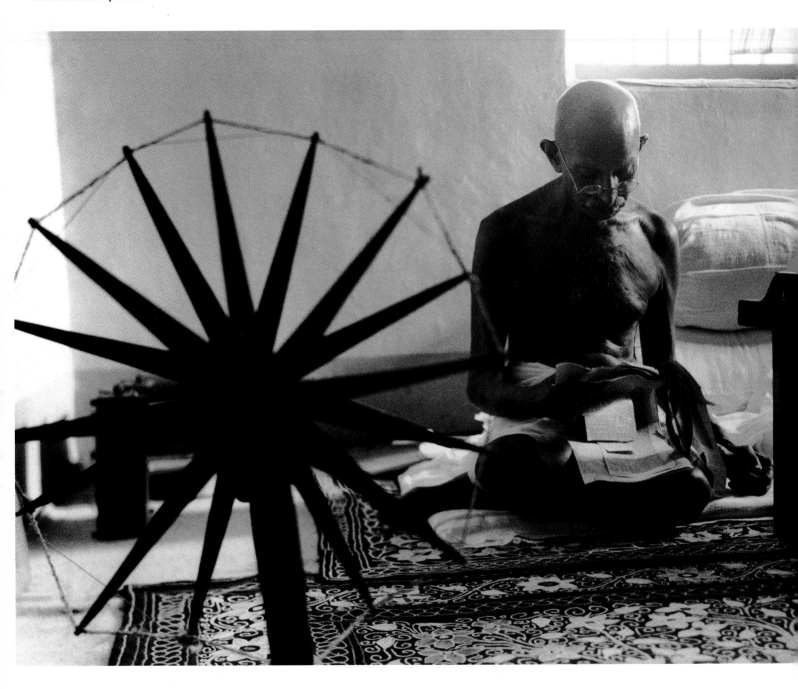

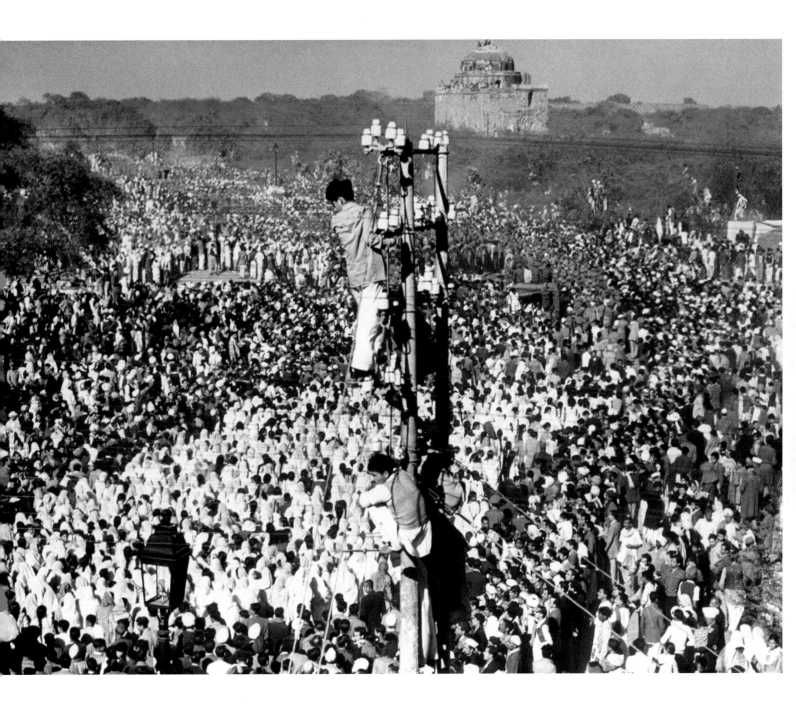

RENE BURRI

An Internet search on René Burri will inevitably lead to one of the thousands of Che Guevara sites out there in cyberspace. The founder of revolutionary chic is as popular as ever, thanks to the hit film *The Motorcycle Diaries* (2004), and, inevitably, because of "that" photograph Burri has also been propelled back into the spotlight. The photograph is, of course, the iconic shot of Che smoking a cigar (in the sequence published here, it is the middle shot in the top row) looking cocky and very handsome. Che Guevara was at the time Minister of Industry in Cuba under Castro. Burri took these photographs to accompany an interview with Che for *Look* magazine, just after the Cuban Missile Crisis. In the book *Magnum – Fifty Years at the Frontline of History* by Russell Miller, Burri recalls Che arguing furiously with the reporter about American politics. He tells Miller, "He was like a caged tiger, pacing up and down, and every now and then he would bite the end off another cigar. I didn't really have any sense that I was in the presence of someone who would become a legend or any idea how significant that picture would become to me." Burri might not have been aware of what his subject would become, but Che is in no doubt, so every pose and gesture is being made with an eye for posterity.

It would be unfair, however, to judge Burri's career in the context of just one photograph. He built up an impressive portfolio prior to this assignment and continued to thrive throughout the next three decades. He first studied design, and a fondness for clean and crisp graphics permeates his photography. By his own admission, he went out of his way to copy Henri Cartier-Bresson. The great man's influence can be seen in Burri's best images, which combine clinical composition with the movement and vibrancy of real life. Like Cartier-Bresson, he was, and still is, an obsessive traveller, and his best photographs celebrate the world's diversity, ethnicity, culture and traditions with insight and sensitivity.

RIGHT: **Politics never looked so sexy as in this mesmerizing portrait of Ernesto Guevara (Che), Argentinean politician (1928–67). At the time, Che was Minister of Industry in revolutionary Cuba and this sequence of photographs was taken in his somewhat cramped office. Che refused to look directly at the camera, but his eyes were very much on history. He was a handsome man and well aware of the power of his own image. The fine Cuban cigar is the perfect macho prop and the top middle image is one of the most iconic shots of all time.**

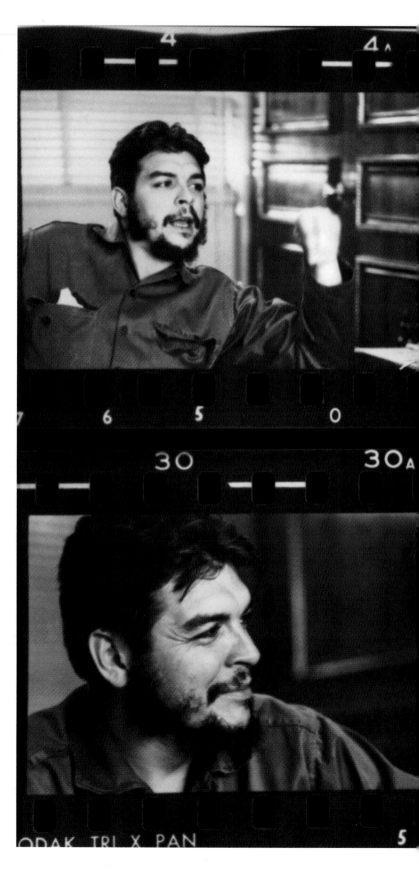

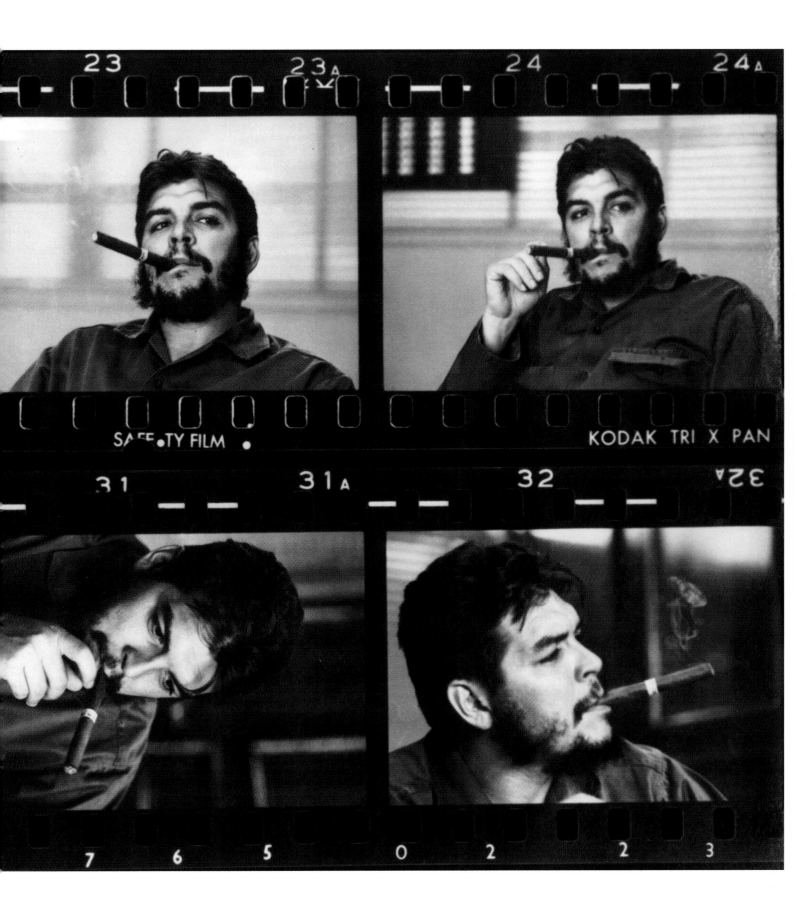

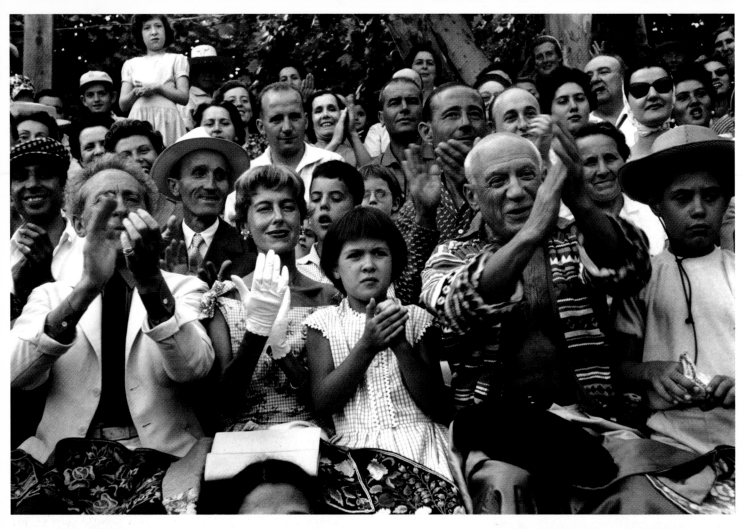

BELOW: **Pablo Picasso, Spanish painter and sculptor, at his villa, "La Californie", in Cannes, France, 1957. Burri's essay on Picasso helped to cement the painter's myth and also introduced him to a wider audience. The strength and total self-assurance of Picasso really leaps out of this photograph.**

LEFT TOP: **Picasso is seen with the French poet Jean Cocteau (far left) and with his own children, Paloma and Claude, in Corrida. It is evident from this photograph that Picasso wished to be portrayed as a doting parent and family man.**

LEFT BOTTOM: **Part of the same essay, this photograph captures the drama of a bull fight. Picasso was a traditional Spaniard who loved the excitement and cruelty of bull fighting.**

LARRY BURROWS

Larry Burrows's work is the most complete photographic record we have of the Vietnam War. When he arrived in the region for the first time in 1962, most Americans were blissfully unaware that Vietnam was a trouble spot whose problems had the potential to become America's problems. In a few years that was all to change, and Burrows should be given credit for educating people about what was really going on. Burrows became embedded in the battle zone before anyone else and he had the foresight to realize that this was not only an important conflict, but one that was going to escalate and probably go badly wrong. Tall and elegant, he was something of a gentleman and the antithesis of the macho war photographer. He was also somewhat aloof and preferred to work alone. Vietnam was very much his story and tragically he gave his life to it.

In the war against Iraq, the access of photographers was carefully monitored by the military, and American news sources were reluctant to publish images of dead Iraqis and wounded American soldiers. In the early 1960s Burrows had complete freedom to photograph the theatre of war and its bloody consequences. Ironically, this access was originally granted because the military believed that on-the-spot photographers would help the public relations effort in selling the war to the folks back home. For months Burrows consorted with small US fighting units, shooting photographs from helicopters and planes and photographing blood-spattered wounded soldiers, bewildered and lost. He was also deeply sympathetic to the plight of the Vietnamese and saw them as innocents caught in the crossfire. He was repelled by much of what he saw and it made him angry, yet he felt morally compelled to photograph it all, much of it in vivid colour. *Life* magazine was under pressure from the new medium of colour television and Burrows's coverage was in direct competition with the television networks. At a time when colour film was not as reliable and sharp as it is today, his years in the darkroom paid off. Burrows's colour images of the Vietnam War changed not just what we saw, but how we saw it – war photography would never be the same again.

LEFT: In one of the most famous images of the Vietnam War, and one of the most powerful war photographs of all time, wounded Marine Gunnery Sgt Jeremiah Purdie is led past a stricken comrade after a fierce firefight for control of Hill 484 in South Vietnam, in 1966. The facial expressions of the two injured soldiers elevate this image into something beyond an action shot. Although one is caked in mud, unable to move, and the other is bleeding and stunned, they are still trying to help and reach out for each other. The fact that one is black and the other white gives the photograph even more resonance.

ABOVE: A US infantryman on the Cambodia/Vietnam frontier overcome by heat and fatigue drinks from a canteen while others lie about on the ground. Burrows has a unique ability to place the viewer right at the heart of the action. The low angle accentuates the soldier's predicament and the sense that these men are trapped.

OVERLEAF LEFT: US marines are pictured on patrol in 1966. The soldier has a gentle and sensitive face, at odds with his heavy combat gear. He seems uncertain about why he is there and what he is doing.

OVERLEAF RIGHT: Although he made his name shooting in colour, Burrows was also adept at photographing in black-and-white, as in this image of marines searching for Vietcong in the Delta 1967.

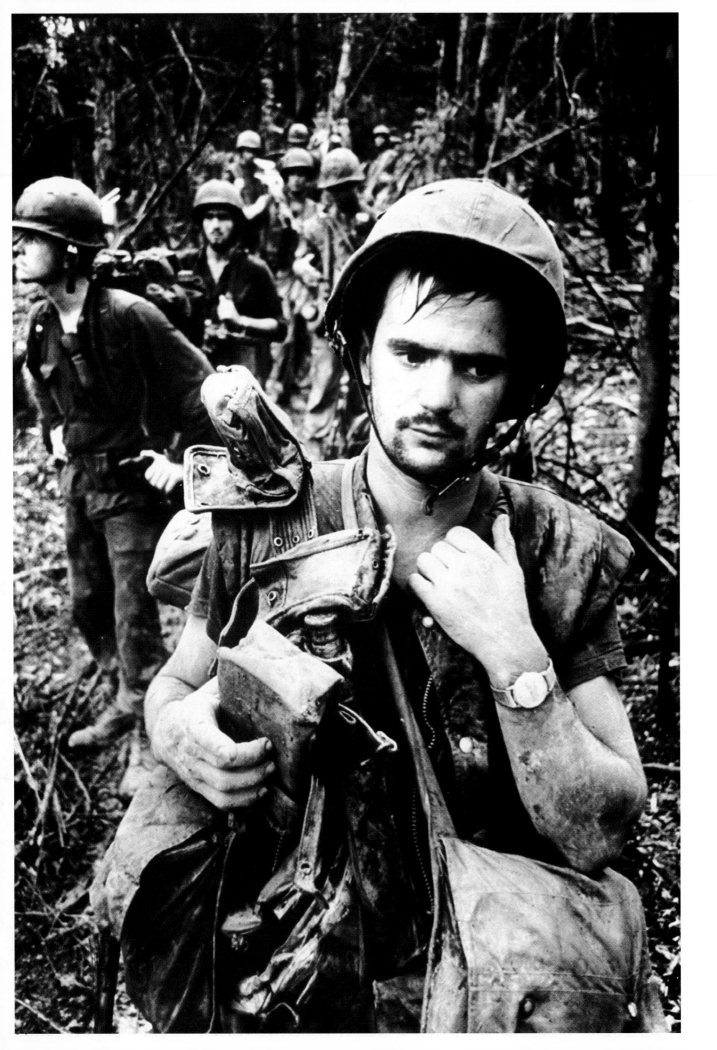

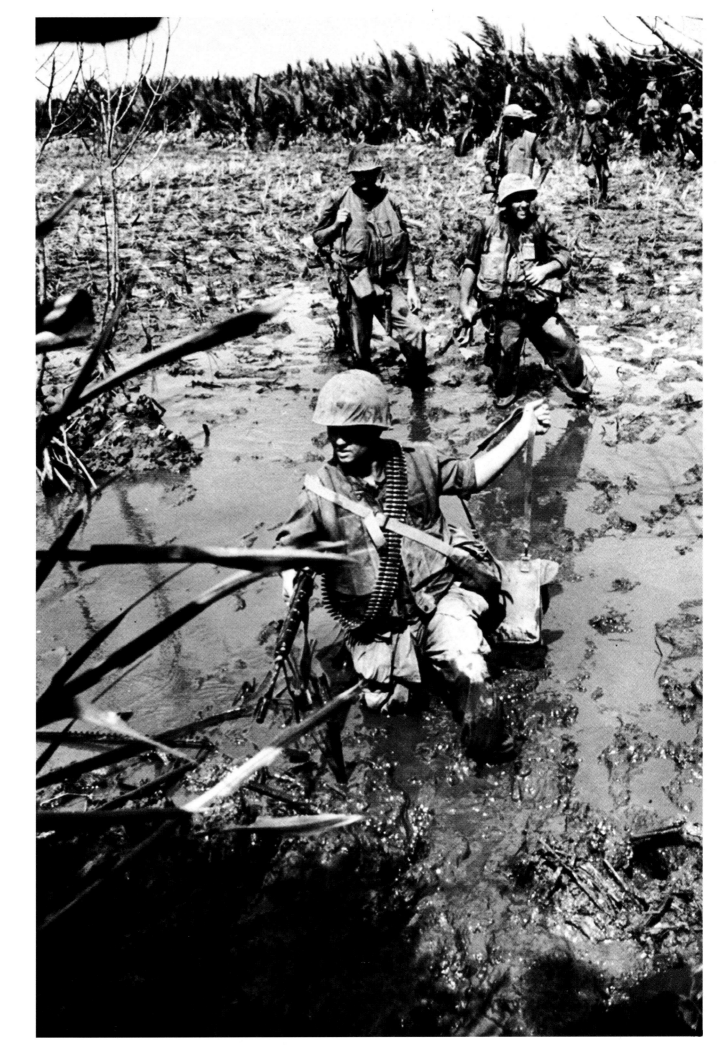

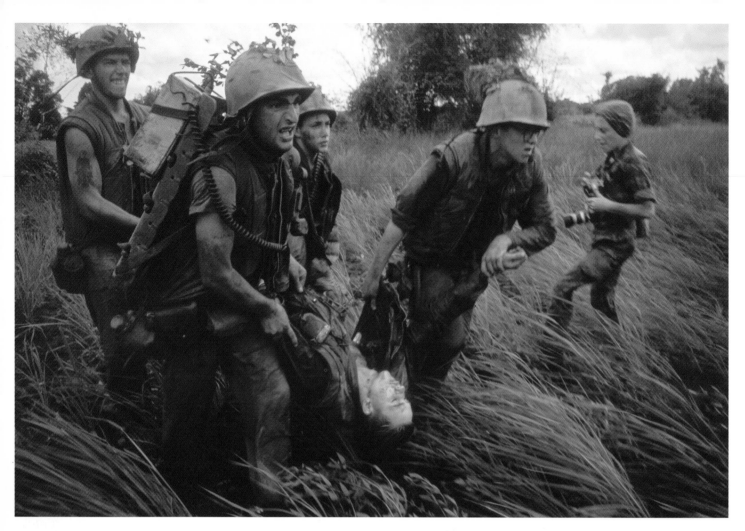

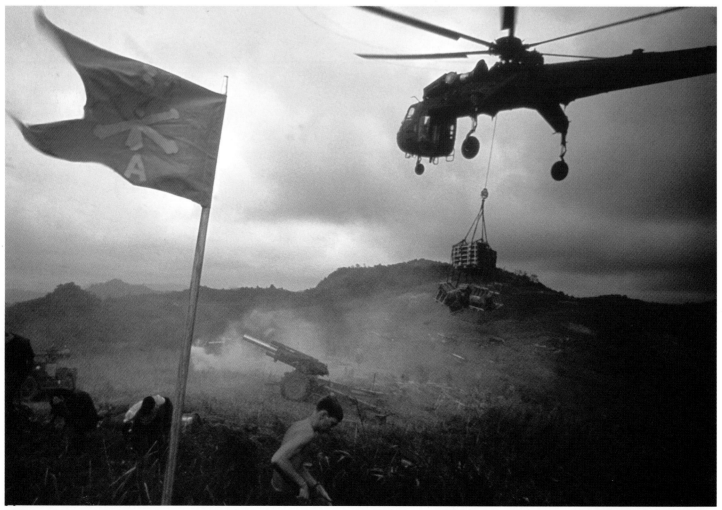

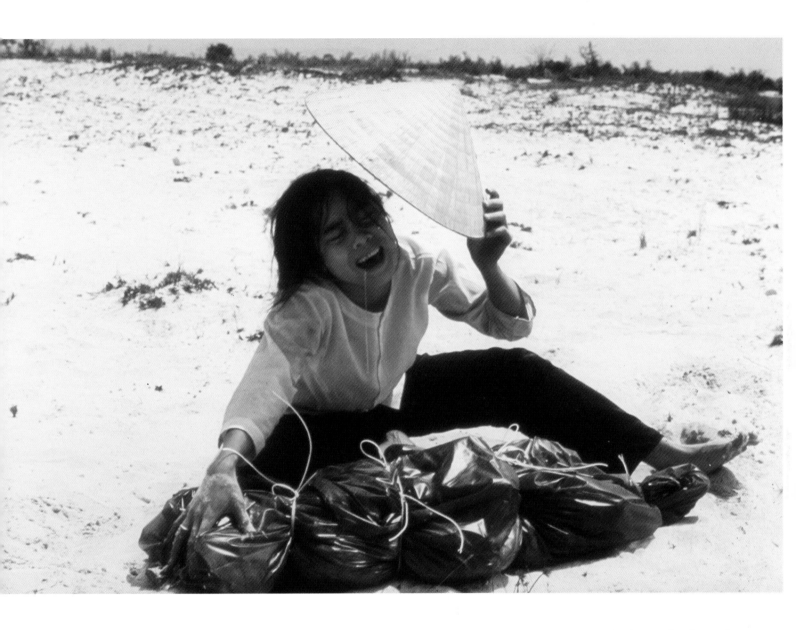

LEFT TOP: Burrows's visceral photography had a profound impact on some of the subsequent films made about the Vietnam War. This image of marines recovering the body of a comrade while under fire from the North Vietnamese could be a still from *Platoon*.

LEFT BOTTOM: During a persistent North Vietnamese attack in 1968, a US 1st Air Cavalry helicopter airlifts ammunition into a marine outpost.

ABOVE: In this harrowing image of raw and absolute grief, a distraught widow cries over a plastic bag that contains the remains of her husband, killed in the 1968 Tet offensive, and recently found in a mass grave. Burrows was the supreme war photographer who could document all sides of the conflict and who had a natural empathy with the Vietnamese people.

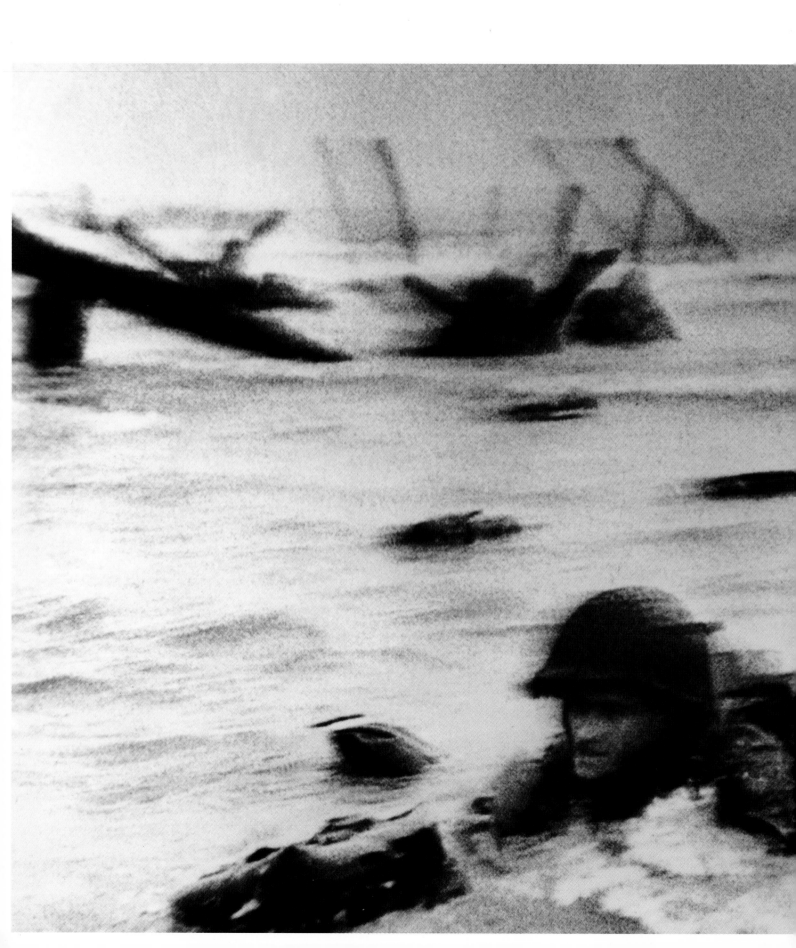

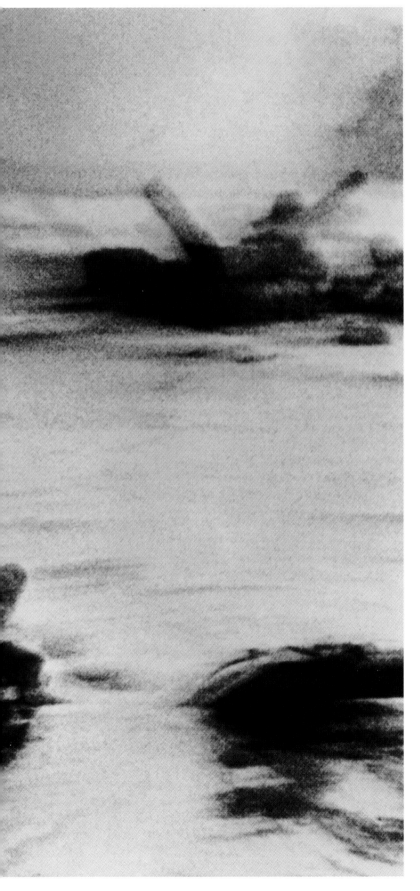

Capa's romantic and heroic reputation hides another side to his work. His dictum "If your pictures aren't good enough it's because you're not close enough" has a double meaning, because it implies that involvement and sympathy with the subject are equally as crucial as being close to the action. He was to draw on his sense of empathy to make important pictures about the situations and people with whom he came into contact. His notoriety — as gambler, drinker, *bon viveur*, serial seducer of beautiful women — was carefully nurtured by him to increase the value of his work.

While covering the Spanish Civil War in 1936, he took the iconic image of the conflict and one of the most important of the twentieth century, the Republican soldier at the moment of death. There has been controversy about it ever since: was it set up? (His biographer Richard Whelan succeeded in putting all doubts about this image to rest in 2002, following a positive identification of the subject and the action in which he died.) After the fall of France in 1940, Capa was in the USA and managed to gain assignments from the leading American magazines *Collier's* and *Life*. His reputation as "the greatest war photographer" was finally confirmed by his pictures of D-Day. He photographed under heavy fire on the American beachhead, and his four films were rushed back to England where a hapless darkroom assistant at *Life* managed to destroy all but 11 frames (out of a total 108) of his film in an overheated drying cabinet. Yet the heavy grain and distortions of the negatives made the pictures graphically powerful. When published, they were immediately seen as defining records of the battle, though *Life* hid its mistake by saying they were "slightly out of focus". His romantic life (which included many friends in Hollywood) and early death made Capa a star known far beyond the narrow confines of photography. But he left a vast photographic legacy, a body of work that showed him to be a perceptive humanist photographer, an outstanding portraitist and masterful at capturing the complexity of a military action. He was also an inspired innovator in the field of photojournalism, creating and nurturing the Magnum cooperative.

LEFT: **"The war correspondent has his stake — his life — in his own hands, and he can put it on this horse or that horse, or he can put it back in his pocket at the very last minute ... I am a gambler. I decided to go in with Company E in the first wave." This photograph of Omaha Beach, Normandy, 6 June 1944, was one of 11 surviving pictures from the four films Capa shot on his Contax. His D-Day images have become the enduring symbol of the struggle for the beachhead.**

BELOW: This photograph of a Spanish Republican soldier at the moment of death, on the Aragon Front in September 1936, made Capa's name. Uncertainty about whether the photograph was "set-up" was finally resolved only when several witnesses to the action in which the soldier was killed were located in 2002.

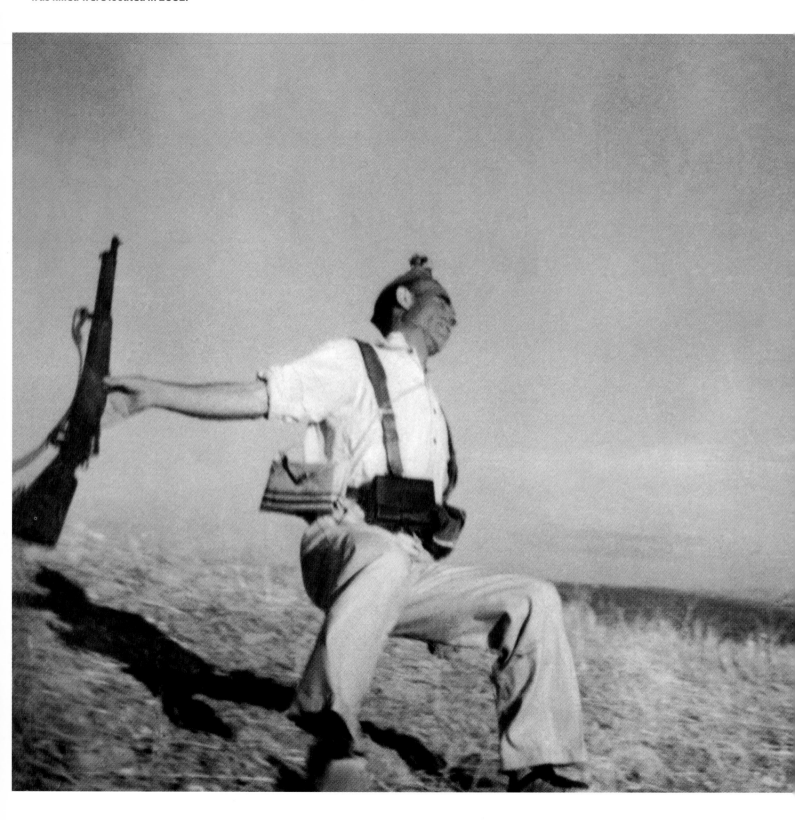

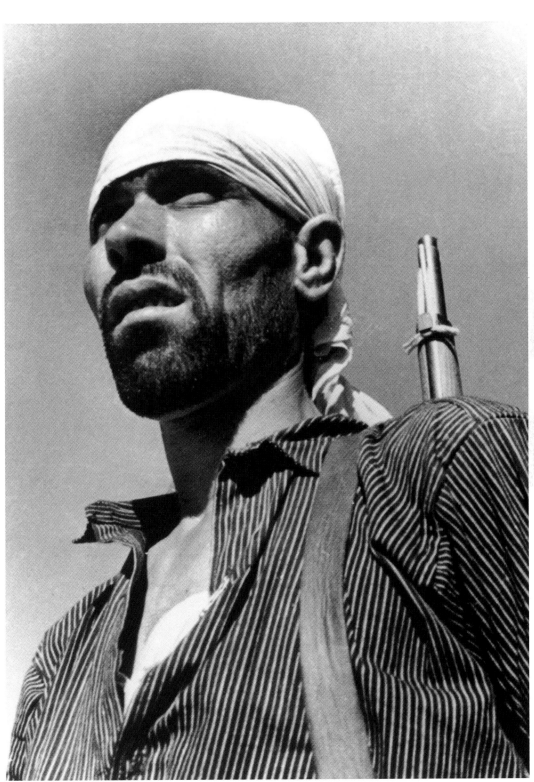

GILLES CARON

The power and beauty of Caron's work as a photojournalist probably owes a great deal to his experiences in Algeria. According to his friend Robert Pledge, photographer and founder of Contact Press Images, Caron's 24 months as a paratrooper were recounted in the almost daily letters he wrote to his mother. They contain remarkable observations on what was going on around him and his feelings and distress about the violence and the horror that took place. It led him to photography. As he wrote, he "felt the need to be there and be a witness and tell the world what was going on".

When he returned to France, he decided to become a photographer and a witness to world events. Caron's pictures of Paris in May 1968 are remarkable for the way they capture the riots as street theatre, like staged and pitched battles in a civil war (not unlike the photos of the insurrection that brought the German occupation to an end in August 1944). All his experience as a soldier and as a war photographer was brought to bear on them. The same turn in world events that had taken Caron to wars in Africa and Indochina brought him back to France and on to the streets of Paris, before he was whisked away to South-East Asia. Don McCullin, a friend and a competitor for the same picture stories, recalled the moment he learnt of Caron's disappearance. "The tragedy about Gilles was that when the Cambodian conflict broke out in a very serious way, being French of course, he was that much closer to the culture. He got there very quick and I got there a week later, and by the time I got there Gilles had already been captured and disappeared out of our lives."

RIGHT: **Caron's knack of capturing the beauty of the balletic stone thrower in the Rue St Jacques emphasizes the theatrical character of so much of what occurred during May 1968.**

BELOW: **This is one of the most enduring images from the 1960s, with the riot policeman representing the full force of repression. It is a surreal isolated moment from a strange time and we certainly feel the demonstrator's pain.**

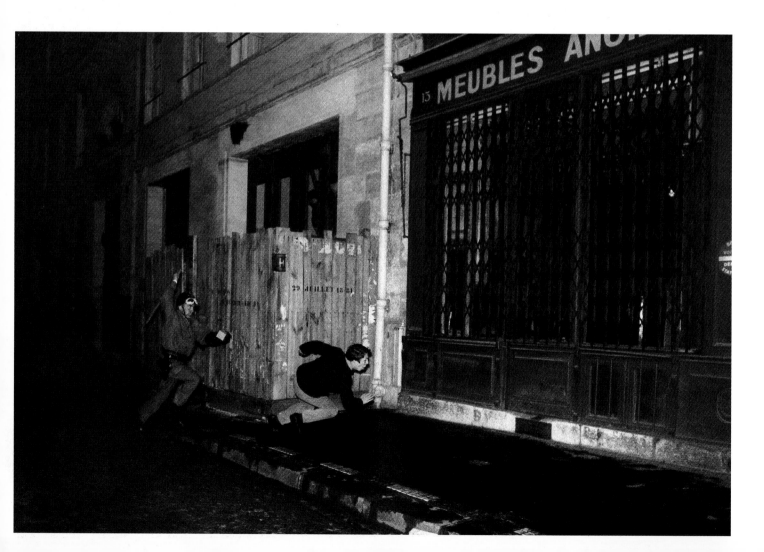

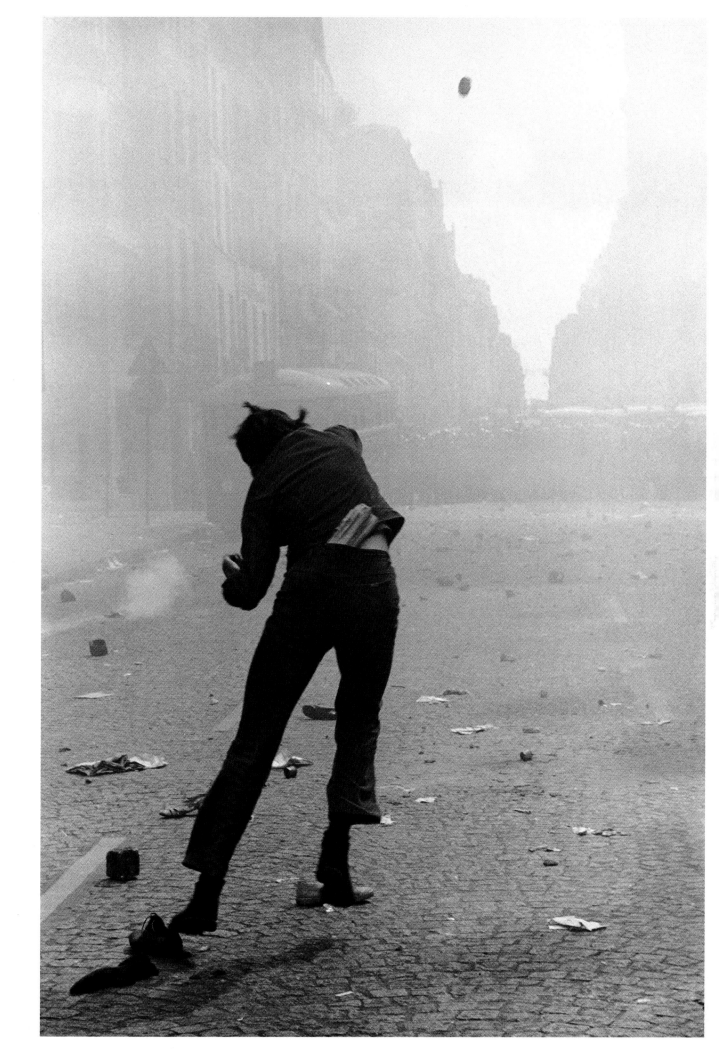

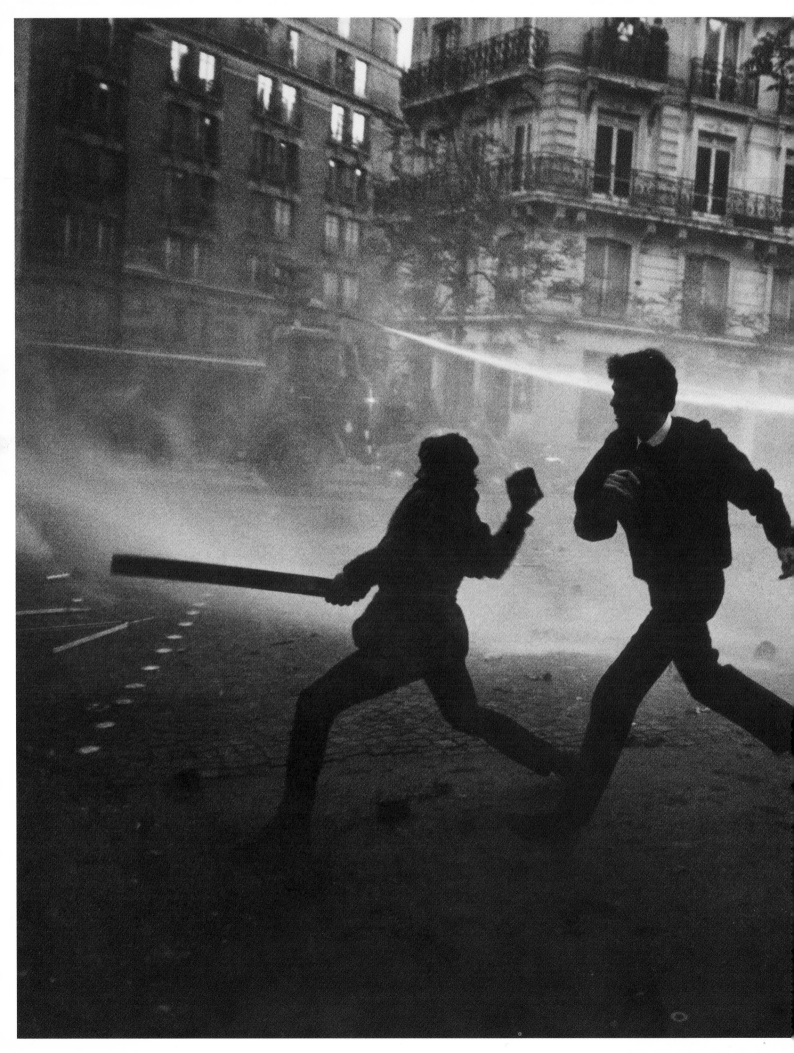

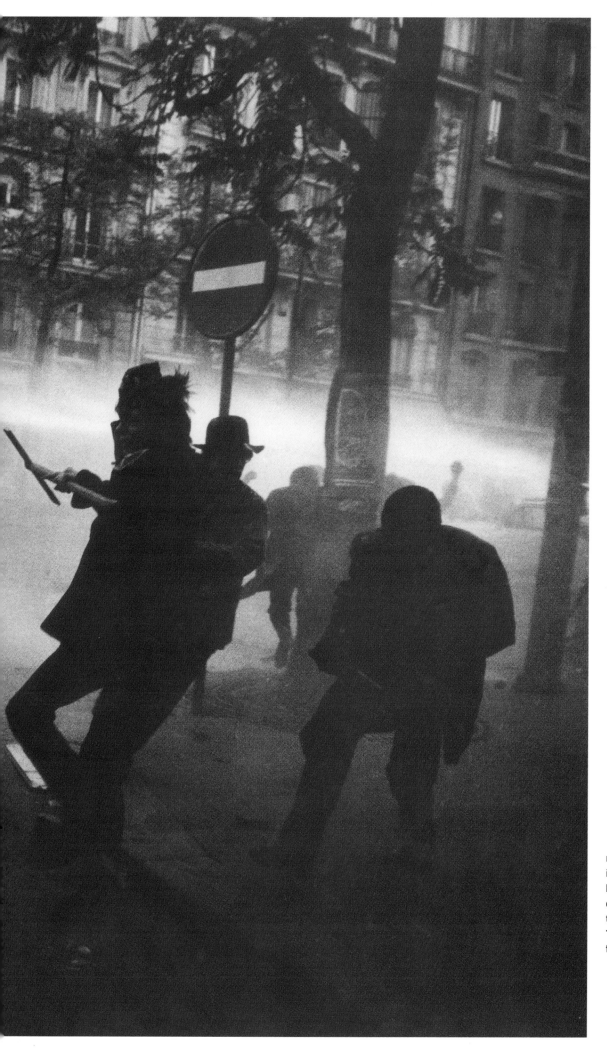

LEFT: A group of demonstrators in action during the pitched battles fought along the streets of the Latin quarter, an echo of the struggles waged in August 1944 when Paris was liberated from the Germans.

HENRI CARTIER-BRESSON

It is ironic that the greatest photojournalist of the twentieth century was somewhat disdainful of the term and in the latter part of his lifetime appeared to be bored with photography itself. But Cartier-Bresson was always something of a contradiction: an upper-class left-wing bohemian; a photojournalist who worked for magazines, yet who regarded himself as an incorruptible artist; and an idealist who was also very much a shrewd businessman with a great sense of his own worth and legacy. In *The Decisive Moment* he writes: "I prowled the streets all day ... ready to pounce, determined to 'trap' life – to preserve life in the art of living. Above all I craved to seize the whole essence, in the confines of a single photograph, of some situation that was in the process of unrolling itself before my eyes."

This "whole essence" comes together when the hand, eye and heart are working in perfect tandem. Cartier-Bresson would study his photographs upside down in order to better assess the lines and composition, in much the same way a painter looks at his canvas. Cartier-Bresson perpetuated his own myths, and one of them was that he would take few photographs, preferring instead to merge into the background, observe a situation through his Leica until the Zen moment and then click the shutter. The reality was somewhat different; Cartier-Bresson probably shot as many rolls of film as some of his Magnum colleagues – he simply had a higher hit rate and was also a very efficient editor of his own work. For all his high-art ideals, he was also an extremely capable and brave frontline news photographer who knew how to jolt his viewers. His experiences had been partly shaped by being imprisoned by the Nazis during the Second World War and his subsequent escape and time in the French Resistance. It is against this background that the famous photograph shown here should be judged. Prior to Cartier-Bresson, photojournalism was considered a trade; he elevated the medium into an art form. A true visionary and a genius, we shall probably never see the like of him again.

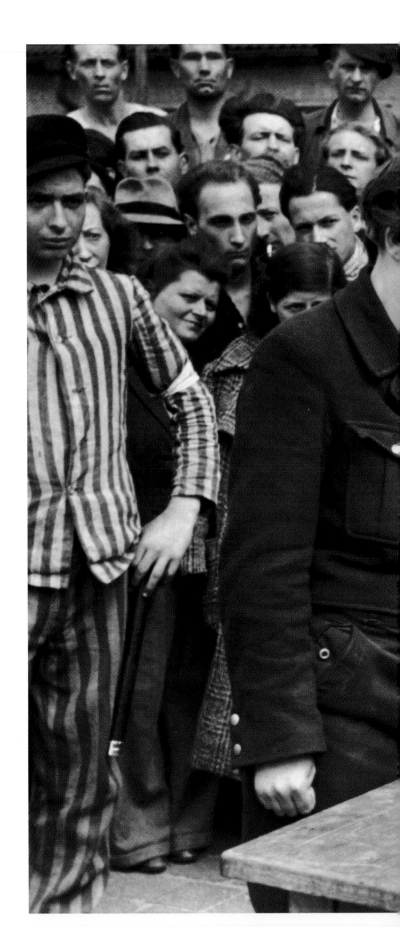

RIGHT: A young Belgian woman and former Gestapo informer is identified as she tried to hide in the crowd in what is probably Cartier-Bresson's most famous on-the-spot news photograph. Cartier-Bresson brilliantly captures the harsh emotions evoked by the scene – anger, shame, curiosity, revenge – and no one comes out of this photograph particularly well.

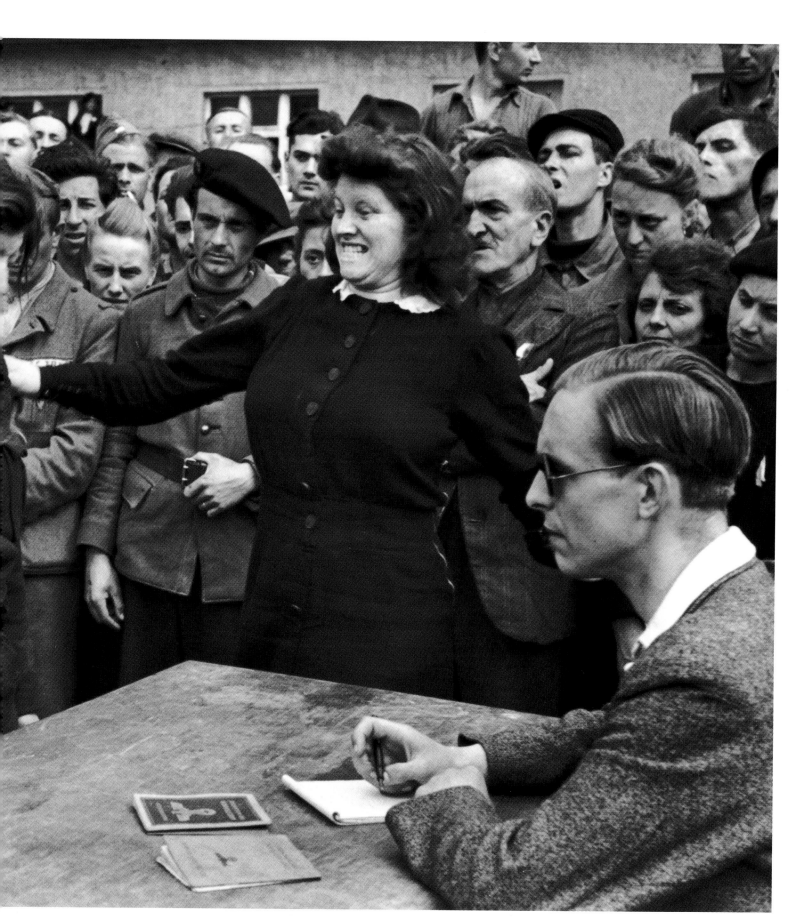

BELOW AND RIGHT: Two views of the crowds waiting in Trafalgar Square, London, in 1937 for the coronation parade of King George VI. This was a strange period in English history because the true heir, the King's brother Edward VIII (the Duke of Windsor), had abdicated in order to marry Wallis Simpson. There is a sense of anticipation, but also uncertainty. Both images show Cartier-Bresson's absolute mastery of conveying an event through human emotion.

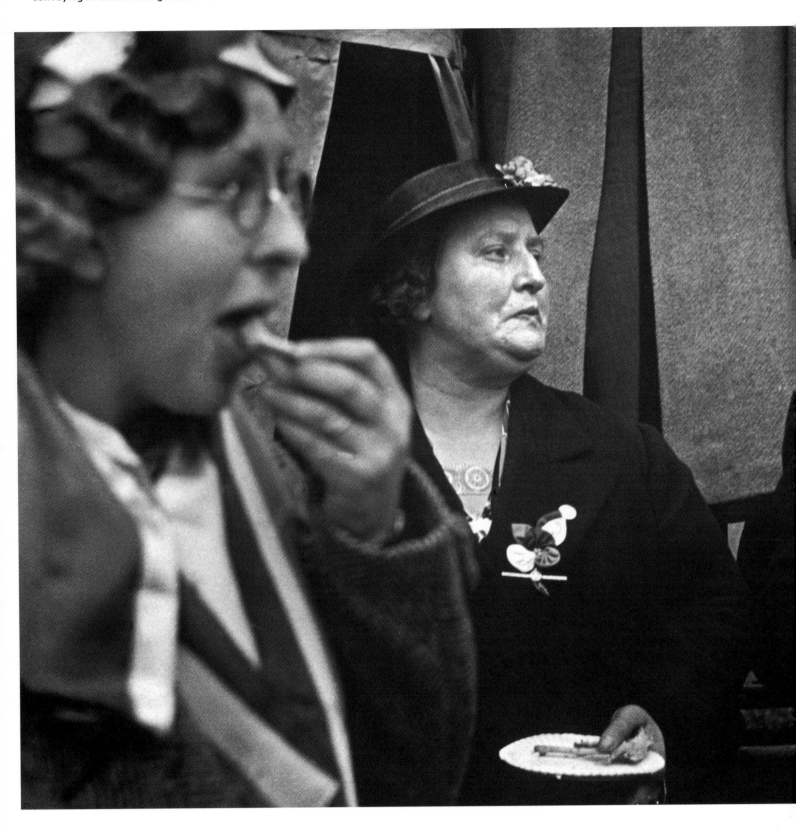

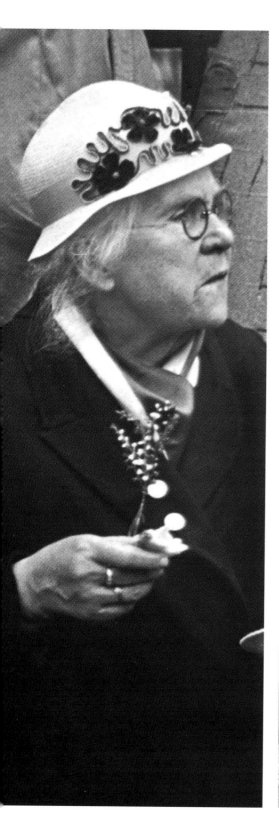

ABOVE: Again Cartier-Bresson applies his trademark technique of revealing an event through human emotion to his essay on the building of the Berlin Wall in 1961–62. We see the drama unfold through the eyes and nervous gestures of the small group of onlookers wondering what is going to happen next.

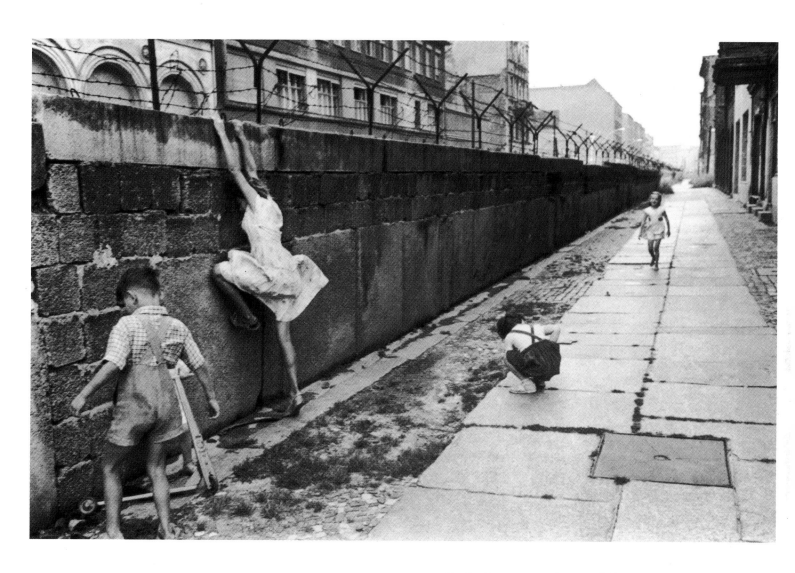

ABOVE: Cartier-Bresson was also very skilful at telling a story through contrasts. Part of the same Berlin Wall essay, this shot completely encapsulates the conflicting elements of the Wall's bleakness and the innocent acceptance of its existence by these children playing in the West Berlin sector.

LUC DELAHAYE

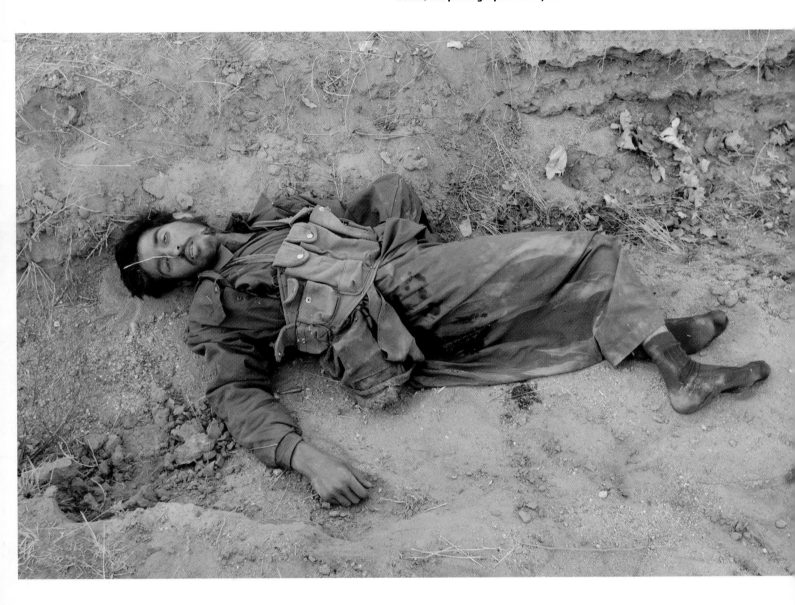

Luc Delahaye is part of a select group of outstanding photojournalists who came of age during the war in the former Yugoslavia. He started out as a more traditional war photographer, intent on getting as near as possible to the action, so close that you can almost hear the bullets whizzing around in his photographs. Yet Delahaye has always been prepared to also take artistic risks as well as personal risks. In the words of Jamie Wellford, International Photo Editor of *Newsweek*, "He challenges himself consistently to define the image as opposed to fulfilling the expectations of what an image should or is expected to be." By challenging himself, he is reinventing the conventions of photojournalism and how conflict should be presented. So for example, he took the unusual decision to photograph the US invasion of Iraq using a larger-format camera, as opposed to the more traditional 35mm. Such a method produced vast panoramas, giving the viewer a literally wider view. Depicted in this way, the story of the invasion was now not just a news event, but an epic struggle. These all-encompassing and sweeping views are closer in spirit to eighteenth- and

nineteenth-century historical paintings, than to modern confrontational war photography.

This conflation of fine art photography and reportage was also used while covering the US invasion of Afghanistan in 2001. The most famous image from this period is Delahaye's photograph of the sprawled figure of a dead Taliban soldier lying in a ditch. No detail is omitted and everything is presented in graphic clarity. It might seem morbid, but in the hands of such a skilled craftsman it is an extremely beautiful photograph. This image was shown on a huge scale at one of New York's most prestigious private galleries and subsequently sold for thousands of dollars. Yet for all his fine art pretensions – Delahaye no longer considers himself a photojournalist, but rather an artist – his work will, according to Wellford, "remain definitive in the world of photojournalism and be recognized as a body of work that redefines, addresses, exposes and ultimately illuminates the medium".

ABOVE: **A clever composition conveys the bleakness of the Palestinian situation at the Jenin refugee camp on the West Bank/Israel in 2002.**

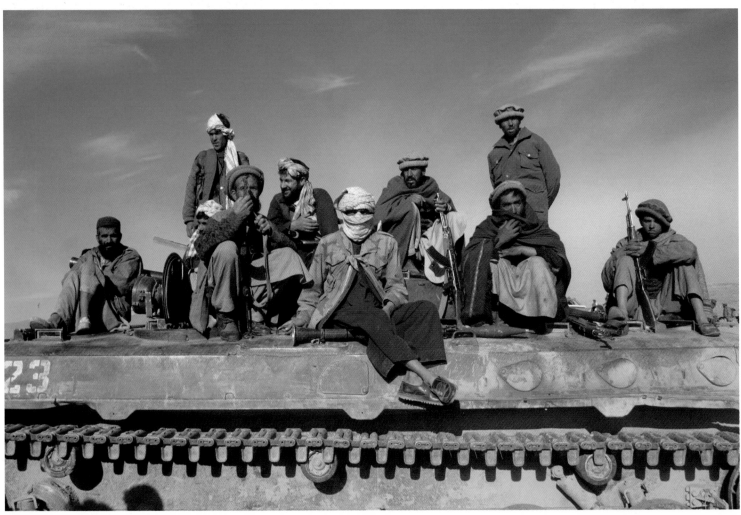

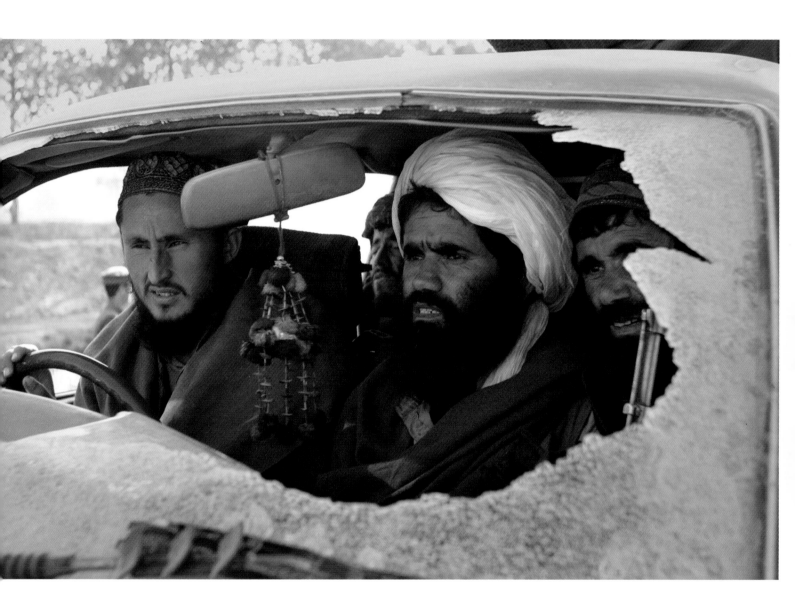

ABOVE: Delahaye captures the uncertainty of surrendering Taliban fighters in Afghanistan 2001. They are arriving by car in Northern Alliance territory near Kunduz and they are clearly fearful about what lies ahead.

LEFT TOP: From the rooftop of the command post of the Bagram military airbase, 12 miles (20 km) north of Kabul in Afghanistan, Northern Alliance soldiers watch the jets bombing nearby Taliban defence lines in 2001. Delahaye combines the lyrical with the dramatic, a fine art sensibility with a hard news edge.

LEFT BOTTOM: It is 6 am, and Northern Alliance forces, intent on the liberation of Kabul, are shown on the outskirts of the city in 2001.

ALFRED EISENSTAEDT

RIGHT: **In one of the most famous images of the twentieth century, a jubilant sailor celebrates a long-awaited victory over Japan in 1945, bending a nurse over backward in a passionate embrace. In the background celebrants jam Times Square, New York. For years after the image was published, a succession of people came forward, claiming to be the original subjects. Eisie revealed that he saw the scene unfolding out of the corner of his eye. He took the one shot and then the couple disappeared.**

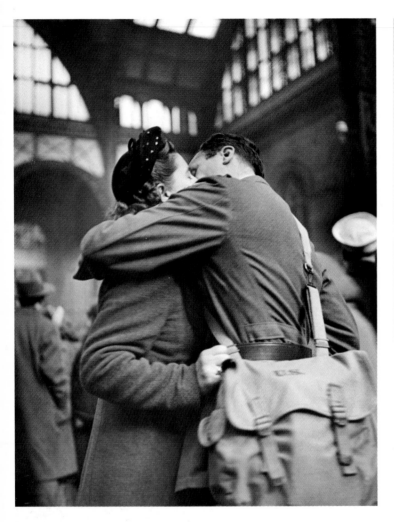

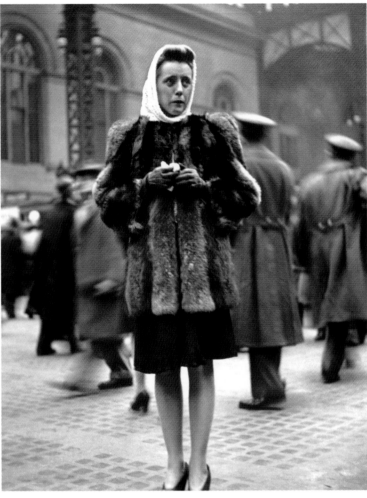

Alfred Eisenstaedt was chosen "Photojournalist of the Century" by the influential web magazine *The Digital Journalist*, beating candidates such as Robert Capa, Cartier-Bresson and W. Eugene Smith. Justifying his choice, the editor Dirk Halstead writes, "He had the most profound impact and leaves the greatest legacy." While he lacked the charisma of Capa, and his work never reached the artistic heights of Cartier-Bresson, he did have a great gift for storytelling, especially when the story was unfolding on the pages of *Life* magazine. In these days of the Internet and 24-hour cable television, it is hard to imagine the power and influence of *Life* magazine during its golden years from the mid-1930s to the mid-1950s. To many Americans it was their only window to a world beyond their front lawns and small towns. Eisie dutifully guided these readers through some of the key moments of the twentieth century, as well as photographing virtually every icon of the past 100 years, including Churchill, Marilyn Monroe and JFK. Eisie was a small man with boundless energy and curiosity about people. He described his technique as "naïve" and argued that "every professional should remain always in his heart an amateur". This meant that Eisie approached every assignment with fresh-faced enthusiasm and a hunger to tell his loyal readers at *Life* about the world. Despite the competitiveness and cynicism of the magazine world, he never became jaded or lost his love of taking pictures. He also kept it simple and his photographs always cut

through the clutter and resonate with the viewer. There are no strange angles, or abstract compositions, there is no ego, or even a sense that Eisie has a point of view – his function is to record it all with great clarity and incisiveness. He made it look very easy and therefore some critics have dismissed his photography as the visual equivalent of easy listening. That description does both the man and his impressive career a great disservice.

ABOVE LEFT: **On New Year's Day 1944, a soldier gives his girlfriend a smothering kiss goodbye at Penn Station, New York before returning to duty after a brief furlough. This was the kind of image that would resonate with *Life* readers, and it has all of Eisie's signatures – straightforward composition with little to distract the viewer from the main storyline.**

ABOVE RIGHT: **The same day, but a different scenario. A distraught woman clutches a tear-sodden handkerchief as she watches her soldier boyfriend walk away after saying goodbye in Penn Station, as he, too, returns to duty.**

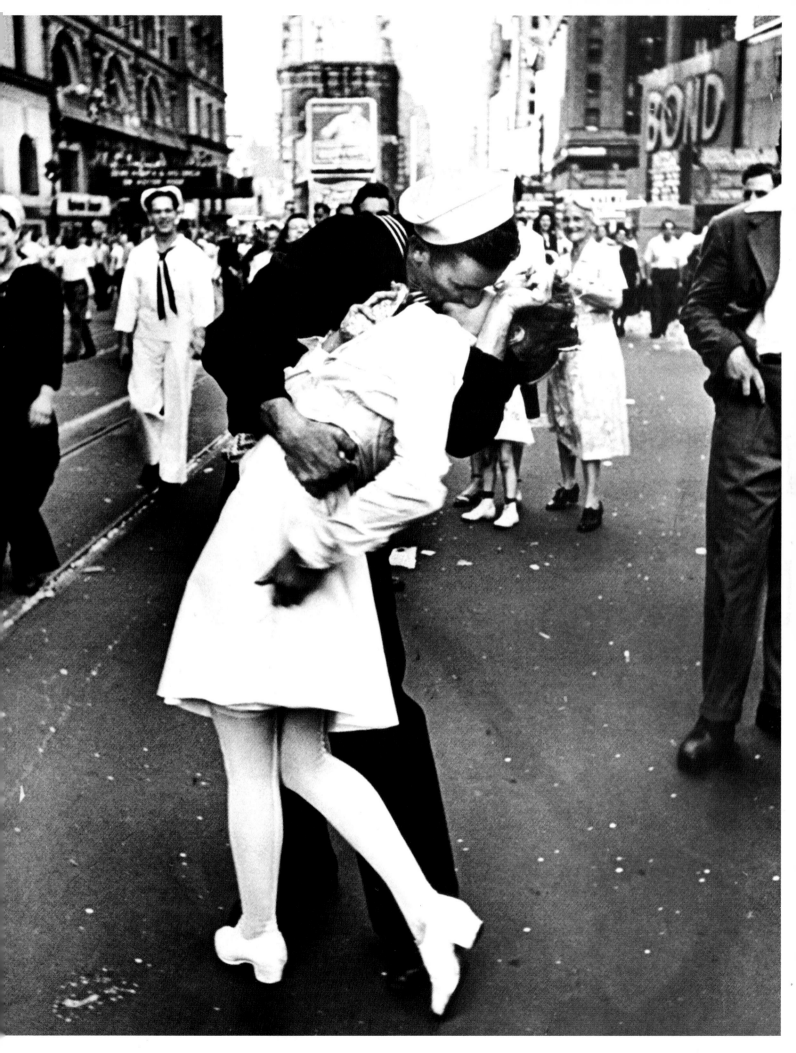

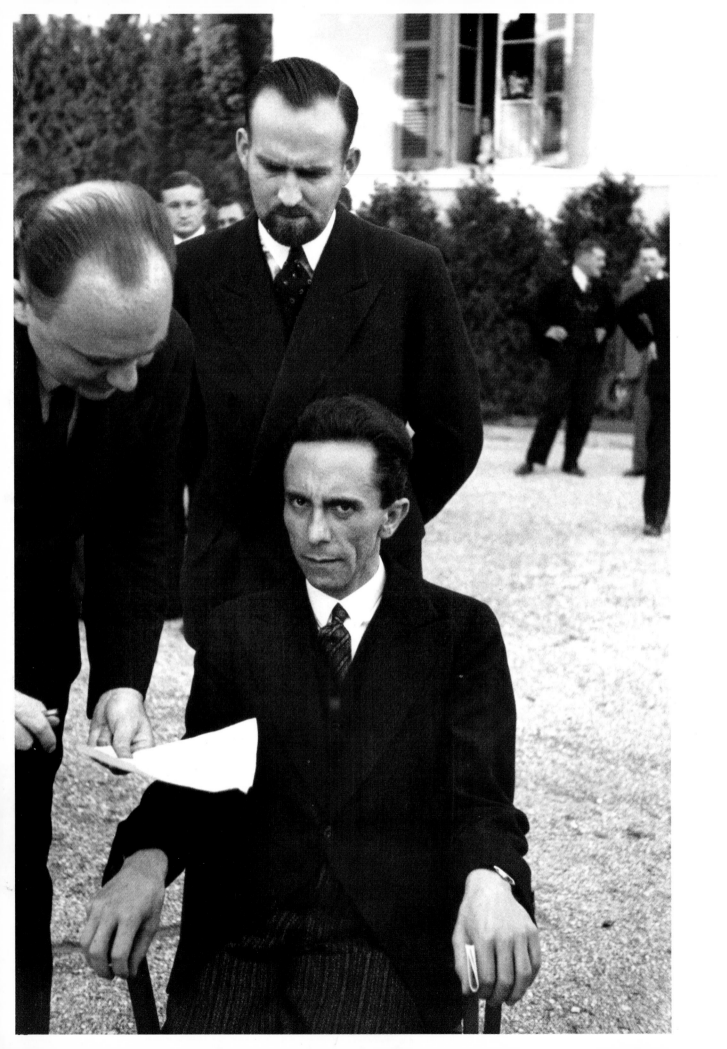

ABOVE: In 1934 Eisie captured the Italian fascist dictator Benito Mussolini giving a speech from a balcony in St Mark's Square, Venice, as a group of Black Shirts looked on. There is a notable contrast between the splendour of the Renaissance architecture and the posturing of Mussolini and his band of thugs. The jabbing, insistent finger reveals something about the nature of the man.

ROGER FENTON

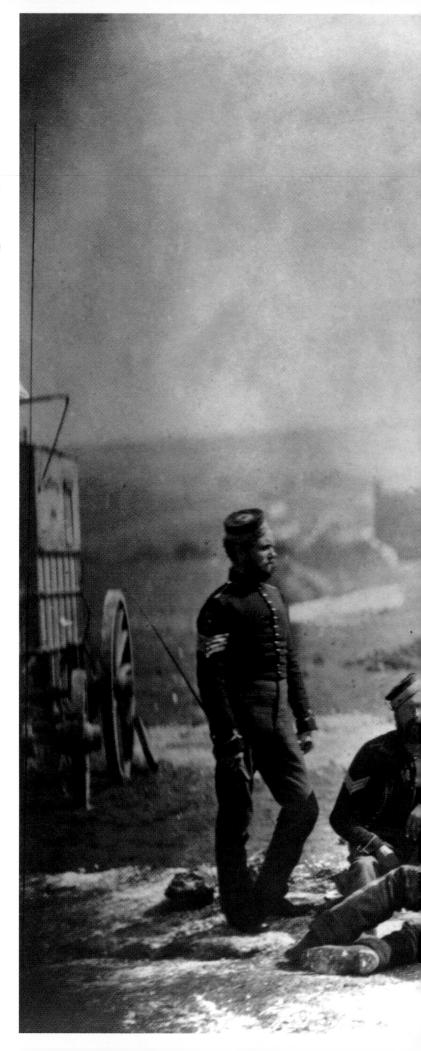

As a photographer, Roger Fenton's chief source of income was from the sale of prints. He benefited greatly from a privileged relationship with the celebrity family of the day, the Royal Family, producing fascinating photographs of Queen Victoria, Prince Albert and their children from 1854. Fenton found favour with them because he was the leading photographer of the era, exhibiting more work over the decade 1852–62 than any other photographer, perhaps as many as a thousand images. Since his pictures were made by labour-intensive methods, initially using wax-paper negatives and then wet-collodion, this output is certainly substantial, particularly as it covered architecture, museum collections, still life, genre studies and portraiture.

Fenton also seems modern in his ceaseless self-promotion, and he derived considerable personal celebrity from his photographs of the Crimean War in 1855 (the commission for which may have been thanks to the influence of Prince Albert). His war images are mostly portraits of officers and notables, made as part of a commercial deal with the London print-seller Agnews, and they seem hardly akin to "war-photography" in the modern sense. Fenton photographed the leading figures of all the Allied armies, as well as the most notable officers in the British regiments. He also made interesting views of military camp life, which included the more exotic combatants – Zouaves, Croats, Turks and of course Highlanders in their kilts. Among the small numbers of landscape views is his photograph of the deserted "Valley of the Shadow of Death", taken shortly after the charge of the Light Brigade, which swiftly became an iconic image of this conflict. Yet it is a picture almost bereft of information about the battle itself, with just a scattering of cannon balls lying on the ground to indicate that anything significant may have happened. Pictures of dead bodies or the chaos of war would not have been considered acceptable. His commission was an attempt to make the war acceptable to the influential classes, many of whom had lost family and friends in the Crimea, by promoting the idea that their loved ones had been sacrificed to a noble cause.

RIGHT: **Fenton's group portraits during the Crimean War were loosely posed because the conventions about such military portraits were still being formulated. Civilian and military groups generally look quite similar around this period, the mid-1850s, as in this case, which shows members of the 8th Hussars gathering around their cookhouse. Note how some soldiers are more aware of the camera than others.**

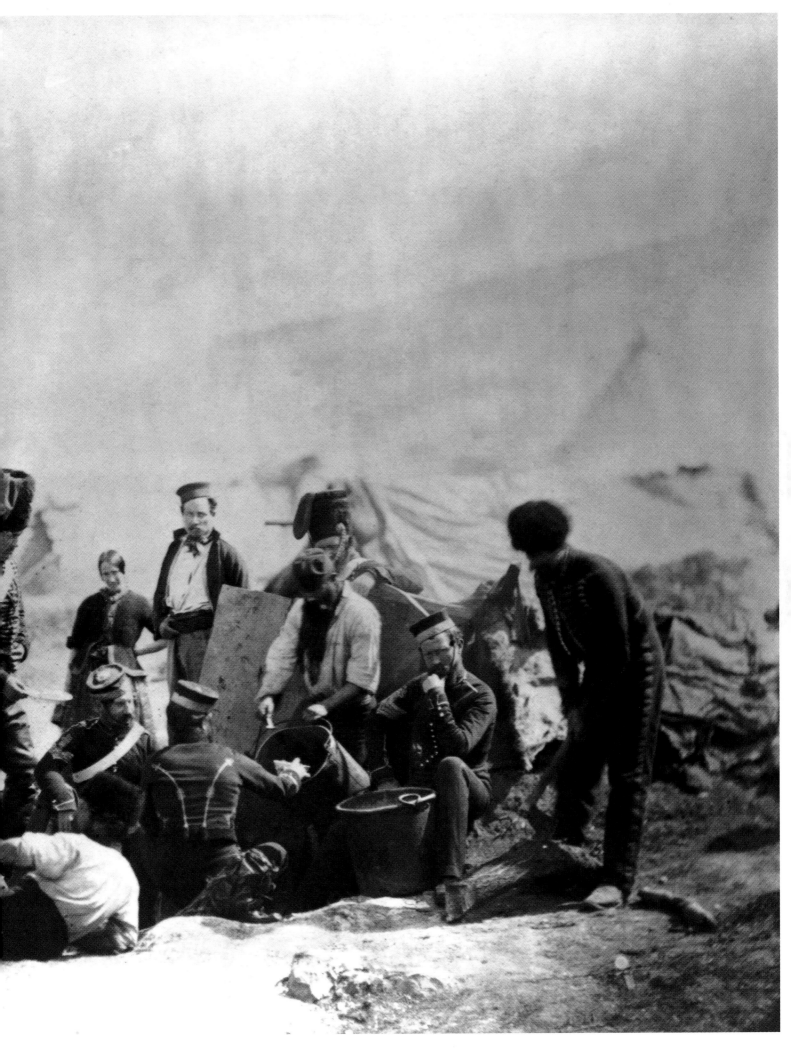

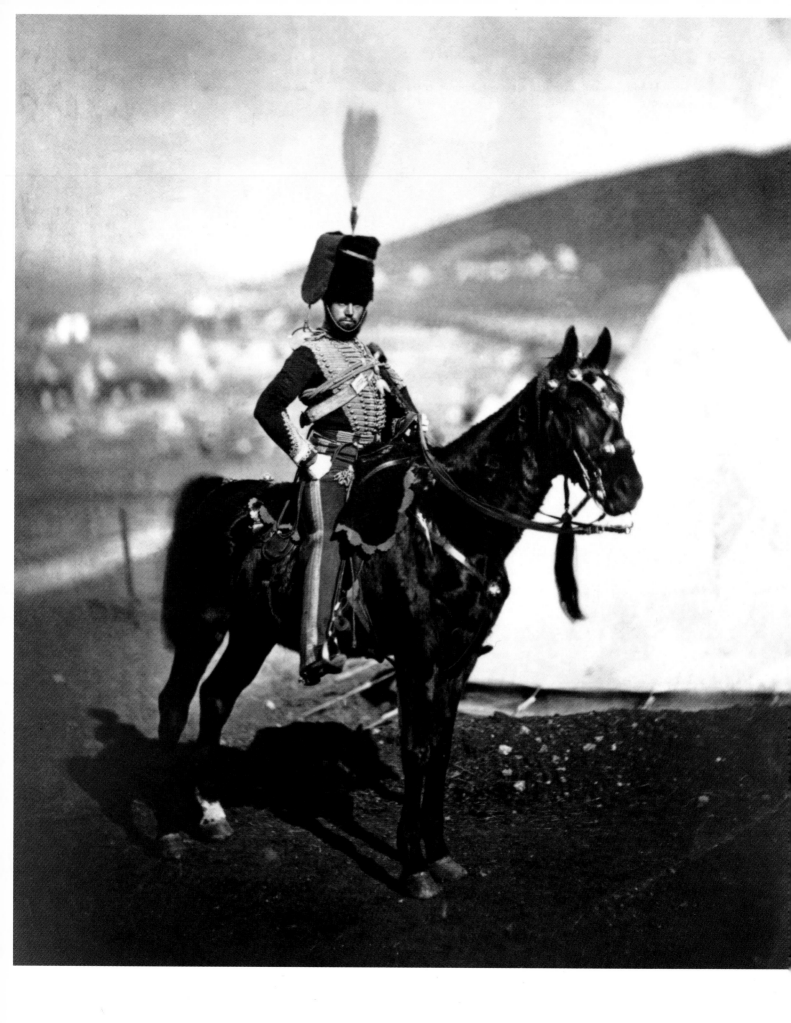

LEFT: The main reason for Fenton's photographic journey to the Crimea was to assemble a series of portraits and views that his client, Agnews, could sell as part of an album or as individual prints. This portrait of Cornet Wilkin of the 8th Hussars is a carefully posed image that would be likely to find a commercial market back in England.

BELOW: The "Valley of the Shadow of Death" on the plain of Balaklava, a photograph taken shortly after the famous Charge of the Light Brigade, and showing spent cannon balls littered along the path of the cavalry charge. This is probably Fenton's most famous image from the campaign.

OVERLEAF TOP LEFT: In his search for interesting images to complement the portraits that make up most of his work, Fenton sought out scenes such as this one showing the camp of the 5th Dragoon Guards looking toward Kadioki in 1855.

OVERLEAF BOTTOM LEFT: A group shot, although it is not clear whether the men are preparing for battle or if this is a respite from the fighting.

OVERLEAF RIGHT: Taken in 1855, this beautifully posed portrait of Major Butler, 28th regiment, is typical of Fenton's work in the Crimea. It is probable that the soldier's family would want to buy a number of prints from the sitting.

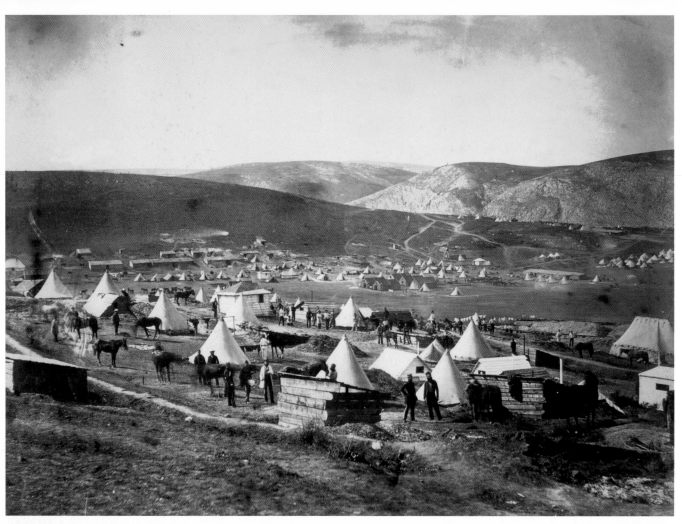

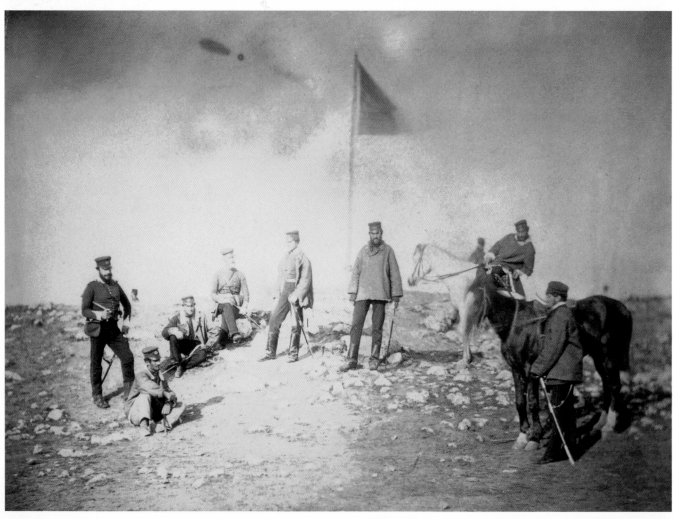

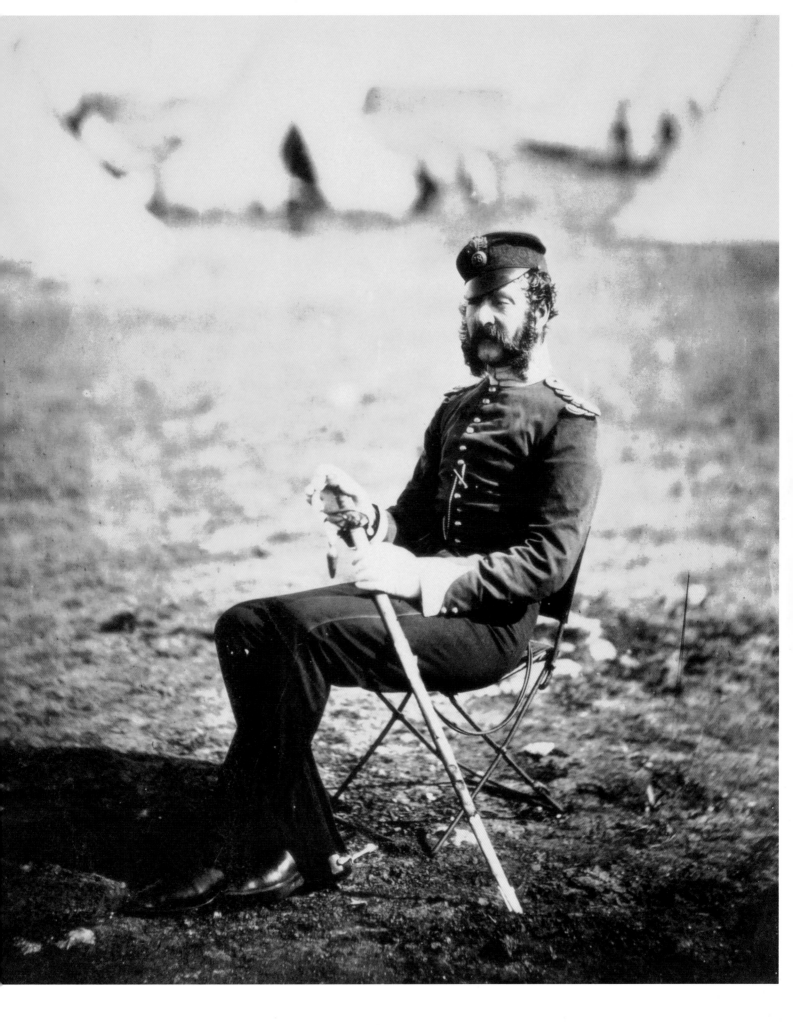

ALEXANDER GARDNER

RIGHT: In 1862, in the midst of the Civil War, Gardner captured (from left to right) Major Allan Pinkerton, US President Abraham Lincoln and General John A. McClernand, standing in front of a pitched tent on a battlefield. The photograph poses the obvious question — what is the President doing so close to the heat of the battle?

BELOW: An overview of the Second Inauguration of Lincoln, 4 March 1864.

On seeing one of Alexander Gardner's photographs from the American Civil War, the famous American writer Oliver Wendell Holmes wrote, "It is so nearly like visiting the battlefield to look at these views that all the emotions excited by the actual sight of the stained and sordid scene, stewed with rags and wrecks, come back to us." Indeed they do. The government gave Gardner and his colleagues complete access to document the Union troops during the campaigns and Gardner set about his task with particular relish. Until then, his photographic experience had been within the more rigid confines of shooting studio portraits, but he had a natural instinct for the demands and rigours of working out in the field. He not only took the photographs, but also had his own travelling darkroom, so that the collodion plates could be processed on the spot. Gardner's images caused a sensation; the public was simply not used to seeing such an accurate representation of war. The scenes of carnage were vivid, macabre and relentless. Unfortunately, for all his ideals and photographic skills, Gardner was also prepared to tamper with the truth in pursuit of a good story. William Frassanito, the writer of *Gettysburg: A Journey In Time*, concludes, after painstaking research, that one of Gardner's more famous photographs, *The Home of a Rebel Sharpshooter, Gettysburg*, is a fake. He suggests that Gardner and his colleague, Timothy O' Sullivan, started by taking photographs of a body in a field. When they noticed a more picturesque sharpshooter's den, they dragged the body some 40 yards away, placed a rifle (probably Gardner's) as a prop, turned the corpse's face toward the camera and took the picture. The soldier is no longer just a body in a field among thousands, but a man who had suffered a lonely and painful death, and the drama of the image is intensified. This one photograph, however, should not diminish his whole legacy. Gardner took more than a thousand images of the American Civil War and as far as we know they are genuine. He was a genius of his day, albeit a flawed one.

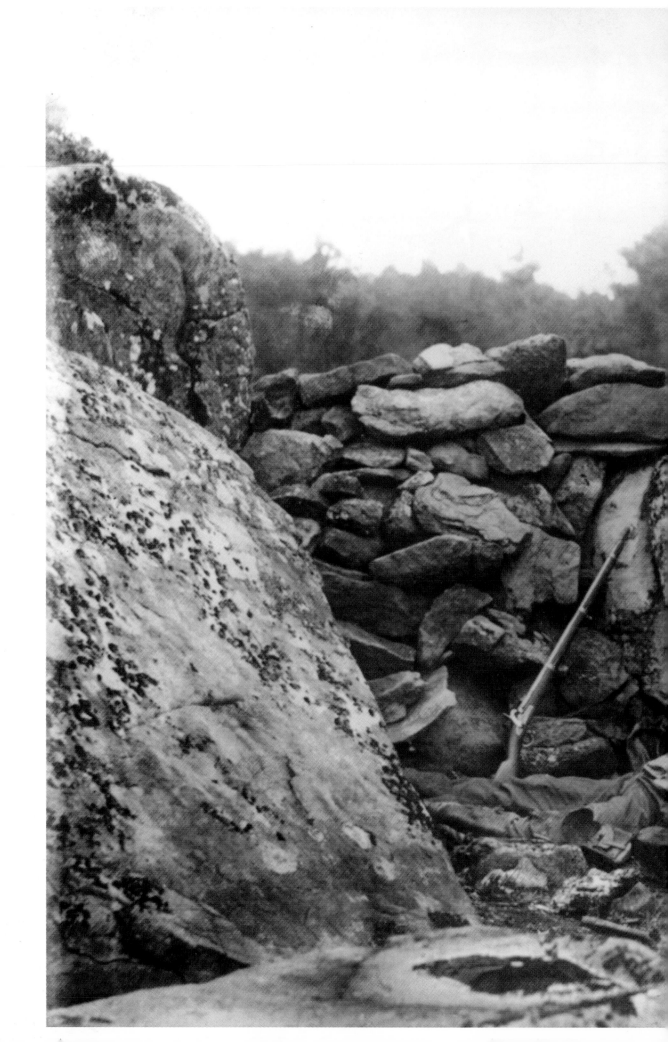

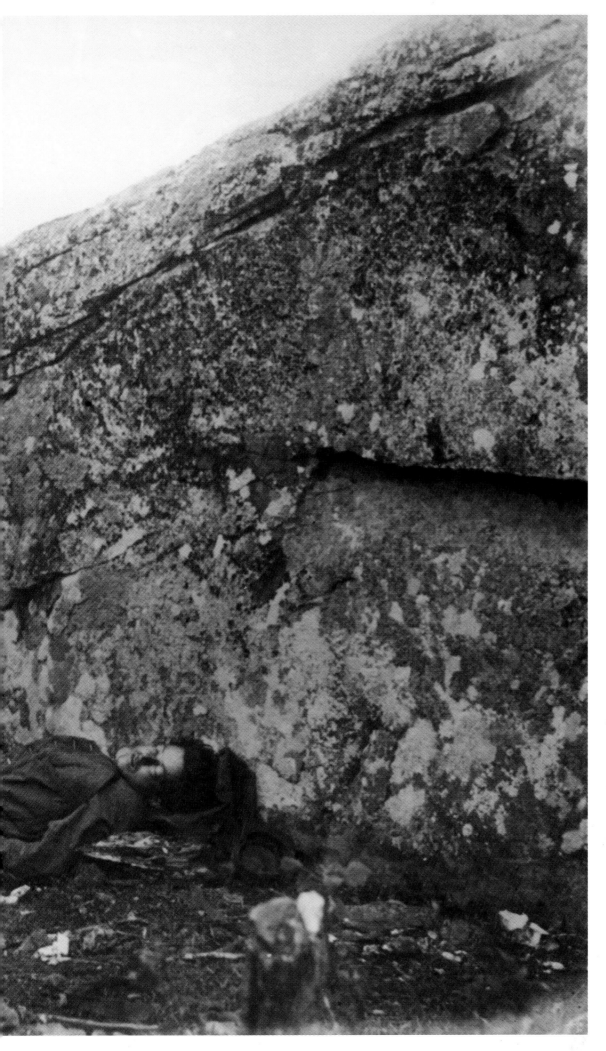

LEFT: Extensive research has shown that this image, *The Home of A Rebel Sharpshooter, Gettysburg, 1863*, is not as it seems. It does not actually portray the "home" of the soldier, who had in fact been dragged by Gardner and a colleague from a nearby meadow and photographed in this more poignant setting. In his *Photographic Sketchbook of the Civil War*, Gardner writes that he came across this dead man, still with his rifle, in the aftermath of battle, but in reality the gun would have been looted long before this picture was taken. It is actually a prop provided by Gardner.

BELOW: Family members visit a relative at the Al-Maaqal prison near Basra, Iraq, where some 300 prisoners have been detained. The framing, featureless foreground and background, and gestures of the subjects — particularly the hand of the prisoner drawing the boy closer to the window — focus viewer attention on the emotionally charged encounter and lend it a clandestine feel.

Jan Grarup began his career as a hard news photographer, but soon found himself in Bosnia and other dangerous places doing work "that didn't have any impact on anyone," he says, "so I had to restructure my whole identity as a photographer." Taking inspiration from W. Eugene Smith, Sebastião Salgado, Gilles Peress and others, Grarup embraced a humanistic documentary approach to exploring social upheaval. "I always keep their work in the back of my mind" Grarup says. "If you take the best of them and put it in a pot and mix it with a little bit of yourself, you come out with a very personalized expression in your own work, and that's very important." The influence of Peress's seminal book, *Telex: Iran*, is strikingly obvious. Tilted horizons, the blur of motion and frames broken by jutting limbs are the clichés of Peress's imitators, but Grarup's use of these techniques is informed and effective, never self-conscious or gratuitous. And the more you look, the more there is to see. He puts every image element to work, achieving balance and tension in the foreground, middle and background. Grarup is also adept at making subtle but powerful use of symbolism.

His work shines with clarity and emotional resonance. "The more simple an image, but still nicely composed and structured, the more impact it will have," he says. Some of the best examples of his work to date include *The Boys of Ramallah* (2000–01), a classic narrative about the undertow of violence in Palestinian society, and his impressionistic take on the aftermath of the 2003 earthquake in Bam, Iran: "What struck me most was the silence. What came out were very dark, very calm pictures of the situation." He is currently at work on projects about the forgotten refugees of Chechnya, Liberia and other war zones, as well as Slovakia's Roma culture. Grarup has no illusions that photojournalism will change the world, however. "I don't believe in that. Photojournalists have an obligation to keep informing the rest of the world," he says. "The fact that people reflect on my work is the most important thing of all."

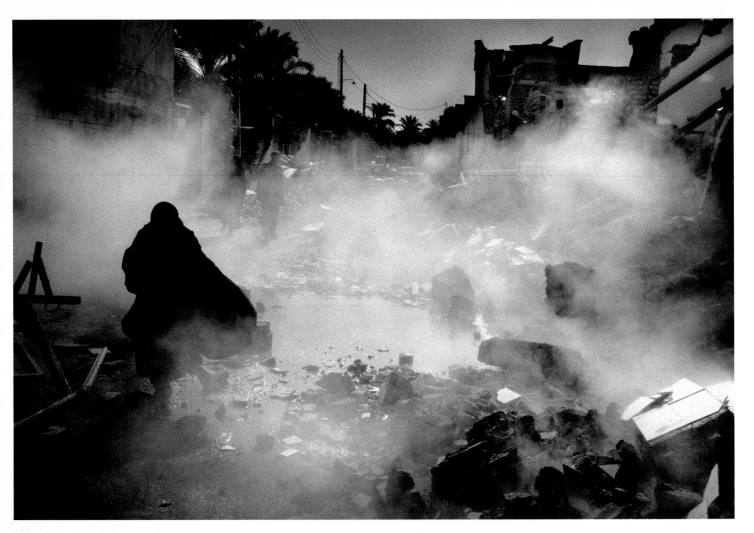

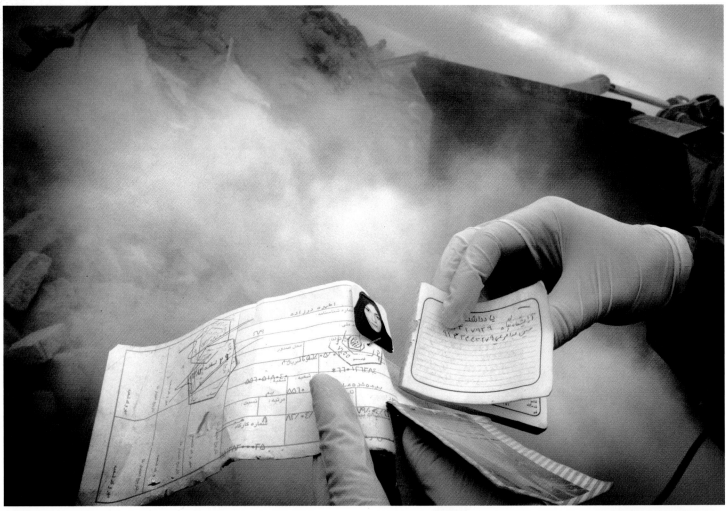

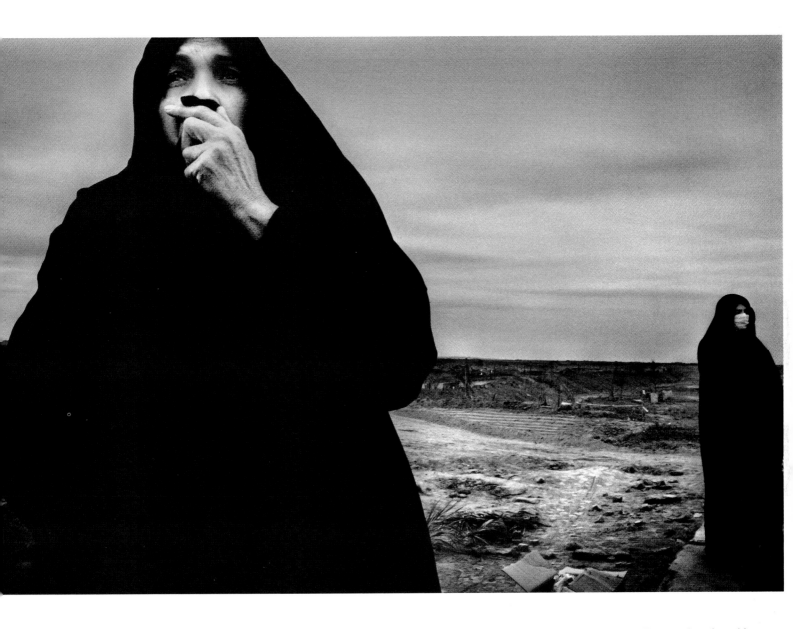

LEFT TOP: A woman glides ghost-like through a fog of dust in Bam, Iran, after a 20-second earthquake in December 2003 that left the city in ruins and killed 35,000 people. Grarup made images such as this one to capture the sense of silence he encountered upon first arriving in the destroyed city.

LEFT BOTTOM: The hands of a rescue worker in Bam hold personal papers found in the debris while a machine clears ruins in the background. This is an example of how Grarup uses layering and symbolism to tell stories with single images: rather than show a victim directly, he engages the viewer's imagination with a remnant of a life that probably ended in sudden, tragic death.

ABOVE: Women wait near mass graves after the Bam earthquake to bless dead women and girls prior to burial, in accordance with Muslim custom. The atmosphere of silent shock and grief is conveyed by the stare and hand gesture of the subject in the foreground, and emphasized by the clothing, the endless grey sky and the desolate background.

CAROL GUZY

Carol Guzy is one of the USA's most high-profile photojournalists who combines an eye for edgy hard news with a sensitive heart. Guzy is both consistent and extremely versatile. She can photograph domestic social issues, political turmoil like the fall of the Berlin Wall, natural disasters like the mudslides in Colombia, the aftermath of 9/11, and the civil conflicts in the former Yugoslavia, Rwanda and Haiti. If there is any place in the world that is currently engulfed by chaos, violence and grief, Guzy is probably there working for the *Washington Post*. She is capable of photographing news images for the front pages, or more feature-based assignments, both in colour and black-and-white, and all for a daily newspaper with demanding editorial standards and a discerning readership.

Guzy has said that her original training in nursing endowed her with a deep level of compassion that might not otherwise have been there. Perhaps, but this degree of empathy with subjects cannot be taught – it is something instinctive that all great photojournalists must have before they ever pick up a camera. When her sense of compassion is combined with her technical proficiency, it is easy to see why she has been so widely acclaimed. There is never a sense that she is exploiting, or even intruding upon, her subjects. She is just trying to relate their terrible and distressing stories in a way that will capture our attention. Often the photographer is the only voice these people have, so Guzy will speak quietly on their behalf and pull back her camera. She will focus on the crowds caught up in terrible situations or take a general scene from a distance. At other times she will shout a little more, jolting us as she captures an individual close up at a moment of grief or despair. She is especially strong on conveying how war and conflicts impact on the innocent. Her photographs enlighten, captivate and inform and, it is to be hoped, spur people and, more importantly, governments into action. It may not be nursing, but a photojournalist as committed as Guzy is performing an equally valid public service.

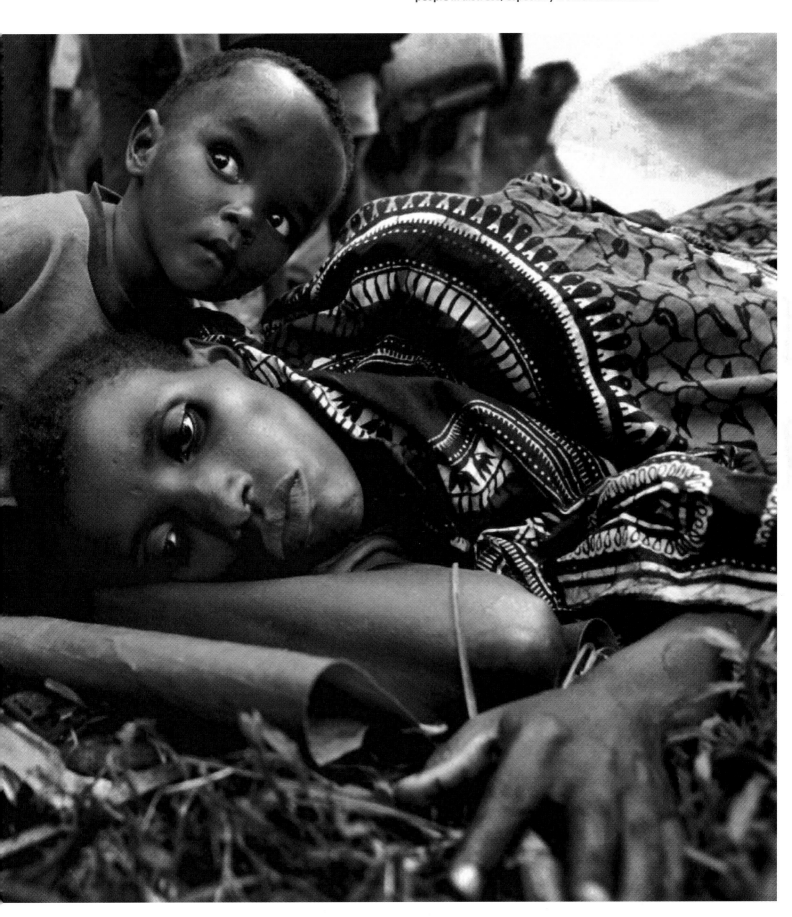

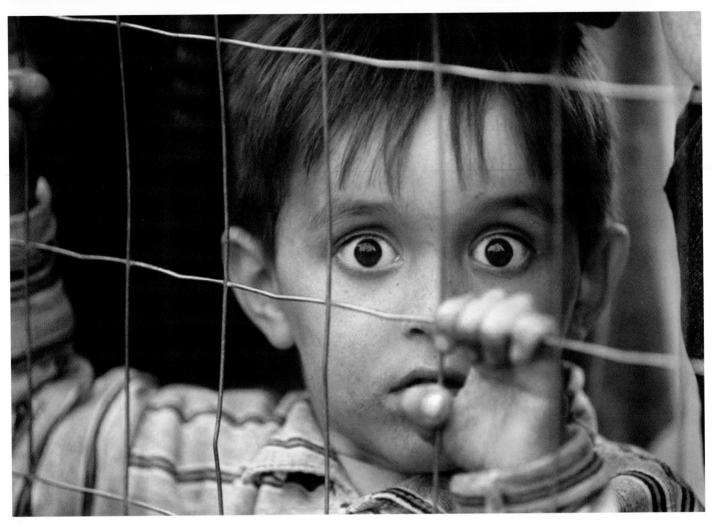
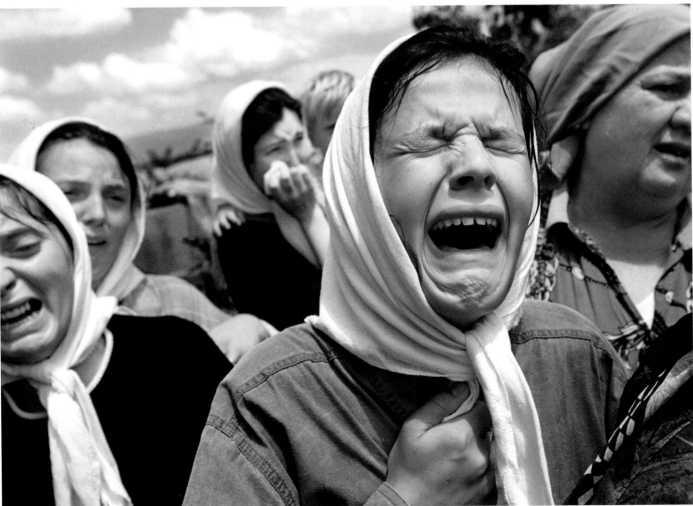

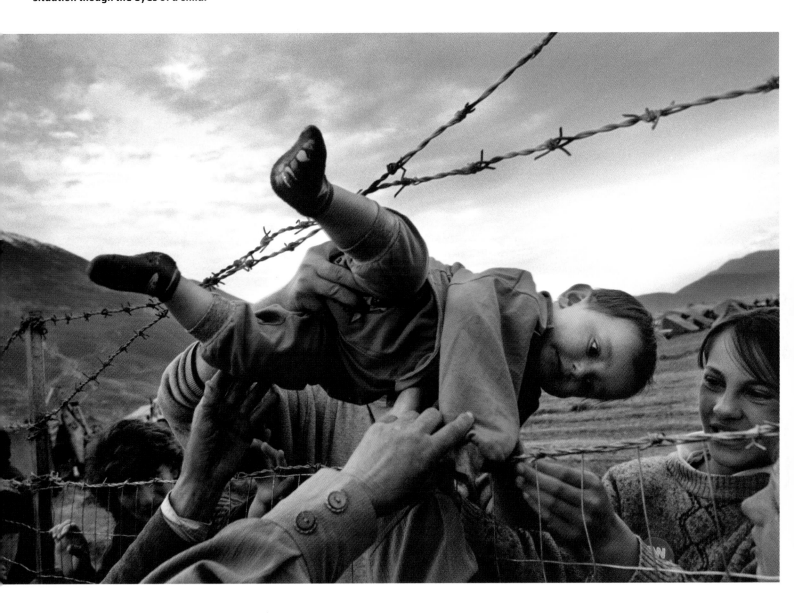

ABOVE: A two-year-old boy is passed into the hands of his grandparents through the barbed wire at a refugee camp in Albania. The members of the family were reunited in 1999 after fleeing Kosovo during the conflict. This is a simply stunning image from Guzy's very powerful essay on the plight of the refugees, work that won her a deserved Pulitzer Prize for Features.

LEFT: A woman wails in grief after the death of her uncle in Kosovo in 1999. His body was found with the body of his daughter. Apparently, Serbs shot them as they tried to reach their family in the mountains.

RIGHT: This is aptly called *Children's Joy* and it was taken at a UNICEF-run camp in Albania for refugee children. At the camp the children are counselled to help them deal with the trauma of their ordeal. This image has it all: beautiful composition, bold colours, a dramatic landscape and most of all hope.

BERT HARDY

RIGHT: One of the subjects of Bert Hardy's work in Northern Ireland during 1955 was the retired lion-tamer Alec Robinson, pictured here in Belfast.

BELOW: As part of his work for the 1955 *Picture Post* story, "One Man in Five is out of Work", Bert Hardy included this picture of an unemployed man and his family in Northern Ireland. Hardy's forte was the reportage of social conditions, and his empathy with his subjects is always apparent.

Bert Hardy's work is one of the high points of British photojournalism. He acquired his first Leica in the 1930s, when Fleet Street smudgers still wedded to the large-format press camera considered it a "toy". But Hardy's Leica pictures were so well made and emotive that they convinced many a picture editor that a new sort of photojournalism was emerging. The photographer's ability to get close to the subject and make intimate and revealing images that seem like a slice of life was becoming all-important. His pictures of the people and communities of working-class districts are touching and realistic evocations of a lost sense of British solidarity. Hardy's Cockney background, his ability to communicate with ordinary people and his genuine affection for his fellow man were as essential to the pictures he could take as his total mastery of the 35mm camera. Hardy's photography fully embraced the humanist spirit, and he was greatly concerned with his

role as a witness. Covering the Korean War in 1950, he and the journalist James Cameron sent back a story to *Picture Post* about how the South Koreans were treating their own political prisoners. The owner of the magazine, Edward Hulton, decided the article was "communist propaganda" and the editor, Tom Hopkinson, was forced to resign. Cameron later wrote about Hardy's evident bravery under fire during their coverage of the decisive Allied landing on Inchon: "it was long ago established that one way you cannot take pictures is lying face-down in a hole. I spent considerable periods of time doing that. Bert, on the other hand, was plying his trade upright in the open, cursing the military exigencies that had organized this invasion in the middle of the night. One of my enduring memories of that strange occasion is of Bert Hardy on the seawall of Blue Beach, blaspheming among the impossible din, and timing his exposures to the momentary flash of the rockets."

LEFT: **In 1955 Bert Hardy took a series of pictures for *Picture Post*, including this photograph of unemployed people and children on the streets of Derry (Londonderry) in Northern Ireland. The characteristically strong composition of Hardy's images focuses attention on the subjects, emphasizing their social conditions. The shadowed figure of the unemployed man in the foreground lends the image a haunting quality. Will the same fate befall the children?**

LEWIS HINE

Hine's basic photographic motivations were strongly humanist and sociological, although his work is increasingly appreciated now for its aesthetic qualities. So powerful were his early pictures of the terrible conditions suffered by child workers that they led to a public outcry when published and displayed, and thus directly to changes in American law. This extraordinary body of work, much of it made in difficult circumstances and despite the inconvenience of working with a large-format 5 in x 7 in (12 cm x 18 cm) camera, a tripod and open flash, shows Hine's evident interest in "witnessing" the social conditions of his subjects. His photographs of the early years of the twentieth century seem closer in spirit to contemporary humanist photojournalism than some of his projects of the 1920s and 1930s. In this later work, Hine's fascination with making heroic portraits of the working man is evidently driven by more aesthetic concerns. Perhaps his acquaintance with Alfred Stieglitz in the early 1920s persuaded him that he should temper his reformist zeal with a more careful attention to the pictorial qualities of his work. Some commentators have even found evidence of a desire to make a striking image out of the misery of his subjects in his early projects, such as his records of newly arrived immigrants on Ellis Island. His portrait of the young Russian Jewess on Ellis Island in 1905 (far right) might fall into this category, for her wan beauty can still transfix the viewer. Although he sometimes experimented with art photography, he worked consistently to the end of his life to document, in as truthful a manner as possible, the realities of life for the poor and the oppressed. Hine's later work was made when his early fame seemed no longer able to generate sufficient commissions to support him. Yet the series on the construction of the Empire State Building remains one of his most masterful achievements. Persuaded that technology could now offer better working conditions to the worker, Hine produced a series that became a hymn to manual labour and the new forms of construction that the famous skyscraper embodied.

ABOVE: **In this carefully posed portrait, Hine depicts an elderly Jewish woman, recently arrived from Russia at Ellis Island in 1905, no doubt a victim of one of the innumerable pogroms against the Jews then raging in Russia. She is shown with the wicker basket that contains all her worldly goods.**

RIGHT: **A young Jewish woman at Ellis Island in 1905 is shown in a proud and defiant pose.**

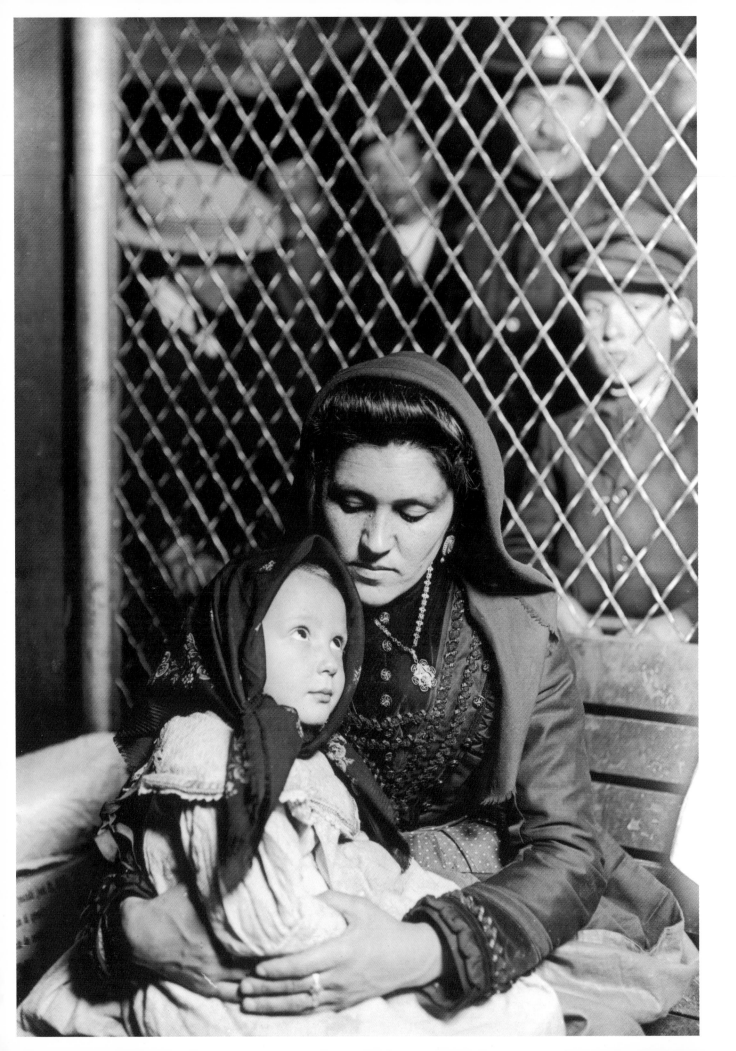

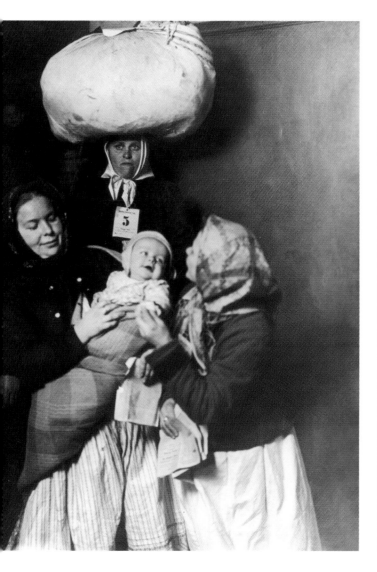

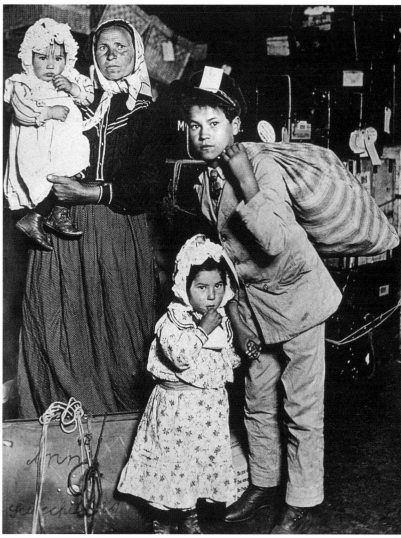

ABOVE: Presented with honesty and compassion, this well-constructed composition portrays three Eastern European women and a baby at Ellis Island in 1905.

LEFT: Hine's framing of this picture, taken in 1905, with the newly arrived Italian immigrant and child so gently captured in front of a grille, emphasizes the way in which immigrants were wrongly seen as dangerous people who needed to be confined, despite their evident innocence.

ABOVE: The careful and straightforward depiction of the newly arrived immigrants at Ellis Island, such as this woman and her children in 1905, presents them as if they were refugees from a distant conflict or disaster, people who require help rather than condemnation.

HEINRICH HOFFMAN

Although Leni Riefenstahl may be better known as Hitler's film-maker, Hoffman was almost certainly much more important as the key image-maker in the fascist leader's rise to power. A close personal friend from 1920, he persuaded Hitler to embrace photography as a central element in his political campaigns, to create the image of celebrity and of malevolent energy that sustains the Hitler myth to this day. In addition, Hoffman managed to acquire the exclusive rights to photograph Hitler as *Reichsbildberichterstatter der NSDAP* (Official State Photographer). His exclusive photographs made him (and Hitler, whom he persuaded to insist on a royalty on every photographic portrait stamp sold by the German Post Office) very wealthy. He also played a key role in Hitler's personal life, for Hoffman's assistant Eva Braun became the Führer's mistress and, during the very last days of the Third Reich, his wife.

Hoffman's photography has two clear purposes: one is to show Hitler as a natural leader, symbolizing the "power of the will" that would eventually make him Führer. But a second aim was to "humanize" the leader. Hoffman's book, *The Hitler Nobody Knows*, published in 1933, shows both sides. It eventually sold half a million copies, and was followed by several other small photo-books that fed the Hitler myth. During the Second World War Hoffman went almost everywhere with his leader, and the huge body of photographs that resulted is an important part of the historical record of the rise, decline and fall of the Third Reich. Hoffman continued to take two distinct approaches to his main subject. His monumental portraits were lit in a way that seemed to endow the Führer with superhuman attributes. Alternatively, he was depicted as a man of the people, attentive despite his great task to their needs. He was shown listening to a carefully posed group of SA stormtroopers, talking to a child, or quietly watching while some farmers went about their work in an idealized Black Forest setting. Despite the propaganda functions of Hoffman's Hitler pictures, they are also instructive about the role of the photograph in the era of totalitarian states, when the mass circulation of such images played such a central part in the creation of leader-myths.

RIGHT: Hoffman shows Hitler posing alongside members of the *Reichswehr* in 1930, General Ludendorff in the centre. Although he is not in uniform, Hoffman has caught Hitler's attempt to make his bearing seem, as befits a veteran of the Great War, entirely military in stance.

OVERLEAF LEFT: Hoffman's construction of this image of Hitler at a Nazi rally places him in a dominant position, the photograph emphasizing his position of "natural" power and authority.

OVERLEAF RIGHT: Hoffman followed Hitler throughout his career, and this photo shows Goering and Hitler discussing the blast that nearly killed the Führer only two hours after the attempt on his life of 20 July 1944. Hitler personally banned the picture because of the expressions on his and Goering's faces.

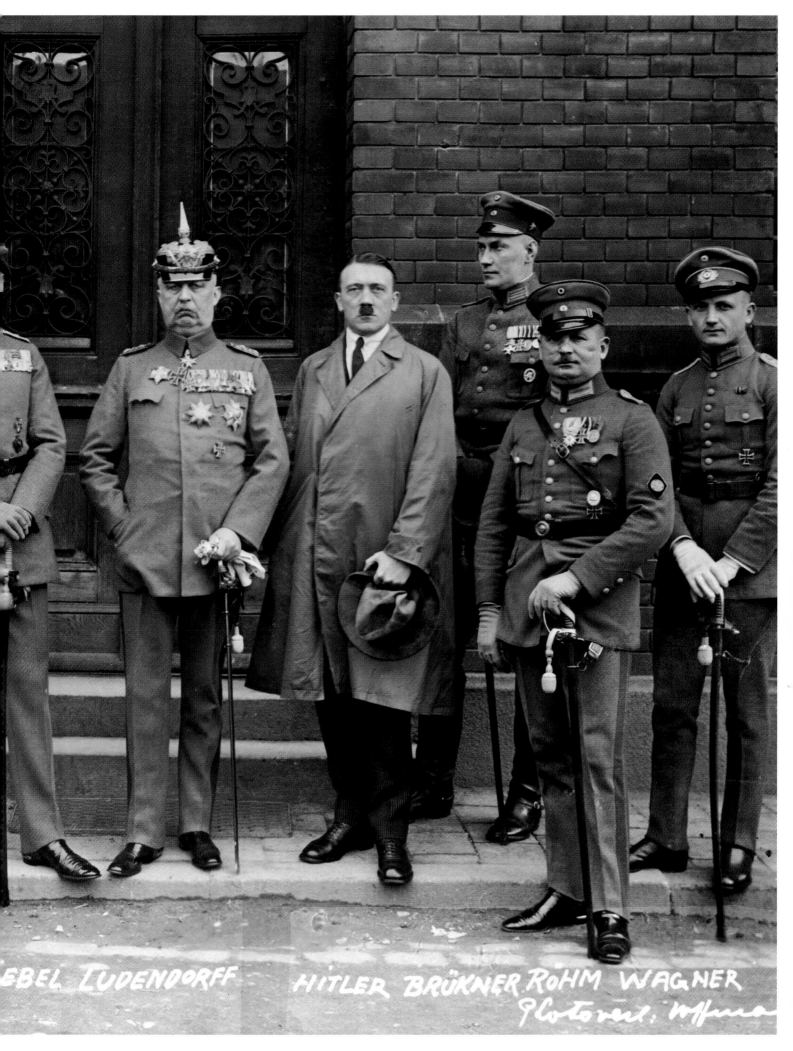

EBEL LUDENDORFF HITLER BRÜKNER RÖHM WAGNER
Photo verl. Hoffmann

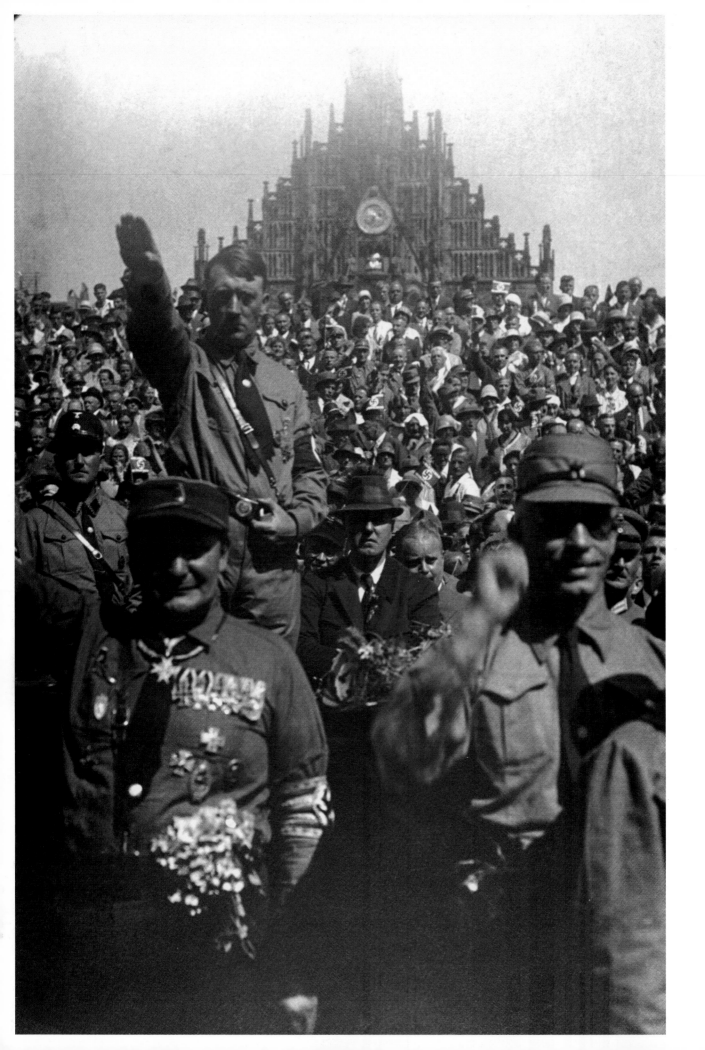

FRANK HURLEY

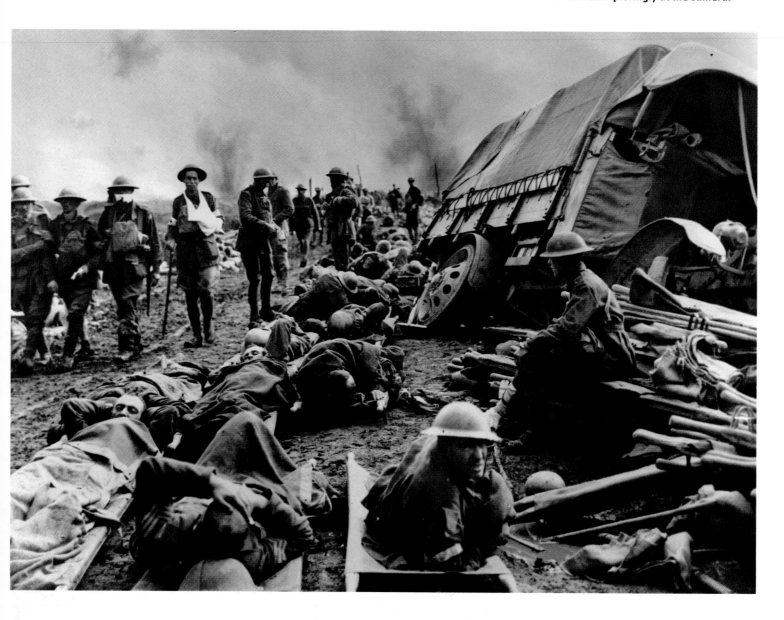

Famed for his photographs of Ernest Shackleton's legendary Antarctic expedition, Frank Hurley was dubbed "hard as nails" by one of Shackleton's crew, because he wouldn't wear a hat and gloves when he photographed. Legend has it that when the *Endurance* started to sink, taking with it Hurley's invaluable glass plates, he jumped into the freezing water shirtless to retrieve them. Yet Hurley was much more than a "warrior with a camera", as another shipmate described him. He was a self-taught highly accomplished photographer with an unusual eye, who also had a great sense of how to compose a picture. In his expedition photographs he often pulls his camera back from the standard shot of explorers looking heroic, and focuses instead on the cruel and unrelenting polar landscape. His diaries reveal that while he wasn't particularly impressed with his fellow explorers, he had a great respect for and affinity with the natural world.

During the ill-fated voyage he also experimented with colour. These colour experiments were to continue with his groundbreaking shots taken during the First World War. Photographs of the war were subject to strict censorship and Hurley reinforced his reputation as a fearless man when he attempted to smuggle his glass plates out of France. His work from the Western Front is again far from the heroic photography typical of the time. Although he admired the soldiers and was fascinated by the ebb and flow of battle, he photographed the reality of the war: mud, misery, chaos, destroyed landscapes, mangled machinery and inevitably death — the British offensive at Ypres alone led to half a million casualties. Fortunately, despite taking great risks, Hurley survived the carnage, and his work is striking evidence of one of the bloodiest periods in history.

This is the morning after the first battle of Passchendaele on the Western Front and wounded Australian infantry are still in the mud seeking assistance. This photograph is almost a homage to a Renaissance painting depicting some gruesome biblical scene. Hurley presents the complete picture: in the foreground we see the consequences of the battle for the men, while in the background there is the bleak landscape and the ominous sky. It really is a photograph of hell on earth.

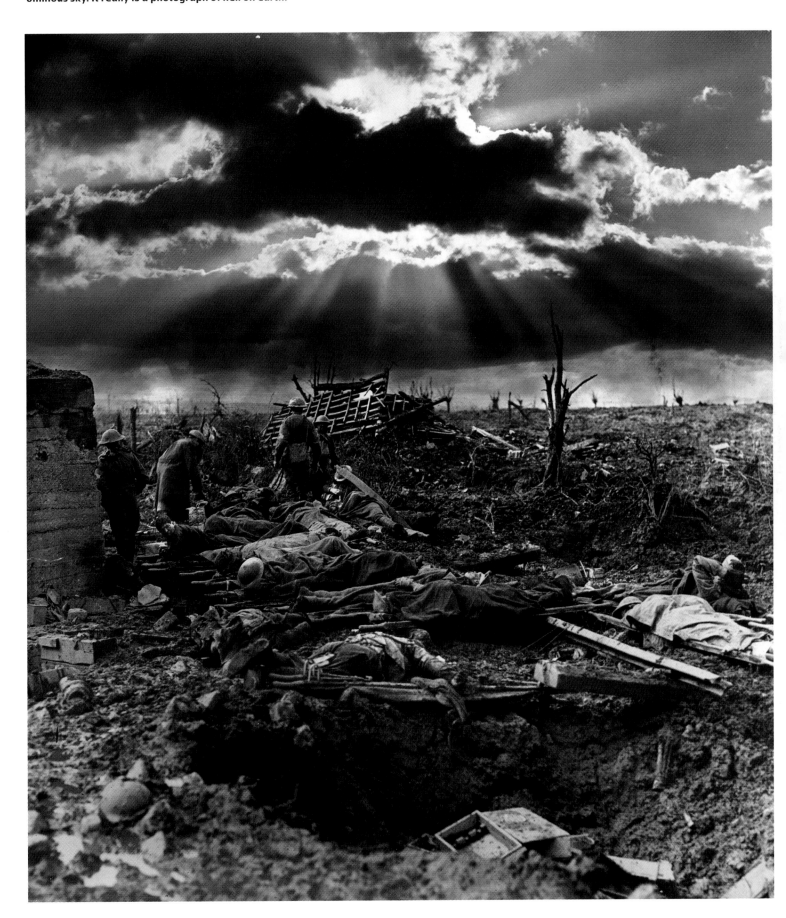

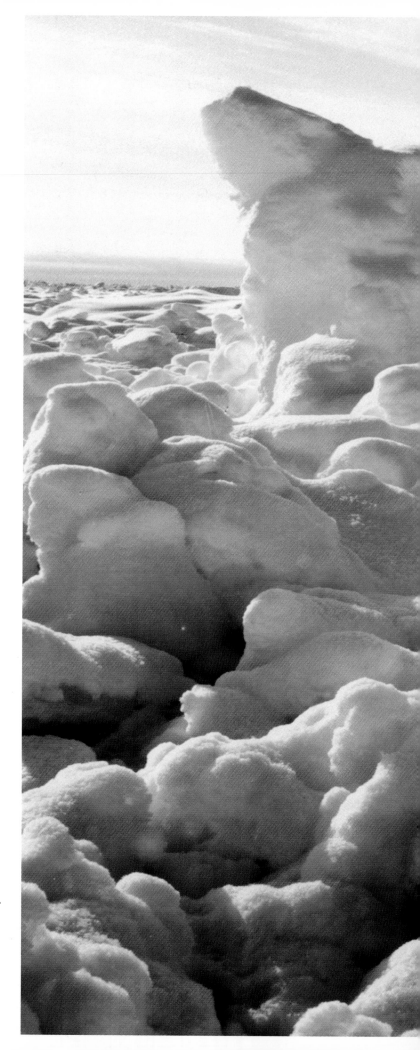

RIGHT: The *Endurance* in full sail amid the ice. Hurley was the official photographer on the Trans Antarctic Expedition 1914–17. He was fascinated by the snowscapes and his diaries seem to suggest that he had more time for the dramatic scenery than for the ship and the crew. Dragging all his camera equipment along the ice was a feat in itself.

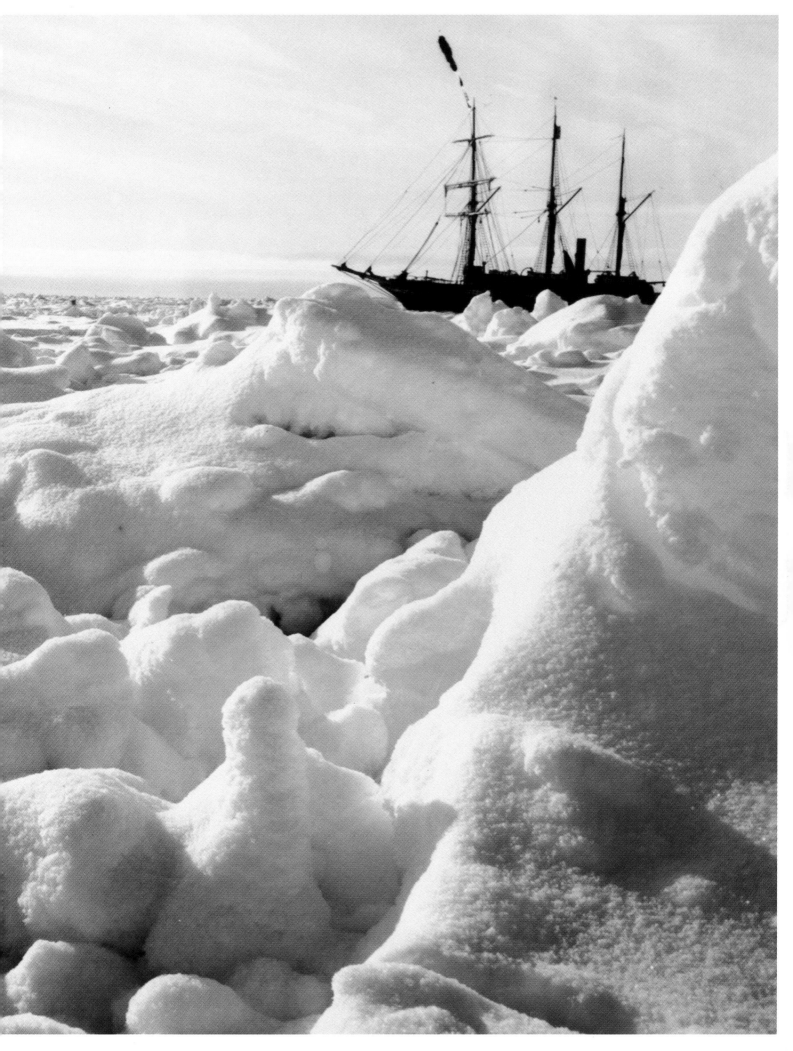

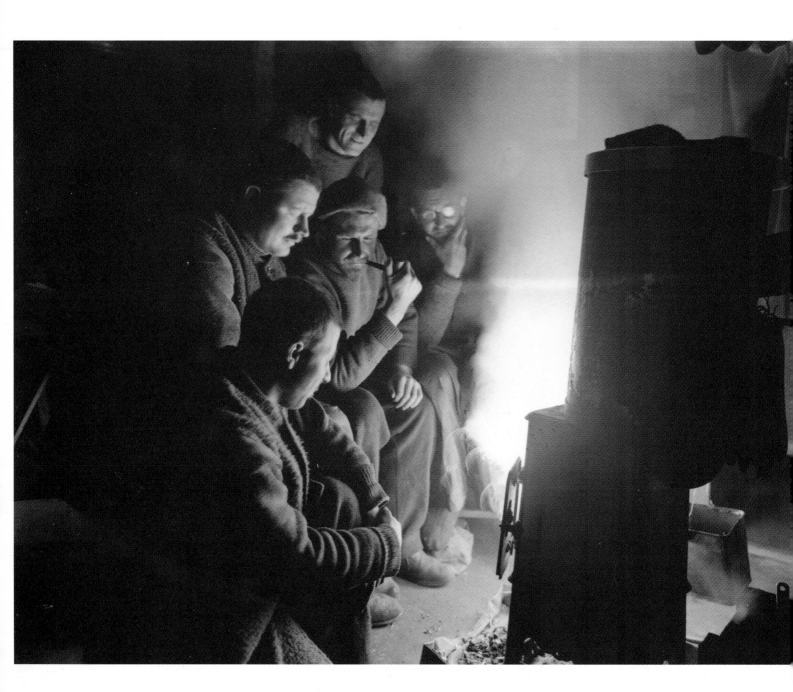

ABOVE: Trying to keep warm in the night watchman's room in the *Endurance*. The scene is skilfully lit and it's as if Hurley has stumbled upon these sea dogs exchanging tales. The men and Hurley, however, seem somewhat detached from each other.

RIGHT: The end for the *Endurance*, crushed in the ice with the dogs looking on. A poignant image where even the dogs look morose and downbeat. It also conveys the sense of man's helplessness in the face of nature.

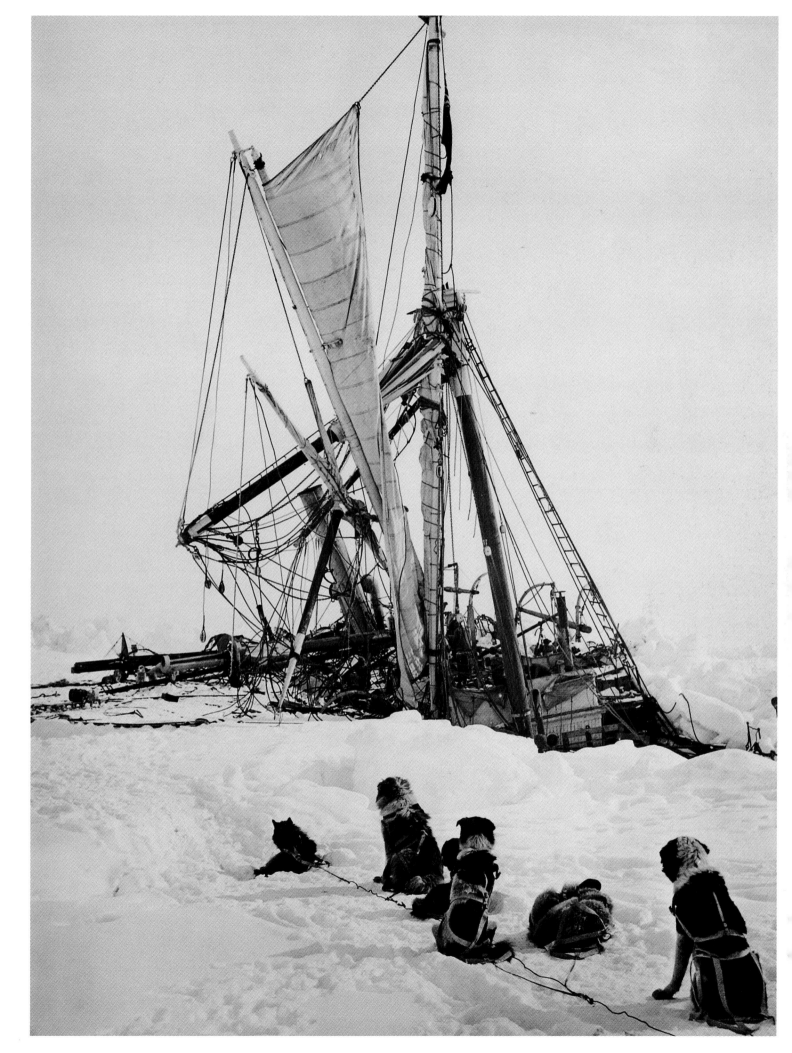

ROGER HUTCHINGS

Roger Hutchings is best known for his remarkable images from war-torn Bosnia: "My aim was to tell the stories of ordinary people caught in this bloody civil war. I was angry at what was happening to the innocent: the civilians, the kids and the elderly." Hutchings is the heir apparent to Philip Jones Griffiths, sharing his lack of interest in photographing the ebbs and flows of combat. Instead, his subjects are people to whom we can relate; they could be us, but for the fact that they are caught up in something terrible and extreme. Yet while Jones Griffiths saw the Vietnam War in imperialist terms, Hutchings sees the civil war in the former Yugoslavia as something more nebulous, preventable and ultimately somewhat absurd. His photographs from that period reflect this ambiguity. Hutchings is frequently angry and he says that he took photographs a lot of the time with "the spineless European politicians and UN bureaucracy in mind", but he is too intelligent a photojournalist to be inspired just by rage. He also has a poet's eye for those idiosyncratic and whimsical moments that unroll in front of him, moments that he describes as "the banality of war, that is, the violence becomes so commonplace that people treat it as normal behaviour". On this page, for example, there is an image of a woman having her hair done. She is serene and at peace, yet sitting in the middle of a war zone. Her insistence that life must go on is admirable, but also slightly preposterous.

In recent years Hutchings has moved away from traditional conflict and concentrated on documenting the fashion industry, often from behind the scenes. This is also a highly charged and absurd environment, which Hutchings appears to both embrace and mock. When asked what is the role of the photojournalist, Hutchings responds, "It may sound like a cliché, but to tell the truth." This is not always an easy task, especially when the subject is a confusing civil war, but Roger Hutchings rises to the challenge.

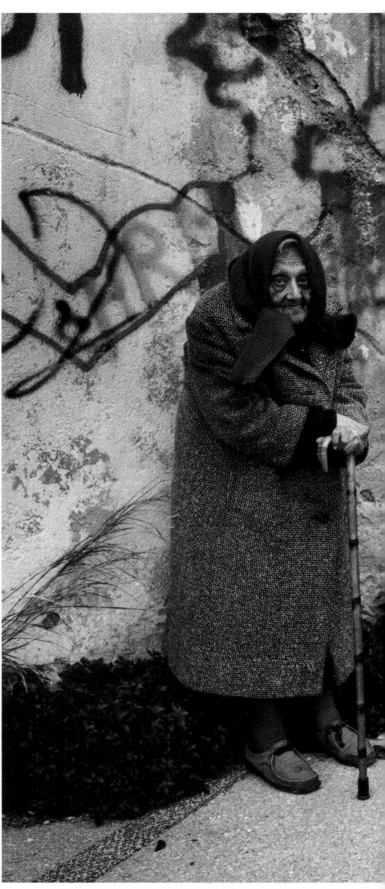

BELOW: Residents struggle to maintain their self-respect and their appearance in the middle of a war zone in Sarajevo, Bosnia. There is something very engaging and original about this image. Hutchings is using humour to convey the absurdity of war – not a typical approach.

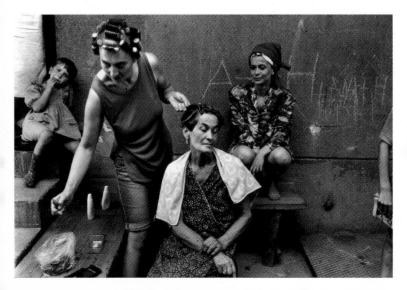

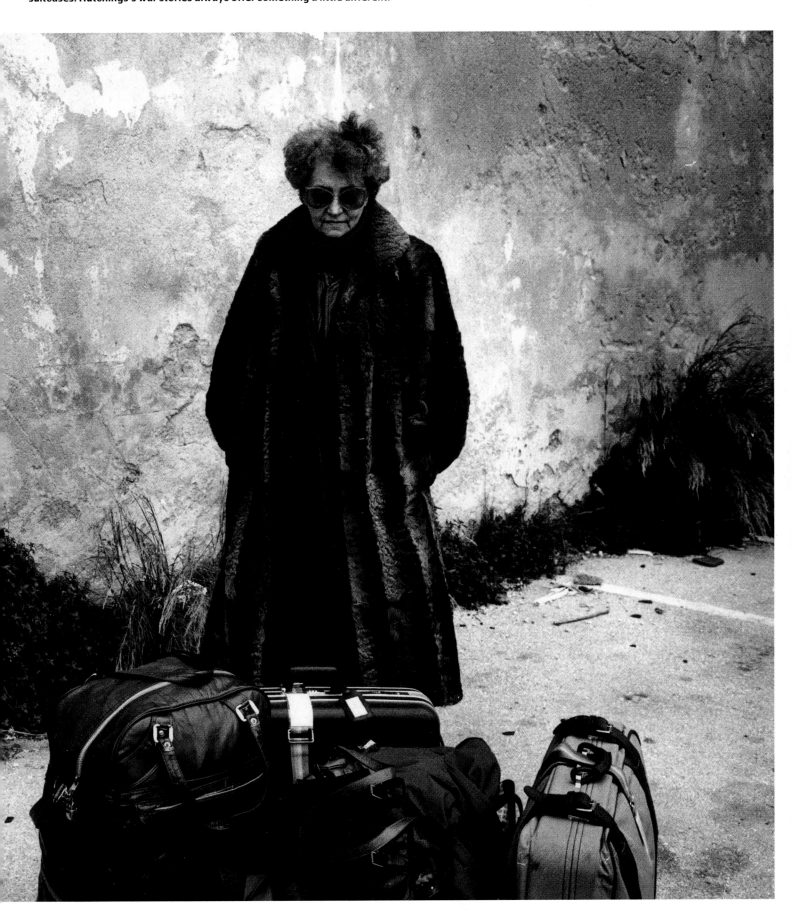

BELOW: **Refugees from Sarajevo arriving in Split, Bosnia. The older woman is a university professor and her daughter a doctor. The older woman's expression says it all. A conflict has reduced two well-educated people to standing in a grim street with everything they own packed into a few suitcases. Hutchings's war stories always offer something a little different.**

BELOW: **Backstage, Fashion in Milan model Alek Wek before the Moschino Cheap and Chic show. Hutchings is usually associated with black-and-white photography, but only colour could convey the sheer lush red of the model's lipstick.**

RIGHT TOP: **Models backstage at the Krizia fashion show, Milan, Italy. "Pretty vacant" is the phrase that springs to mind.**

RIGHT BOTTOM: **A photographer works to get the right shot as a model pauses to turn on the catwalk at London Fashion Week. Hutchings is, of course, photographing the photographer, so who is watching who?**

PHILIP JONES GRIFFITHS

Philip Jones Griffiths has said that what motivates him as a photographer is trying to answer the question "Why?". Jones Griffiths has spent the past five decades trying to find an answer to two urgent questions; why terrible wars and conflicts happen, and why they have such a terrible impact on innocent people. He is part of that exclusive club of legendary Vietnam photojournalists, which also includes Larry Burrows and Don McCullin, who redefined the way war is photographed. A fierce Welsh nationalist, to him the Vietnam War was a clear case of one country trying to impose its will on another. In classic black-and-white he photographed the often crass attempts by American soldiers to endear themselves to the locals, demonstrating how the beautiful Vietnamese landscape and its 2,000 years of tradition were the real casualties of war. He saw the conflict in Vietnam in imperialist terms and not surprisingly his images were perceived as being anti-American. Consequently, Jones Griffiths found himself being shunned by the media and his images went largely unseen at the time. He responded by publishing *Vietnam Inc*, which not only helped change the course of the conflict, but also empowered both Jones Griffiths and photojournalism itself. He took all the photographs, designed a very personal layout and wrote a commentary and captions, which veered from the matter of fact to the ironic and sardonic. W. Eugene Smith would have approved. The book proved that photojournalism didn't have to be subservient to the agenda of magazines and it could thrive in a different medium. From that moment onward, every self-respecting photojournalist aspired to get his or her own book published.

In his coverage of Northern Ireland, there is also the sense that Jones Griffiths clearly sees the British as the occupying force. Yet again, he is drawn to ask what kind of an impact the conflict is having on the civilian population and, in a wider context, questions why the occupying force is there in the first place. As a war photographer, he demands more from his viewer than a knee-jerk response to blood and gore; he wants you to think and question what you are seeing.

RIGHT: This photograph taken in Cam Nghia, Vietnam, in 1998, shows Pham Hong Quy, 24, who has several epileptic fits a day. During the war his father was in the South where much Agent Orange was sprayed. Jones Griffiths has dedicated his professional life to photographing every facet of the conflict in Vietnam and its grim epilogue. His style is always direct and unflinching.

BELOW: "In the narrow terraced streets of working-class Northern Ireland, 1965 (every house except the last needs only three walls), the closely-knit communities of differing religious persuasions are encouraged to battle with one another." As well as being a great photographer, Jones Griffiths is an eloquent and sardonic writer, who provides the captions for his photos, giving them his own cynical and illuminating spin.

RIGHT: This abstract portrait of a British soldier was taken in Northern Ireland in 1973. What he thought about Jones Griffiths we will never know, but it is the photo's ambiguity that holds our attention.

YEVGENY KHALDEI

Yevgeny Khaldei's most famous photograph is of a Russian soldier waving the Red Flag over the Reichstag during the battle for Berlin in May 1945. The soldier is wearing at least two wristwatches, possibly the result of looting – a fact retouched out in later uses of this "patriotic" image. Although the picture was staged, its composition and setting are dramatic and dynamic, hallmarks of Khaldei's work. As a TASS photographer, he had every opportunity to be present at the turning-points of history, and he made the most of them. He was at the Potsdam conference where he photographed the "Big Three" – Stalin, Churchill and Roosevelt – and at the Nuremberg War Crimes Trials in 1945–46. As he said about the latter, "I photographed the atrocities wrought by the Fascists in the Soviet Union. Now I am photographing the vengeance."

Khaldei was an invaluable witness to some of the key events of the twentieth century. But there is another aspect to his work, which was much informed by the cultural currents that raged around photography, constructivism and socialist realism in Russia during the 1920s and 1930s. This has only recently come to light through the rediscovery of the early personal work he made while learning the craft of photography, his *Photo Album Devoted to the Happy Life of a Young Man*, c. 1934. It shows just how much his photojournalism relies on his experiments with form, collage and dynamic points of view. His early work for *Pravda* emphasizes the image of the heroic worker – a strong element of Soviet iconography in the 1930s – for Khaldei always thought that a good picture should be strong, easily understood and capable of communicating directly with the viewer. The great importance of photography to the Soviet regime, its role as a medium of propaganda and communication, allowed Khaldei freer rein to make striking and beautiful images, but it came with a heavy price. Despite his great achievements, his mistreatment by the Soviet regime because of his Jewish origins must have been a bitter pill to swallow.

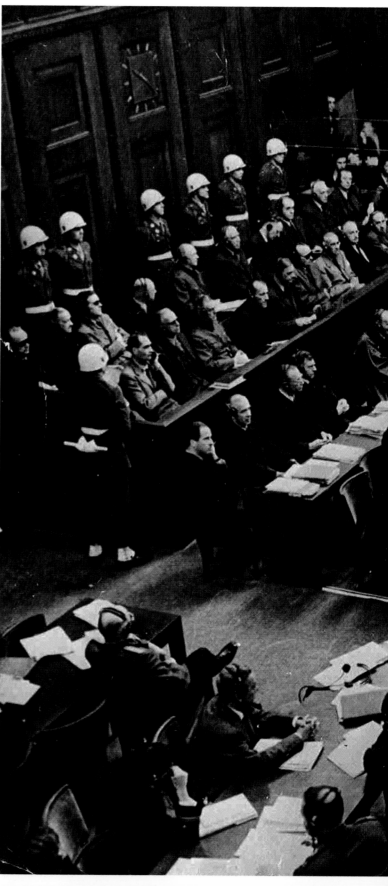

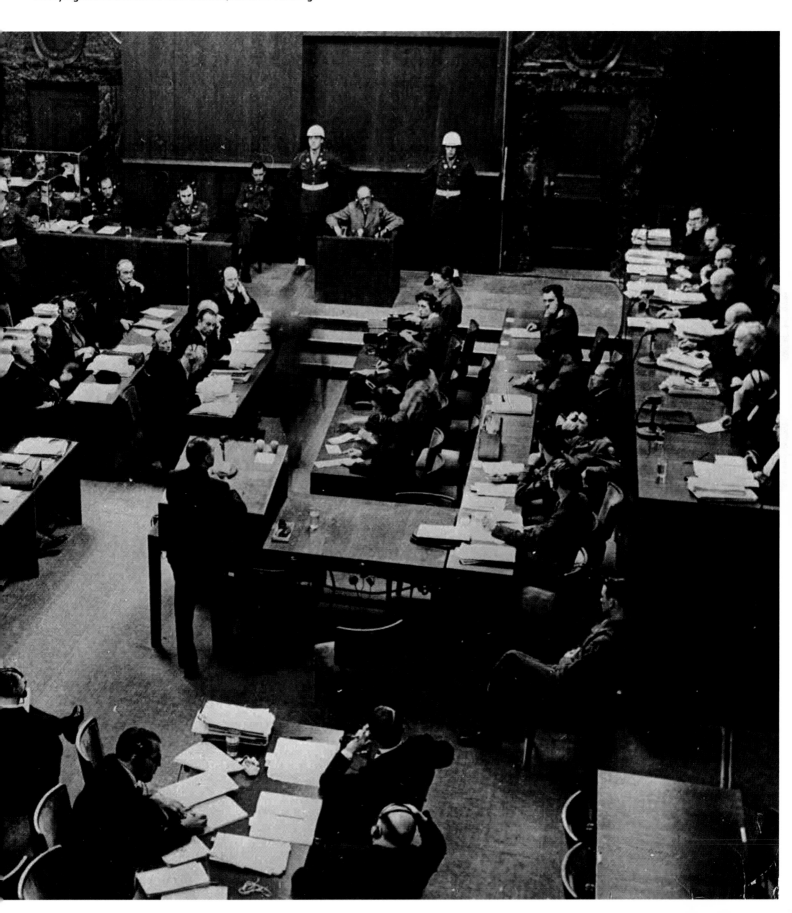

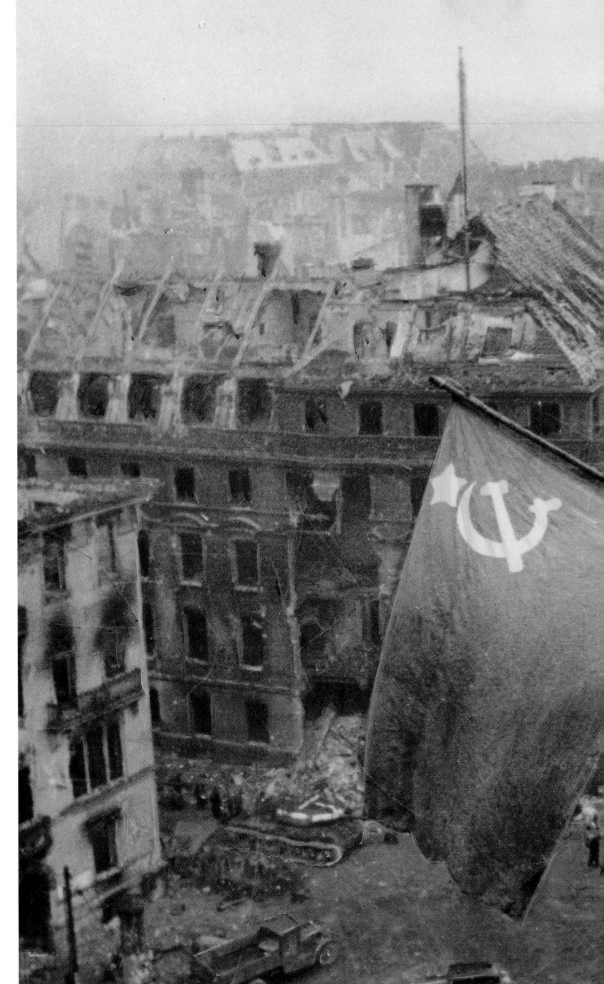

RIGHT: Khaldei's war culminated in the fall of Berlin in 1945, when he raced to the roof of the burning Reichstag to capture this monumental photograph of a soldier hoisting the Soviet flag. From the various versions of the picture, we know that Khaldei asked the soldier to perform the action several times. When it was used at the time, the fact that the soldier appears to be wearing at least two wristwatches was retouched out of the photograph, for accounts of Russian soldiers looting German civilians were rife.

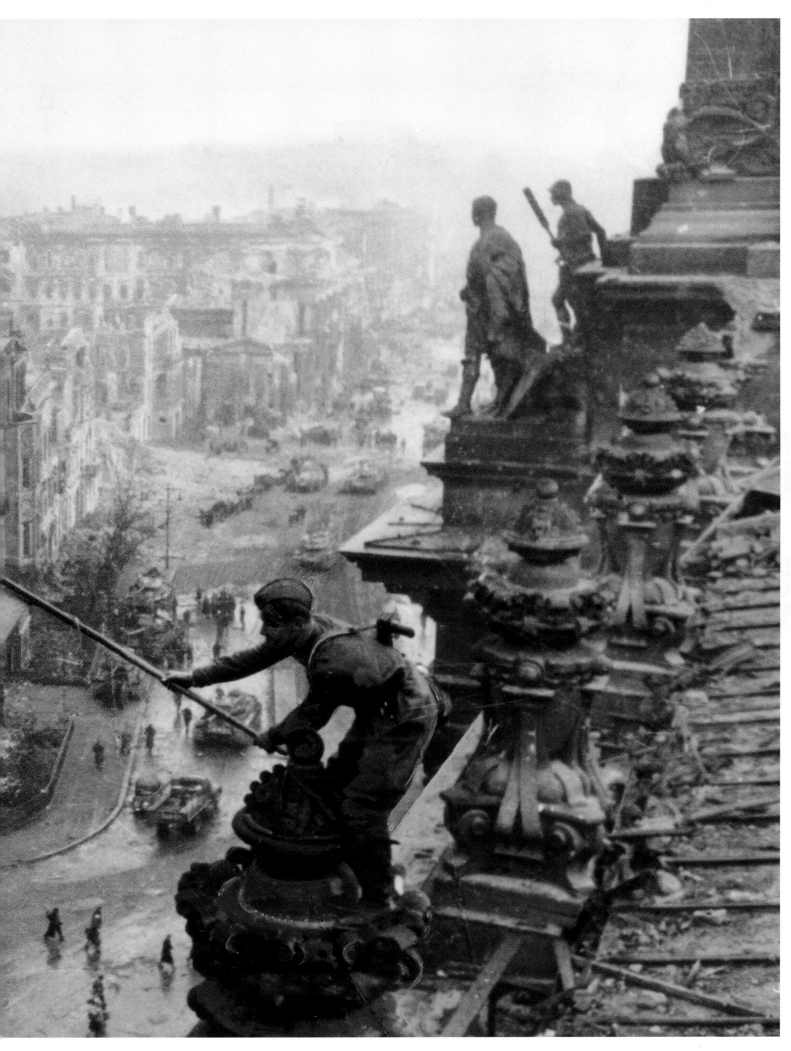

JOSEF KOUDELKA

BELOW: As in so many of Koudelka's pictures of the August 1968 invasion of Czechoslovakia by Warsaw Pact troops, the precise context of the images remains unclear. This group of people are demonstrating against the invasion in a clearly peaceful way.

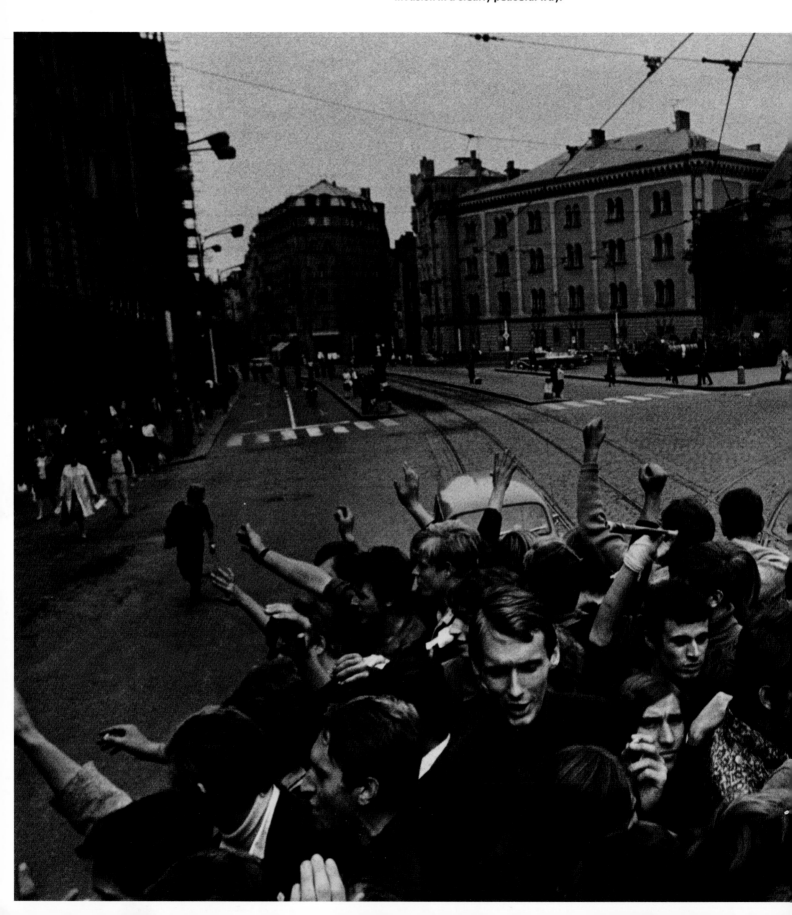

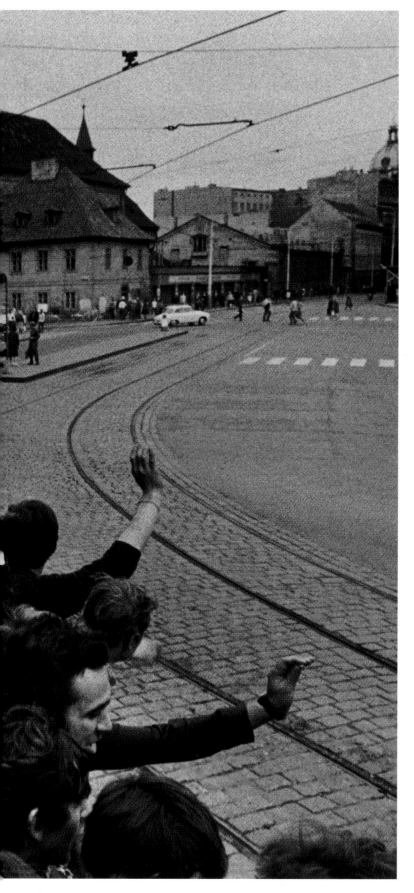

Josef Koudelka cemented his international reputation in the Prague Spring of 1968. Ian Berry, the only Western photographer in the city to cover the Warsaw Pact's invasion of Czechoslovakia, remembered, "I was walking around hiding a couple of Leicas under my coat, taking the occasional picture, because the Russians would shoot at anybody with a camera. I came across this lunatic, with two Exaktas on strings round his neck and a cardboard box as a camera case, taking photographs in full view of the Russians, with the support of the crowd!"

The "lunatic" was Koudelka, who produced the definitive, highly dramatic images of the end of Dubcek's brave attempt to introduce "communism with a human face". Koudelka takes us into the action of the Russian invasion: we feel so close to the reaction of the Czechs to their oppressors and invaders because, as in all of Josef Koudelka's work, we see his life through his eyes. His pictures are powerful, strongly composed and beautifully made. Yet Koudelka, though evidently a brave and committed witness to these terrible events, was working in much the same way as he had during his earlier project on the oppression of the Slovakian gypsies. Although credited anonymously as P.P. (Prague Photographer) until 1984, Koudelka could not stay in his homeland: "Everybody knew it was me who made the pictures. I got afraid. I asked Magnum to send me a letter inviting me to photograph gypsies. I still had a few friends in the Ministry of Culture, so I got the letter signed there, and then I was given permission to leave the country for three months to photograph the gypsies. I took my best negatives with me." He thus began a long period of exile and ceaseless movement between the only two anchor points for his nomadic life, London and Paris, until the Velvet Revolution in 1989. He would travel throughout the summer months, often sleeping rough, and spend the winters in a friend's darkroom, processing and printing the work. It was a life not unlike that of the gypsies who have been his constant subject.

BELOW: In this, the best known of Koudelka's photographs of the invasion of Czechoslovakia by Warsaw Pact troops, the image is made more poignant by the outstretched arm of the demonstrator, his gesture imitating both the Nazi and the Soviet salute.

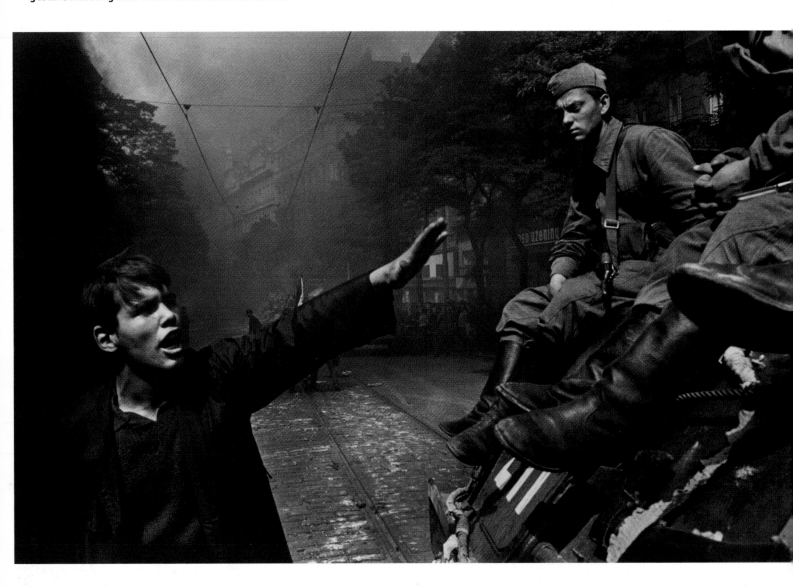

RIGHT: From the angle of the photograph it looks as if the foolhardy Koudelka has jumped on to the tank in order to achieve this menacing perspective of Prague, 1968. Perhaps the crowd is waving at him.

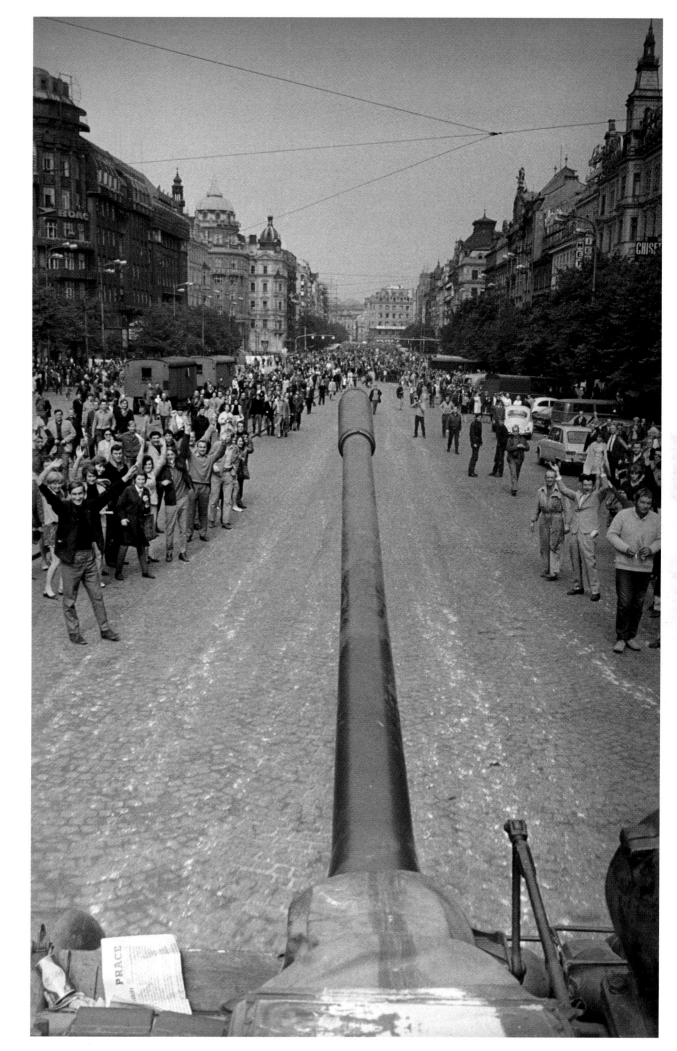

JOACHIM LADEFOGED

BELOW: The trailer camp in the Kreutzberg district of Berlin, otherwise known as the Wagon Camp, in 1993. None of the residents worked full-time and their days were spent hanging out, drinking and partying. These men might be Ladefoged's subjects, but it is the feet in the foreground that we really want to know about.

Joachim Ladefoged is part of a generation of outstanding Danish photojournalists who have gained international recognition in the past five years. So far, in an eventful career, he has alternated between shooting social documentary stories and more traditional hard news. Ladefoged has also varied his style, veering between bold colour and graphic black-and-white; he is equally at home photographing sports and travel assignments. This essay on the Wagon Camp in Berlin was taken in the early 1990s, when Ladefoged was just 22. In the 1990s New Age travellers/hippies were very much in the news and their somewhat casual, feckless, drug-influenced lifestyle was seen as a threat to Europe's middle classes. This is the first story that Ladefoged shot outside Denmark and his curiosity was aroused when driving past the camp while vacationing with his father in Berlin. He says his aim was threefold: "I wanted to record history, give a very honest image of the life in the camp and learn how to shoot in colour."

The work is certainly honest. It is also engaging and a notable document of a sub-culture from a particular era. In the photographs these people are not threatening at all; they may need a bath and perhaps a stylist, but they also have a certain poise. Says Ladefoged, "I hope that these photos will help people to understand a different way of life and that people even if they are dirty, drink, smoke dope and have no jobs, still have dignity and a right to live their life the way they want to". Ladefoged spent a long time in the camp, gaining the trust of his subjects and earning their respect. In time he had complete access to photograph whatever he wanted; he is present during private and intimate moments between the camp dwellers; he shoots them when they are frankly a little out of it, chatting and just playing with their pets. The camp does not exist any more, so Ladefoged achieved his aim of recording a strange little chapter in late twentieth-century European history.

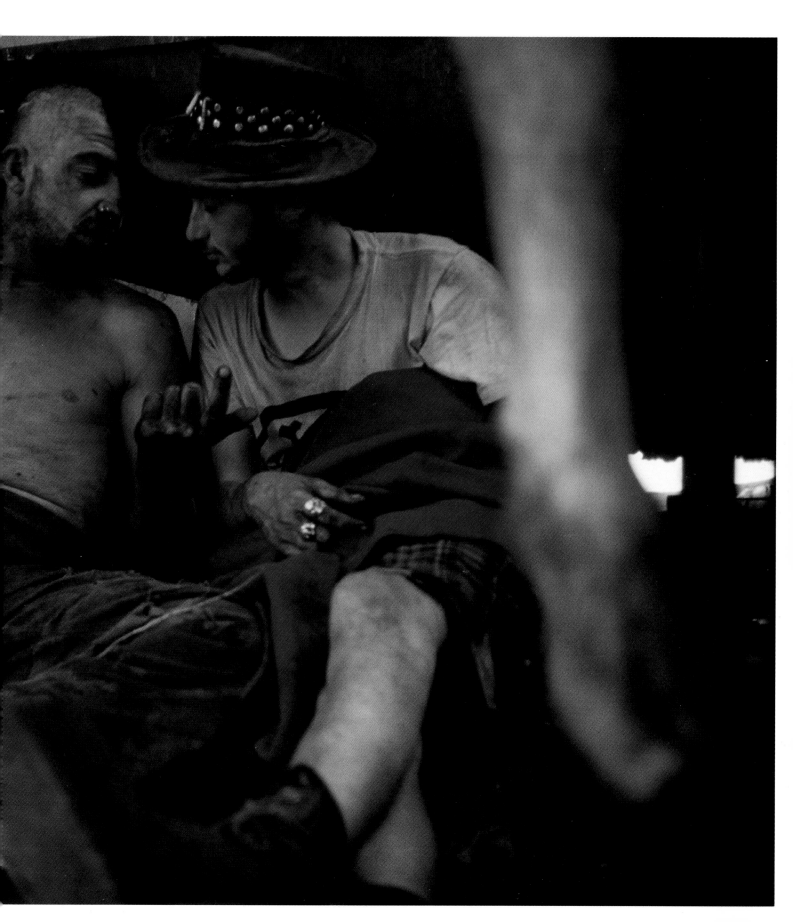

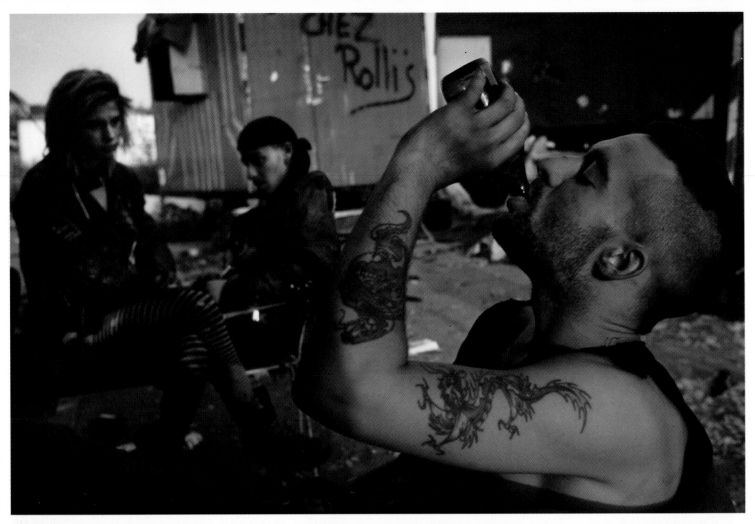

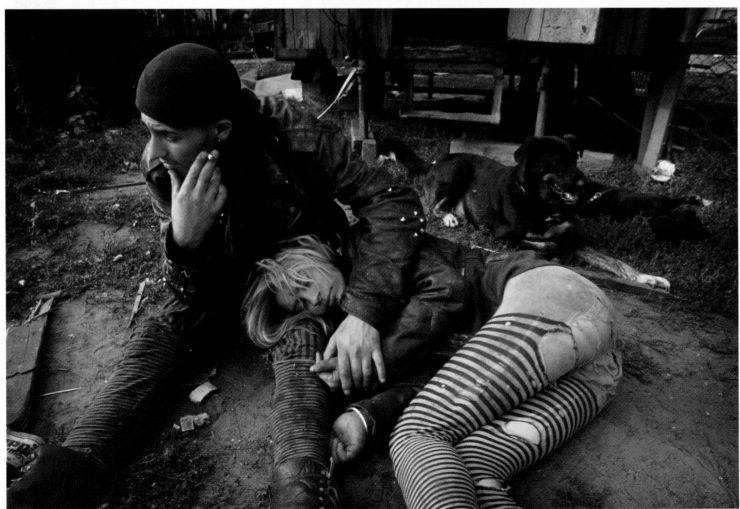

LEFT AND BELOW: **Ladefoged spent a long time with his subjects, so he eventually just blended into the ramshackle scenery. He photographs quiet moments of contemplation, but also drunken, riotous behaviour. It is amazing to think that he was only in his early twenties when he completed this essay — perhaps that is why he was able to earn the trust of these New Age hippies.**

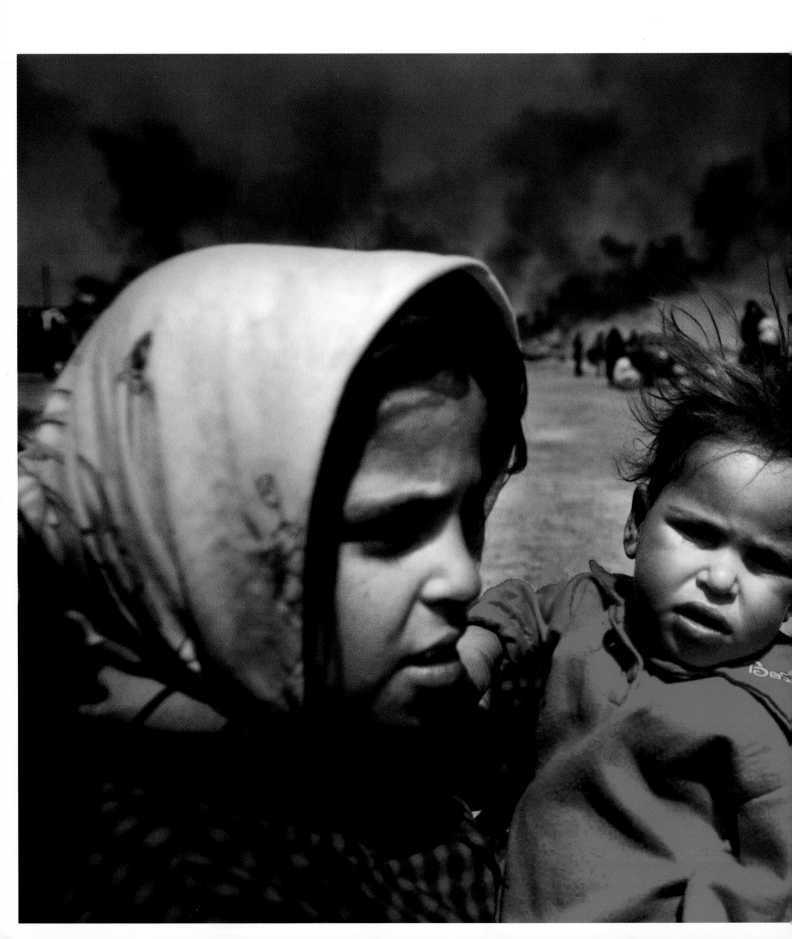

BELOW: **An Iraqi girl holds her sister as she waits for her mother to bring food bought in Basra. This photograph taken in 2003 has a sweeping epic quality with despairing figures in the background as far as the eye can see, while in the foreground the little girl's glazed expression is just heart-wrenching.**

Photographing a war is never straightforward, but the recent conflict in Iraq was a particular logistical and ideological challenge. The photographers were embedded within military units, so their access and thus their ability to present a different viewpoint was limited. While the military was not censoring their images, it was clear that, in the early stages at least, there was an unspoken agreement between the allies and their respective media outlets that the conflict should be portrayed as one of liberation. This is certainly how the Iraqi people initially saw it, but very quickly disillusionment set in. "One moment people felt liberated, and in particular the older people were thanking the American soldiers, but within a matter of a few days, people's attitudes were changing. There was no water and electricity and they were asking me what was going on," recalls the highly accomplished Jerry Lampen. Working for Reuters, he says, he had a duty to remain objective. Yet at the same time, it was clear that the war was an ambiguous one and innocent people were suffering. "I tried to focus on the victims and in particular the children because they get forgotten. It is the adults fighting over land, religion, oil, but all the kids want to do is play football and play with their dolls," he says.

Shooting for a newswire means that the photographer's greatest enemy is the ever-present deadline, but Lampen's images, all shot on digital cameras, never appear rushed or hackneyed. He may be engulfed by chaos, but it never interferes with his ability to calmly compose a photograph that gives equal weight to the foreground and middle ground. Lampen also has the knack of getting right into his subject's space, yet somehow remaining unobtrusive. He says that his photographs are never going to change the world, but if they make people think a little more about what is going on, he feels that he has accomplished something. On that score he need be in no doubt. Many very big names covered this story, but few with as much distinction as Lampen.

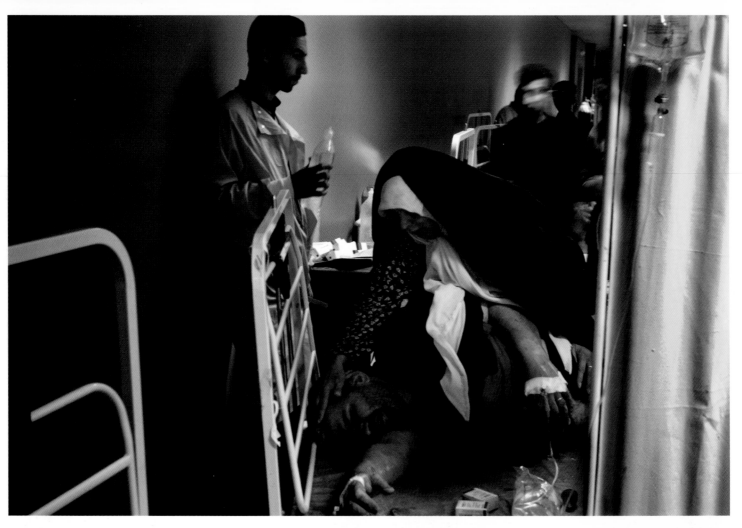
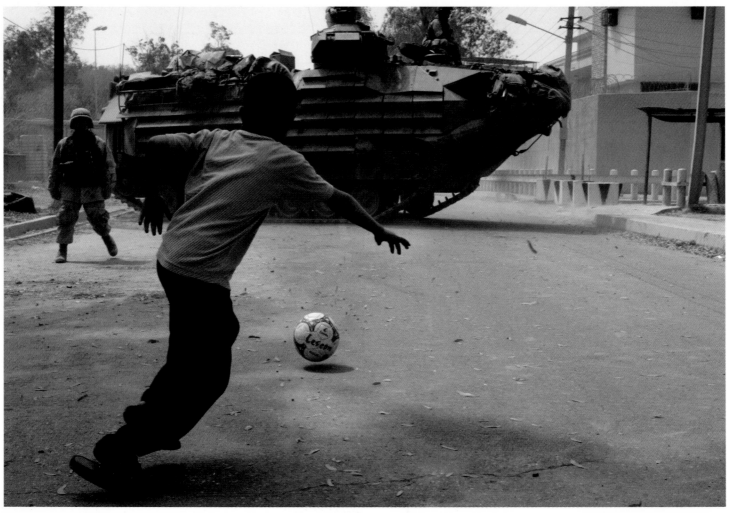

LEFT: **A woman and her husband with severe burns at a ramshackle and chaotic hospital in central Baghdad, April 2003. This is an unsettling image with the photographer close, almost too close, to the pain.**

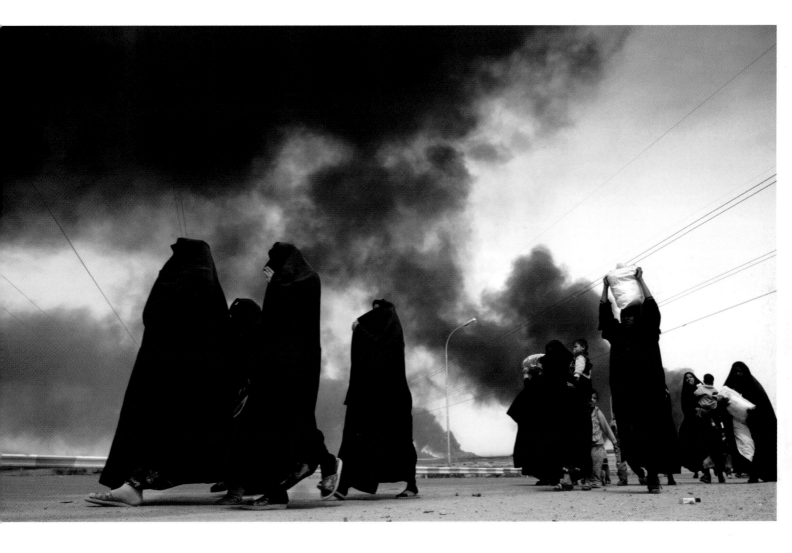

ABOVE: **Iraqi women leave the besieged city of Basra. Once again, we see the consequences of war — the suffering of the innocent fleeing under a shroud of black smoke.**

LEFT: **An Iraqi boy plays football with a US soldier at a checkpoint in central Baghdad. This is a welcome respite from the fighting and the scene suggests that perhaps a better and more peaceful Iraq might emerge from the conflict. Note the soldier sitting on the tank staring into the distance at the top of the frame.**

DOROTHEA LANGE

BELOW: **The family of an Alabama turpentine worker who earns $1 per day. Lange appeals for help on behalf of her subjects by emphasizing the obvious signs of their poverty, such as shoeless feet, and tattered clothing and window screens. But the faces connect viewers emotionally, and elevate images such as this beyond mere government documents.**

A seminal figure in social documentary photography, Dorothea Lange gave voice to the "everyman" (and woman), convinced that arresting images of society's disadvantaged people could compel government officials to intervene. Although Lange never considered herself an artist, her photographs are highly subjective and resonate with emotion. Her instantly recognizable photograph, *Migrant Mother, Nipomo, California* (1936), is the iconic image of America's Great Depression and the touchstone of her *oeuvre*. Talking about the subject of that photograph, Lange once told an interviewer, "[She] seemed to know that my pictures might help her, and so she helped me. There was a sort of equality about it."

Lange ran a portrait studio catering to a wealthy clientele during the 1920s, but began dabbling with documentary work when she photographed Native Americans while travelling with her first husband, Maynard Dixon, in 1923. By the early 1930s, she was restless; portrait work seemed static and increasingly irrelevant after the 1929 stock market crash. "It came to me that what I had to do," she later recalled to an interviewer, "was concentrate on people, all kinds of people, people who paid me and people who didn't." In the tradition of Lewis Hine and Jacob Riis, Lange took her camera to the streets and started photographing the throngs of unemployed in bread lines and striking dock-workers along the San Francisco waterfront. Lange's strong personality informed her work. Biographers have described her as egotistical, domineering and contentious, but also kind-hearted and empathetic. She approached her subjects with simple questions about their routines and activities, asked permission to photograph them, then lingered until they stopped trying to pose. Although best known for images of the destitute farmers whom she shot in the 1930s for the Farm Security Administration, Lange also worked for government agencies during the Second World War. She documented women and minorities working in wartime industries and also the internment camps for Japanese Americans. The latter work was at times scathingly critical of US Government policies, portraying the prisoners' spirit and hope against a backdrop of their oppressive living conditions. In the 1950s she turned her attention to the rapid cultural changes in post-war America, for example the relentless spread of the suburbs.

RIGHT: **This image of the *Migrant Mother, Nipomo, California* taken in 1936 is an icon of America's Great Depression and stands for the personal tragedy of millions of ordinary citizens suffering from economic forces beyond their control. The mother's burdens are written in the sleeping baby in her lap, the children leaning listlessly on her shoulders, the worry on her face and the pensive gesture of her right hand. But her demeanour also reflects strength and determination. The image makes a powerful appeal for public sympathy and assistance, which was Lange's intent.**

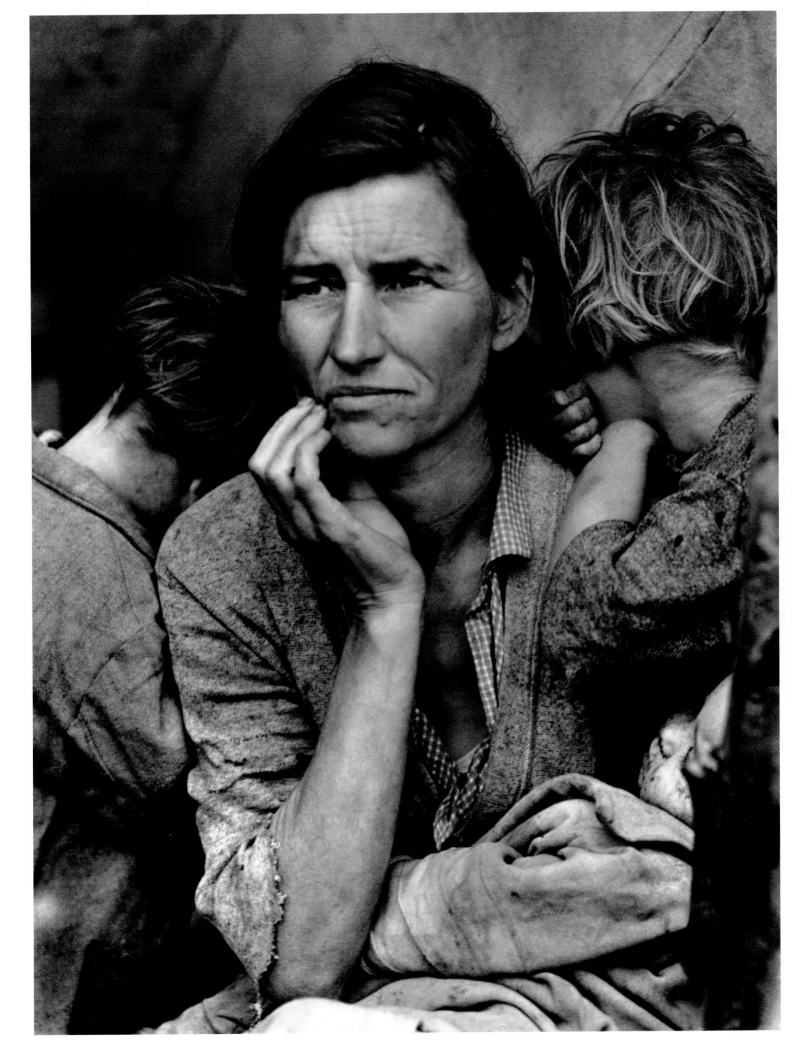

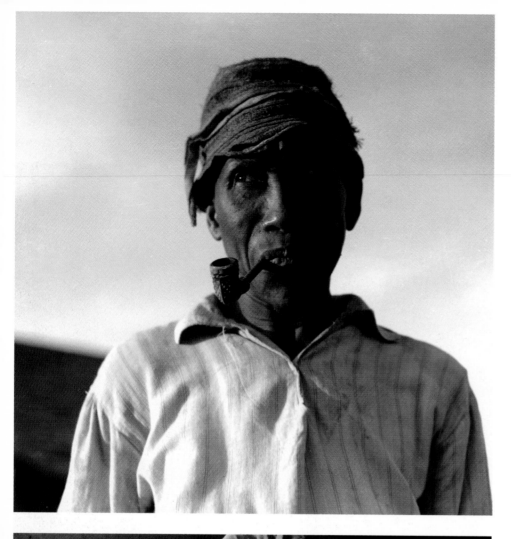

LEFT: A tattered hat, leathery skin and a wary glance convey the hard life of this Mississippi plantation resident. But the pipe, combined with Lange's low camera angle, lend her subject an air of dignity and pride.

LEFT: This 1939 portrait of an irrigation project resident in Oregon endorses government social intervention with its subtle suggestion that this woman is a deserving beneficiary: her dress and demeanour suggest poverty, but also a determination to work, and her face reflects a ray of guarded hope.

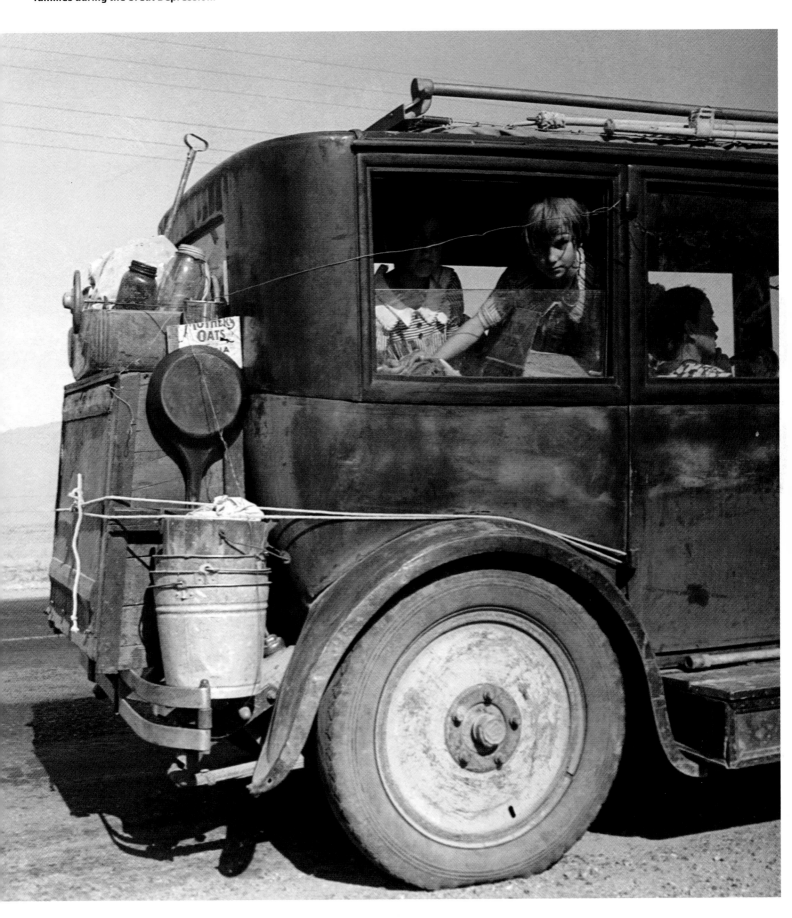

BELOW: Drought refugees from Abilene, Texas, are following the crops to California. The trepidation on the faces of the subjects and the household effects tied to the automobile convey the desperation of Dust Bowl farm families during the Great Depression.

GERD LUDWIG

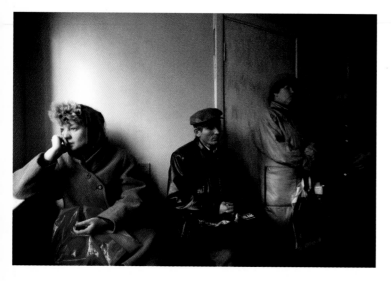

Gerd Ludwig's personal relationship with Russia began as a young boy, when he was growing up in post-war Germany. His father was drafted into the Germany Sixth Army that invaded the USSR in 1942 and was lucky to survive the disastrous campaign. The young Ludwig would listen to his father's harrowing tales of the endless winter landscapes and soldiers battling their way through bitter snowstorms. Later, as a member of the first post-war generation of Germans, filled with guilt, Ludwig compensated by glorifying everything Germany had tried to destroy. So when he went on his first assignment to the USSR in 1980, he was more than a merely curious observer, he was a photographer embarking on his own personal journey.

His journey also coincided with the gradual thawing of the communist regime. Glasnost offered Ludwig a chance to document just what kind of impact this new call for openness was having on ordinary Russians. Ludwig's images catch the Russian people at something of a crossroads. We see glimpses of the new USSR and its accompanying material benefits, yet he also reveals people living in grim social and economic conditions that for generations have been hidden from Western eyes. Often these two worlds collide in the same image. Yet despite these harsh realities, Ludwig's photographs are imbued with an infectious optimism. Many photojournalists succumb to a slightly clichéd view of Russia and photograph the country in stark monochrome. Ludwig takes a more bold and colourful approach, which makes his subjects appear more human and less one-dimensional. He has a marvellous eye for the surreal juxtaposition of subject matter and a sure touch in the way he composes and crops his images. The optimism also comes from something within the Russian soul, known as "Dasha". Ludwig explains: "It does not acknowledge harsh reality. It is the antithesis of everyday modern Western life. It is forgiveness, empathy, conscience and the ability of humans to partake in the Divine." Gerd Ludwig is part travel photographer, part social documentarian and part classic photojournalist. His images tell us something about the human condition in an accessible, yet always challenging way. Dasha indeed.

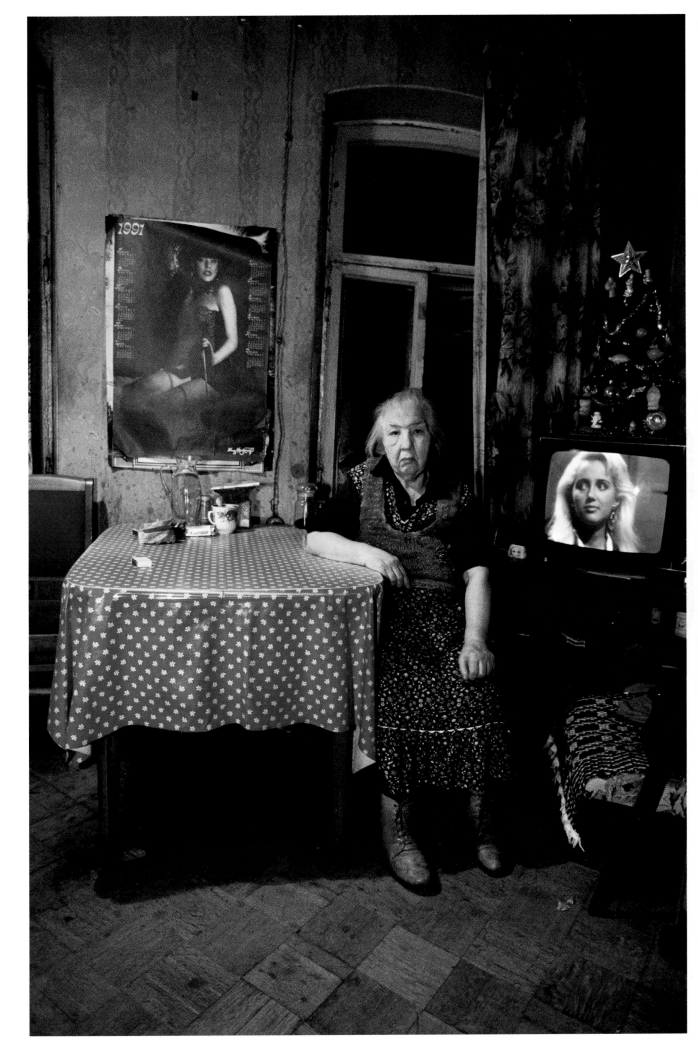

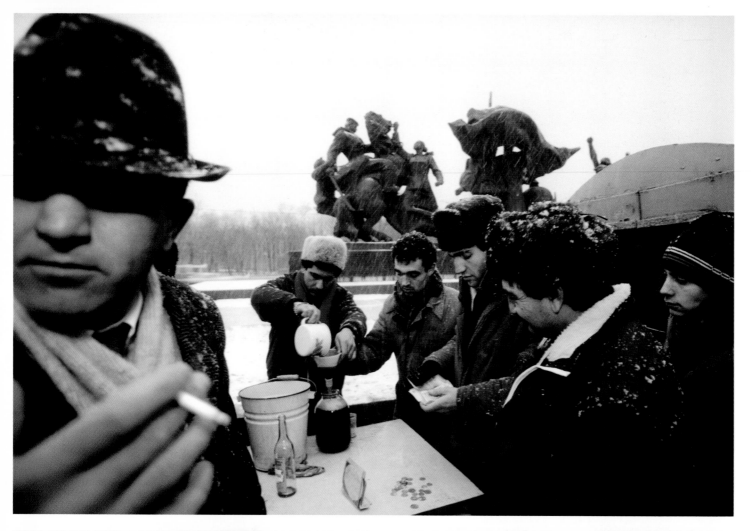

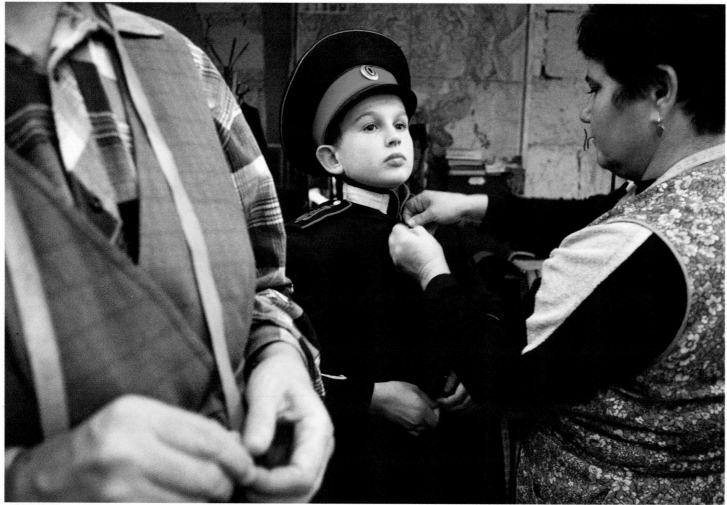

DON McCULLIN

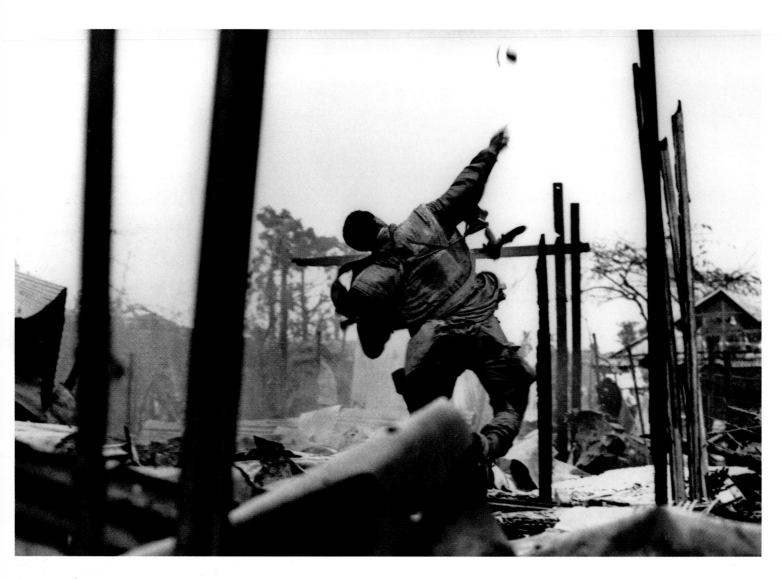

Don McCullin's photographs combine a sense of pictorial drama with humanist concern. Heir to the great pictorialist tradition, he has combined an eye for the beautifully constructed image with an acute social conscience. No greater tribute could have been paid to him than Cartier-Bresson's term "Goya with a camera", to describe his war photographs. McCullin is an obsessive photographer who also claims that he "hates carrying a camera". He was the creator of several pictures that have come to define in a single image some key conflicts of the second half of the twentieth century, from the Nigerian civil war of the 1960s, to Vietnam, Bangladesh, Northern Ireland, the Lebanon and Paraguay. His desire to get as close as possible to scenes of conflict and suffering reflected a deeply felt need to "witness" these events on the behalf of humanity, an urge that is present more generally in his social reportage.

His extraordinary study of the British underclass, *Homecoming* (1971) is a dark and disturbing view of a nation that ignores the social problems of its disadvantaged groups, a particularly poignant portrait at a time when the magazines for which he worked were becoming increasingly obsessed with "lifestyle" consumerism.

McCullin bears the scars of his numerous close brushes with death, yet ironically his remarkable record worked against him when he was denied access to the Gulf War in 1991 because of the heavy censorship employed by the military authorities. He has continued to report on the other great struggles of modern times, on poverty, AIDS and deprivation in the Third World. Yet McCullin's reportage on situations of conflict and deprivation has always been interspersed with projects dedicated to seeking out settings in which to renew his faith in humanity and nature. His pictures of New Guinea tribes (1985) and of Indian people and places (since 1988), his dark and beautiful and wintry Somerset landscapes, and the classically constructed large-format still lifes made in the coal shed of his Somerset home may indeed play a redemptive role in his life. Without a doubt, he is Britain's greatest ever photojournalist.

BELOW: This photograph of a shell-shocked US marine during the battle for Hue in February 1968 has become an iconic image of the Vietnam War, symbolizing both the power and the impotence of American military might against its enemy, and the failure of American society to support the war.

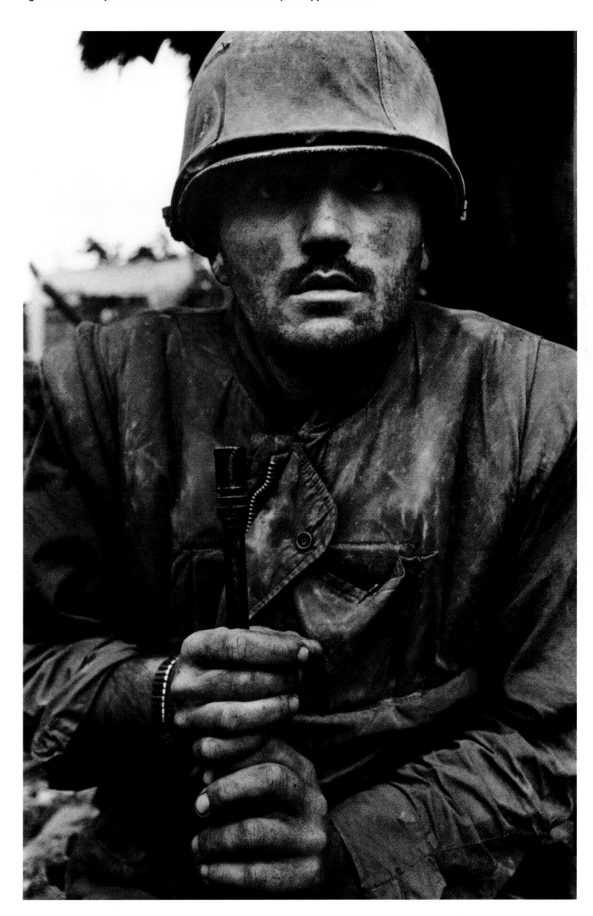

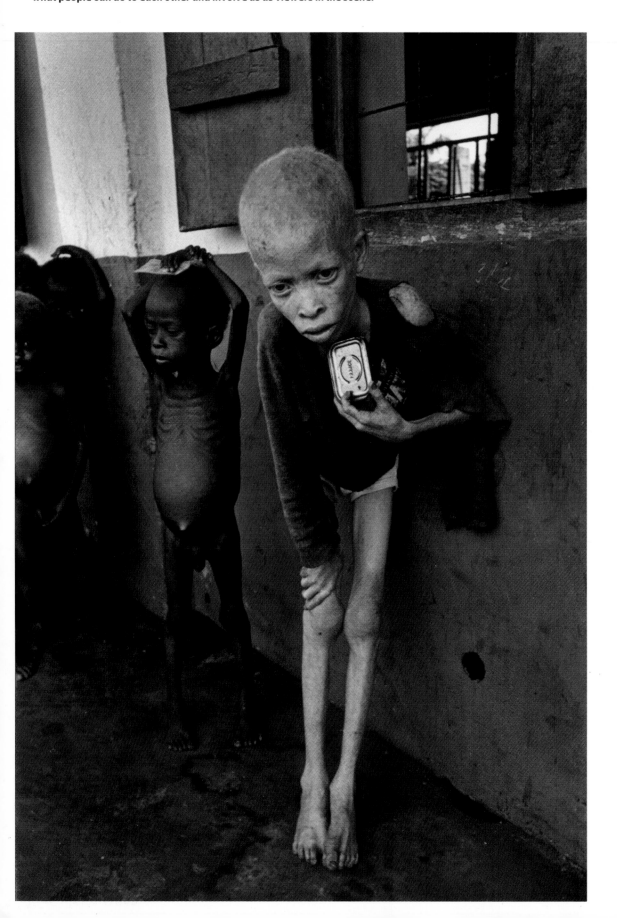

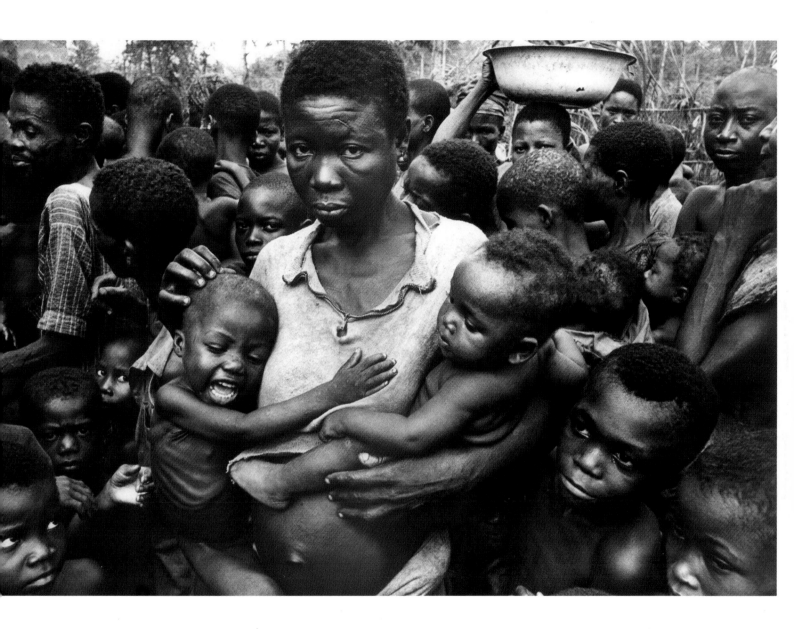

ABOVE: **A food distribution centre in Biafra during the failed secession war with Nigeria in 1968.**

PETER MAGUBANE

Peter Magubane once said, "I knew I could use my camera to tell the world how apartheid operated. I was demonstrating with the camera." Throughout a long career he has paid a high price, more than once, for being prepared to observe and record the harsh realties of life under apartheid. He has spent long periods in solitary confinement, been shot at, been badly beaten up by the South African police on several occasions and in 1969 was banned from taking pictures for five years. Yet Magubane was never deterred from carrying out what he regards as his mission. When he was prohibited from carrying a camera, he took pictures with his trusted Leica, which he hid in a hollowed-out Bible. On another occasion he smuggled his camera into a trial concealed inside a loaf of bread.

Despite his treatment by what were in effect white oppressors, his photographs are always balanced. He documents the brutality of the black kangaroo courts, which often resulted in burnt corpses of supposed informers, and he also took sympathetic photographs of ordinary Afrikaners. He has been present at most of the key moments in the post-war South Africa and his images are part of the country's dark history. Thankfully, light does emerge toward the end of Magubane's photojournalistic career with the release of Nelson Mandela and the emergence of a new South Africa. Technically, Magubane was solid, rather than outstanding, but in terms of commitment, resourcefulness and sheer courage, he is one of the key figures in post-war photojournalism. Steven Sack, Director of Arts, Culture and Heritage for the City of Johannesburg, says of his legacy, "Every attempt at documenting the daily lives and regular confrontations endured by black South Africans was a risky and dangerous activity. Peter Magubane placed himself between the apartheid state and the black majority in order to report on and capture the many instances of the ongoing abuse. These photographs kept the spirit of resistance alive. They inspired many others to resist by giving a face to the courageous."

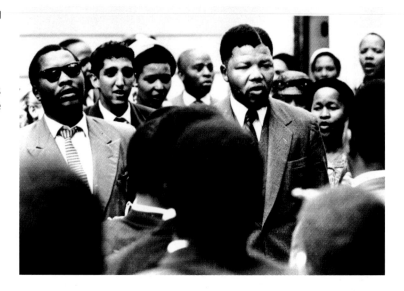

ABOVE: **During the first treason trial in Johannesburg, South Africa, in 1956, the attorney Nelson Mandela (centre), with his wife Winnie behind him, stands singing in the midst of a group of his co-defendants. These trials made Mandela an international figure. His charismatic presence dominates this image.**

RIGHT: **This photograph of ranks of coffins at the mass funeral for victims killed in demonstrations in Sharpeville, South Africa, in 1960 is one of the most famous images from this era and it alerted the world to the horrors of the apartheid regime.**

BELOW LEFT: **Magubane, always on the front-line, captured this image of black South Africans setting up a barricade by setting fire to tyres in the street during a protest against apartheid during Election Day in 1989.**

BELOW RIGHT: **On Election Day in 1989 South African police killed 14-year-old Patric Mueller. In this photograph throngs of mourners, including South African clergy, comfort the distraught mother at the funeral.**

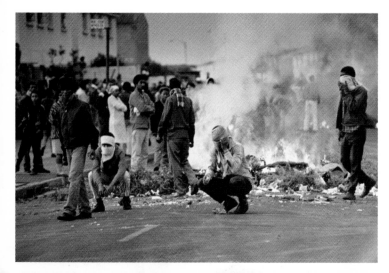

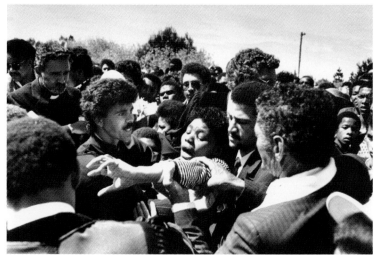

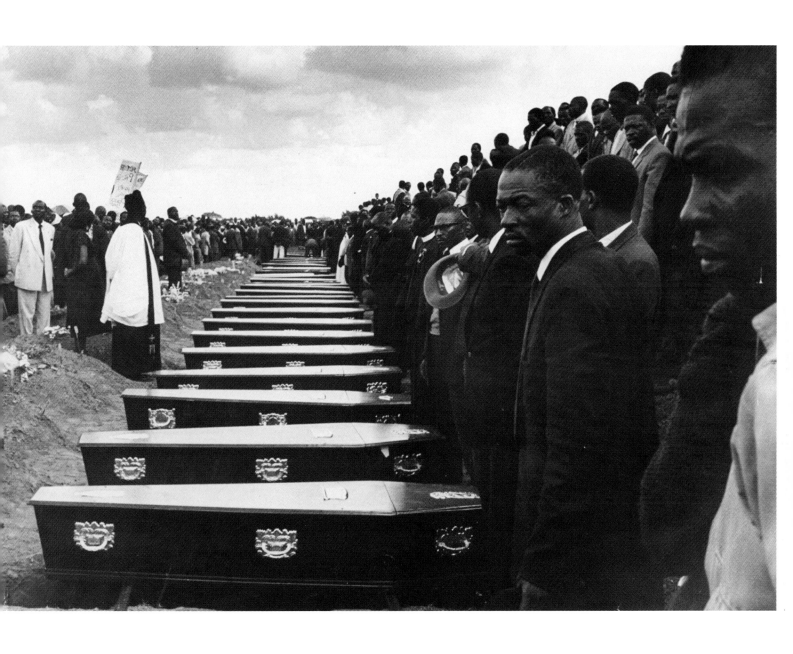

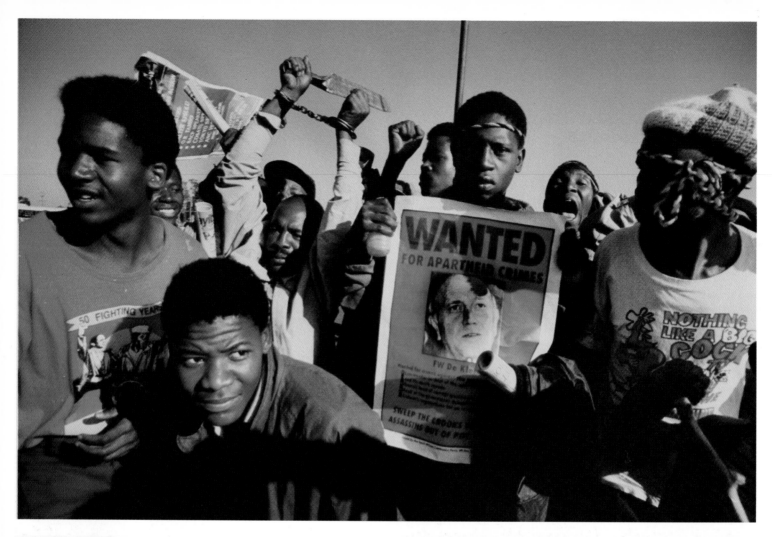

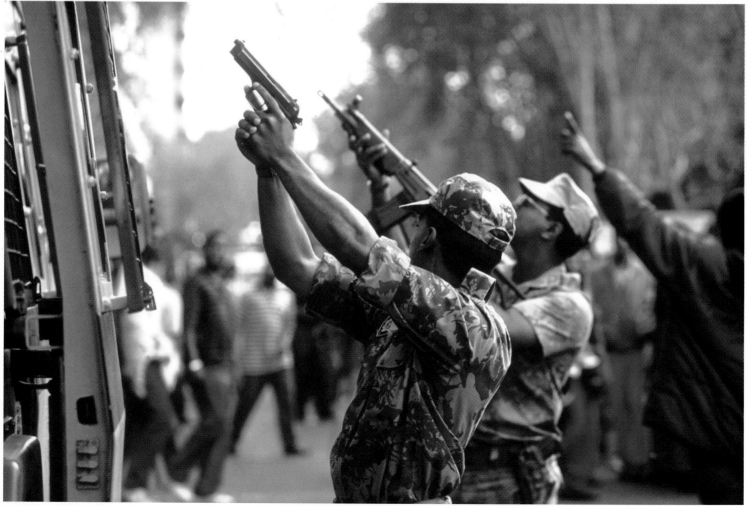

LEFT: On 17 June 1992 armed KwaMadal Zulu hostel residents – enraged by persistent attacks on Inkatha Freedom Party supporters – fell upon the Vaal Triangle township of Boipatong and massacred some 45 men, women and children. In this photograph we see people protesting against the massacre. Magubane expertly captures their anger and sense of injustice. He never sanitized the struggle for freedom and always saw it in grey terms.

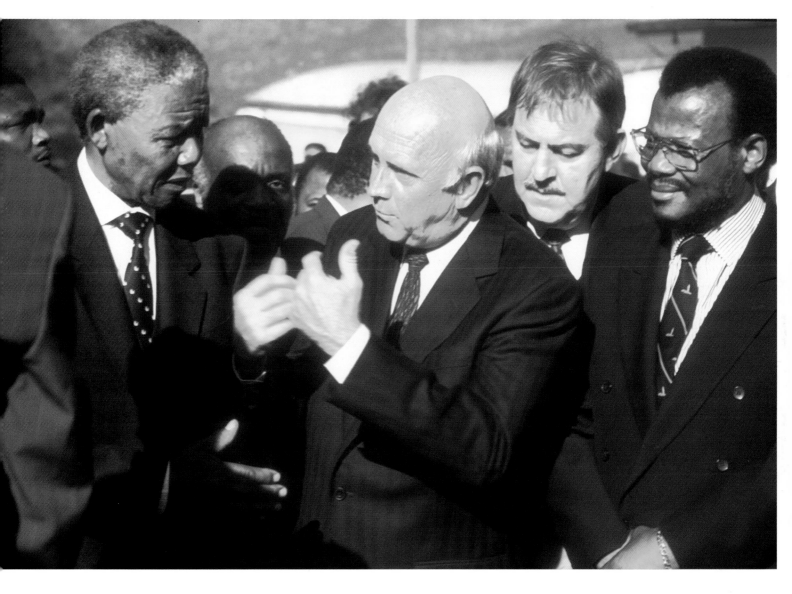

LEFT: In Johannesburg, South Africa, 1994, police return fire during a deadly mêlée started by gunmen firing on protesting Zulus, with ensuing gun battles between Zulus, ANC and the police.

ABOVE: It was a major coup for Magubane to capture all these men from different ends of the political spectrum and tribes in one image during the election campaign of 1994. The rival candidates are from left to right, ANC leader Nelson Mandela, President de Klerk, Inkatha Zulu leader Buthelezi, with former minister Pik Botha behind them.

ALEX MAJOLI

BELOW AND RIGHT: These extremely disturbing photographs are from Majoli['s] most famous project, *Leros*. These seriously mentally ill people are bein[g] left to fend for themselves in a squalid and inhumane environment. Despite the religious iconography in the main photograph, it is clear tha[t] no charity or compassion has ever touched this man. The starkness of th[e] room accentuates the man's despair. In the portrait on the right, the composition conveys a sense of claustrophobia.

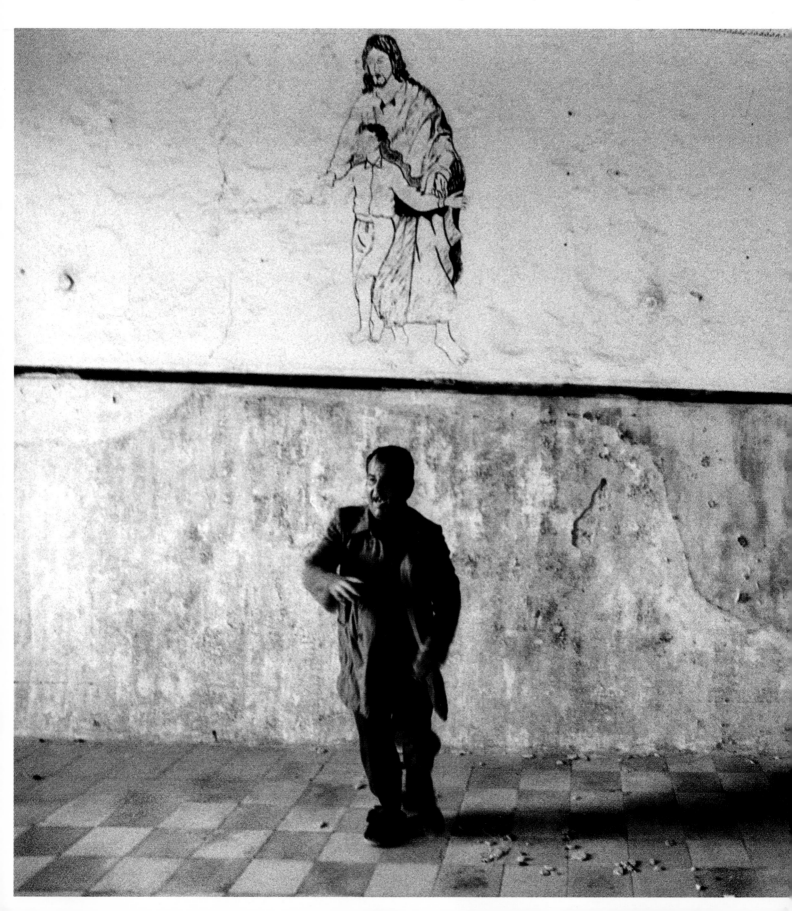

A Greek Island is normally associated with beauty and serenity. The Greek island that Alex Majoli came across in the mid-1990s, however, was so extreme and barbaric that it compares with Stalin's Gulags, albeit on a smaller scale. Leros was home to an asylum for the insane that, in a former life, had been a political prison. Its occupants were now Greece's most seriously mentally disturbed cases, casually shipped by the psychiatric hospitals to this squalid and inhumane hellhole. Majoli arrived at the point when the European Union was looking to close down Leros. His project looks at the conditions in which these poor people lived and their subsequent, gradual rehabilitation back into island life. In various shades of black and grey, Majoli documents their physical and mental anguish, the squalor, the cruelty of the staff (local goat herders, rather than doctors or nurses) who controlled the patients with brute terror. His images are so claustrophobic, unflinching and relentless that they hit the senses at full tilt. You don't just see the asylum, you smell the stench and hear the screams. Chinks of light, however, start to illuminate some of the photographs, as the hospital closes down and the patients start on their unsteady journey back into society.

Since this project, Majoli has covered most of the key events of the past 10 years. Everywhere he goes, he produces remarkable stories, but he seems to be at his best when he is working in the more wild and uncompromising parts of Europe: Albania, the former Yugoslavia and of course Leros. *Newsweek*'s International Photo Editor, Jamie Wellford, calls Majoli a visionary, but a modest one: "Alex has never claimed to have the absolute photograph when I have spoken to him about an assignment. On the contrary, he has frequently apologized for not having that moment, which must be understood as his continuing search for the picture, for the story and for the eternal." Long may Majoli search.

BELOW: **In 1997 this 10-year-old boy, photographed in Scutari hospital, Albania, lost a leg after stepping on a landmine near the town's military barracks. In the words of a photo editor who works with Majoli, "He strikes the chord of humility every time he makes a picture".**

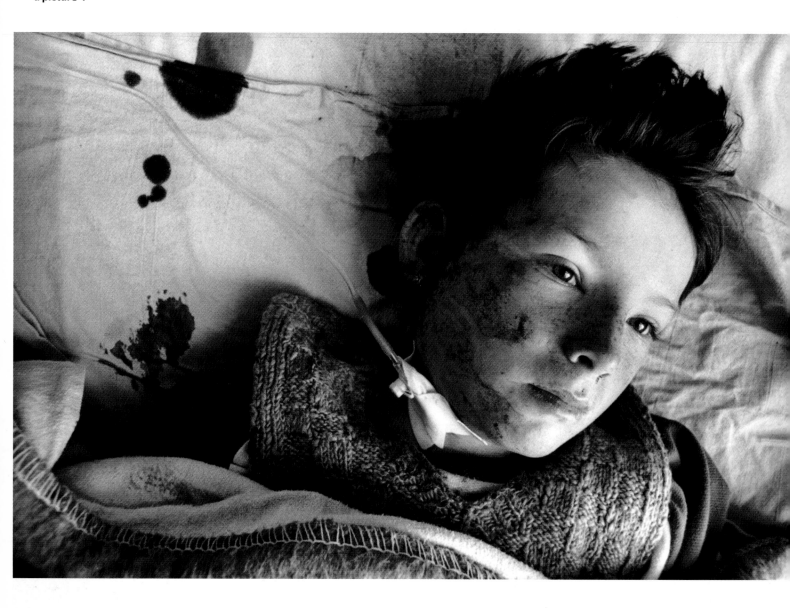

RIGHT TOP: **After two attempts, a train carrying thousands of refugees from Albania crosses the Macedonian border in 1999. While there is hope for the refugees on the train, the reflection of the refugees still awaiting their fate is heart-wrenching, a fine example of Majoli's ability to extract something unique from a situation.**

RIGHT BOTTOM: **A mother and son battle the elements and the landscape as they return from work in Albania,1998. There is a tension between the subjects' stoicism and the dramatic, ominous sky.**

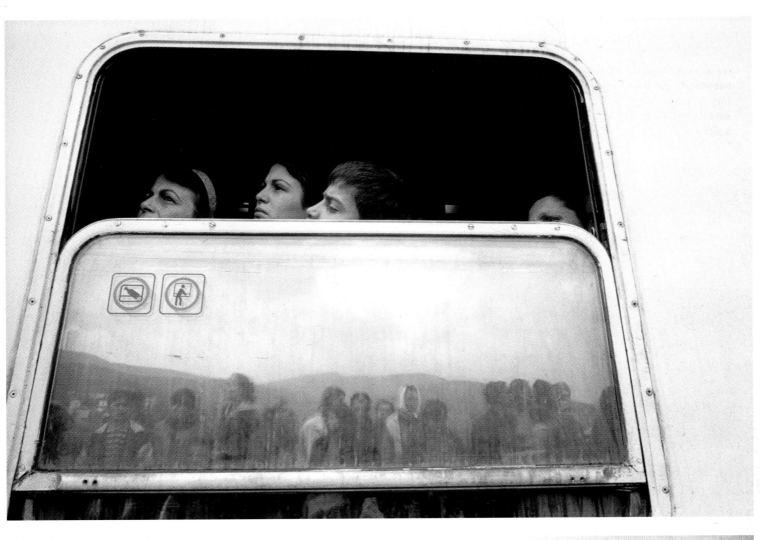

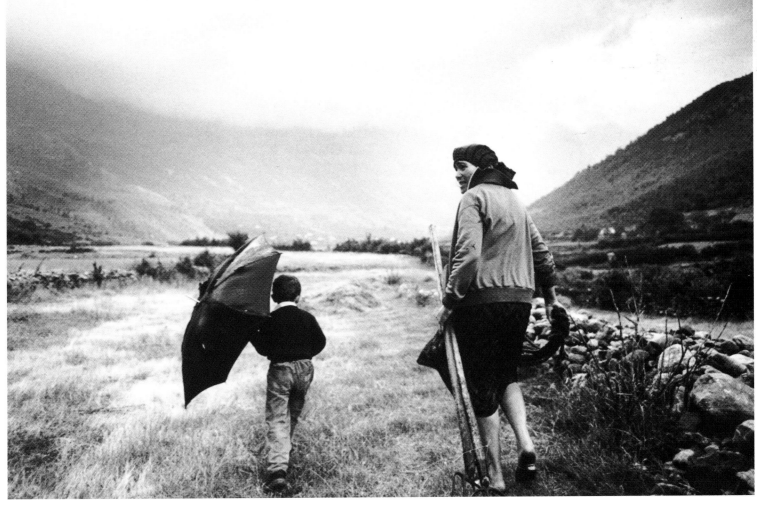

MARY ELLEN MARK

BELOW: Lillie with her rag doll in Pike Street, Seattle, Washington. Taken in 1983, this is from Mark's seminal essay on the troubled homeless children who survive through hustling, stealing and prostitution. The girl is probably not much older than 12, but there is a look in her eyes of an innocence lost, despite the fact that she is clutching a doll.

Mary Ellen Mark has been the USA's leading female photojournalist for the past 25 years. She does not so much simply photograph a story, but immerses herself in it, like a method actor tackling a difficult role. In the late 1970s, for example, she lived in a mental hospital in Oregon with the patients, while she worked on a photo essay about the institution. Throughout her career she has been attracted to photographing people on the fringes of society: prostitutes, the mentally ill, the homeless, the helpless, drug addicts and the people who simply do not get the breaks. In her unflinching black-and-white beautifully composed images, she asks us to acknowledge, but never to sentimentalize, her subjects' harsh lives. Her photographs are often stark, with little to distract the viewer from the stories they tell. She is very much the antithesis of the overly complex or "arty" photographer, and her best images combine reportage with classic portraiture, relying on strong eye contact between the viewer and the subject.

She has produced so many remarkable essays over the years that it is hard to pinpoint one, but it is perhaps her story on Seattle's street children that is her greatest. These children were surviving on the streets through hustling, pimping and prostitution, so potentially it is a subject that could be mishandled and exploited. Mark, however, pitches it just perfectly. She got to know the children, they trusted her and the result is a melancholy and soulful collaboration between the kids and a photojournalist at the height of her powers. These images never flinch from the grim reality, but they are also filled with beauty. Buzz Hartson, head of the International Photography Center in New York, which has shown a huge retrospective of her photographs, says of Mark, "Her work is documentary with all of the social awareness and immediacy that implies, and it is also remarkably personal in its feel. It is clear from her work that her subjects are comfortable with her and this gives an intimacy that is rare in all but the best photography."

BELOW: **The Damm family in their car in Los Angeles, 1987. Mark photographed this family for several years as the parents drifted in and out of various degrees of addiction and homelessness. This image became a symbol for an American underclass forgotten and largely ignored in the Reagan years.**

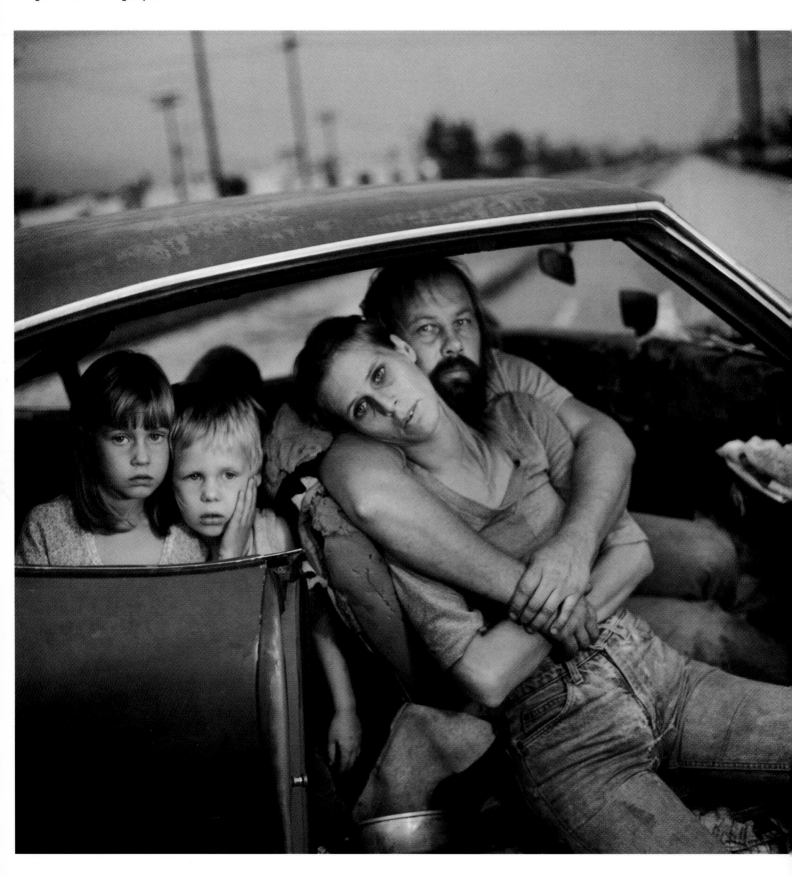

BELOW: This image, titled *Christopher with his Kitten, Sandgap,* was taken in Kentucky in 1990. Mark has always favoured strong and direct eye contact in her portraiture. This is taken from the essay *Rural Poverty*.

PETER MARLOW

BELOW: Marlow was sent on assignment to photograph the destruction of the rainforest in Borneo, Malaysia, in 1990. There is an arresting contrast between the innocent expression on the man's face and the havoc he has wreaked behind him.

"A photojournalist's role is not to wear his or her heart on their sleeve, but respond to the world and then find their own response through photography, in a way that works for them," says Peter Marlow. What works for him are quiet and understated images that are finely balanced between informing the viewers and leaving them wanting to know more. He started out as a more traditional war photographer, but by his own admission he didn't fit in. The next phase in his career was humanist social documentary. He displayed compassion and soul in his project on the decline of Liverpool in the 1980s. The images here, from 1990, are part of an essay on the destruction of the rainforests of Northern Borneo, Malaysia, an assignment for the *Telegraph Magazine*. They were taken when his career was at something of a crossroads, when his Liverpool project had reached its natural conclusion. The brief he gave himself was to record what he saw using contrasting juxtaposition: "Rich versus poor, lush virgin rainforests versus forest burnt out by settlers to create palm oil plantations on land owned by Malaysian cabinet ministers who operated above the law," as he explains.

Marlow has an innate sense of how to narrate a story, when to make his points subtly and when to jolt the viewer. Loud or quiet, his photographs always resonate. In these images we see not just the physical destruction of this beautiful landscape, but also the erosion of the traditional hunter-gatherer lifestyle of the Penan Indian. The images are therefore dreadfully poignant; as Marlow says, "The loggers had moved in and cut down the Indians' world. They were being taught how to be farmers, they were trying so hard, but in the end you could sense that it was not going to work out." Marlow says that for him photojournalism does not have to be dramatic or dangerous. "It could be mundane, boring, undramatic and still have more to say about life than the more macho style of many lauded exponents of the genre." In Marlow's world, less is definitely more.

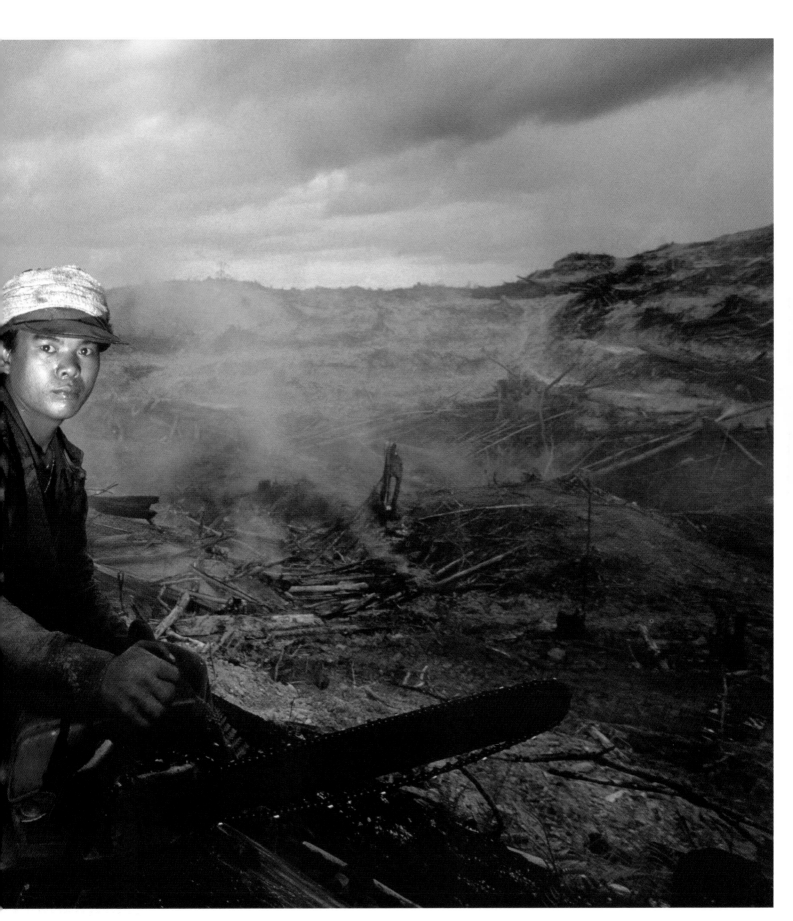

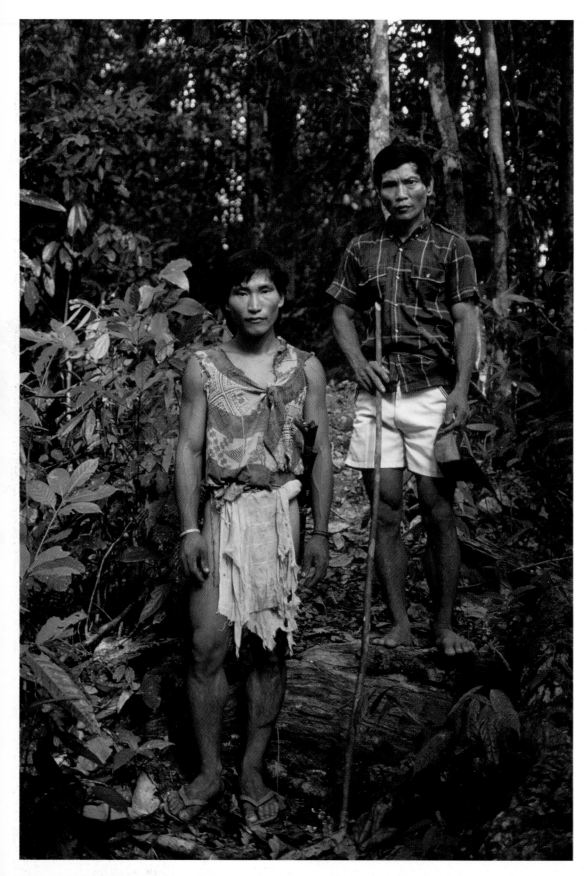

RIGHT TOP: **The sheer scale and majesty of the trees being destroyed in the Baram River region of Borneo, Malaysia, is enhanced by this angle with the camera looking skywards.**

RIGHT BOTTOM: **Here the lowland forests are being burnt off before they are planted with cash crops.**

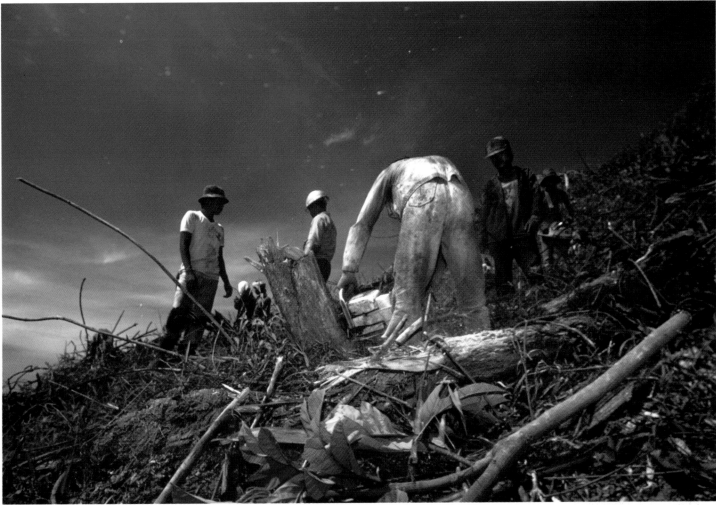

When Susan Meiselas flew to Nicaragua in 1978, she had never covered a major political story, she had little money, couldn't speak Spanish and had no prospects of any major commissions. Yet despite all of these things, Meiselas had a lot going for her. Her previous project, *Carnival Strippers*, although very different in content from a civil war, showed that she could present a coherent and complete narrative of a unique way of life. She was observant and unassuming. She could quietly watch the more mundane moments of carnival life, but also be alert to the strange, the quirky and the sleazy. Nicaragua presented a whole different set of challenges, including staying alive, but her methodology remained the same. She embedded herself in the story and used the virtues of time and patience to get the photographs. The brief that she gave herself was to document the struggle between the Sandinista rebels and the despised regime of President Somoza and its wider impact on a country that she grew to love. The story is very much told from the point of view of the rebels and Meiselas is clearly sympathetic to their cause. She spent months with the Sandinistas, training, eating and marching with them through the jungle, and subsequently recording the street fighting, where she gets perilously close to the action. Her use of colour is so vibrant and some of the fighters are so photogenic with their beards, scarves, hats and guns, that at times it seems like the struggle is being a touch glamorized. But Meiselas is too much of an intelligent photographer to fall into this trap for long, and we also see the inevitable consequences of war, the chaos and the suffering of the innocent. What also emerges from Nicaragua is the affection she has for the people, culture and landscape of the country. It is this affection that ultimately elevates her work to a level beyond straightforward war photography. She has created a complete portrait of a country in crisis, but her photographs suggest that a new Nicaragua, perhaps even a better one, will emerge from the devastation.

LEFT TOP: As Sandinista comrades await counterattack by the Guard in Nicaragua in 1978, there is a strong sense of anticipation, a moment of calm before explosive action.

LEFT BOTTOM: The crouching figure of a Nicaraguan streetfighter dominates the photograph (1979), but our eyes are also drawn to the anonymous cropped figures in the background who look somewhat menacing.

ABOVE: In an understated photograph, recruits pass by an official state portrait of Anastasio Somoza Debayle as President and Commander-in-Chief of the armed forces, Nicaragua, 1978. The photograph makes the point that the President is out of touch with this people — none of the recruits seem even to notice him — and that he is not a man to be trusted.

GIDEON MENDEL

ABOVE: **This is taken from Mendel's epic project *A Broken Landscape* and was photographed in Malawi in 2000. The woman is weeping for her daughter Mary who had died the previous night in hospital, her sixth child to die of AIDS. This picture might be regarded as intrusive if it had been taken by someone else, but Mendel is so committed to both the issues and his subjects (and they clearly trust him), that you feel that he has a right to be there.**

Many photographers have shot stories on AIDS, but Gideon Mendel has concentrated and focused on this devastating disease more than any other, producing over a decade a body of work that is without parallel. His first exposure to the issue was photographing an AIDS ward in London in 1993. He says that the situation was different from any he had experienced as a photojournalist, and describes it as 10 per cent photography and 90 per cent communication. From that assignment, Mendel felt that as an African photographer he needed to find a way to respond to the AIDS crisis that was clearly developing on the continent and so he began this groundbreaking work. His former agent Neil Burgess says of his AIDS photographs, "It is the continuity of concern and the depth of knowledge and understanding of the issues which make him and his work unique." Mendel's work on AIDS is more than just a project, it is a campaign of which he is no longer an impartial observer, but an activist with a camera. Mendel has repeatedly returned to places such as Tanzania, Malawi, Zambia and Zimbabwe, allowing him to develop meaningful relations with his subjects. This in turn has produced photographs that have depth, humanity, and most importantly of all, compassion. He is not just interested in showing the horror, but also proving that there are 30 million people living with AIDS in Africa who can still lead productive lives. For example, one of his favourite subjects is an inspirational priest in Uganda who is HIV-positive and who plays an active role in educational work and campaigning about AIDS. The way the "campaign" has been photographed has also evolved over time. It started with Mendel shooting in traditional black-and-white, but in recent years he has been using colour, video and panoramic photography. He has also been incorporating the images online into a multi-media experience accompanied by his own moving audio commentary. In his own words, "Photographs can be powerful weapons, they can convey intimacy, tragedy, passion and hope." Mendel's work does all of this and more.

RIGHT: **This truck is used by the AIDS and HIV home-care team as they drive around the villages of Zambia offering much-needed medical supplies and aid. It is not clear in this instance whether the children are in dire need of help or just having fun. What makes this picture so compelling is the hand that almost floats into the frame — the hand of salvation, perhaps? That and the child's great grin make it a photograph of hope.**

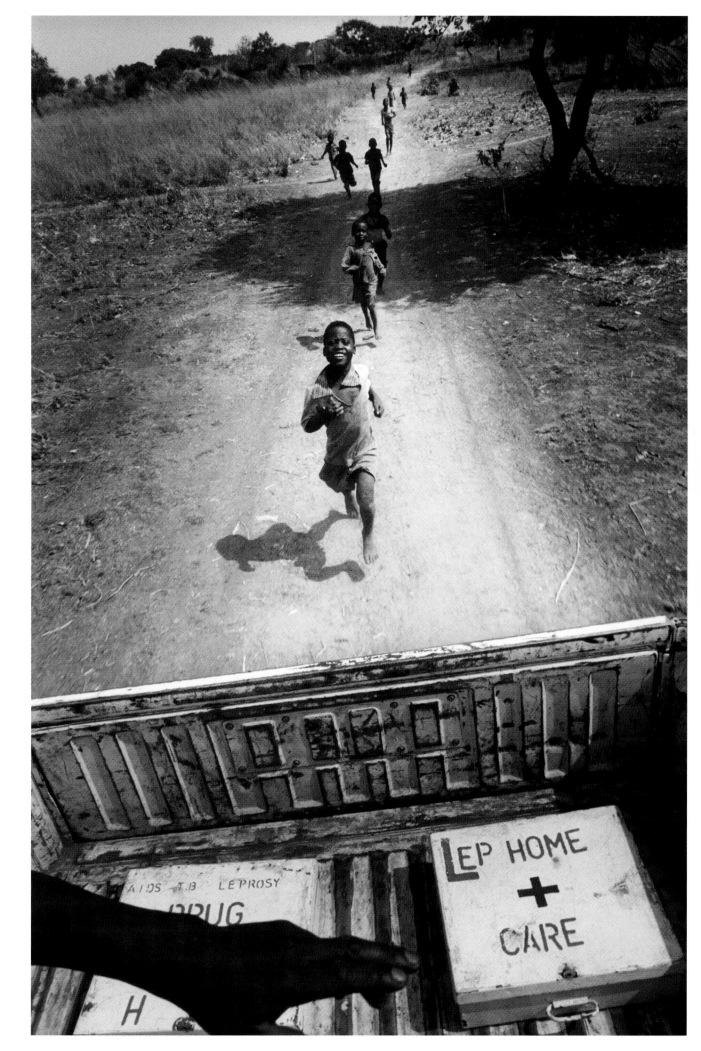

BELOW: This image was photographed at an orphanage for abandoned children with HIV or AIDS in Cape Town, South Africa, in 1995. The little boy Josaphat is receiving an aromatherapy massage, but he died shortly after this picture was taken. There is a dramatic contrast between the tender hands of the masseuse and the tiny, fungal-infected hands of the boy. Just pitiful.

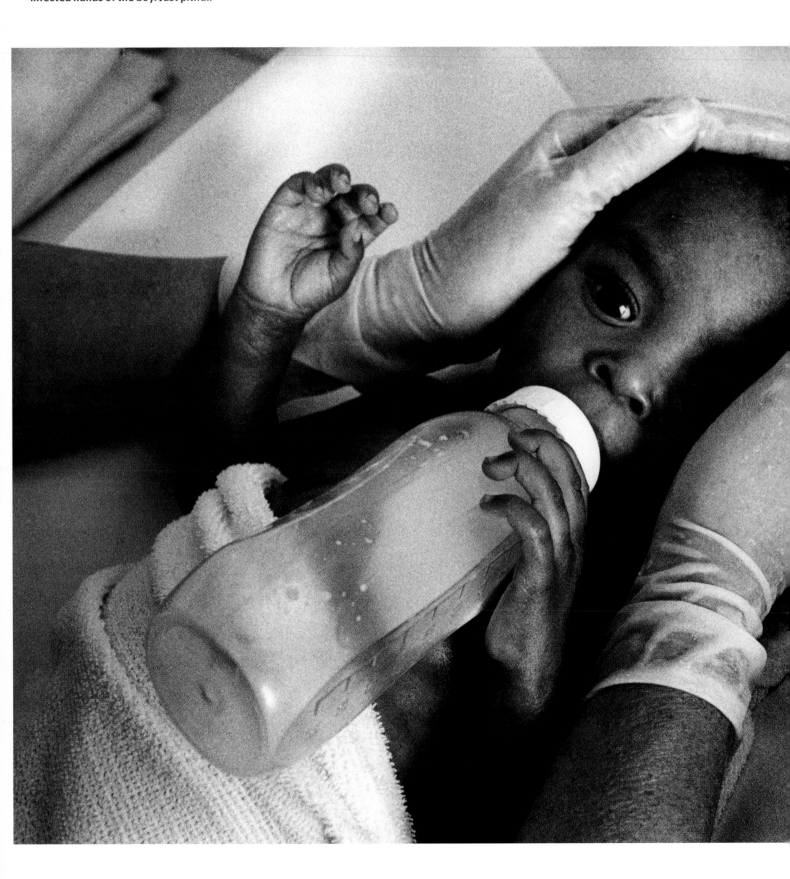

BELOW: Eliza is being supported by her aunt so that her other aunt can try to feed her in an AIDS hospital ward in Malawi. Eliza died later that night, so this may well have been the last shot of her alive. Despite her frailty and suffering, she remains defiant. This is another example of Mendel's photography humanizing such a destructive disease. For him it is not about facts and figures, but raw emotion; naturally there is suffering, but there is also great love and tenderness.

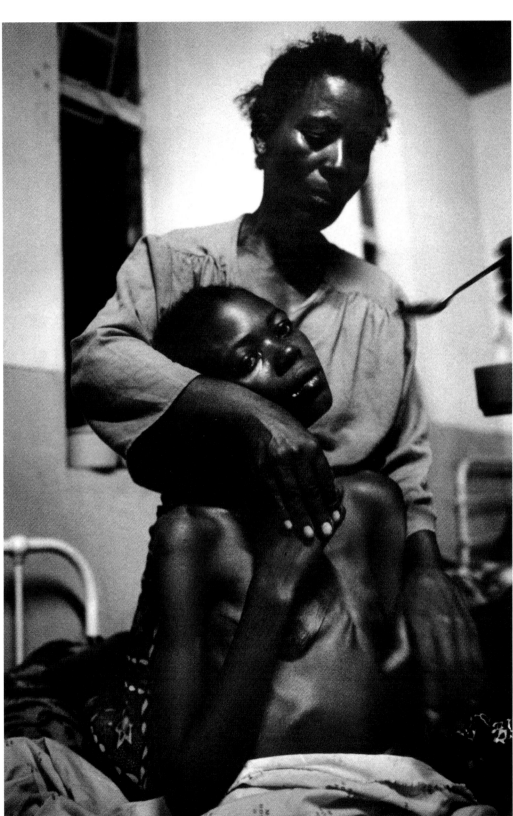

RIGHT: Mendel has adopted different shooting styles over the years for his AIDS project, moving from traditional black-and-white to these colour panoramas. This is more recent work from 2004 and was photographed in collaboration with The International HIV/AIDS Alliance. Seven orphans from the Muroemba family walk the long distance (approximately four-and-a-half miles) through the bush from their school to the home of their grandfather where they live.

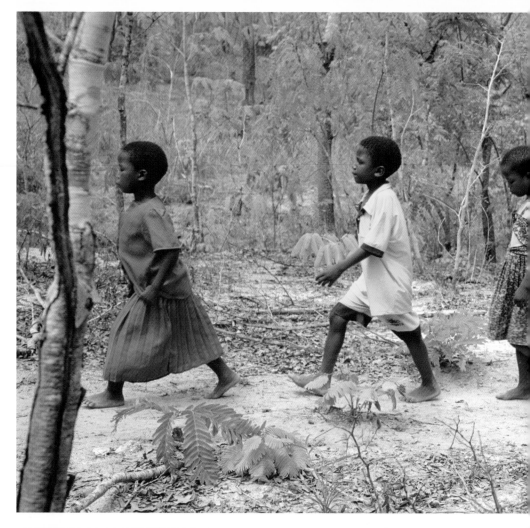

RIGHT: Elisa Tomas (12) takes care of her brother, eight-year-old Tomas Tomas, in the village of Penhalonga near the border with Zimbabwe. Both their parents are dead. Mendel skilfully lights his subjects and makes them dominate the frame.

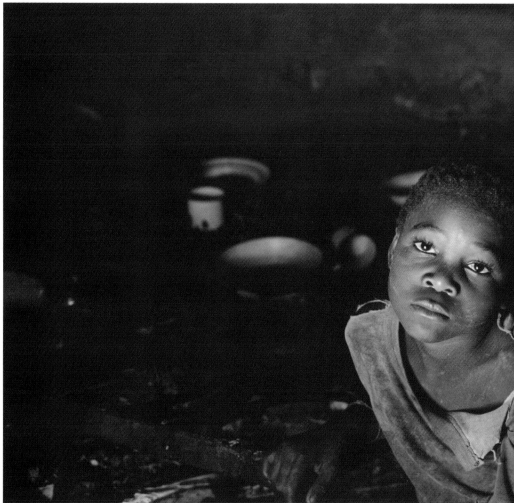

BERTRAND MEUNIER

In the highly competitive world of photojournalism, tenacity and technical brilliance is not enough. To make work that is really outstanding, the big story has to be approached from a different angle, and Bertrand Meunier is a case in point. In the late 1990s, the West became fixated with China's so-called economic boom under Deng Xiaoping, who had introduced a series of reforms that were transforming parts of the country as it started to lurch toward capitalism. Meunier, however, had a different story to tell: "I discovered the great industrial centres of the north of China. The cities were living through the full impact of the reforms, with apocalyptic effects on the social landscape. Everyone's eyes were turned toward the coast, so it seemed to me, therefore, that it was crucial to work on an unknown aspect of contemporary China."

In his carefully constructed black-and-white photographs, the word "contemporary" is almost ironic. These grainy photographs might have been taken in the last few years or so, but they do not depict a Chinese economic boom – far from it. They capture a bleak, developing urban landscape, which is more reminiscent of communist China under Mao. Meunier's subjects are not thriving, but enduring and struggling. Life here is very hard and development is slow and labour-intensive. It is a story that is so close to Meunier's heart that he never veers from absolute respect for his subjects and empathy with them. His images are also highly evocative , and the dust, grime and pollution of these half-built cities are almost tangible. Above all, perhaps his greatest strength is his innate grasp of what a photograph should do. As Amy Pereira-Frears, a photo editor at *Newsweek* explains, "Bertrand gives you so much more than simply relaying information; he sees the poetry of what it means to be human. He tells the story of suffering and sadness, all in the quiet, subtle moments of time, and in those fleeting seconds he finds the texture of the scene that makes you understand."

RIGHT: This 11-year-old girl was found as a newborn baby in the public toilets of their quarter by an old couple in Wanxian City. As well as living with them, she does all their housework. Meunier has caught the girl in rapt concentration, but our eyes are more drawn to the urban squalor behind her. It really is the gate to hell.

BELOW: Here we have an overview of the construction of a dam. As in the previous image of the little girl, Meunier shows himself to be very adept at juxtaposing people against their environment.

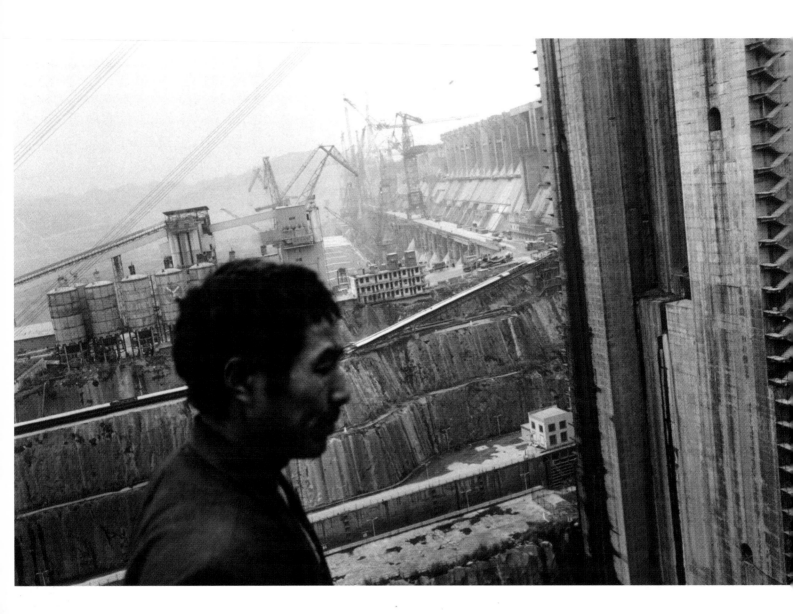

RIGHT TOP: This is almost a parody of a communist propaganda poster with the macho worker swinging a hammer. Again we are made aware of contrast, but this time it is between the manmade environment and the natural landscape.

RIGHT BOTTOM: At Wushan, coal porters carry their burdens all the way to the barges that deliver to the factories upstream. Coal is one of the principal sources of energy in China. The porters are paid three centimes for each trip over a distance of 164 yards (150m) carrying about 154 pounds (70kg) on their shoulders. The blur on the photo intensifies the experience and gives a sense of motion.

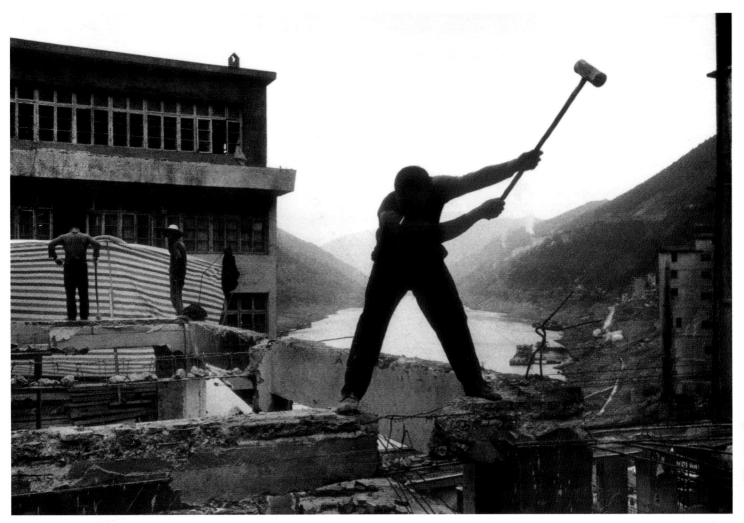

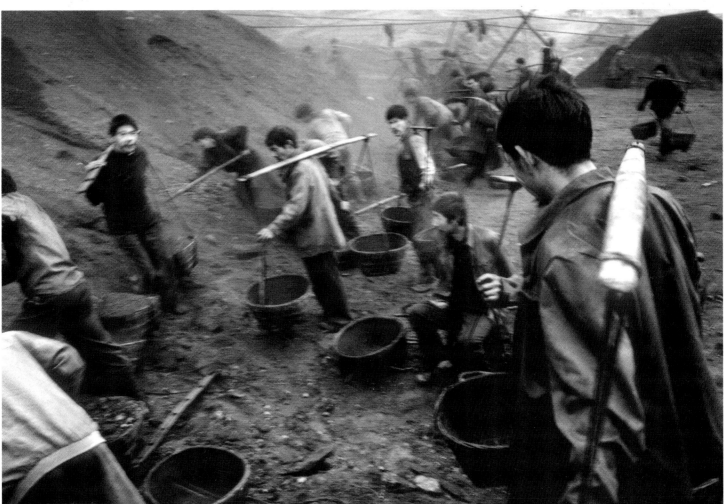

DAVID MODELL

David Modell has lived in London all his life and has an insider's knowledge of how his countrymen behave and interact with each other. He is not so much concerned with the differences in class (a particular British obsession), but rather the post-Thatcher notion of the classless society. He can photograph the mundane and the routine – for instance, a photographic essay on train commuting – but more often he looks for those moments of high emotion and drama that unite people across different social boundaries. These moments occur at political rallies (recorded in his seminal work *Tory Story*), at office Christmas parties, at betting tracks or in his essay *Diana is Dead*. He defines his style as "observational and non-interventionist. I use small cameras and try not to influence the events that I'm photographing in any way. That's not to say that I'm trying to be 'invisible'. As a photographer, you can't ignore your presence in any scene – but I do all I can to blend in and allow people to behave as they would if I wasn't there."

The English have a reputation for keeping their emotions in check, but when Princess Diana died in such a horrific and pointless way there was an unprecedented, almost irrational, outpouring of national grief. Modell's images of this strange time really capture the English behaving in a most extraordinary way. He describes the brief he gave himself: "When I went out to shoot the Diana pictures I was simply reacting to a big story in the only way that I felt was natural, which was to get out to the streets and see how people were responding. What I found was quite bizarre; a monumental expression of grief for a person that no one knew, but clearly felt that they had a connection with." Modell's images make an emotional association with the people caught up in the drama and this in turn forms a connection with the viewer. His deceptively simple and arresting style makes us feel as if we were present – one of the hallmarks of a great photojournalist.

BELOW: **An England fan during the 1994 World Cup. Modell always tries to tell a story from a slightly different point of view. The cropping of the image enhances the raw and very likely drunken emotion of the fan who is confronting the photographer with his rage/joy/frustration – we shall never know. As a side note England never qualified for the 1994 World Cup.**

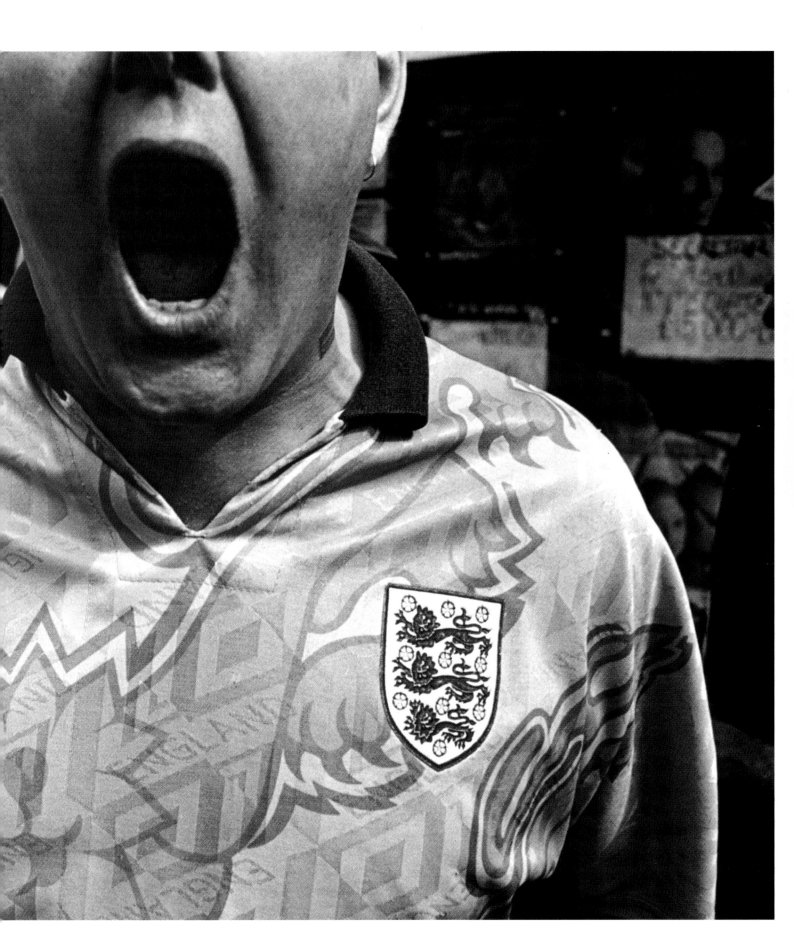

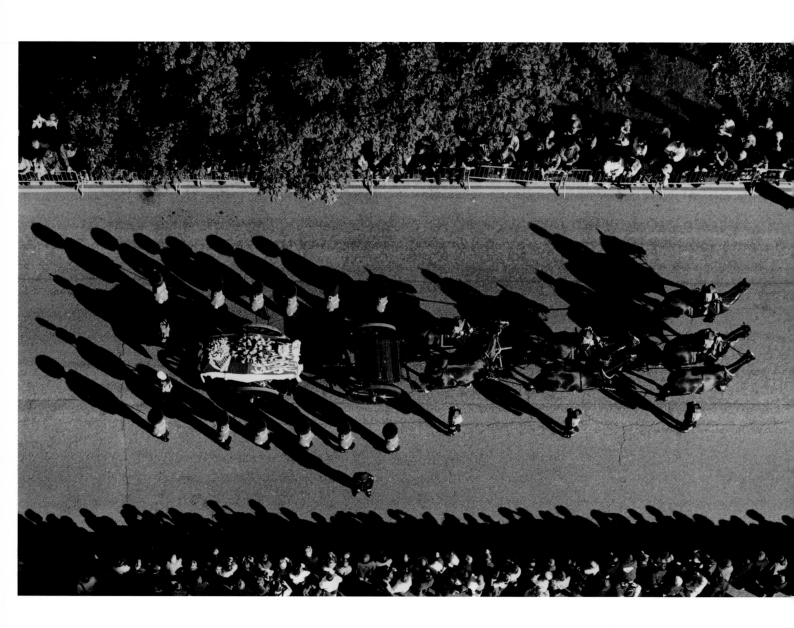

ABOVE: **This aerial shot of Princess Diana's funeral in 1997 puts this poignant moment of recent British history in some kind of universal, almost spiritual, context. Modell says that it was a lucky shot, but the best photojournalism nearly always is. The shadows emphasize the deep sense of loss.**

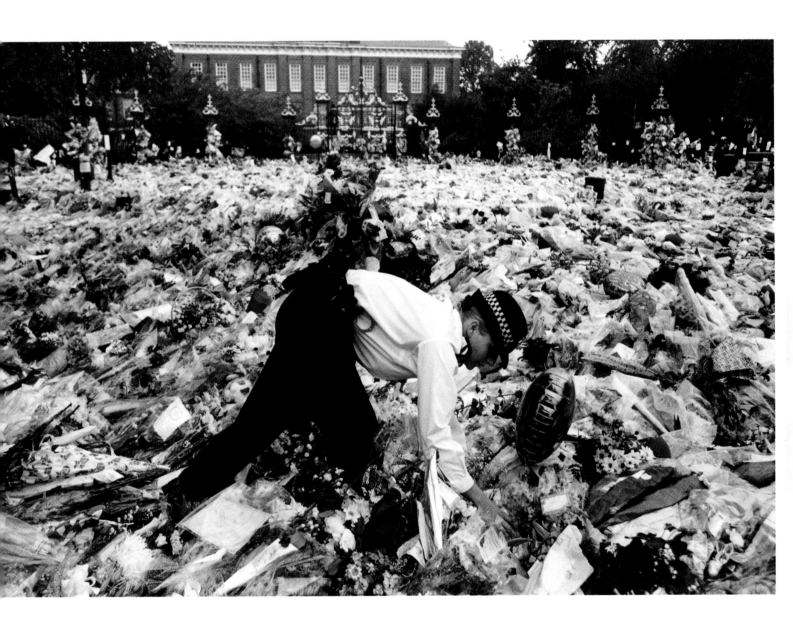

ABOVE: **A sea of flowers placed outside Kensington Palace, Princess Diana's residence, in central London. Her death led to an unprecedented outpouring of national grief. The fact that the policewoman looks a little like the late princess makes the photograph somewhat eerie.**

RALPH MORSE

The golden age of the space programme of the 1950s and 1960s was not just about exploring the "final frontier". It was also a major front in the Cold War against the Soviet Union. The editors at *Life* magazine sensed that the space race was a compelling story that had it all: science, politics, danger and human interest. They signed an exclusive contract with the astronauts and NASA in the late 1950s, just in time for the first manned space flight. Ralph Morse was an obvious candidate for the assignment. He had the right macho credentials, which he had earned during the Second World War. He was also fascinated by the mechanics of photography, with a scientific ability to adapt and experiment with cameras, lighting and shooting techniques. Morse also bonded easily with people and in time one of the team of the *Mercury Seven* dubbed Morse "the Eighth Astronaut".

Morse's brief was twofold. He had to convey to *Life* readers the magnitude and significance of space travel, yet his role was also to humanize the astronauts. They were the new breed of supermen carrying the hopes of America, but *Life* also rightly felt that they should be portrayed as regular guys — family men with children. As a result, Morse photographed them in their homes, bonding with their children, reading, eating and being doted on by their adoring wives, as well as seated at the controls of the rockets that would launch them on the ultimate voyage. His images of astronauts at home are prototypes for the celebrity spreads of *Hello!* magazine, and for readers in the 1950s they were just as addictive. Morse shows great skill in capturing these moments and since he was in effect living with the astronauts, the images never appear too posed. He was also highly adept at documenting space travel using such practices as multiple exposures, or firing off remote cameras under very difficult conditions with sometimes less than a second to get the shot. Over the years, he became known as the dean of space photography. No wonder one of his former managing editors said, "If *Life* magazine could afford only one photographer, it would have to be Ralph Morse."

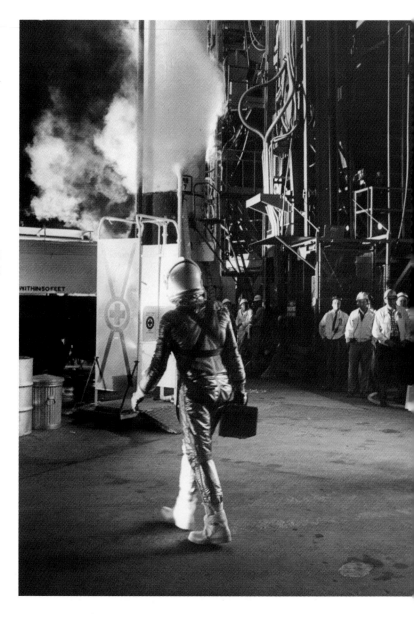

ABOVE: **This is the astronaut Alan Shephard in an air suit heading toward the capsule for the first manned space flight in 1961. It is photographed as if it is just another day at the office for the astronaut, as he carries his "briefcase". Morse was such a part of their lives that he was dubbed the "Eighth Astronaut".**

RIGHT: **The *Apollo* spaceship lifting off on its historic flight during which astronauts Edwin Aldrin and Neil Armstrong walked on the surface of the moon in 1969. It is not clear from where Morse took this photograph, but his contacts within NASA probably secured him the best vantage point.**

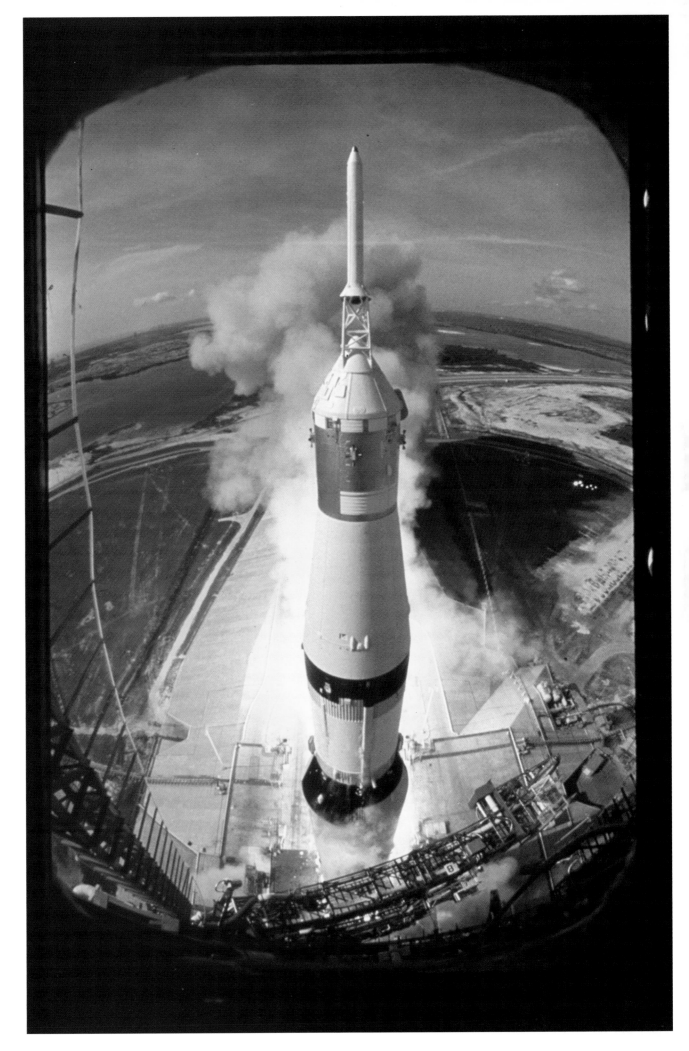

LEFT: A concrete air duct that acts as an escape route for astronauts, photographed in 1968. This was the sort of image beloved of *Life* readers who were intrigued by the marvel and mystery of space travel.

ABOVE: American astronaut Jim Lovell eating a turkey dinner with his wife and three children, Houston, 1965. It was important that the astronauts were seen as "regular guys" with families who just happened to have extraordinary talents — Morse was therefore given complete access to photograph them in their homes. The image is intimate, but also somewhat stiff.

CARL MYDANS

Carl Mydans is not as well known as two of the other original *Life* photographers, Margaret Bourke-White and Alfred Eisenstaedt, yet he had the charm of "Eisie" and the tenacity of Bourke-White, combined with a perfect hard news sensibility. Mydans was not an especially stylish photojournalist (he was a more talented portrait photographer), but he had a natural instinct for taking powerful images that would transport the viewer to the heart of the action. In 1948, for instance, he produced a dramatic and terrifying photo-essay on the Japanese earthquake in Fakui. The story of how Mydans got to be there in the first place reveals much about the forgiving and easygoing nature of the man. Despite his internment by the Japanese during the war, he bore them no ill will and, together with his wife, he jumped at the opportunity in 1946 to become *Life*'s bureau chief in Tokyo. He just happened to be the only journalist in Fakui when the tumultuous earthquake struck and he ran out into the street shooting pictures as buildings collapsed around him. These incredible images of devastation are perhaps the most powerful record ever of an unfolding earthquake. It is incredible to think that Mydans was able to compose a photograph and develop a narrative under such fraught circumstances. At the time of this earthquake, Americans were still ambivalent about the Japanese, but these images shifted attitudes, arousing sympathy and empathy toward the perceived enemy. In his book *More Than Meets the Eye*, an eloquent discussion of his profession that contains no photographs, he says, "All of us live in history, whether we are aware of it or not." Mydans was very aware of history, was an authoritative witness to it, understood it and recognized, without any pomposity, his own important role in recording what he called "the great flowing river of time and humanity." Since his death in 2004, his work is receiving renewed acclaim.

ABOVE: **In 1948 the manmade landscape was devastated by the Fakui earthquake. In the background of this image, the mountains are unchanged, suggesting the precarious nature of these people's existence. As well as the mountains, our eyes are drawn toward the cyclist who appears in the frame, as if he is guiding us through the chaos.**

RIGHT: **During the earthquake buildings crumble and break apart.**

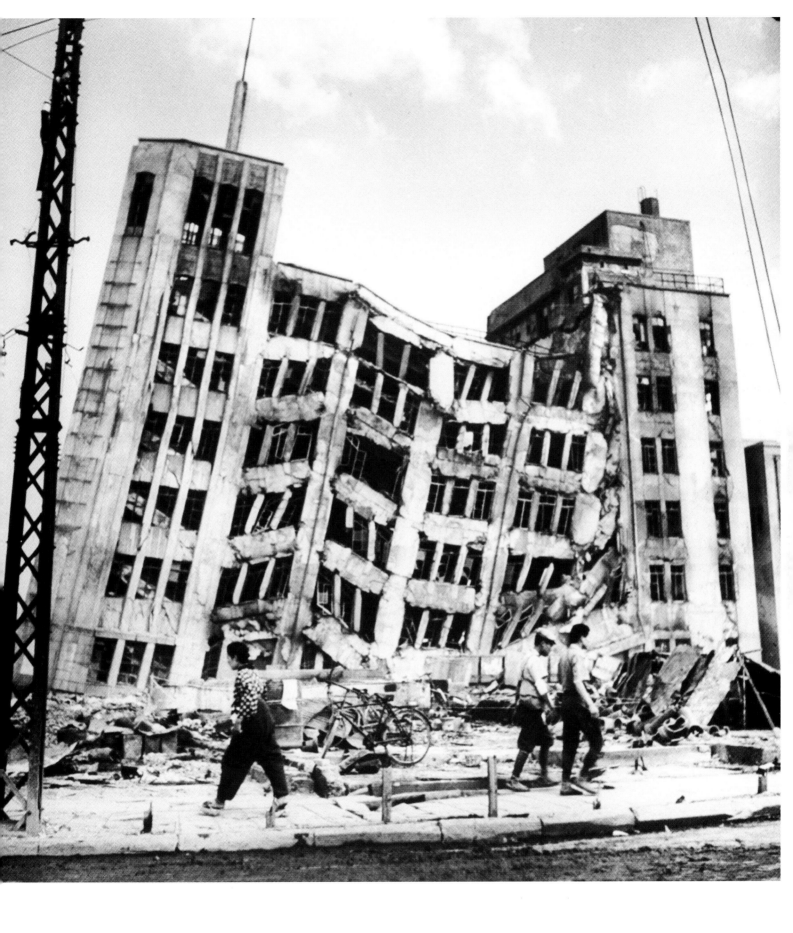

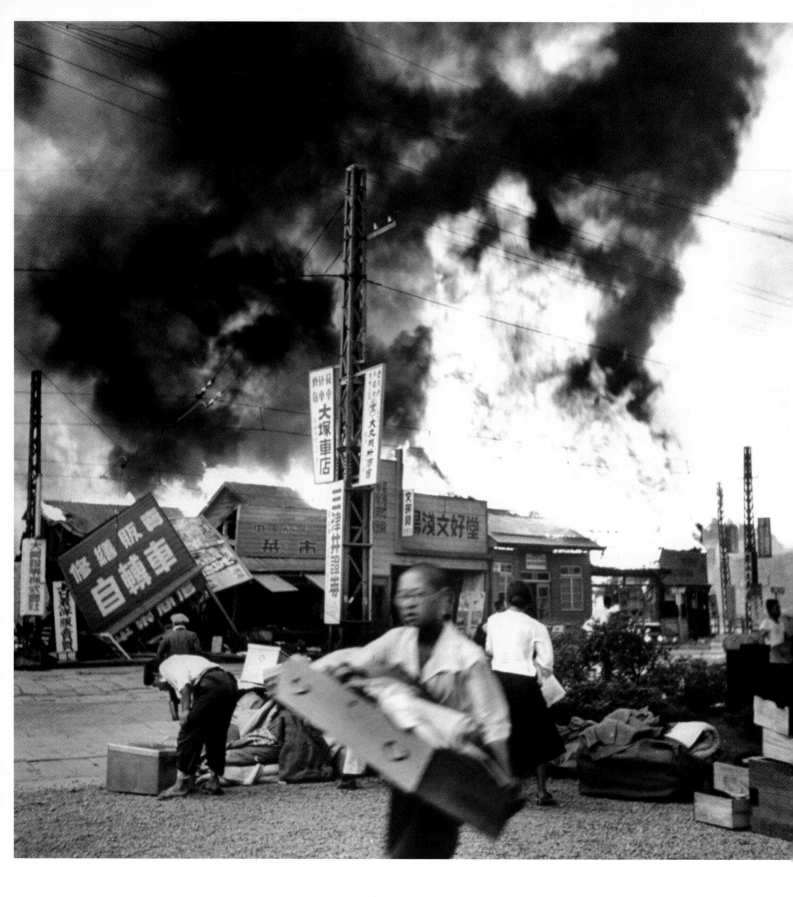

ABOVE: After the Fakui earthquake in 1948, Mydans captured scenes of ruin and devastation, as people fled burning buildings.

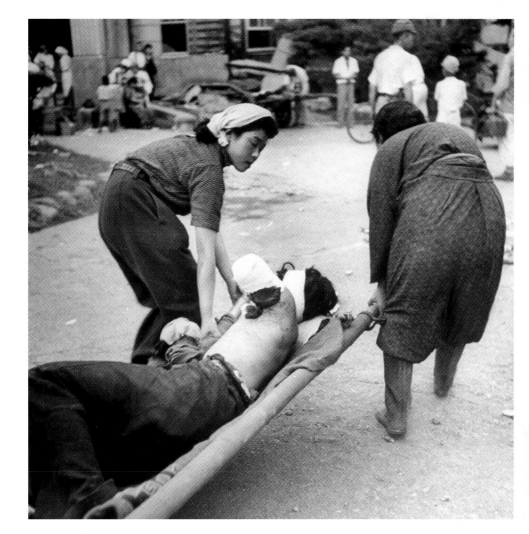

RIGHT: A wounded man, his body contorted with pain, is stretchered to safety during the Fakui earthquake.

RIGHT: American GIs were drafted in to administer first aid to victims of the Fakui earthquake. Everywhere you look in this photograph, there is ruin and suffering, with the ever-present smoke billowing in the distance, suggesting that this scene is just a small detail of a terrible whole. *Life* readers would have also appreciated the patriotic subtext, with the American GI a central, composed figure in the midst of the crisis.

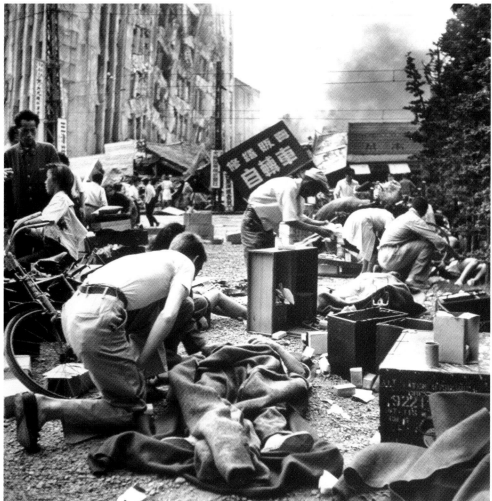

JAMES NACHTWEY

BELOW: Dazed survivors and a police officer walk through an apocalyptic landscape in lower Manhattan after the collapse of the World Trade Center Twin Towers on 11 September, 2001. The formal composition and ethereal beauty of the image are typical of Nachtwey's style.

Nachtwey is one of the most renowned and enigmatic of contemporary photojournalists. Inspired in the 1960s by images of the Vietnam War and civil rights movement, he trained himself to become a war photographer with near-religious zeal and single-mindedness. Among photographers, Nachtwey is very much a loner, and discipline, self-control and a deliberate style are his hallmarks. He seems to have a limitless capacity for fear, anger and grief – emotions that he says he channels back into his work. Nachtwey is known for getting physically closer to his subjects than other photojournalists, and has explained to various interviewers that he likes to work within the same space that his subjects inhabit, so that viewers can connect viscerally. His daring and risk-taking have nearly cost Nachtwey his life on several occasions – in 2003, for instance, he was badly wounded in Iraq by a grenade thrown into a vehicle in which he was riding. His personality and working style stir plenty of curiosity, but Nachtwey is an extremely private person who deflects questions about himself, insisting over and over again that he wants his audience to concern themselves with his subjects instead.

To draw attention to his subject matter, he shoots images that are formally composed and strikingly beautiful. His book *Inferno*, a collection of photographs he shot during the 1990s, features 480 pages of the most graphic, gruesome and beautifully photographed horrors of humanity. Not surprisingly, he has been criticized for creating objects of beauty out of other people's misery, but he counters that images need to be compelling to draw the attention and outrage that his subjects need and deserve. Nachtwey has also been criticized for giving short shrift to the context of the horrors he photographs, but he's less concerned with explaining situations than stirring an instinctive reaction. To accusations that he is a war junkie, Nachtwey admits an attraction, but if it were a mere addiction, he has asserted, he would have burnt out long ago. In recent years, he has taken to referring to himself as an "anti-war" photographer with a mission to sway public opinion and pressure politicians and policy-makers into redressing injustices.

OVERLEAF LEFT: A businessman stops amid dust and detritus to stare up at the burning World Trade Center Towers in Lower Manhattan after the terrorist attacks. Nachtwey's impeccable composition and the subject's pose convey the awe-inspiring magnitude of the horror.

OVERLEAF TOP RIGHT: Firemen and rescue workers stand in the wreckage of the World Trade Center Towers after their collapse. By framing the scene in a jagged, broken panel of an adjacent building, Nachtwey suggests the violence of the attacks that precipitated the disaster.

OVERLEAF BOTTOM RIGHT: A stairwell near the World Trade Center in Lower Manhattan is littered with paper and dust following the attacks. Nachtwey uses the light, debris, and the lone figure at the top of the left-hand staircase to portray a post-apocalyptic scene.

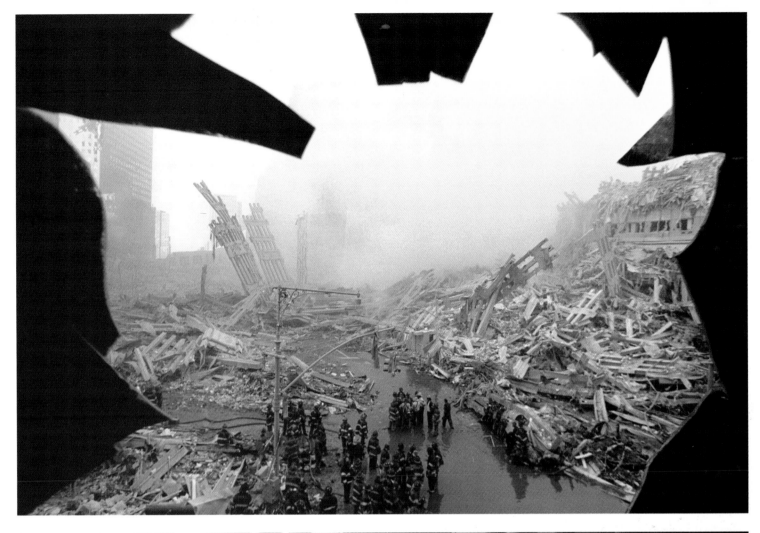

ZED NELSON

Zed Nelson is part of a select group of photographers who can seamlessly combine dynamic 35mm spot-news photojournalism, medium-format portraiture and social documentary. This straddling of genres was displayed to devastating effect in his seminal essay *Gun Nation*. The project, he says, was in many ways a spin-off of spending years working in war zones where violence is the natural law. Nelson himself came very close to becoming a victim while on assignment in Afghanistan, when his car came under fire, and his driver and a close friend were shot and badly injured. Weapons and guns were at the crux of this tragedy, and this revelation led to a career change when Nelson abandoned the path of war photography. "I decided to document America's example, of a nation that had accepted, embraced and even popularized gun ownership and where a nation is in denial of a problem that allows 30,000 people to be killed by gunfire every year," he says. Rather than photographing the usual stereotypical groups normally associated with guns – right-wing extremists or gang members – Nelson documents, in a matter-of-fact way, the normal citizens who see guns as part of their social landscape, in much the same way as baseball and apple pie. We see these law-abiding middle-class and (almost exclusively) white folks at gun shops and conventions, in living rooms, emergency rooms and school yards. It is the banality of it all that makes it so chilling. The project created such a stir in the USA that after a television interview on *Good Morning America* Nelson received death threats.

Since this essay, Nelson has continued looking for projects that, in his words, "investigate our own obsessions and weaknesses". Guns are one obsession; food is another. In *Obesity in the USA* Nelson photographs extremely overweight people at leisure with a satirical eye and in unforgiving colour. Hidden beneath the frivolity is the serious message that too much wrong food is as potent a killer as a gun. Zed Nelson is an astute social commentator. Whatever the project, he consistently emerges with original and thought-provoking images.

RIGHT AND BELOW: The line between celebrating and exploiting your subjects can be a thin one, but Nelson here manages to stay on the right side of respecting who he is photographing. These people at a Fat Convention in the USA are happy in their skin and therefore relishing the attention.

BELOW: A cowboy shows his gun to young admirers at Universal Studios, Hollywood, Los Angeles. Nelson shows how the cycle of gun worship can start in very conventional ways — this seemingly harmless sheriff with his friendly grin is perhaps a man to be avoided. Subtle and sinister.

RIGHT: "It's my constitutional right to own a gun and protect my family," says Mike, a father and gun owner. This photograph is really terrifying; the man's expression alone is reason enough to look away. It is also ironic that he is talking about protecting his family and yet pointing the gun in the direction of his child.

MARTIN PARR

BELOW: This photograph, along with those on the opposite page, are taken from Parr's essay on New Brighton, an English resort just outside Liverpool, 1984–85. Parr photographed with cheap amateur colour film to make everything look even more gaudy and tacky. Named *The Last Resort*, the essay depicts the resort as dirty, overcrowded, bleak and grim. This work is unforgiving, but also very funny.

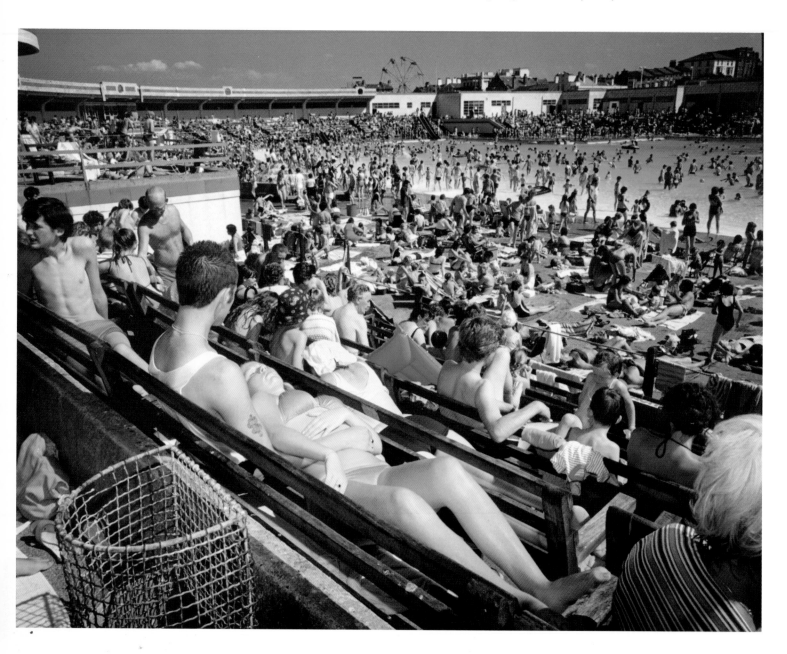

Photojournalism and documentary photography have always had a strong element of exploitation and voyeurism. Humanistic photojournalists led by Cartier-Bresson, however, have always rejected this charge of exploitation, saying that their images celebrate life. At the other end of the spectrum is the equally brilliant Martin Parr, who acknowledges that his photographs are unashamedly voyeuristic. Parr was a controversial choice to be admitted into the Magnum cooperative in the 1990s, yet ironically he is one of the most commercially successful photographers in Magnum's history. When he met Parr for the first time, Cartier-Bresson allegedly expressed his unease to the British photographer: "I have only one thing to say to you. You are from a completely different planet to me." Parr's reputation, or infamy, depending on your viewpoint, was established in the 1980s with his seminal essay on New Brighton, a seaside town just outside Liverpool. This

body of work, *The Last Resort*, is aptly named because in Parr's somewhat cruel and brutal view it is a grim place of pink and overweight people sunbathing next to rubbish and eating greasy food. Parr photographs in saturated and unforgiving colour and has a surreal sense of composition. His work was seen as unflinching to the point of reactionary; the photographer defended the work from his mainly middle-class critics, saying that their comments confirmed their bourgeois prejudices.

Since then, Parr, although still cynical, has become more humorous with the passing of time. He has dealt with such themes as the absurdity of global tourism, relentless mass consumerism and the homogenization of culture. Often he likes to get in very close, using a macro lens, in order to convey the horror of a particular tacky item of clothing or inedible food. Parr is relentless in his quest to document how we live, what we buy and how we look – a unique British talent.

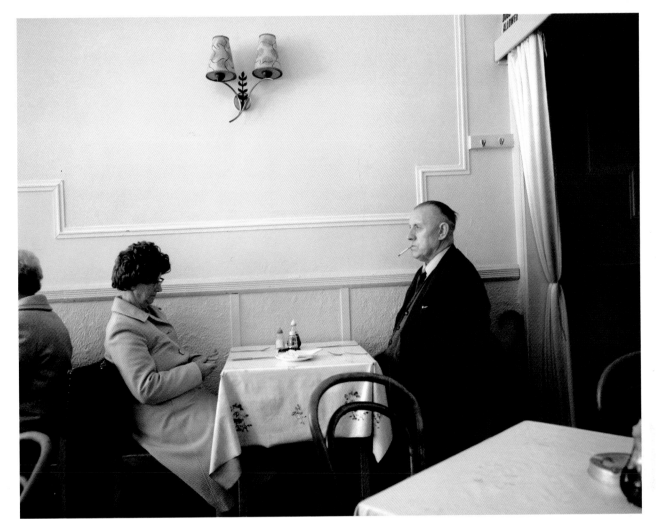

RIGHT: **This image could have been taken at any time in the past 50 years — the woman fiddling nervously with her hands and the man's pained expression say it all.**

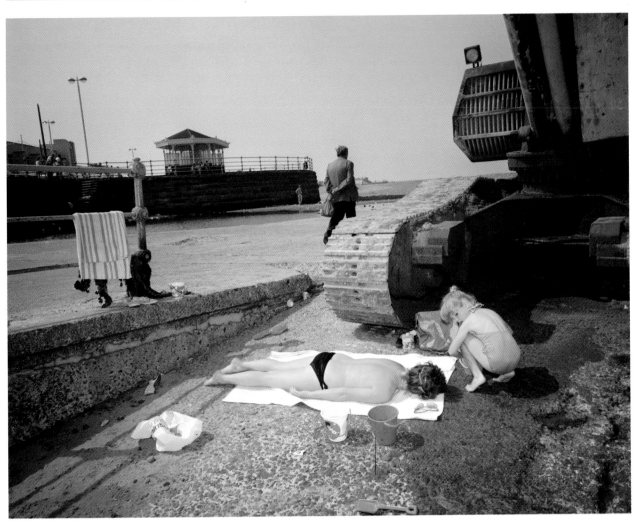

RIGHT: **A woman and her child sunbathe forlornly on concrete. Parr's surreal sense of composition and colour makes the bleak appear absurd.**

RIGHT: **In the summer of 1999, more than half a million people flocked to St Ives in Cornwall, England, to witness a total eclipse of the sun. Parr is more interested in the somewhat tacky human celebration and forced jollity than the cosmic phenomenon. Weather and its impact upon us is a recurring theme in Parr's work.**

JUDAH PASSOW

The Middle East, and in particular the Israeli-Palestinian conflict, has proved irresistible to many of the famous photojournalists featured in this book. For Judah Passow, however, the Middle East is not a tour of duty, but a life's work. It is an intricate religious, nationalist and ideological conflict with many shades of grey and it needs a photographer with Passow's integrity, dedication and intellect to try make sense of it all. "The conflict is complex and requires a nuanced reading of history and the abandoning of dogma to understand," he says. "My photographs reflect hopefully the lack of preconceived notions from which I approach both sides of the ideological divide."

Despite being Jewish and born in Israel, Passow – especially in his work in the West Bank and in Beirut (1982–85) – is clearly not portraying the Israeli occupation sympathetically. The Palestinians in these deceptively simple images are very much photographed as the victims. We see in these images the young, stripped of their youth, and the elderly, divested of their dignity, while the Israeli soldiers alternate between empathy, arrogance and confusion. Steven Mayes, formerly head of Network Photographers and secretary to the jury of the World Press Photo awards, says that Passow has

the ability to "produce clean graphic frames that combine metaphor and actuality". Mayes adds, "His signature black-and-white technique has cut-glass clarity and beauty with a sensual quality that seduces the viewer to engage with even the grimmest reality." Yet these images are far more than simply a journalistic record of conflict and turmoil. They are also quite intimate personal statements from Passow. As Passow himself says of his work, "It is an exploration across the battered emotional landscape of the neighbourhood I grew up in and keep returning to out of a sense of longing and belonging. The streets have names like Lebanon, Israel, West Bank and Gaza." Judah Passow is very much a photojournalist from the old school. He is not motivated by personal glory or the adrenaline rush of working in a war zone, but rather a quest for meaning.

RIGHT: **This photograph is from *Days of Rage*, and shows the abandoned headquarters of the PLO, West Beirut, in 1982. Arafat is now dead and the effectiveness of his legacy is still being determined. In the early 1980s, he was a dominant figurehead at his peak, and his presence was felt everywhere.**

ABOVE: Brooklyn, New York has a huge Muslim and Arab population. In this essay Passow was attempting to discover the impact of 9/11 on the community that immediately after the terrorist attacks was being singled out by angry Americans. This is a belly dancer during a break between sessions in an Arab nightclub in Brooklyn, 2001.

ABOVE: **Reflections of the USA in the window of a Muslim-owned shoe store in Bay Ridge, Brooklyn, New York, 2001. Passow is a photojournalist who favours quiet observation and uses symbolism to reach his viewer.**

GILLES PERESS

In a French-Canadian documentary about war photographers made in the late 1990s, a somewhat shell-shocked Gilles Peress says at one point that "photography is part of human memory". If that is the case, then Peress has enough bad memories to last several lifetimes. For the past 35 years, he has been faithfully documenting some of the darkest moments of the late twentieth century, what he himself has called the "curse of history". Peress was active in the student riots in Paris in the late 1960s and he comes from a generation of people who grew up mistrusting the media. This is something of a paradox for a photographer who is employed by newspapers and magazines, yet in the same film he says, "You cannot define yourself and your reality through your relationship to the press." One way he defines himself is by getting books of his work published. He was also one of the earliest photojournalists to explore the interactive storytelling potential of the Internet.

So what is his reality? He prefers to shoot with an open mind, rather than having a preconceived notion of what he should be photographing. He says that his primary goal on assignment is to photograph something so that he will have a better perception of what is actually going on. It is a voyage of self-enlightenment which the viewer is compelled to join. He has also said that it is difficult to maintain total objectivity while shooting, but it can be achieved at the editing stage. Technically Peress has everything. He can compose a photograph like Cartier-Bresson and can capture the essence of an unfolding scene in just one image with telling precision, often using visual metaphors and symbols. Yet he also has a perfect sense of drama and knows how to develop a haunting narrative from a series of pictures in the best traditions of W. Eugene Smith. He is also sensitive to what, and who, he is photographing and has the intellect to grasp the magnitude of his role. He is a worthy heir to some of the great Magnum photographers of the past.

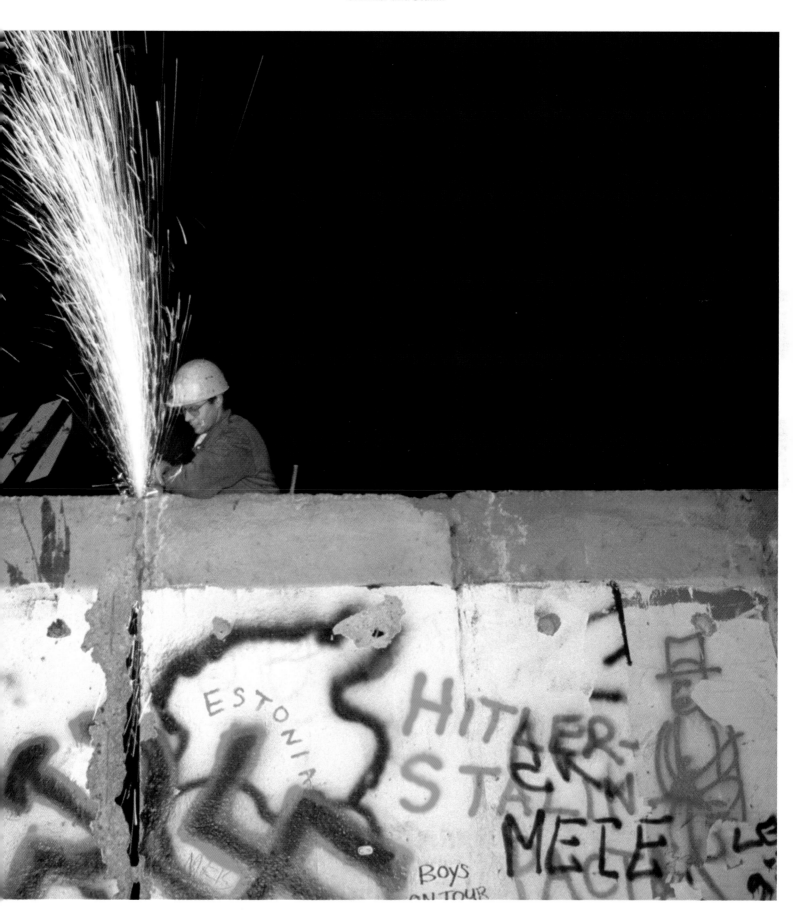

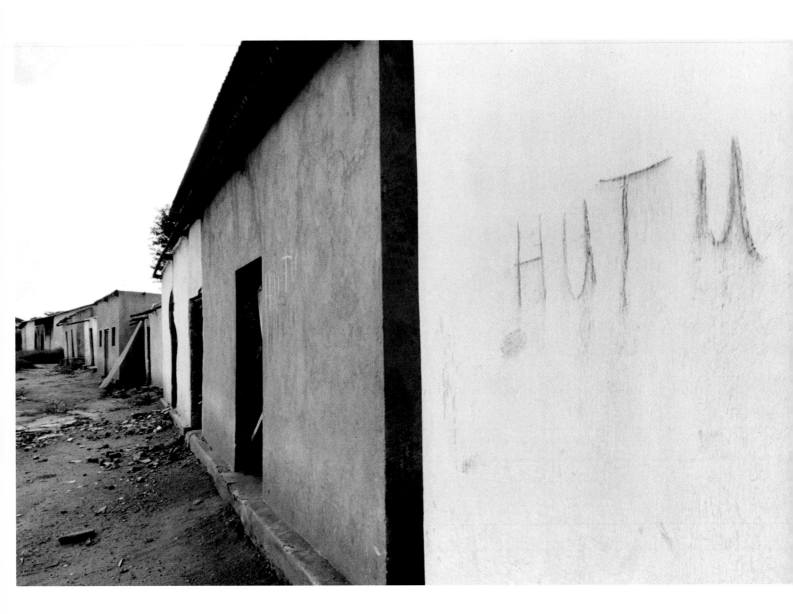

ABOVE: **Hutus living in this house in Rwanda in 1994 scrawled their ethnicity on the wall to prevent looting. The advance of the rebel Rwandan Patriotic Army caused the Hutus to flee in turn. The Western press portrayed the Rwandan tragedy as a typically disorganized and chaotic African conflict, but it was in fact a highly systematic and regimented genocide. Peress is a remarkably subtle photojournalist who thinks deeply about what he is photographing and what impact his images will have on the viewers. He has the ability to be direct without always being graphic.**

ABOVE: **A photo album found at a massacre site at Nyamata in Rwanda, 1994. Sometimes it is this kind of poignant image that has the power to get the viewer to really feel and question what they are seeing, as opposed to a photograph of a blood-strewn corpse. The stains on the photos are dramatic and emotional symbols. A classic Peress image.**

BELOW: **Mother Teresa being greeted during a visit to one of her missions in Shillom, Assam, India. This image is one of pure joy and manages to humanize the saint-like figure. Rai must have been sitting at the front of the car in order to get such a complete view. The boys' expressions are also a sight to behold.**

In December 1984, 27 tons of a deadly gas began to leak out of a Union Carbide plant in Bhopal, India. None of the six safety systems was working, resulting in 20,000 deaths, with more than 100,000 people still suffering from a variety of serious ailments. It was a "corporate crime" (the title of Rai's book) on an epic scale – the worst in history – and it is a crime that its perpetrators still refuse to acknowledge fully. The victims, however, do have India's greatest photojournalist, Raghu Rai, fighting their cause. He was there the morning after the tragedy photographing what he called "the silence of death." He shot the mass cremations, the overflowing hospitals, the grieving and the confused. He has also repeatedly returned to Bhopal over the past 20 years, photographing the slow death of thousands of people, while also documenting in steady and unrelenting black-and-white the survivors' struggle to lead normal, healthy and productive lives. He also shows the victims still fighting for justice and compensation from an essentially indifferent West.

One person who could never be accused of being indifferent to suffering in India is Mother Teresa who, like the tragedy at Bhopal, had a profound effect on Rai's personal and professional life. Mother Teresa granted Rai unlimited access to photograph her work with the Mission of Charity, an order devoted to helping Calcutta's poor and needy. The result is a powerful and moving portrait of both her spiritual commitment and a gruelling daily routine – being a saint is clearly hard work. Mother Teresa was initially reluctant to allow Rai into her inner sanctum, but his persistence, conviction and absolute respect for her work won her over. In the early stages of their relationship, however, there were some tricky moments. At one point Rai photographed three sisters at prayer. Mother Teresa saw this and thundered up to him asking, "What the hell on earth are you doing here?" Rai told her that they looked like angels and the moment was too good to miss. She relented and from that moment their relationship gelled, resulting in a remarkable essay.

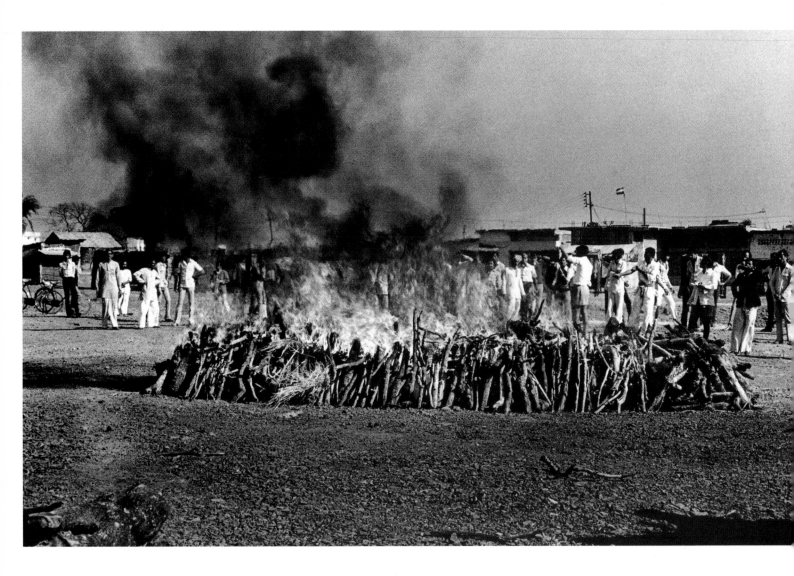

ABOVE: Rai has been documenting the Indian Bhopal disaster of 1984 for the past 20 years, from the morning after the disaster to the present; thousands of people still bear physical and emotional scars. Here we see the mass cremation of victims held alongside the communal graves.

RIGHT TOP: Dr Sathpathy is the forensic expert at the Hamida hospital. He has performed more than 20,000 autopsies so far. No relative of a gas victim can claim compensation for a death without his certificate. This powerful portrait was taken in 2002.

RIGHT BOTTOM: A family suffering from serious eye and lung damage after the Bhopal tragedy.

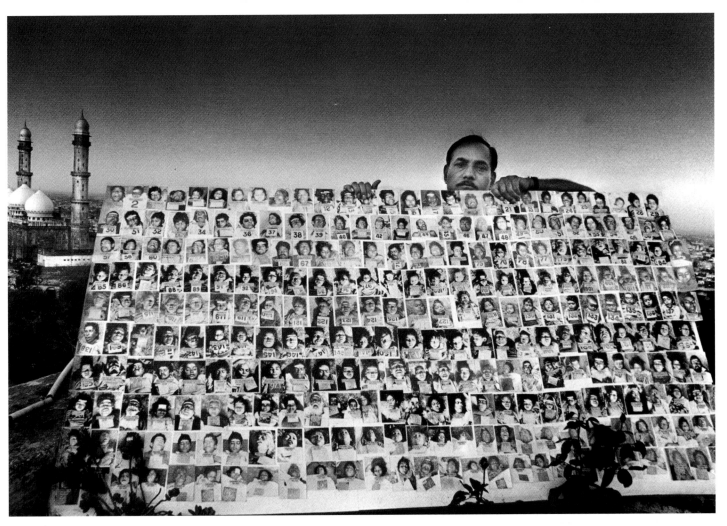

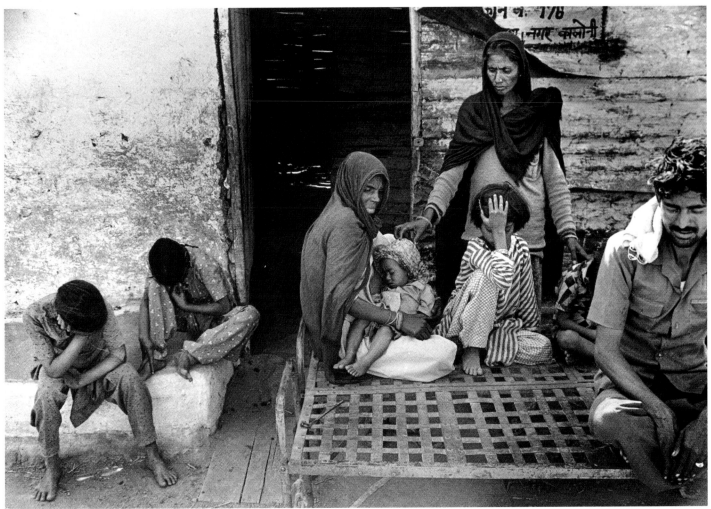

ELI REED

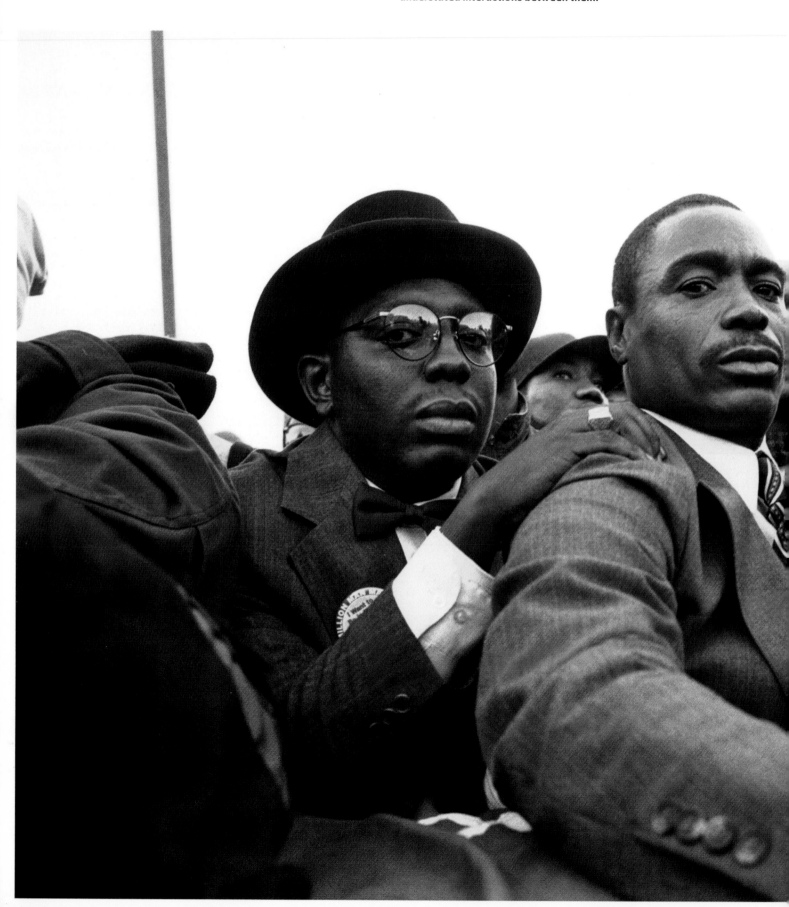

Eli Reed's defining work is *Black in America*, his 1997 collection of impressionistic images of the experience of African Americans from the 1970s onward. *"Black in America* is my favourite work because it is from the heart," he said in a television interview. "I just try to go in quietly and I try to see things from all the different angles." The book reflects the compassion, sensitivity and optimism apparent in all of his work, but his anger over lingering injustice is also present in a quiet way. Reed juxtaposes images of what he describes as "the beat of life" – a moment from a wedding, a father looking lovingly at his infant – with scenes from the Los Angeles riots, the Million Man March and other events. He has said that he is a painter at heart, drawn particularly to the Impressionists and their use of light and shadow to interpret everyday life. But he came of age in the tumultuous 1960s, and the work of Larry Burrows, W. Eugene Smith and others stirred his interest in photography. "It seemed like the guy with the camera knew what was going to happen next," he told one interviewer. Over the years, he has done in-depth stories on Central America, Haiti, Beirut, Africa and other locations. His work shows a keen eye for universal emotion in quotidian interaction, and Reed never objectifies his subjects. While others tend to depict Africans as victims in a wasteland of war, poverty and disease, for instance, Reed emphasizes their dignity and strength and focuses on how they go about life under abject conditions. "Africa is ignored in a lot of ways until a disaster happens, but there is other life in Africa," he said in a magazine interview. That isn't to say that Reed romanticizes his subjects, though. For a project on refugees called *The Lost Boys of Sudan*, he followed his subjects to the USA, where he saw past the trappings of their new middle-class lives to capture their lingering trauma and loss. "If you don't fear the unknown," he told an interviewer, "you can go a lot of places you can't imagine. And that's what I've tried to do all my life."

ABOVE: **Attendees of the Million Man March embrace on the steps of the Capitol Building. The tension of this image arises from the contrast between the emotional reserve and restraint of the man on the left and the warmth and intimacy exhibited by the man on the right.**

RIGHT: **The focal point of this image from the Million Man March — a raised fist against a placard reading "America" — harks back to the Black Power movement of the 1960s, although the defiance and anger that characterized that movement are less evident in the faces here.**

EUGENE RICHARDS

BELOW: **In North Philadelphia, Pennsylvania, two men, one with a needle still in his leg, died moments after shooting too-pure cocaine. This photograph, taken in 1989, might look like an episode from *Law and Order*, but it is a vivid record of the painful reality of two pointless and public deaths.**

The legendary photojournalist Don McCullin is not known for being especially effusive, but in the twentieth anniversary issue of *Photo District News* magazine, he said of Eugene Richards, "He brings tremendous pain into his vision, and he makes you very aware of what you are looking at At the moment, he's possibly the best walking, living photographer in the world." Richards's sense of outrage at the injustices of the world was partly shaped by the previous generation of photojournalists, typified by people such as McCullin. Richards is very much carrying on their tradition, but for him the front-line is not to be found in a foreign conflict, but within the USA itself. He prefers to turn his camera on the pain and suffering brought about by poverty, drug addiction, bad housing and education. He tells stories about the blight of the inner cities where the so-called American Dream is barely alive.

Richards is a straightforward man who appears to be free of any artistic pretension or ego. His mission is simply to tell it like it is and if it is going to take him a few years to get to the core of the subject, he is prepared to dedicate time to his work. He spent four years on his epic project on the impact of crack-cocaine and heroin within sections of the African-American and Hispanic communities. He photographed in seriously deprived areas, mainly Brooklyn, New York, which had been ravaged by the drugs and inevitably their side effects of violence, death, prostitution and AIDS. Richards quietly, but with compassion and a non-judgemental eye, photographs it all. His subjects allow him to focus very closely, trusting him to tell their story, to tell the truth. This is clearly collaboration, and yet when the book came out, certain curators and magazine editors deemed Richards's work racist and exploitative. His critics said that a white photographer had no right to be there and even less right to present a one-dimensional and negative view of black and Hispanic society. Indeed, very few photographers came to Richards's defence, but the few that did were mainly African-American. They pointed out, as is obvious, that Eugene Richards is a photographer with a rare insight and integrity.

RIGHT: **In an example of Richards's ability to quietly observe and record, a mother of one child, now pregnant with twins, smokes crack in Red Hook Houses, Brooklyn, New York, 1988. The woman has a blissful look on her face as she takes a hit, but it is momentary. The future is bleak for her and her unborn twins.**

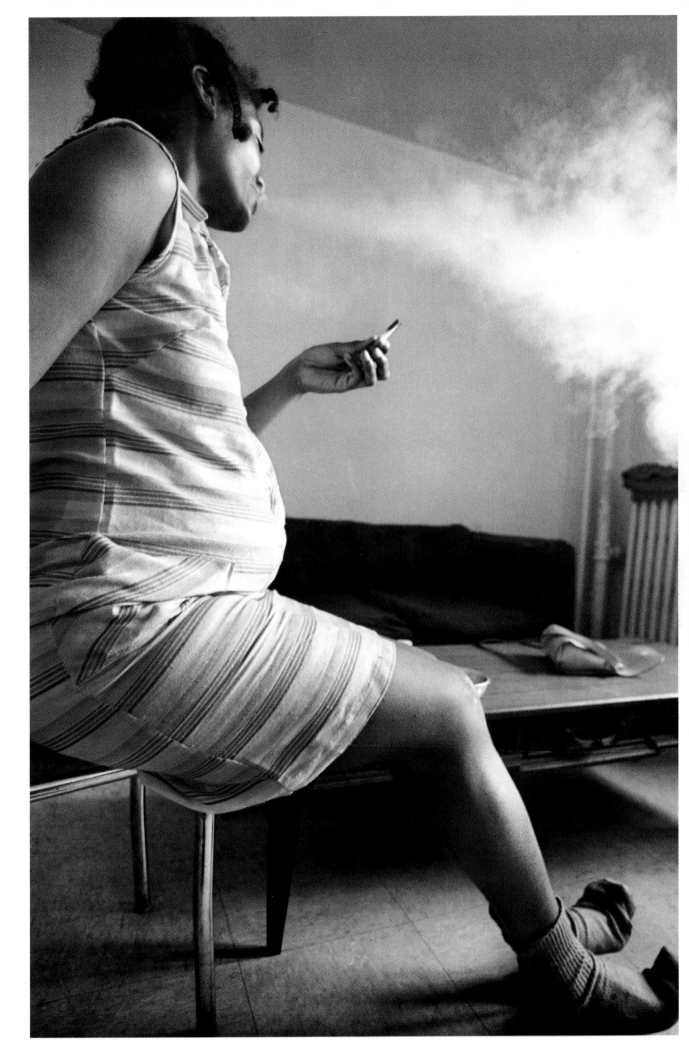

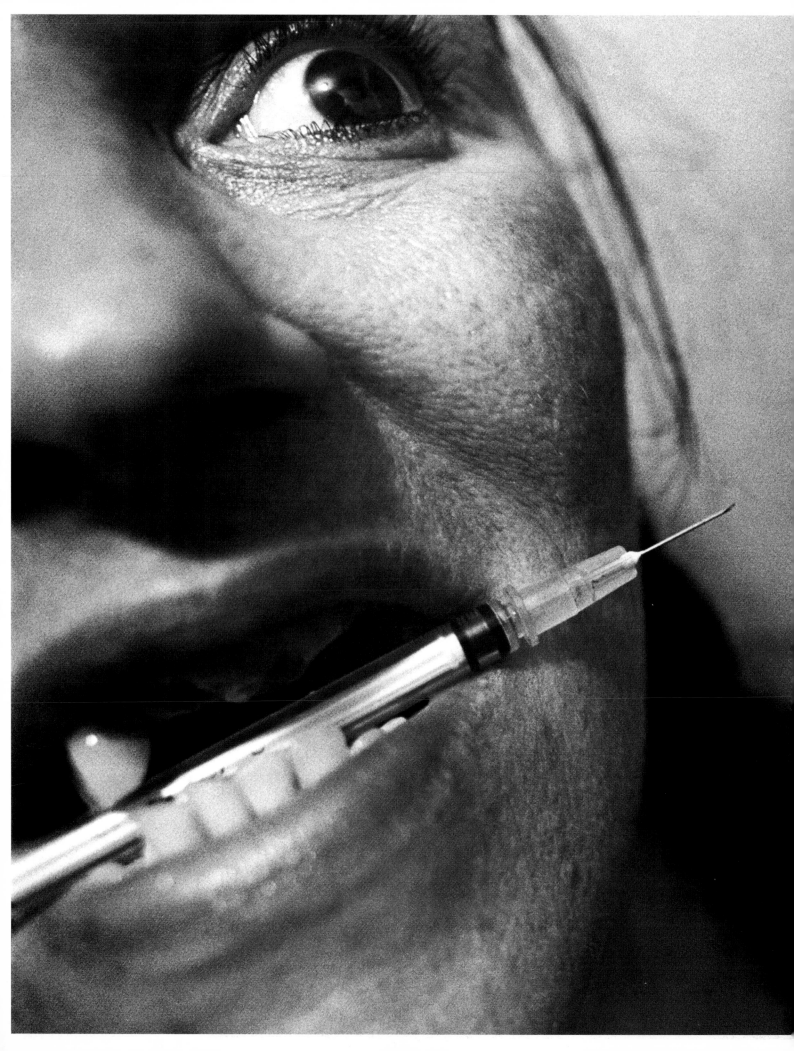

LEFT: This shot, which shows "Mariella" just before shooting up cocaine in Brooklyn, New York, was used for the cover of Richards's seminal book *Cocaine True Cocaine Blue*. It is one of the most forceful photos ever taken of someone in the grip of an addiction.

HENRYK ROSS

BELOW: **Children of the ghetto playing as ghetto policemen. The Lodz ghetto was self-administering to a degree, with its own security force. The chubby child at the end of the line features in a significant number of Ross's pictures and may perhaps have been the son of a policeman himself, for he seems to wear an authentic cap and brassard. The picture is dated 22 October 1943, more than a year after the majority of ghetto children were deported.**

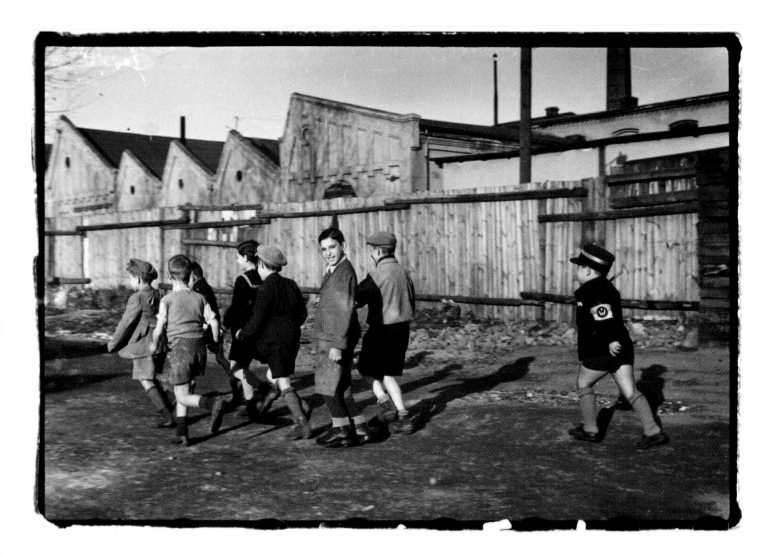

Henryk Ross was a witness to one of the worst episodes in history, in Aushchwitz and before that the Lodz ghetto. The ghetto served as a forced labour camp and as a prison for Jews in transit toward the Final Solution, their destinies sealed by a trip to the gas lorries of Chelmno or the sham showers of Auschwitz. Ross had been trained as a photojournalist, and this may have helped him turn his camera into a tool in the desperate task of recording a truth that the German state wished to obliterate. Yet he was the "official" photographer in Lodz, a role assigned him by a Jewish body, the Department of Statistics, that kept records for its German overlords. The ghetto was run by the notorious Chaim Rumkowski, who believed that by conforming to German requirements he could save the majority of its denizens. Ross and Mendel Grossman, the other "official" ghetto photographer, took thousands of images of living conditions in the ghetto. Of the 170,000 people in the ghetto, 95 per cent died, either in Lodz or in the concentration camps, and Ross himself survived only because he was one of those whom the Germans kept back to clean up the ghetto after they had removed its last remaining occupants to Auschwitz in August 1944. Ross photographed the worst and the best of the ghetto: starvation on the one hand, but also the celebrations of those who managed to find enough

to eat; executions and deportations, but also embracing couples and smiling children. The Ross archive offers a complex picture of a complex tragedy, much of it kept out of public view until after Ross's death, perhaps for fear that it told too difficult a tale, particularly about those who managed to create a quasi-normal existence under German oppression as opposed to those who were starved, beaten, executed or deported. A brave and committed photojournalist who was part of this terrible story.

RIGHT TOP: **One of the ghetto's garment factories, with feathers being attached to hats, photographed by Ross in a style that would not have been out of place in a fashion magazine of the 1930s.**

RIGHT BOTTOM: **Captioned by Ross *Ghetto life*, this picture shows a ghetto policeman, his wife and his child. Although the 35mm negative is badly damaged, the gentle charm of the image has not been lost.**

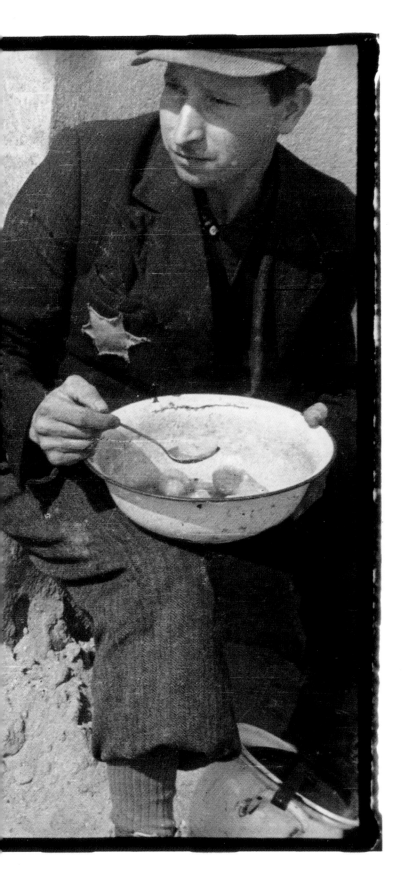

ABOVE: Shortage of food and its effects is one of the most poignant aspects of Ross's photographs of the Lodz ghetto, where the poorest inhabitants were literally starved to death. This man has fallen in the street from hunger.

LEFT: Ross captioned this photograph *Lunch break — Soup for Lunch* and it is part of a series that focuses on the distribution of soup from a public kitchen to the poorest members of the ghetto, those able to survive only through what was handed out to them by the community.

SEBASTIAO SALGADO

Sebastião Salgado does not do small projects. He produces only epic masterpieces, which take years to shoot and are huge in scope and ambition. His first great body of work was *Workers*, which is both a homage to and critique of manual labour. Salgado went to the mines, the oil wells, the factories, the fisheries, the car plants and the fields, photographing men and women as they toiled and sweated. In these stunningly composed prints, which veer from sweeping panoramas to more detailed studies, we see human experience on both the smallest and grandest of scales. Salgado is a passionate photographer who has a clear ideological affinity with his subjects, yet he has the intelligence not to allow this sympathy to cloud his vision. Perhaps it is the economist in him, but his photographs remain detached and objective. Salgado has in the past been condemned for beautifying his subject matter and some people have found his images just too crisp and perfect. He is, rightly, not concerned with these quibbles, arguing that he just wants to engage as many people as he can and why not do that with a beautiful photograph?

He describes *Migrations* as the second chapter to *Workers*. This, too, has a socio-economic viewpoint, but here Salgado looks at "Humanity in Transition" (the subtitle of the book). He photographs desperate migrants leaving rural areas to look for work, as well as displaced people and refugees. This huge and complex body of work involved Salgado criss-crossing the globe trying to make sense of an issue that is permanently in a state of flux. Perhaps the most memorable section of this project is "Megacities", for which Salgado travelled to the urban centres of Brazil, Mexico, India, China and Indonesia. Here he photographed the chronic overcrowding, poor sanitation, pollution and sheer mass of people that characterize these sprawling cities. Salgado has now had a change of direction and is working on what he says will be his last project, *Genesis*, photographing the parts of the earth and the wildlife that have been untainted by man. We can't wait to see the results from this master photographer.

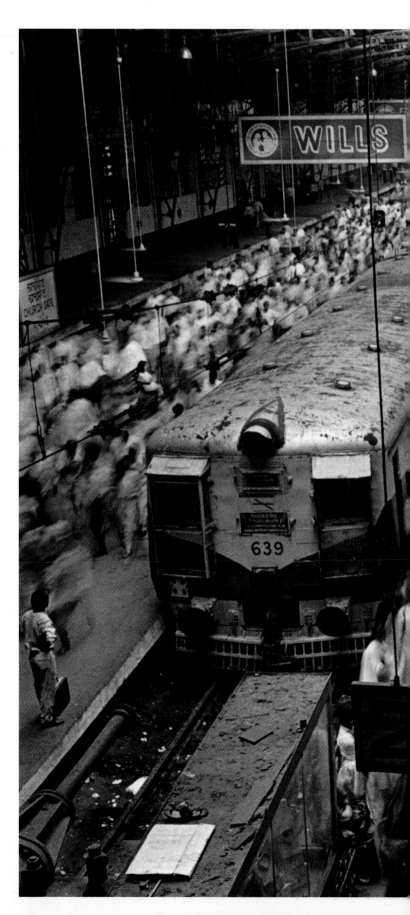

RIGHT: **This image of the Church Gate railway station, Bombay, taken in 1995, is from Salgado's essay "Megacities", just one chapter in his epic project *Migrations*. In one remarkable image, Salgado has managed to capture the density of human traffic that passes through the station; around 2.7 million people flow through every day. Salgado used blur to intensify the experience and the effect also dehumanizes the individualism of the commuters, turning them into one struggling mass.**

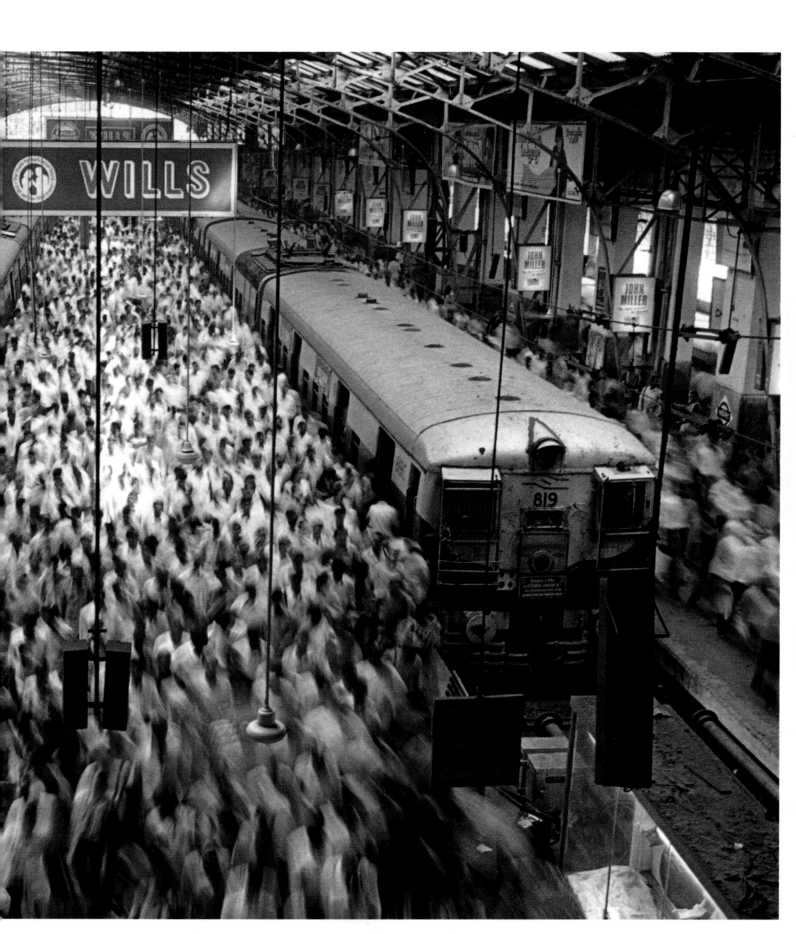

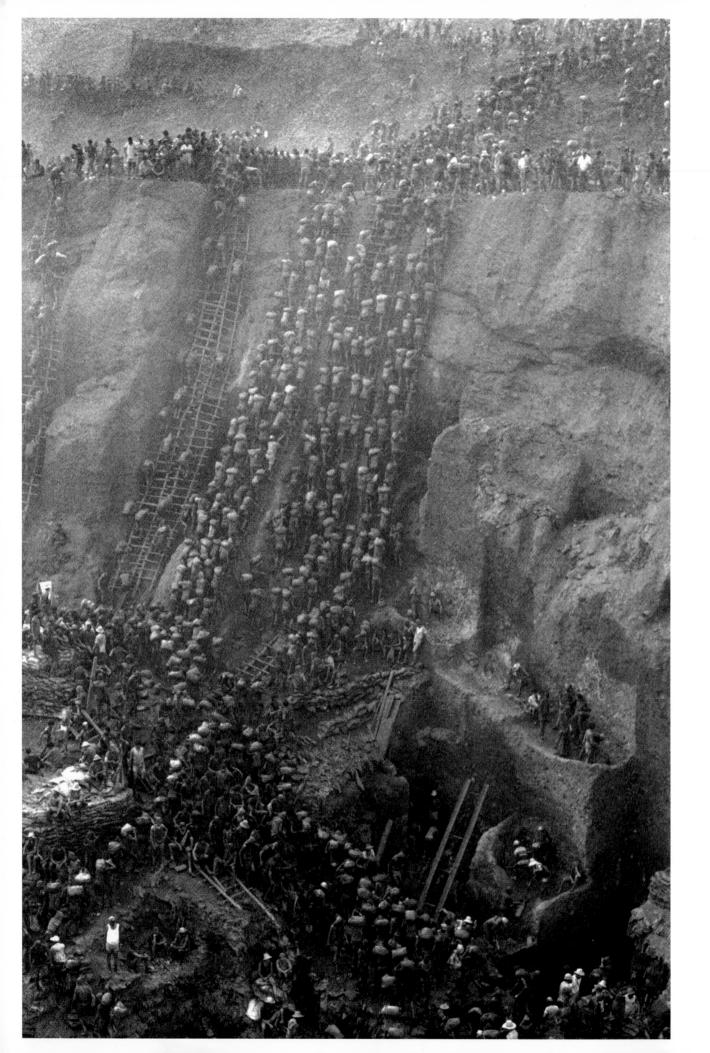

LEFT AND ABOVE: **Every day 50,000** *garimpeiros* **(gold diggers) descend Sierra Pelada's open-top mine in Brazil. The gold diggers are called mud hogs, as they wade in the dirt and slime. These two images from 1980 are part of Salgado's seminal epic project** *Workers,* **a documentation of manual labour throughout the world. The religious symbolism jumps out of these majestic photos. The image on the left could be a photographic record of Dante's** *Inferno,* **while in the photograph above, the man leaning against the wooden stake has a saint-like presence amid the dirt and the sweat. Photography has never been so powerful.**

W. EUGENE SMITH

W. Eugene Smith did not invent the photo essay, but he revolutionized both its aesthetic and the role of the photographer in relation to it. Until Smith, photo essays were just stories, and the photographer was merely the objective commentator. Smith had loftier ideas. He believed that he was there not just to document, but also to interpret and offer moral judgement on what he was photographing. Smith's relationship with his subject becomes the story and through that dynamic photojournalism redefines itself and becomes art. For the true artist to realize their vision, therefore, they must have absolute mastery over every stage of the artistic process.

These are lofty ideals, but Smith was operating in a commercial environment and being assigned stories by photographic editors with budgets and deadlines. The dogmatic photographer, however, fought them every inch of the way. He felt that it was his job to come up with the stories, and to shoot as many pictures as he wanted in the format of his choice, time and money being no object. Moreover, only he would see the contact sheets, edit the work, write the captions, allocate the pages to his story and have absolute control over the layout. His essay on Pittsburgh virtually destroyed him both personally (Smith was a heavy drinker and highly strung) and professionally, and almost sank Magnum. He had been assigned to spend a couple of weeks in the city shooting about 100 photos. Instead, he spent five months there taking over 13,000 images and then spent a further 18 months printing them. For his most famous essay, *The Country Doctor*, he also went AWOL and fell out with *Life* after it ran the story to his inevitable dissatisfaction. Yet in this case the ends certainly justified the (increasingly difficult) means. Through his dramatic composition and lighting, we learn not just what the doctor does, but what he represents and in turn something about Smith himself. This is a masterpiece of story-telling and was a blueprint for a new kind of photo essay. It is an exaggerated, often a staged, reality, but it is absolutely enthralling nonetheless. Smith was truly a genius who redefined his craft.

RIGHT: **Dr Ernest C. Ceriani, a country doctor, going to visit his patients in their remote villages around rural Colorado in 1948. Smith shadowed the doctor for weeks, learning everything he could about the man and his routine. In Smith's essay he becomes an understated but true American hero, selflessly devoting himself to the community. He is also highly photogenic, which helped Smith get his point across. Note how he is perfectly framed in the middle of the image, while the brooding sky gives him even more gravitas.**

RIGHT: This is a second view of the incident shown above. Here Smith has gone for the tight crop and we see the doctor calm and composed. It is actually quite a graphic photograph, but there is something oddly stilted about the image, as if it is from a movie. Smith was known to construct his photos occasionally, and although there is a genuine injury, you do wonder why the doctor seems to be posing at such a moment.

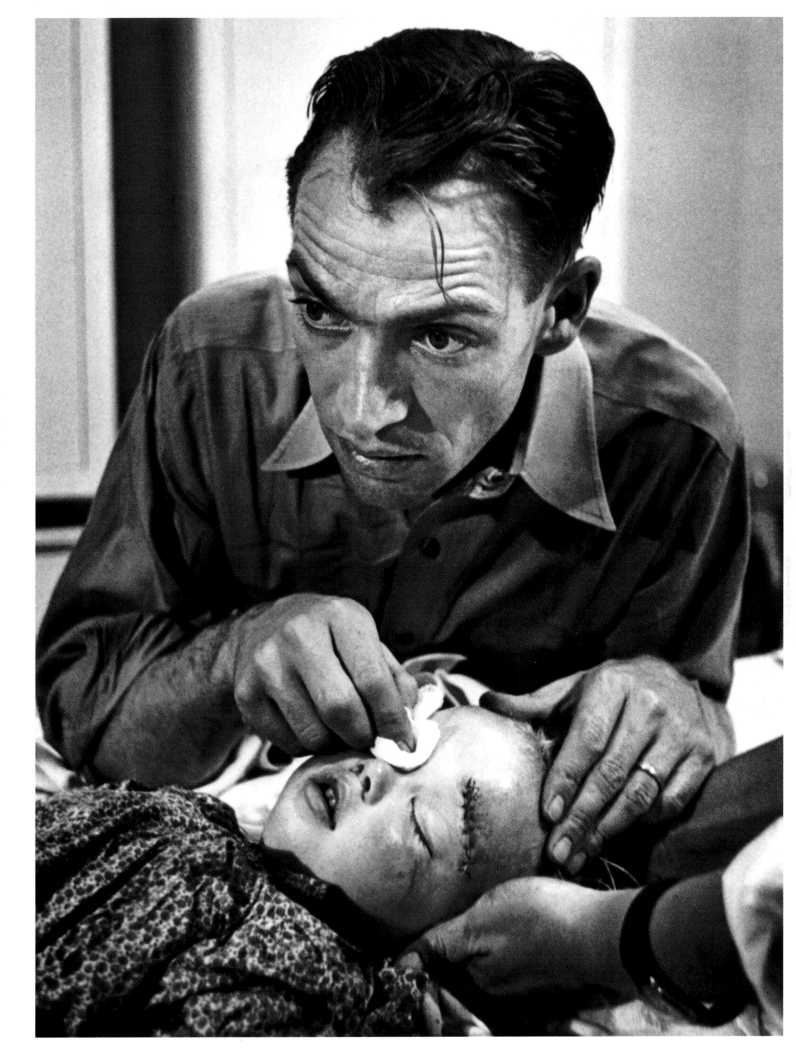

JOHN STANMEYER

BELOW: A Sri Lankan woman salvages a few possessions from her tsunami-destroyed house in the city of Batticaloa. On the surface, this image is straightforward and simple, but it gives viewers a sense of the power of the tsunami, and personalizes the devastating losses.

One of the first photographers to arrive in Sri Lanka after the tsunami on 26 December, 2004, John Stanmeyer conveyed a sense of the disaster's magnitude with a dramatic series of images shot for *Time* magazine. His take interspersed aerial images of widespread destruction with close-ups of the human toll: a water-scoured cemetery where a drowning victim had come to rest atop a tomb, residents of a decimated village scrounging for scraps to build shelters, mass burials ... "No matter how difficult a situation is, you know John will get where he has to go and get what you need," says photo editor Robert Stevens of *Time* magazine. "His tsunami pictures were amazing." Stanmeyer is not so easily satisfied. "I feel I've only touched the surface," he said shortly after the disaster. "It's beyond words and visually what I can see framed in my cameras. I am simply too small." Stanmeyer, who doesn't let stories go easily, plans to spend at least a year documenting the tsunami recovery efforts.

He has spent the past seven years documenting the growing AIDS crisis in Asia, and exploring stories about the children of Asian sex workers and the state of mental health care in the region. "I am fascinated by the [Asian] people, the history, the culture, the music, the literature, the progress and the lack thereof, the movements forward and the movements backward," he explains. Stanmeyer says that his parents encouraged his interest in photography from a young age, but his journey into photojournalism was an unlikely one. "I didn't have any solid enlightenment whatsoever in photojournalism. I was mostly inspired by the work of Helmut Newton, Arthur Elgort, Peter Lindbergh, Albert Watson and Nadar," he says. After art school, where he failed all three photojournalism courses that he took, Stanmeyer gained immediate success as a fashion photographer. But he soon grew disillusioned, and lost interest. "I woke up and realized the greatest power of all: reality photography."

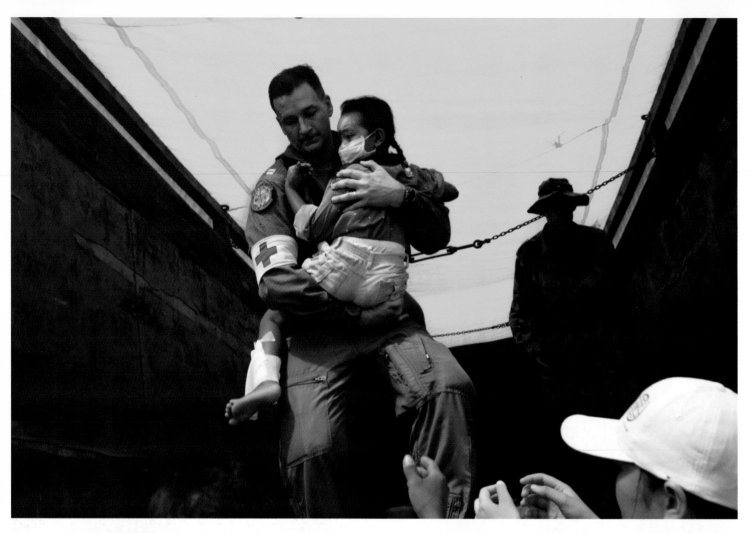

LEFT TOP: **US troops evacuate injured children from Banda Aceh after a giant tsunami struck the Indonesian province on 26 December, 2004. This image symbolizes the fragility and innocence of survivors, particularly the youngest.**

LEFT BOTTOM: **This photograph shows the sheer scale and devastation of the tsunami and its impact on both the people and the landscape. Here we see the crumpled wreckage of a passenger train after the tsunami hit Galle in southern Sri Lanka, littering bodies everywhere.**

On the home page of Tom Stoddart's website, he quotes from one of the greatest and most controversial figures in the history of photojournalism, the American Civil War photographer Matthew Brady: "A spirit in my feet said 'go' and I went." Stoddart has certainly followed in his mentor's footsteps. He is a relentless, multi-prizewinning and much travelled photojournalist who says that the "real prize has been the privilege of witnessing history unfolding in front of my cameras". A modest, softly spoken man from the north of England, Stoddart is not only an extremely sensitive photographer, but also a very brave one, who was shot in the leg while working in the besieged city of Sarajevo. His most famous photographs are often of women and their children, caught in the middle of a conflict or a natural disaster, trying to not only survive, but to get on with their lives with stoicism and dignity.

Stoddart is one of the old school of photojournalists, who prefers to spend time, often years, with his subjects, living side by side with them. This intimacy is reflected in his images, which get up so close, both physically and mentally, that you get the sense that Stoddart is there for his subjects, speaking for them and letting the world know of their plight. Yet he doesn't just photograph victims, and some of his most powerful work is from the last Gulf War when Stoddart was embedded with the Royal Marines. Whatever the subject matter, the images always resonate, since he is such a technically accomplished photographer. Working almost exclusively in black-and-white, it seems that Stoddart always manages to produce an image that is akin to fine art photography, no matter how terrible the circumstances. In fact, he once said that he is often in something of a moral quandary while on assignment. People might be suffering and there he is, in the centre of all the chaos, looking through the viewfinder and trying to get his composition just right. Yet at the same time, he is professional enough to know that if he didn't worry about the look of an image, he wouldn't be doing his job.

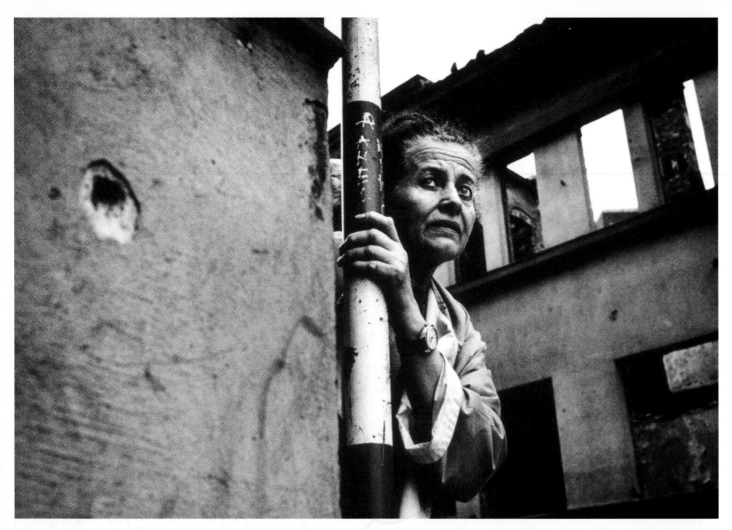
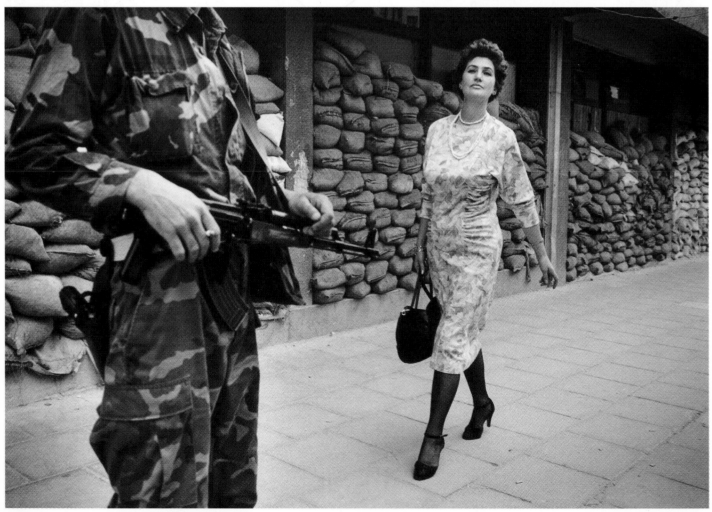

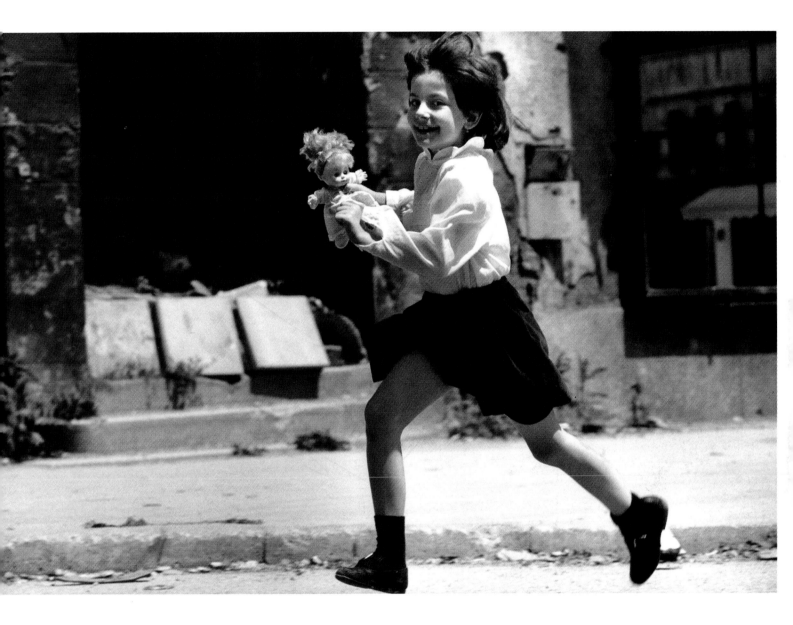

LEFT AND ABOVE: Three images from the notorious "sniper alley" in Sarajevo, Bosnia. Stoddart, no matter, how dangerous the situation, has the ability to compose his images calmly and make them resonate with the viewer. In the photograph top left, the woman is trying to summon the courage to venture out as the Serbs shoot people indiscriminately. The wall, the woman and the burnt-out building in the background are all working in tandem. In the photograph bottom left, Meliha Vareshanovic walks proudly and defiantly to work in a gesture of defiance towards the seen and unseen tormentors responsible for the terrible plight of her city. The photograph above is one of the most famous images from this whole period. It is the ultimate photograph of an innocent caught in the crossfire, and the fact that the girl has the inclination to grin at the camera while running for her life makes her adorable.

WEEGEE

Weegee was originally named Arthur Fellig. His pseudonym, adopted by him in around 1938, comes from the Ouija board. The girls at Acme Photos gave him the name because he always seemed to know where to find the best stories. Although he is best known for his striking crime pictures, Weegee's photography seems now to be much more about character and caricature than it is about murder, robbery and mayhem. Arthur Fellig began his photographic career as a portraitist. He worked for small studios in New York, and even, from around 1915–17, as a street photographer on the Lower East Side, taking pictures of children with a 5 in x 7 in (12 cm x 18 cm) camera and a pony called Hypo. A relentless, brash and hyperbolic self-publicist, self-titled "Weegee the world's most famous photographer", he was also consumed by an overwhelming obsession with his work. This is borne out by the car he used as a crime reporter, which was equipped with every requirement for his photographic work on the streets of the "Naked City", including a police radio, cigars, salami and a change of clothes. "I was no longer glued to the Teletype machine at police headquarters. I had my wings. I no longer had to wait for crime to come to me; I could go after it. The police radio was my lifeline. My camera ... my life and my love ... was my Aladdin's lamp" (*Weegee by Weegee*, 1961).

Weegee's pictures exerted a great influence on several photographers of the "New York School", particularly William Klein, Helen Levitt and Lisette Model, and this may have been because they eschew style in favour of content, a sort of visual truth that requires no cultural wrapping. Iconoclastic and self-taught, Weegee learnt his craft in a hard commercial environment where if his picture could hit the editor's desk before anybody else's he got the credit and the fee. Yet the truth and power of his images were quickly recognized as having a value beyond their ephemeral use in the tabloids. A few were acquired by the Museum of Modern Art in 1943, and his reputation was assured for ever after.

RIGHT: **Gunman Anthony Esposito, accused of the murder of a businessman and a policeman in the "Battle of Fifth Avenue", is captured in the line-up room in police headquarters, New York, 1941. The harsh lighting of Weegee's picture, created by the direct flash on his camera, both delineates and caricatures the scene.**

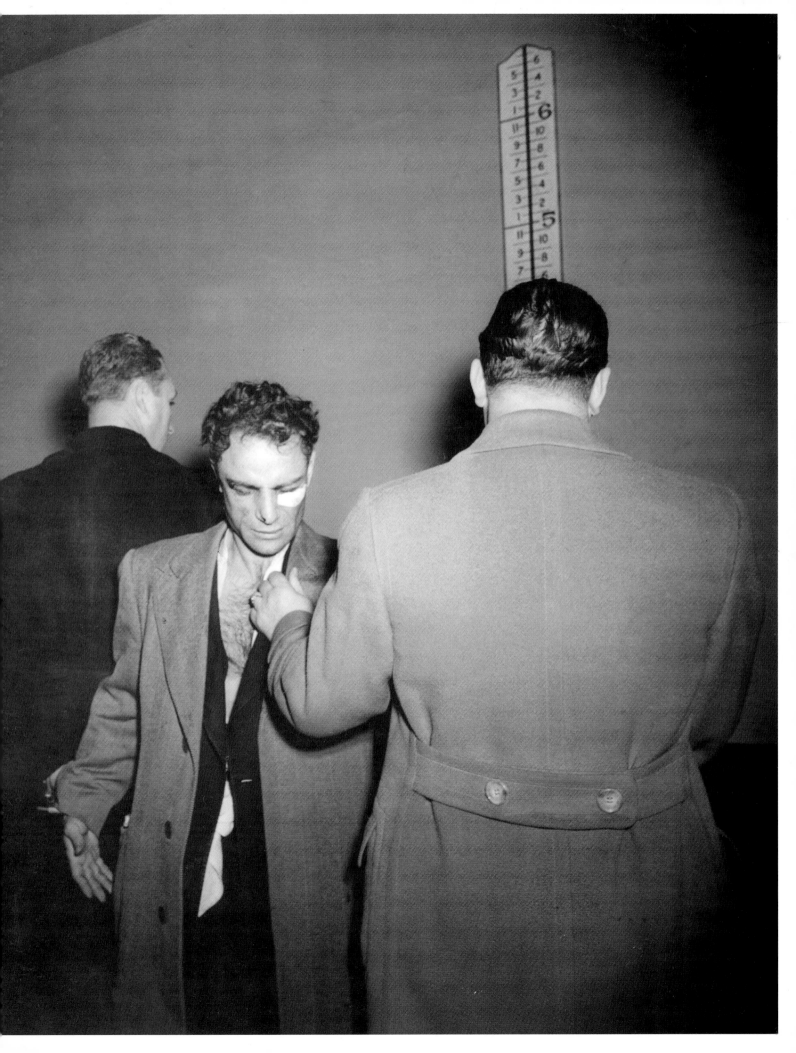

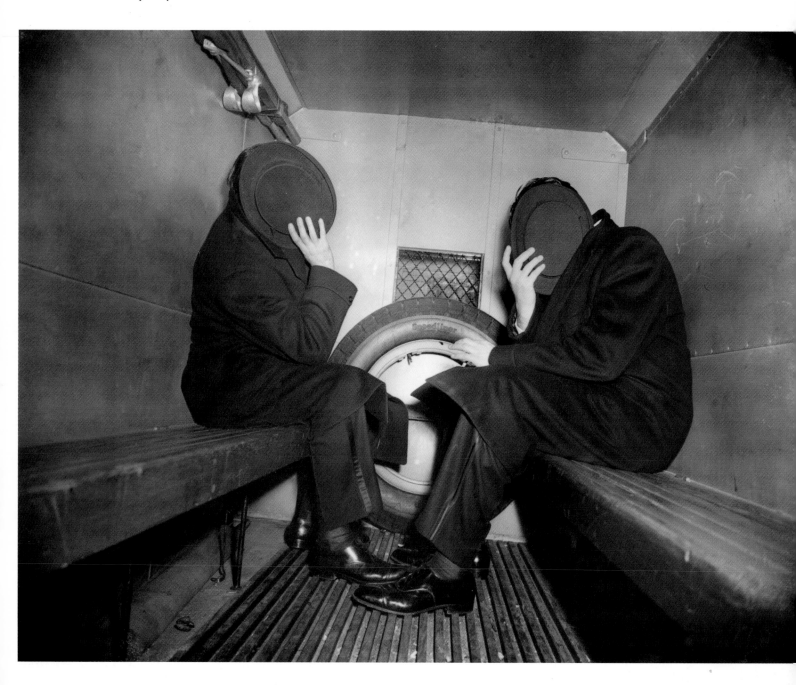

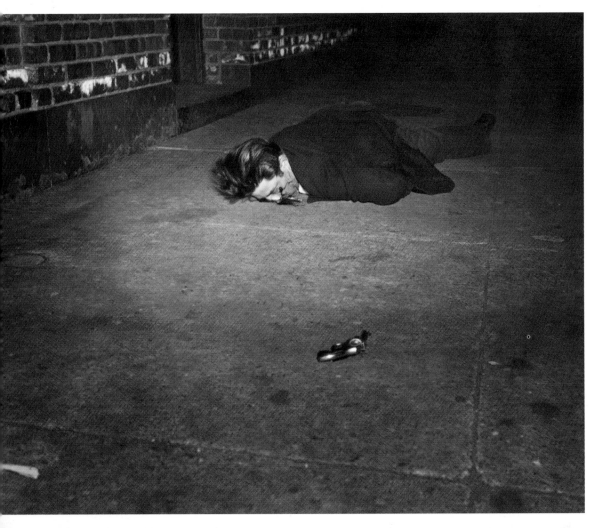

LEFT: **When a gunman attempted a hold-up at the Spring Arrow Social and Athletic Club in New York City, 1942, he was shot by off-duty policeman, Eligio Sarro, who was at the scene by chance. The circle of light in which the gunman's torso and head are placed has undoubtedly been accentuated for dramatic effect by Weegee's printing of the negative.**

BELOW: **"Here he is as he was left in the gutter, in a pool of his own blood." The body of a young man, with DOA (Dead on Arrival) tag already fixed to his right arm, lies in a New York Street, 1941.**

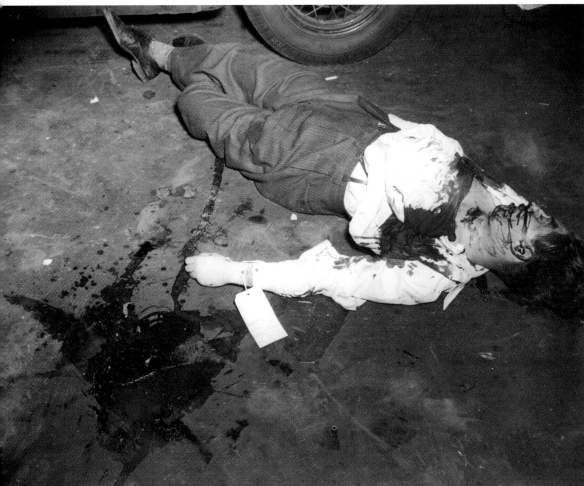

OVERLEAF LEFT: **This image of firemen extinguishing a fire in the Ameko American Kitchen Products Company building in New York, 1937, is a classic example of Weegee's ability to find images that are both documentary reportage and ironic commentary on the events depicted. The sign "Simply add boiling water" is an advertisement for a brand of frankfurter.**

OVERLEAF RIGHT: **A New York fireman holds a hose at the scene of a fire in New York, 1940. Weegee's work, much of it made at night with a 4 x 5 inch (10 cm x 12 cm) press camera and a powerful flashbulb, plays with the caricature qualities of black-and-white photography.**

LI ZHENSHENG

Li's photographs are a rare, and possibly unique, pictorial record of the horror, absurdity and brutality that accompanied Mao's Cultural Revolution. Published as *Red-color News Soldier* (2003), the book also contains much of the sort of imagery distributed as propaganda during this era, which showed the parades, demonstrations and processions that were part and parcel of this extraordinary moment in Chinese history. Li's pictures also reveal the ritual humiliations of those denounced as bourgeois speculators. Their meagre possessions are organized into a still life, bearing witness to their decadence – a wristwatch, a handbag or a pair of foreign-made shoes are displayed as the paltry evidence of their counter-revolutionary nature.

There is a much darker side to this work, for Li also photographed executions, and the grisly sequences of events leading up to them. In one of his photographs, taken in 1967, the Chinese leader Chairman Mao appears, crossing Beijing's Tiananmen Square in a jeep that speeds through a crowd of admirers. Although Li got only one chance to capture Mao in person, his image is omnipresent in many of Li's photographs, carried by the rebel groups and political zealots on banners or large framed portraits, shown on massive posters, or blazoned across cinema screens saluted by Red Guards.

The most remarkable aspect of Li's work is that he managed to safeguard so much of it. He had been, in 1966 and 1967, a supporter of the revolution, so his access to many of the events that marked this period was privileged, and in due course it rebounded upon him. To retain the negatives of these pictures was highly subversive. They show that Li was visually gifted, and was interested in making a good picture. They reveal how he tried to compose these photographs to dramatic effect, and how he surmounted the limitations of his equipment (Russian 35mm cameras and a Rolleiflex 6x6cm). The "joiners" (overlapping 35mm or 6x6cm negatives) that were used by Li to make a panorama, sometimes 6–7 frames wide, capture the wider view of a political rally or a group pasting posters on a billboard, and offer another perspective on this troubled era.

INDEX

Note: page numbers in **bold** refer to picture captions.

Abilene, Texas **139**
Abu Ghuraib 8, 9
Acme Photos 17, 242
Adams, Ansel 10, 13
Afghanistan 11, 15, 66, **69**, 194
Africa 15, 56, 215
African Americans 16, **214**, 215, **216**, 218
Afrikaners 148
Agence-France-Presse 15
Agent Orange **116**
Agnews 74, **77**
AIDS 7, 15, 144, 168, **168**, **170–2**, 218, 234
Al-Maaqal Prison, Iraq **84**
Alabama **136**
Albania 14, **91–2**, 153, **154**
Albert, Prince 74
Aldrin, Edwin **182**
Algeria 11, 13, 56
Allied forces 94
Ameko American Kitchen Products Company **245**
American Civil War 8, 12, 80, **80**, **83**, 239
American Dream 218
American underclass 156, **156**, **158–9**
Amiens 14
ANC 14, **151**
Anglo-French expedition to China, 1860 **33**
Angola 15
apartheid 14, 34, 148
Aperture magazine 13
Apis agency 11
Apollo spaceship **182**
Arabs **204**
Arafat **202**
Aragon Front **54–5**
Arena magazine 14
Armani, Georgio 13
Armstrong, Neil **182**
Arts Council, The 16
Asian tsunami, 2004 13, 234, **234**, **237**
Associated Press 10
astronauts 182, **182**, **185**
Auschwitz 16, 222
Australian army 12, **106**, **107**

Baghdad 8, **135**
Bagram military airbase **69**
Balaklava **77**
Balkans 15
Baltermants, Dmitri 10, 18–23, **18**, **21–2**
Bam, Iran 85, **87**
Banda Aceh **237**
Bangladesh 34, **34–5**, 144
Basra, Iraq **133**, **135**

Battaglia, Letizia 10, 24–7
Battaglia, Vincenzo **25**
Beato, Antoine 10
Beato, Felice A. 8, 10, 28–33
Beijing 28, 248
Beirut 10, 16, **202**, 202, 215
Belfast **94**
Benetton **140**
Berlin 13, **65**, 128, **128**
Berlin, battle of 1945 120, **122**
Berlin Wall 16, 17, **64–5**, 88, **207**
Berry, Ian 10, 34–7, 125
Bhopal, India 16, 211, **212**
Biafra 11, **146–7**
Black Forest 102
Black Power **216**
Black Shirts **73**
Black Star agency 17
Blair, Tony 17
Bloody Sunday 16
Blue Beach 94
Boipatong massacre **151**
Borneo, Malaysia 160, **160**, **162**
Bosnia 11, 13, 16–17, 85, 112, **112–13**, **239**, **241**
Boston Globe (newspaper) 15
Botha, Pik **151**
Bourke-White, Margaret 10, 38–41, 186
Brady, Matthew 8, 12, 239
Braun, Eva 102
Brazil 14, 226, **229**
Brezhnev, Leonid 10
British Army **32–3**
 5th Dragoon Guards 77
 8th Hussars **74**, 77
 28th Regiment 77
 93rd Highlanders **30**
 Hodson's Horse **30**
 Light Brigade 74, 77
British Broadcasting Corporation (BBC) 16
British Museum 11
British underclass 144
Bronx 14
Brooklyn, New York **204–5**, 218, **221**, **244**
bull fighting **45**
Burgess, Neil 7, 168
Burma 10
Burri, René 10, 42–5
Burrows, Larry 9, 10–11, 46–51, 116, 215
Buthelezi **151**
Butler, Major 77

Calcutta 211
Caldwell, Arsine 38

Cam Nghia, Vietnam **116**
Cambodia 10, 11, 13, 56
Cameron, James 94
Capa, Robert 8–9, 11, 52–5, 70
Cape Town, South Africa **170**
Capitol Building **216**
Carlton Hotel, Geneva **73**
Caron, Gilles 9, 11, 56–9
Cartier-Bresson, Henri 9–11, 15, 16, 42, 60–5, 70, 144, 198, 206
Castro, Fidel 42
Caucasus **140**
Central America 15, 215
Ceriani, Ernest C. **230**, **232**
Chad 11
Chaoyang Commune, Shuangcheng County **248**
"cheap and chic" show **114**
Chechnya 11, 85
Chernobyl nuclear disaster **140**
China 10–11, 13–15, 28, **33**, 174, **174**, **176**, 226
Chinese Army **32**
Church Gate railway station, Bombay **226**
Churchill, Winston 70, 120
classless society 178
Cocteau, Jean **45**
Collier's magazine 53
Colorado **230**
Columbia mud slides 88
Communism 10, 17, 38, 125, 140, **176**
Congo 10, 14
Contact Press Images 56
Corrida **45**
Cowboys **196**
Crimea 10, 18, **18**, **22**
Crimean war 8, 28, 74, **74**, 77
Croatia 13
Cuba 11, 42, **42**
Cultural Revolution 17, 248
Czechoslovakia 10, 13, **124**, 125, **126**

D-Day 12, 53, **53**
Damm family 14, **158**
DC4 **38**
de Klerk, President **151**
Delahaye, Luc 8, 9, 11, 66–9
Delta, Vietnam **47**
Dephot agency 11
Detroit News (newspaper) 16
Diana, Princess 178, **180–1**
Digital Journalist, The 70
Dixon, Maynard 13, 136
Doolittle Raid 15
drug culture **218**, **221**

Drum magazine 10, 14
Dubcek, Alexander 125

eclipses **200**
Eisenhower, Dwight D. 15
Eisenstaedt, Alfred 11, 15, 70–3, 186
Ekstra Bladet (newspaper) 12
El Salvador 14
Elgort, Arthur 234
Ellis Island 12, 98, **98, 101**
Empire State Building 12, 98
Endurance (ship) 12, 106, **108, 110**
England **178, 180–1**
Esposito, Anthony **242**
Ethiopia 10
European Union (EU) 153

Fahme, Palestine **202**
Fakui earthquake, Japan 186, **186, 188–9**
Farm Security Administration 13, 15, 136
Fascists 120
 see also Black Shirts
fashion photography 13, 17, **114**
Fat Convention **194**
Fengdu **174**
Fenton, Roger 8, 11, 74–9
Fifth Avenue, battle of **242**
Final Solution 222
First World War 10, 12, 106
floods **34–5**
former Yugoslavia 9, 66, 88, 112, 153
Fortune magazine 10, 38
France 15, 106
Frassanito, William 80
French Resistance 60
Friedman, Endre *see* Capa, Robert
Führer 102
 see also Hitler, Adolf

Gandhi, Mahatma 10, 38, **40, 41**
Gardner, Alexander 8, 12, 80–3
Gaza 13
Genthe, Arnold 13
Geo 14, 15, 16
George VI, King of England **62**
German Army 12, 15
 Sixth 140
Germany 12, 56, **59,** 140
Gestapo **60**
glasnost 140
Goebbels, Joseph **73**
Goering, Herman **102, 121**
Good Morning America 194

Gorbachev, Mikhail 13
GQ magazine 14
Grarup, Jan 12, 84–7
Grazia Neri agency 14
Great Depression 10, 38, 136, **136, 139**
Great Patriotic War **121**
Griffiths, Philip Jones 9, 13, 112
Grossman, Mendel 222
Grossman, Ross 222
Guadalcanal 15
Guardian, The (newspaper) 15
Guevara, Che 10, 42, **42**
Gulag 153
Gulf War 1991 144, 239
gun culture 15, 194, **196**
Guttman, Simon 11
Guzy, Carol 9, 12, 88–93

Haiti 13, 17, 88, 215
Halstead, Dirk 70
Harbin 17, **250, 251**
Hardy, Bert 12, 94–7
Harper's Bazaar magazine 17
Hartson, Buzz 156
Hello! magazine 182
Hill 484, Vietnam **47**
Hindustan Times (newspaper) 16
Hine, Lewis 9, 12, 98–101, 136
Hispanic Americans 218
Hitler, Adolf 12, 102, **102, 207**
HIV 7, 168, **168, 170, 172**
 see also AIDS
Hodson **30**
Hoffman, Heinrich 12, 102–5
Holmes, Oliver Wendell 80
Hong Kong 28
Hopkinson, Tom 94
Hulton, Edward 94
Hurley, Frank 12, 106–11
Hussein, Saddam 8
Hutchings, Roger 9, 13, 112–15
Hutus **208**

Inchon 94
Independent, The (newspaper) 14
Independent Magazine 15
India 10, 11, 13, 14, 16, 144, 211, **212,** 226
India Today magazine 16
Indian Army
 4th Punjab Regiment **30**
 Hodson's Horse **30**
 Sikh troops **28**
Indian independence **40**

Indian Mutiny (1857–8) 28, **28**
Indochina 11, 56
Indonesia 226
Inkatha Freedom Party **151**
International HIV/AIDS Alliance, The **172**
International Photography Center, New York
 156
Internet 206
Iran 14, 15, 16, 85, **87**
Iraq 8–9, 11, 13–14, 47, 66, 133, **133, 135**
Israel 10, 11, 16, 67, 202

Japan 10, 13, **70**
Japanese Americans 136
Jenin, Palestine **67, 202**
Jewish people 98, **98,** 222, **222**
Johannesburg, South Africa **151**
Johannesburg Star (newspaper) 15
Jones Griffiths, Philip 116–19

Kabul **66, 69**
Kennedy, John F. 70
Kensington Palace, London **181**
Kentucky, USA **159**
Kerch, Crimea 18, **18, 22**
Khaldei, Yevgeny 13, 120–3
Khaliajuri **35**
Khmer-Rouge 11
Kiev **140**
Klein, William 242
Korea 28
 see also South Korea
Korean War 94
Kosovo 12, **91**
Koudelka, Josef 13, 124–7, **126**
Krasnopresnenskaya Square **140**
"Krizia" **114**
Krueng Raya **237**
Krushchev, Nikita 10
Kukes camp, Albania **91**
Kurdistan 14
KwaMadal Zulu **151**

"La Californie" villa, Cannes **45**
LA Times (newspaper) 9
Ladefoged, Joachim 13, 128–31
Lampen, Jerry 8, 13, 132–5
Lange, Dorothea 13, 136–9
League of Nations **73**
Lebanon 11, 14, 144
Leros mental hospital 14, **152,** 153
Levitt, Helen 242
Liberia 85

Life magazine 8–11, 13–17, 38, 47, 53, 70, **70**, 182, **185**, 186, **189**, 230
Lincoln, Abraham **80**
Lindbergh, Peter 234
Lodz ghetto 16, 222, **222**, **225**
London Fashion Week **114**
Londonderry **97**
Look magazine 42
L'Ora (newspaper) 10
Los Angeles riots 215
Louisville, Kentucky **38**
Lovell, Jim **185**
Luce, Henry 10
Lucknow **30**
Ludendorff, General **102**
Ludwig, Gerd 14, 140–3

MacArthur, General 15
Madden, Roger 10
Mafia 10, 25, **26**, **140**
Magnum Photos cooperative 9–11, 13–16, 17, 53
Magubane, Peter 14, 148–51
Mahat, Begum Zenal **28**
Majoli, Alex 14, 152–5
Malawi 7, 168, **168**, **171**
Manchester Guardian (newspaper) 13
Mandela, Nelson 14, 17, 148, **148**, **151**
Mandela, Winnie **148**
Mao Zedong 174, 248, **249**, **251**
Mark, Mary Ellen 14, 156–9
Marlow, Peter 14, 160–3
Mawson, Douglas 12
Mayes, Steven 202
McClernand, John A. **80**
McCullin, Don 9, 14, 56, 116, 144–7, 218
Meiselas, Susan 14, 164–7
Mendel, Gideon 7, 15, 168–73
Menin Road **106**
Mercury Seven 182
Meunier, Bertrand 15, 174–7
Mexico 15, 226
Miami Herald (newspaper) 12
Middle East 9, 10, 12, 13, 15, 16, 202
Miller, Russell 42
Million Man March **214**, 215, **216**
mining **176**, **229**
Mission of Charity 211
Mississippi **138**
Model, Lisette 242
Modell, David 15, 178–81
Molinard, Patrice 11
Monroe, Marilyn 70
Morse, Ralph 15, 182–5

Motorcycle Diaries, The (2004) 42
Mueller, Patric **148**
Muroemba family **172**
Museum of Modern Art 16, 242
Muslims **87**, **204–5**
Mussolini, Benito **73**
Mydans, Carl 15, 186–9

Nachtwey, James 8, 9, 15, 190–3
Nadar 234
NASA 182, **182**
NATASHA department store **140**
National Geographic magazine 14, 16, **140**
Native Americans 136
Nazis 11–12, 18, 60, **73**, **102**, **121**, 222
Nelson, Zed 9, 15, 194–7
Network Photographers 13, 15, 16, 202
New Age travellers 128, **128**, **131**
New Brighton 198, **198**
New Delhi **41**
New Guinea 144
New York 17, **38**, 242, **242**, **244**, **245**
New York School 242
New York Times (newspaper) 14, 16, 17
New York Times Magazine 17
Newsweek 11, 14–17, 66, 153, 174
Newton, Helmut 234
Nicaragua 14, 165, **167**
Nigeria 11, **147**
Nigerian civil war 144
Northern Alliance **66**, **69**
Northern Ireland 11, 13, 16, **94**, **97**, 116, **118**, 144
Nuremberg War Crimes Trials 15, 120, **121**
Nyamata, Rwanda **209**

obesity 15, 194, **194**
Observer, The (newspaper) 13
Ogonyok (news publication) 10
Olympic Games 2004 13
Omaha Beach, Normandy **53**
Opium Wars 28, **32**
Oregon **138**, 156
O'Sullivan, Timothy 80

Pakistan 10, 13, 15
Palestine 16, **67**, 85, 202, **202**
Palmero, Sicily 25, **26**
Panan Indians 160, **162**
Paraguay 144
Paris 11, 12, 56, **56**, **59**
Paris Match 15, 16
Paris student riots, 1960s 16, 206
Parr, Martin 9, 16, 198–201

Passchendaele **107**
Passow, Judah 16, 202–5
Patton, George S. 15
Pehtang Fort **32**
Penhalonga **172**
Penn Station **70**
Pennsylvania Station **70**
Pereira-Frears, Amy 174
Peress, Gilles 9, 16, 85, 206–9
Philadelphia, Pennsylvania **218**
Philippines 15
Photo District News magazine 218
Photographic Society of London 11
Picasso, Claude **45**
Picasso, Pablo 10, **45**
Picasso, Paloma **45**
Picture Post (magazine) 12, 94, **94**, **97**
Pinkerton, Major Allan **80**
Pledge, Robert 56
PLO headquarters, West Beirut **202**
pogroms **98**
Poland 10, 16
Politiken (newspaper) 12, 13
Potsdam conference 120
Prague 11, 13
Prague Spring, 1968 125, **126**
Pravda (newspaper) 120
Pulitzer Prize **91**
Purdie, Sgt Jeremiah **47**

Quy, Pham Hong **116**

Rai, Raghu 16, 210–13
rainforests **160**, **162**
Rand Daily Mail, The (newspaper) 14
Rand Daily News (newspaper) 10
Rapho agency 12
Reagan, Ronald 17
Reagan administration **158**
Red Army 13
Red Cross 12
Red Guards 248, **250**
Reed, Eli 9, 16, 214–17
Reichstag 12, 120, **122**
Reichswehr **102**
Republic of Macedonia 14
Reuters 13, **133**
Riboud, Marc 15
Richards, Eugene 16, 218–19
Riefenstahl, Leni 102
Riis, Jacob 136
Robertson, James 10, 28
Robinson, Alec **94**

Roma culture 85
Romania 12
Roosevelt, Franklin D. 120
Ross, Henryk 16, 222–5
Royal Academy 11
Royal Air Force (RAF) 14
Royal Cossack Cadet Academy **140**
Royal Marines 239
Rumkowski, Chaim 222
Russia 10, **98**, 120, 140, **140**
Russian army 120, **122**, 125
Rwanda 11, 16, 17, 88, **208–9**
Rwandan Patriot Army **208**

SA stormtroopers 102
Sack, Steven 148
Sahel 17
St Ives, Cornwall **200**
St Marks Square, Venice **73**
Salgado, Sebastião 9, 17, 85, 226–9
San Francisco Examiner (newspaper) 16
Sandinistra rebels 165, **167**
Sarajevo, Bosnia 17, **112–13**, **239**, **241**
Sarro, Eligiio **245**
Scutari hospital, Albania **154**
Seattle street children 14, 156, **156**
Second World War 9–12, 15, 17, 18, **18**, **21–2**, 53, **53**, 60, 136, 182
Serbians **91**, **239**
Shackleton, Ernest 12, 106
Shala, Bekir 91
Sharpsville, South Africa 10, 14, **148**
Shephard, Alan **182**
Shillom, Assaam **211**
Sierra Pelada **229**
Simpson, Wallis **62**
Sino-Japanese War 17
Six-Day War 11
Slovakia 85
Slovakian gypsies 13, 125
Smith, Shelly 15
Smith, W. Eugene 9, 17, 70, 85, 116, 206, 215, 230–3
sniper alley, Sarajevo, Bosnia **241**
Sochi cemetery **140**
social class 144, 156, **156**, **158–9**, 178
Sodokoff, Charles **244**
Somalia 15
Somerset 144
Somoza Debayle, Anastasio 165, **167**
South Africa 10, 14, 34, 148, **148**, **151**, **170**
South Korea 94
Soviet Union 11, 13, 38, 120, 140, 182
Soweto student uprisings 14

Spanish Civil War 11, 53, **54**
Spanish Republican Army 53, 54–5
Spiegel 14
Split, Bosnia **113**
Spring Arrow Social and Athletic Club, New York **245**
Sri Lanka 13, 234, **234**
Stalin, Josef 13, 120, 153, 207
Stanmeyer, John 17, 234–7
Statesman, The 16
Stern 14, 15
Stevens, Robert 234
Stieglitz, Alfred 98
Stoddart, Tom 8, 9, 17, 238–41
Strand, Paul 12
strippers 165, **165**
Sudan 10, 13, 17, 28
Sunday Telegraph (newspaper) 15
Sunday Times, The (newspaper) 14, 16
Sunday Times Magazine 14, 15
Sygma 14

Taj Mahal 10–11
Taku Forts **32**
Taliban 66, **66**, **69**
Tampa Tribune (newspaper) 17
Tanzania 7, 168
TASS 13, 120
Taylor, Paul 13
Telegraph Magazine 160
Teresa, Mother 211, **211**
Tet Offensive, 1968 **51**, **144**, **145**
Thailand 13
Thatcher, Margaret 178
Third Reich 102
Tianmen Square 248
Time magazine 14, 15, 16, 17, 234
Times Square, New York 11, **70**
Tokyo 15
Tomas, Elisa **172**
Tomas, Tomas **172**
Toubou uprising 11
tourism 198, **198**, **199**
Trafalgar Square, London **62**
Trans Antarctic Expedition, 1914–17 12, 106, **108**
Treason Trials 14
Trotsky, Leon 11
Turkey 13

Uganda 168
underclasses 144, 156, **156**, **158–9**
Union Carbide 211
Union Pacific Railroad 12
Union troops 80

United Arab Emirates **91**
United Nations (UN) 112
United Nations Children's Fund (UNICEF) **92**
United States 66, 194, 218
Universal Studios **196**
US 1st Air Cavalry **51**
US Marines **47**, **144**
US Navy **237**
US troops **133**, **189**

Vaal Triangle township **151**
Vanity Fair magazine 14, 17
Velvet Revolution, 1989 125
Victoria, Queen 74
Vietcong **47**
Vietnam War 9–11, 13, 47, **47**, **51**, 112, 116, **116**, 144, **144–5**, 191
VII agency 13, 15, 17
VISUM 14
VU agency 15

Wagon Camp, Berlin 128, **128**
Wanxian City **174**
Warsaw Pact troops **124**, 125, **126**
Washington Post (newspaper) 12, 88
water crisis **34**
Watson, Albert 234
Webber, Arthur **244**
Weegee 17, 242–7
Wek, Alek **114**
Wellford, Jamie 66, 153
West Bank **67**, 202
West Berlin **65**
Western Front 106, **107**
Whelan, Richard 53
White, Clarence 13
Wilder, Thornton 15
Wilkin, Cornet **77**
Windsor, Duke of **62**
World Cup, 1994 **178**
World Trade Center attacks 16, 88, **191**, **204**
Wushan **176**

Xiaoping, Deng 174

Yemen 13
Ypres 12, 106
Yugoslavia 13, 14

Zambia 7, 168, **168**
Zhensheng, Li 17, 248–51
Zimbabwe 7, 168, **172**
Zulus **151**

CREDITS

The publishers would like to thank the following sources for their kind permission to reproduce the pictures in this book.

Agence VU:
Bertrand Meunier: 174, 175, 176, 177

Archive of Modern Conflict 2004:
Henryk Ross/Courtesy Chris Boot Ltd: 222, 223, 224, 225

Letizia Battaglia:
24–5, 26, 27

Corbis Images:
Roger Fenton: 74–5, 76; /Alexander Gardner/Bettmann: 80; /Heinrich Hoffman/Bettmann: 102–3, 104, 105; /Jerry Lampen/Reuters: 132–3, 134, 135; /Dorothea Lange: 6–7, 136, 137, 138, 139; /Gideon Mendel for the International HIV/AIDS Alliance: 4–5; /Gideon Mendel: 168, 169, 170, 171, 172–3

Getty Images:
Felice Beato: 28, 29, 30, 31, 32, 33; /Margaret Bourke-White/Time Life Pictures: 38, 38–9, 40, 41; /Larry Burrows/Time Life Pictures: 46, 47, 48, 49, 50, 51; /Alfred Eisenstaedt/Pix Inc./Time LifePictures: 70, 71, 72, 73; /Roger Fenton: 77; /Alexander Gardner/Mathew Brady Collection/National Archives/Time Life Pictures: 8; /Alexander Gardner: 82–3; /Bert Hardy: 6, 94, 95, 96–7; /Lewis W. Hine: 99; /Lewis W. Hine/George Eastman House: 98, 100, 101; /Lewis W. Hine/Museum of City of N. York: 101; /Ralph Morse/Time Life Pictures: 182, 183, 184, 185; /Peter Mugabane/Time Life Pictures: 148, 149,150, 151; /Carl Mydans/Time Life Pictures: 186, 187, 188, 189; /Weegee (Arthur Fellig) International Centre of Photography: 9, Endpapers

Katz Pictures/IPG:
David Modell: 178–9, 180, 181; /Zed Nelson: 194, 195, 196, 197; /Tom Stoddart: 238–9, 240, 241

Library of Congress Prints & Photographs Division:
Roger Fenton: 78, 79

Magnum Photos Ltd:
Ian Berry: 34, 35, 36–7; /Rene Burri: 42–3, 44, 45; /Cornell Capa Photos by Robert Capa: 52–3, 54, 55; /Henri Cartier-Bresson: 60–1, 62, 63, 64, 65; /Luc Delahaye: 66, 67, 68, 69; /Philip Jones Griffiths: 116–17, 118, 119; /Josef Koudelka: 124–5,

126, 127; /Alex Majoli: 152, 153, 154, 155; /Peter Marlow: 160–1, 162, 163; /Susan Meiselas: 164–5, 166, 167; /Martin Parr: 198. 199, 200–1; /Gilles Peress: 206–7, 208, 209; /Raghu Rai: 210–11, 212, 213; /Eli Reed: 214–15, 216, 217; /Eugene W. Smith: 230–1, 232; 233

Mary Ellen Mark:
156–7, 158, 159

Moscow House of Photography:
Dmitri Baltermants: 18, 19, 20, 21, 22–3

National Library of Australia:
Frank Hurley: 106, 107

nbpictures:
Gilles Caron/Contact Press Images: 56, 57, 58–9; /Don McCullin/Contact Press Images: 144, 145, 146, 147; /Sebastião Salgado/Amazanos: 226–7, 228, 229; /Li Zhensheng/Contact Press Images: 248, 249, 250, 251

Network Photographers:
Roger Hutchings: 112, 113, 114, 115; /Judah Passow: 202, 203, 204, 205

Novosti Picture Library:
Yevgney Khaldei: 120, 120–1, 122–3

Panos Pictures:
Gerd Ludwig: 140, 141, 142, 143

Rapho:
Top/Jan Grarup: 84–5, 86, 87

Royal Geographical Society:
Frank Hurley: 108–9, 110, 111

VII:
Joachim Ladefoged: 128–9, 130, 131; /James Nachtwey: 190–1, 192, 193; /John Stanmeyer: 234–5, 236, 237

Washington Post Writer's Group:
Carol Guzy: 88–9, 90, 91, 92–3

Every effort has been made to acknowledge correctly and contact the source and/or copyright holder of each picture and Carlton Books Limited apologizes for any unintentional errors or omissions that will be corrected in future editions of this book.

Author's Acknowledgements

This book could not have turned out the way it did and on schedule without the invaluable help of my co-writers, Peter Hamilton and David Walker, who are friends as well as colleagues. Peter wrote the profiles on the following photographers: Dmitri Baltermants, Felice Beato, Ian Berry, Robert Capa, Gilles Caron, Roger Fenton, Bert Hardy, Lewis Hine, Heinrich Hoffman, Yevgeny Khaldei, Josef Koudelka, Don McCullin, Henry Ross, Weegee and Li Zhensheng, David wrote the profiles for the following five photographers: Jan Grarup, Dorothea Lange, James Nachtwey, Eli Reed and John Stanmeyer.

I would also like to thank my editor at Carlton Books, Stella Caldwell, who originally approved my idea for such a book and then intelligently and coolly brought the project together from concept to execution. Thanks also to Sarah Edwards for photo research and to the design team of Stuart Smith, Anita Ruddell and Emma Wicks.

I would also like to thank Jeanine Fijol, my colleague at *Photo District News* for her help with the initial photo research. Thanks also to Holly Stuart Hughes, my editor in chief at PDN, for her insights and suggestions. Also at PDN, Darren Ching, Jay DeFoore, John Gimenez, Michelle Golden, Jane Helmick, Anthony LaSala, Jacqueline Tobin and Michael Goesele were all helpful in different ways and always encouraging.

Steve Mayes at Art Commerce, Paul Moakley at *Newsweek*, Neil Burgess at NB Pictures and Nadja Masri at Geo all came up with some great photographers for possible inclusion in the book. Thanks also to Chris Boot, Abby Johnson and Michelle Franklin at Getty, Jackie Ching and Gideon Rachman.

I would also like to thank some of the photographers featured in this book who took the time to answer my questions about their work. Interviews were conducted both by phone and e-mail. Thanks also to the various experts and photo editors for their critical judgments, in particular Jamie Wellford at *Newsweek*.

Finally, I would also like to thank my wife Emma for her love, assistance and wisdom. This book is dedicated to you.

Reuel Golden